PIERRE BONNARD: The Graphic Art

PIERRE BONNARD
The Graphic Art

COLTA IVES

HELEN GIAMBRUNI

SASHA M. NEWMAN

The Metropolitan Museum of Art, New York
DISTRIBUTED BY Harry N. Abrams, Inc., New York

This book is published
in conjunction with the exhibition

PIERRE BONNARD : The Graphic Art

The Metropolitan Museum of Art, New York
DECEMBER 2, 1989 – FEBRUARY 4, 1990

Museum of Fine Arts, Houston
FEBRUARY 25 – APRIL 29, 1990

Museum of Fine Arts, Boston
MAY 25 – JULY 29, 1990

The exhibition is made possible by

The Real Estate Council
of The Metropolitan Museum of Art.

Additional support has been provided by
the William Randolph Hearst Foundation
and the National Endowment for the Arts.

PUBLISHED BY
The Metropolitan Museum of Art, New York

John P. O'Neill, *Editor in Chief*
M. E. D. Laing, *Editor, with the assistance of*
 Rodolfo G. Aiello, Cynthia Clark, and Ann Lucke
Peter Oldenburg, *Designer*
Helga Lose, *Production*

Typeset by Dix Type Inc., Syracuse, N.Y.
Printed and bound by Imprimerie Jean Genoud SA,
Lausanne, Switzerland

COVER / JACKET
La Revue blanche poster (detail), 1894

LIBRARY OF CONGRESS
CATALOGING IN PUBLISHING DATA

Bonnard, Pierre, 1867–1947.
 Pierre Bonnard, the graphic art.
 Published in conjunction with an exhibition held at
Metropolitan Museum of Art, New York, Dec. 2, 1989–Feb.
4, 1990; Museum of Fine Arts, Houston, Feb. 25–Apr. 29,
1990; Museum of Fine Arts, Boston, May 25–July 29, 1990.
 Includes catalog. Bibliographical references. Index.
ISBN 0-87099-566-9; ISBN 0-87099-567-7 (pbk.);
ISBN 0-8109-3100-1 (Abrams)
 1. Bonnard, Pierre, 1867–1947—Exhibitions. I. Ives,
Colta Feller. II. Giambruni, Helen Emery. III. Newman,
Sasha M. IV. Metropolitan Museum of Art (New York,
N.Y.). V. Museum of Fine Arts, Houston. VI. Museum
of Fine Arts, Boston. VII. Title.
NE2349.5.B66A4 1989 769.92 89-12847

Permission to quote in chapter 2 from Stéphane Mallarmé,
Selected Poems, trans./ed. C. F. MacIntyre (© 1957 1986
C. F. MacIntyre) and from Paul Verlaine, *Selected Poems*,
trans./ed. C. F. MacIntyre (© 1948 The Regents of the
University of California) has been granted by the publisher,
The University of California Press.

CONTENTS

FOREWORD

RECENT EXHIBITIONS in Paris, Washington, D.C., Dallas, Zurich, Bordeaux, and Milan attest to a widespread resurgence of enthusiasm for the paintings of Pierre Bonnard, particularly as his pursuit of an independent course is evaluated on its own terms, apart from the dominant trends of the twentieth century. Until now, however, the artist's graphic work—his color lithographs, poster designs, and inventive illustrations—has not received the same public attention, and only rarely is it seen in the larger context of Bonnard's oeuvre. Indeed, twenty-five years have passed since the Museum of Modern Art, New York, the Los Angeles County Museum of Art, and the Art Institute of Chicago collaborated in the production of "Bonnard and His Environment," the most recent exhibition in this country to encompass the broad range of Bonnard's expression in all media.

The Metropolitan Museum is particularly well equipped to host "Pierre Bonnard: The Graphic Art," for its collection of Bonnard's prints and illustrated books, which began with curatorial purchases in 1922, is extremely fine. In fact, it forms the core of the exhibition, which includes over one hundred works—lithographs, etchings, illustrated books, drawings, paintings, and photographs—drawn from thirty-six public and private collections in Europe and the United States. It is gratifying that after New York the exhibition travels to the Museum of Fine Arts, Houston, and the Museum of Fine Arts, Boston, where the study of French prints and paintings of the late nineteenth and early twentieth centuries is also actively pursued.

The organization of this project and the selection of works shown are the result of over three years' research and field work on the part of Colta Ives, Curator-in-charge of the Metropolitan Museum's Department of Prints and Photographs. In putting together a publication suited to the occasion, Ms Ives invited two other scholars to share in the writing of the individual essays: Helen Giambruni, whose doctoral dissertation at the University of California, Berkeley, focused on Bonnard's early works;

and Sasha M. Newman, Seymour H. Knox, Jr., Curator of European and Contemporary Art at Yale University Art Gallery, who was formerly at the Phillips Collection, Washington, D.C., and was one of the organizers of the 1984 exhibition "Bonnard: The Late Paintings."

Without the generosity of many institutions and private collectors who helped in the research and preparation of the show and who graciously agreed to share treasured works of art, this exhibition could not have been realized. Among those who deserve our gratitude for their unstinting assistance are Antoine Terrasse (the artist's grandnephew), Leopoldo Rodés Castañé, Margrit Hahnloser-Ingold, Virginia and Ira Jackson, Samuel Josefowitz, Alice Mason, Mr. and Mrs. Derald H. Ruttenberg, Eugene Victor Thaw, and Daniel Wildenstein.

For the financial support so essential to this undertaking we are grateful to the Real Estate Council of The Metropolitan Museum of Art, which funded the exhibition in New York, and to the William Randolph Hearst Foundation and the National Endowment for the Arts, which provided additional funding.

PHILIPPE DE MONTEBELLO
Director, The Metropolitan Museum of Art

PREFACE
and Acknowledgments

THE SPECIAL PLACE of printmaking and illustration in Bonnard's career warrants our attention, as much as the ingenuity and wit of the work itself. The artist's graphic production, which came close to outweighing his activity in painting during the first decade or so of his career, continued, albeit intermittently, throughout his life. Indeed, it can be described as the public face of Bonnard's art, the one that shows him at his most gregarious and entertaining.

To be properly understood and appreciated this material must be studied, not in isolation, but in light of Bonnard's oeuvre as a whole. Otherwise, like a phrase quoted out of context, it runs the risk of having its meaning changed or even rendered unintelligible once it is no longer part of the larger passage. This belief lies behind the authors' decision to organize their material around the broad themes that engaged Bonnard's attention, and through these to address questions of continuity and change in his aesthetic and stylistic development.

In an introductory chapter Colta Ives presents an overview of Bonnard's activities as a graphic artist. She relates them at their outset to the publishing of posters, prints, and illustrated periodicals in the late nineteenth century, to the exploitation of lithography as a means of reaching a wider audience, and to the young painter's concern for "the connections between art and life" and the creation of "a popular production with everyday application."

Helen Giambruni looks at Bonnard's domestic subjects, including his illustrations of and for children, connecting them to his personal experience and examining them in the light of aesthetic concepts he drew from the Symbolist movement during his early years. She holds that Bonnard's lifetime habit of working from memory stemmed from a concern for emotional rather than visual truth, and that the seeming awkwardness of his drawing reflects not lack of skill but beliefs about the expressiveness of "primitive" or naive arts. She reinterprets the Intimist works

of the later nineties as a new kind of Symbolism, developed in concert with Vuillard, and founded on ideas suggested by the philosophy of Bergson and by Symbolist poetry and theater.

In discussing the theme of Paris life, Colta Ives observes Bonnard's perpetual reinvention and restaging of day-to-day reality. Surveying the artist's exploration of urban motifs from popular nightlife to the traffic of the streets, she notes the stimulating effect of Bonnard's associations with the avant-garde of the 1890s. Her redating of some of the principal graphic works of this period establishes a clearer and more logical development of Bonnard's style during the formative first decade of his career, thereby laying the groundwork for a reassessment of the dating of many of his early paintings.

In the final chapter, Sasha M. Newman examines Bonnard's treatment of the nude and the landscape, culminating in the lithographs for his two great *livres de peintre* at the turn of the century, *Parallèlement* and *Daphnis et Chloé*. She sees in them an attempt to revitalize *la grande tradition française*, reflecting the contemporary French search for a renewed national style. At the same time Bonnard's attitude toward the past can be read as ambivalent, often subtly subversive, and his work was colored by personal as well as art-historical references. In *Parallèlement* he juxtaposed caricature with allusions to the sensuality of the Rococo; in *Daphnis et Chloé* he used the vocabulary of Impressionism to remake classical landscape.

Although these essays dovetail, they differ in individual approach, as befits their subject—an artist who asserted at the beginning of his career that he belonged to no school but looked only "to do something personal." Taken together they show that Bonnard was never as immune to trends in the broader world of the arts as has been thought. During his early years in Paris, the years of his most intensive graphic production, he was immersed in that world as he would never be again. These studies underscore the lasting importance for Bonnard's work of his early activities and ideas, countering the still frequently held belief that they had little bearing on his later development.

Colta Ives's conviction that much more could be learned about Bonnard's prints, and indeed about the artist as well, from a closely focused study of his graphic work prompted her to initiate this project over a decade ago. During the past three years she has visited more than forty public and private collections, from which the items in the exhibition were selected. In order to enlarge the scope of this volume beyond her own specialization in nineteenth-century European prints, she invited

the participation of Helen Giambruni, a scholar of Bonnard's early works, and Sasha M. Newman, an expert in Bonnard's later paintings. The three authors met and regularly discussed the aims and materials of their essays, with the result that the entire project has greatly benefited from an exchange of knowledge and ideas. In the second part of the book, the catalogue entries were prepared by Colta Ives, the chronology and bibliography by Helen Giambruni and Colta Ives together.

THE CONTRIBUTIONS of others toward the realization of this project are many, and their valuable support at various stages of its completion is greatly appreciated. For their help throughout the preparation of this work, the authors are particularly grateful to Antoine Terrasse, Antoine Salomon, Margrit Hahnloser-Ingold, Virginia and Ira Jackson, and Samuel Josefowitz. The editing of the text of the book and the coordination of all its parts were accomplished with the utmost care and sensitivity by Mary Laing, to whom the authors owe a profound debt of thanks. The book's design is the masterful work of Peter Oldenburg; its production was finely organized and expedited by Helga Lose.

Several members of the staff of the Metropolitan Museum contributed generously to the project, especially Paula Birnbaum, Alison Gallup, and Elizabeth Wyckoff, who handled the myriad details of exhibition planning and manuscript preparation. Sincere appreciation is owed also to Rodolfo G. Aiello, Kay Bearman, Barbara Bridgers, John Buchanan, Cynthia Clark, Sharon Cott, Deanna Cross, David Del Gaizo, Nina Diefenbach, Teresa Egan, Carol Ehler, Priscilla Farah, Betty Fiske, Maria Morris Hambourg, Gene Herbert, Diana Kaplan, Steffie Kaplan, Norman Keyes, David W. Kiehl, Sue Koch, Linda Lawton, William S. Lieberman, Ann Lucke, Douglas Maple, Nina Maruca, John P. O'Neill, Helen Otis, Emily Kernan Rafferty, John Ross, Marjorie Shelley, Olga Sichel, Edmund Stack, Linda Sylling, Mahrukh Tarapor, Gary Tinterow, and Linda Winters.

For their encouragement and assistance in the realization of the exhibition and this publication the authors wish to express sincere gratitude also to the following: Clifford S. Ackley, Dita Amory, Juliet Wilson Bareau, Laure Beaumont-Maillet, Huguette Berès, Nelson Blitz, Jr., the Mlles Bowers, Patricia Eckert Boyer, Elke von Brentano, David Brooks, Françoise Cachin, Leopoldo Rodés Castañé, Riva Castleman, Elizabeth Childs, Jean Clair, Elisabeth Dean, Douglas W. Druick, Richard S. Field, Nancy Finlay, Eliot Freidson, Eleanor M. Garvey, Jean Genoud, Guy Georges, Teréz Gerszi, Catherine Gillot, Pat Gilmour, Lucien Goldschmidt, Deborah Goodman, Marianne Gourary, Anne Coffin Hanson, Françoise Heilbrun, Sabine Helms, Ay-whang Hsia, Gary Ives, Robert Flynn Johnson, Paul and Ellen Josefowitz, Eberhardt

W. Kornfeld, Linda Kramer, Jan Krugier, Gabriel Landau, Elizabeth Llewellyn, Kristin Makolm, Peter C. Marzio, Alice Mason, Suzanne McCullagh, Charles S. Moffett, Bruno Muheim, Joshua Murray, Christian Neffe, Valerie Olsen, Geoffrey Perkins, Ursula Perucchi-Petri, M. et Mme Hubert Prouté, Robert Rainwater, Andrew Robison, Derald H. and Janet Ruttenberg, Bertha Saunders, Herbert Schimmel, Judith Schub, George Shackelford, Barbara Stern Shapiro, Kay Shelemay, Alan Shestack, Verna Steiner-Jaeggli, Margret Stuffmann, Marilyn Symmes, Eugene Victor Thaw, Barbara Trelstad, David Tunick, Annette Vaillant, Kirk Varnedoe, Pierrette Vernon, Françoise Viatte, Roberta Waddell, Gerrard White, and Françoise Woimant.

COLTA IVES

HELEN GIAMBRUNI

SASHA M. NEWMAN

PIERRE BONNARD: The Graphic Art

NOTE TO THE READER

DIMENSIONS ARE GIVEN in millimeters in the captions, in millimeters and inches in the catalogue (pages 211–235). Height precedes width. Unless otherwise stated, the dimensions in the captions refer to the size of the image for lithographs, the plate for etchings, the sheet for drawings, and the page for books.

Relatively few of Bonnard's prints were officially titled in his lifetime, and most are known today by descriptive titles applied by cataloguers and other commentators. Titles for which contemporary evidence exists are cited in the original French, all others are in English. Works listed in a catalogue raisonné that are referred to but not otherwise discussed are, however, cited under the titles, French or English, used by the catalogue in question.

1 AN ART FOR EVERYDAY

Colta Ives

PERHAPS THE GREATEST CHALLENGE to our understanding of the rich and abundant work of Pierre Bonnard (1867–1947) comes in reconciling the precocious art of his youth with the sonorous products of his maturity. He began and ended his long career in such full command of his talents that it might almost seem as if there were two Bonnards, one in the nineteenth century and one in the twentieth; one, the boyish cartoonist of life's lighter moments (fig. 1), and the other, the serene connoisseur of private vistas.

There is Bonnard the painter, and there is Bonnard the poster designer, printmaker, and illustrator who, although he was by nature a private man, found boundless satisfaction in the public presentation of his art. Assignments for the printing press, in which he mastered graphic expression in both black-and-white and color, frequently brought out the best in him: a keen and playful wit, the power to concentrate narrative and emotion in compact imagery, and an affecting, lyrical spontaneity. It is in his graphic projects that we are often best able to trace a continuity between the precise abstractions of Bonnard's youth and the painterly scenes of his maturity (figs. 2, 3).

More than any of the Nabi painters with whom he was associated and who also made prints, including Edouard Vuillard, Maurice Denis, and Félix Vallotton, Bonnard practiced and expanded the full range of his art through the process of printmaking. And more completely than Henri de Toulouse-Lautrec, whom he inspired to pursue color lithography but who died relatively young, Bonnard wove the graphic arts into the entire fabric of a long painting career.

At no other time was Bonnard so thoroughly involved with printing and publishing as he was during the first decade of his professional life. Between 1889 and 1902 he produced over 250 lithographs, most of which were designed either to announce, advertise, ornament, or illustrate

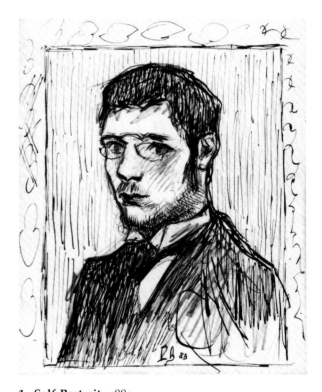

1. Self-Portrait, 1889

Pen and ink over pencil. France, private collection

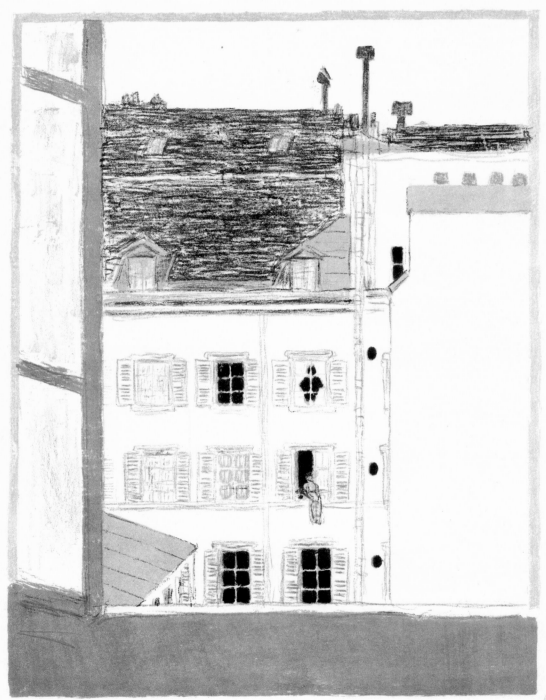

2

publications in which he collaborated with many of the avant-garde poets, novelists, musicians, and dramatists of his day.[1] This intense and richly varied activity extended from his first commission to design a poster for champagne in 1889 to the turn of the century, when he completed three deluxe publications: a suite of twelve color lithographs, *Quelques Aspects de la vie de Paris* (*Some Aspects of Paris Life*), 1899; the illustrations for an edition of Paul Verlaine's *Parallèlement*, 1900; and the illustrations for a French version of Longus's pastoral, *Daphnis et Chloé*, 1902.

2. Houses in the Courtyard, 1895–96 [cat. 60]

From the suite *Quelques Aspects de la vie de Paris*, 1899. Color lithograph, 345 x 257 mm. New York, The Metropolitan Museum of Art, Harris Brisbane Dick Fund, 1928

3. The Studio and Mimosa, Le Cannet, 1946 (begun 1939)

Oil on canvas, 1270 x 1270 mm. Paris, Musée National d'Art Moderne, Centre Georges Pompidou

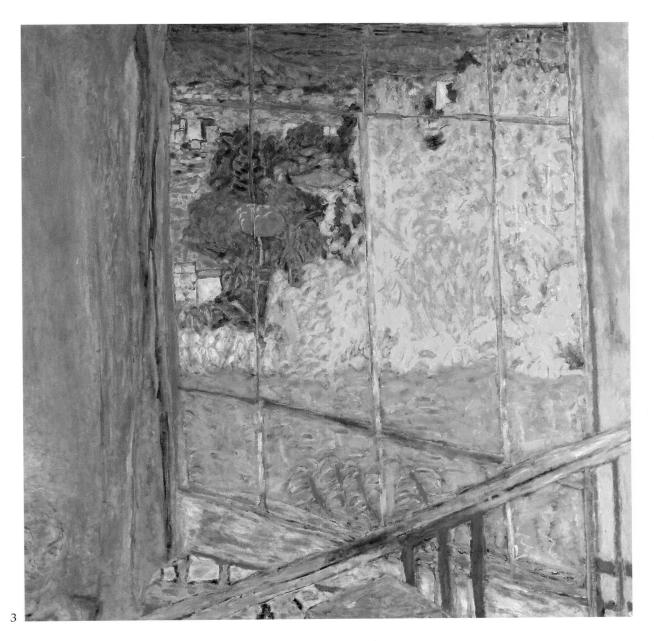

3

The decline in Bonnard's activity as a printmaker that occurred soon after his greatest triumphs, when he had scarcely reached his mid-thirties, may be explained in part by the lukewarm reception his most ambitious works received. But there is the fact also that in the course of his passage from youth to maturity, and in his departure from a life centered in Paris to one rooted in the provinces, the artist's attentions turned elsewhere. The loosening of his ties to the Nabi group with which he had been allied gave further rein to his independent spirit, and he gained deeper confidence in his own keenly felt sensations. Bonnard became captivated with the substance of paint as a means of embracing the out-of-doors and seizing light. After 1900, he discovered that he was most serenely content gazing upon the placid comforts of the luncheon table, his intimate companion's familiar form, and the lush landscape of the countryside. "When one is young," the artist said in his sixties, "one becomes enthralled with a place, a motif, an object discovered by accident. . . . Later one works differently, guided by the need to express a sentiment."[2]

In his youth, Bonnard found himself under the spell of Paris, drawn by the prospect of the avant-garde life. Born just outside the city limits, in the suburb of Fontenay-aux-Roses, and educated in the most exacting schools, he only narrowly escaped a civil servant's career like his father's. "At that time I had not quite realized that I wanted to be a painter," he said. "I think that what attracted me then was less art itself than the artistic life, with all that I thought it meant in terms of free expression of imagination and freedom to live as one pleased."[3]

Eager to demonstrate that he could make his way as an artist, Bonnard took up the practical graphic assignments which simultaneously helped him to earn a livelihood and to gain a public audience, linking his name with those of modern writers and dramatists. To a large degree, Bonnard's early work is defined by his production of posters, piano music and playbill designs, magazine and book illustrations, and colorful prints that were offered to collectors in suites. Such projects were so central to his artistic existence that when he was later asked to summarize his career from his student days until 1900, he cited not a single painting from this period by name but referred instead to his published works: the poster for France-Champagne, his designs for the sheet music *Petites Scènes familières* (*Little Familiar Scenes*), and the illustrations he created for *Parallèlement*.[4] In fact, Bonnard exhibited his printed work almost as often as his paintings in the 1890s, displaying selections of his posters, music il-

lustrations, and color lithographs in shows at the galleries Le Barc de Boutteville, Vollard, and Laffitte, and at the Galeries Durand-Ruel where his first one-man show was mounted in January 1896. His prints were also represented at the international exhibitions of La Libre Esthétique in Brussels in 1894 and 1897, and at the Paris "Centenaire de la Lithographie" in 1895.[5] As it happened, the prints Bonnard made in the 1890s reflected activity at the absolute center of the Parisian avant-garde in a way his art would never do again, for once he found his own voice he ceased to bother much with what was considered *au courant*.

While he was still in law school, Bonnard enrolled as an art student at the Académie Julian where, it was observed, he "painted gray and copied the model scrupulously";[6] the young artist at a life class figures among the autobiographical sketches he made some twenty years later (fig. 4). He studied at the academy intermittently over a period of two to three years, even after he had been accepted into classes at the Ecole des Beaux-Arts, and probably continued with increased enthusiasm as his options narrowed (not too disappointingly, one suspects) when he failed both the Beaux-Arts competition for the Prix de Rome and his examination for the civil service.

At the Académie Julian, Bonnard rubbed shoulders with the youthful idealists who became the decade's most promising new talent, and he gathered with them one day in the autumn of 1888 around a painting on a cigar-box lid that Paul Sérusier brought in to demonstrate the revolutionary practices of Paul Gauguin. This "Talisman," as it was called, a pocket-size landscape blocked in with patches of pure color, became a model for the aspiring student artists. By mid-1889 several of them, including Bonnard, had banded together in dedication to this new bold and direct approach to painting, sometimes signing their pictures or their letters to one another "Nabi," the Hebrew word for "prophet" and the Arabic for "messenger."[7] Of the fourteen principal members of this group, among whom were Maurice Denis, Paul Ranson, and Henri-Gabriel Ibels, only Edouard Vuillard and Ker-Xavier Roussel remained close, lifelong friends with Bonnard, who later recorded them strolling at his side across the Place de Clichy (fig. 4, lower left). Bonnard also portrayed Denis, the chief theoretician of the Nabis, striding off at a tangent from Toulouse-Lautrec (fig. 4, lower right).

By 1890 Bonnard had successfully assimilated the influence of Gauguin's pared-down, color-rich style (fig. 5). *L'Exercice* (*The Drill;* fig. 6), which evidently records a brief period of military service, presents its

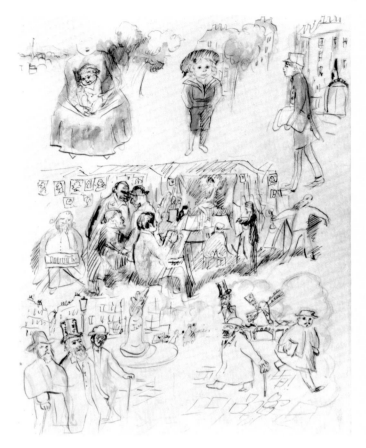

4. The Painter's Life, ca. 1910

Page 1 of a sketchbook. Pen and brown ink with blue wash. France, private collection

The opening page of Bonnard's pictorial autobiography shows him as a child, as a schoolboy at the Lycée Louis-le-Grand in Paris, and as a student at the Académie Julian, where he draws from the model with Sérusier (seated at his left) and Vallotton (painting, in profile, at his far right). The color merchant Père Tanguy, who exhibited Japanese prints and paintings by van Gogh in his Montmartre shop, appears at far left. Below, in the Place de Clichy (left), are the three friends Roussel, Vuillard, and Bonnard, and in the Place Blanche with the Moulin Rouge in the background (right), Toulouse-Lautrec, his cousin Tapié de Celeyran, and Denis.

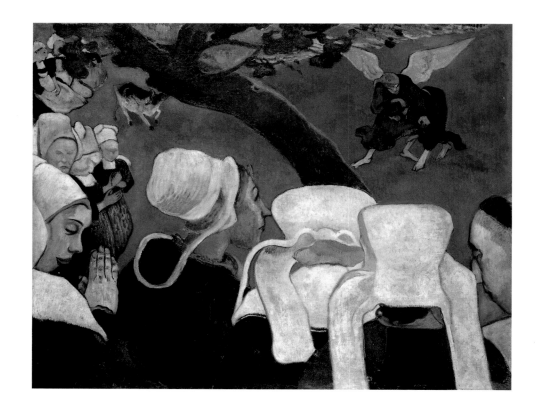

5. PAUL GAUGUIN, **The Vision After the Sermon,** 1888

Oil on canvas, 730 x 920 mm. Edinburgh, National Gallery of Scotland

6. L'Exercice (The Drill), 1890

Oil on canvas, 229 x 321 mm. Switzerland, private collection

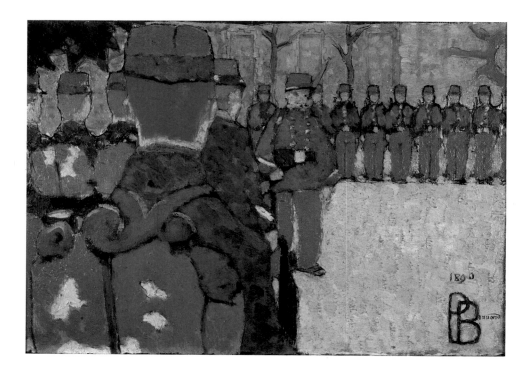

subject in exemplary decorative array. This brilliant demonstration of the brand-new abstracted art style is also a nimble-witted glimpse of regimental life seen through the eyes of the recalcitrant son of a War Ministry official.

Bonnard apparently came to grips with Gauguin's theories on art after seeing a sampling of his works displayed in Volpini's café at the 1889 Exposition Universelle. It was not long afterwards that he sold a poster design (see fig. 125), which cunningly employed Gauguin's highly charged and simplified mode of expression. Although Manet had made covers for sheet music and created a poster for his friend Champfleury's book *Les Chats*, such excursions into commercial design were rare for French painters. It was thus a rather daring move on Bonnard's part to venture into the field of advertising. It may have been in part an act of desperation, to end any further discussion of his entering the legal profession, but his talent was more than equal to the task and the timing was right. During the 1890s posters and color prints were to become the most popular, widespread vehicles of art, broadcasting new trends and new talent with such success and speed that, in the end, they came to epitomize the entire fin-de-siècle era. Prints by artists issued in special editions, which were the late blooms of the century's consumer explosion, upgraded the standards of commercial design, while their distribution and sale coincidentally established new practices in art dealing and collecting.

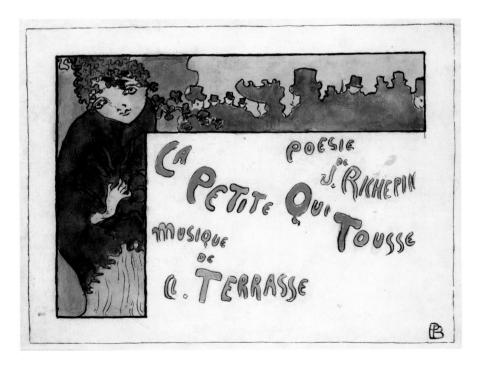

7. **La Petite qui tousse** (The Girl with a Cough), ca. 1890 [cat. 3]

Front cover design for sheet music. Ink and watercolor over pencil, 276 x 365 mm. Houston, Virginia and Ira Jackson Collection

The traditional, centuries-old guidelines between the fine and applied arts were now showing signs of erosion; the distinctions were being deliberately dismissed in order to encourage refinement in the design and manufacture of decorative objects, which had deteriorated in quality during the Industrial Revolution. Active collaboration between art and industry was promoted first in England, then in many European countries, fostering the British Arts and Crafts movement, La Libre Esthétique in Belgium, and the Wiener Werkstätte in Vienna. The production of color prints to decorate the home and to embellish ephemeral paper goods such as menus, programs, book covers, and advertisements was part of this effort. In 1889 the French were even prompted to award the Legion of Honor to a commercial artist, Jules Chéret, because by masterminding the kiosk-sized color posters that gaily addressed Paris's expanded consumer market, he had "created a new branch of art."[8] Six years later an elegant emporium, L'Art Nouveau, dedicated to finely crafted decorative objects in the latest style, was opened in Paris by Siegfried Bing;[9] and an art-stationery store with a line of artist-designed products was opened by André Marty.[10]

As a group, the Nabis believed with almost religious conviction that painters ought not to isolate themselves from the other arts but should rather share in the creation of objects of daily utility. Their efforts to realize this aim, which ranged from designing lampshades and wallpaper to mural decoration and theater costumes, placed them in the very forefront of innovative activity. "Our generation has always looked for the connections between art and life," Bonnard recalled. "At that time, I myself had the idea of a popular production with everyday application: prints, furniture, fans, screens, etc."[11] Indeed, his own endeavors resulted in articles of just such variety and more, including stained glass, theater scenery, advertisements, sheet music and book covers, playbills, magazine illustrations, birth announcements, a bronze table centerpiece, jewelry, and even marionettes.

It was after selling his first poster design that Bonnard began preparing images for the popular press in earnest. His brother-in-law, Claude Terrasse, a pianist, teacher, and composer, provided the impetus for several projects aimed at the avid French market for music, which in the 1890s generated twelve to fifteen thousand new songs a year.[12] Among Bonnard's designs is one created (though never used) for a setting of Jean Richepin's words on a young woman suffering from consumption, *La Petite qui tousse* (*The Girl with a Cough*; fig. 7).[13] The similarity between this piquant song-sheet decoration and the easel painting *L'Exercice* reveals

how little Bonnard distinguished at the time between painting and the most casual, even comic-book sort of popular illustration (fig. 8). It demonstrates, furthermore, how susceptible the concise Nabi style was to translation into graphic media.[14]

Terrasse's musical ambitions also led to two larger publishing projects in which Bonnard took a hand and which were completed in 1893 and 1895 (see chapter 2): *Petit Solfège illustré* (*Little Illustrated Solfeggio*), an ingeniously ornamented primer for children on music theory; and *Petites Scènes familières*, a collection of nineteen piano pieces illustrated with endearing and often amusing episodes of everyday life, which the composer and illustrator are likely to have shared.

Bonnard's work on the *Petit Solfège illustré* began as early as 1891, and to judge from the seventy-two or more preparatory drawings that survive,[15] considerable effort went into the project. One of these compositions, connected with the lesson on waltz time (figs. 9–11), exhibits Bonnard's frequent practice of tracing his designs on the backs of his drawing sheets, incorporating corrections and adjustments. The same procedure could be used to create a reversed image for copying onto the lithographic stone, so that once printed, it would correspond in direction to the original concept. Evidence of Bonnard's employment of this efficient tracing device survives in a number of double-faced preliminary drawings: *Conversation*, for example, of 1893 (figs. 12–14), and *Woman with an Umbrella* (see figs. 147, 148).[16]

Unlike many contemporary printmakers, who corrected their work directly on the printing stone or plate, Bonnard apparently made most of his adjustments to a design before the press stage. We are thus more likely to find series of preparatory drawings than we are working proofs marked with extensive alterations.

At the very outset of his career, Bonnard made it clear that he intended to remain independent of any prescribed set of theories that might restrict his freedom. Indeed, soon after his first exhibition with the Nabis at the Galerie Le Barc de Boutteville in 1891, he declared in an interview with the press: "I am of no school. I am looking only to do something personal."[17] His contemporaries also attest to his refusal to be tied to any dogma, a position of stubborn individualism he maintained throughout his life. Yet there is ample evidence that Bonnard, like his fellow Nabis, was fascinated by the work of Gauguin, Seurat, and Redon; he also shared the Nabis' appreciation of the Symbolist poets' approach to the experiences of life. In fact, Bonnard's art consistently reflects, over a period of nearly sixty years, the Symbolist taste for the oblique expression of

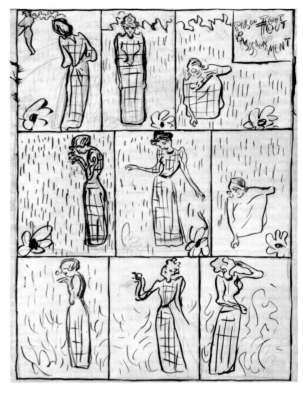

8. **Pas du tout, passionnément**
(Not at All, Passionately), 1891–92 [cat. 11]

Pencil and ink, 400 x 300 mm. Josefowitz Collection

Possibly designed to illustrate a magazine or a song sheet, this series of drawings in a format like that of a film strip or comic book traces a young woman's test of her fortunes in a daisy: "He loves me, he loves me not." Vuillard, too, made such whimsical figure studies in the early 1890s. Both he and Bonnard may have been inspired by the *manga*, or comic sketches, in Hokusai's illustrated pocketbooks.

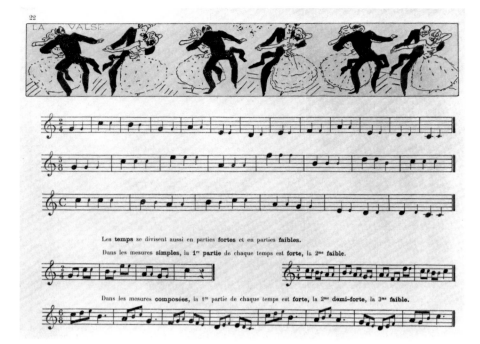

9. La Valse (The Waltz), ca. 1891–93 [cat. 19]

Page 22 of *Petit Solfège illustré*, 1893. Lithograph illustration, page 213 x 283 mm. New York, The Metropolitan Museum of Art, Mary Martin Fund, 1987

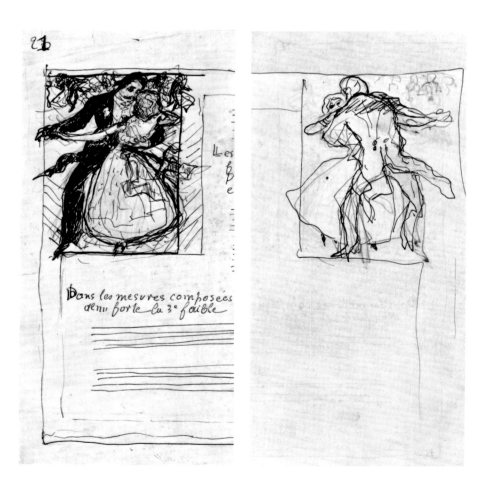

10, 11. Studies for **La Valse,** ca. 1891–93 [cat. 23]

Ink over pencil (recto and verso), 202 x 108 mm. Munich, Sabine Helms

By turning over his first drawing and then tracing it (with modifications) on the back, Bonnard waltzed his couple around a full 180 degrees and presented the pair from a new angle.

emotions through subjects heavily layered with personal meaning. The poems of Stéphane Mallarmé, Symbolism's acknowledged master, were read aloud at meetings of the Nabis, and the poet, whom Bonnard knew, "was the profound admiration of [his] mature years, and up until old age he read, and reread him, verse by verse, line by line."[18] Through Mallarmé, the Nabis and Bonnard came to an understanding of art as an expression of emotion more than the representation of visual experience; they aimed beyond Impressionism's emphasis on the sights of a single moment in order to explore Symbolism's sensitivity to the mood and response of a single individual.

Bonnard asserted the force of the "primary conception" through which, he said, "the painter achieves universality." Indeed, it remained true for him in the 1940s, as it had in the 1890s, that "the starting-point of a picture is an idea." After that, he said, it was important to rely on memory, for "if the object is there at the moment he is working, the artist is always in danger of allowing himself to be distracted by the effects of direct and immediate vision, and to lose the primary idea on the way."[19] The value of working without a model had also been realized by Degas,

12, 13. Studies for **Conversation,** 1893

> Ink and wash over pencil (recto and verso), 311 x 245 mm. New York, The Museum of Modern Art, The Joan and Lester Avnet Collection

> Bonnard's practice of tracing a drawing on the back of the sheet furnished a reverse image and at the same time allowed him to revise his initial composition while still retaining it.

14. Conversation, 1893

> Lithograph for the magazine *L'Escarmouche,* 300 x 260 mm. New York Public Library, Astor, Lenox, and Tilden Foundations, Division of Art, Prints, and Photographs, Print Collection of Miriam and Ira D. Wallach

 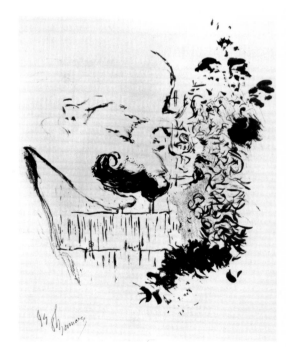

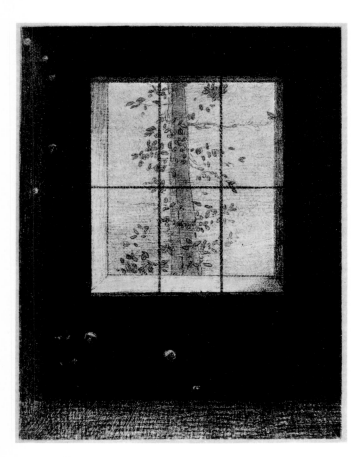

15. ODILON REDON, **Le Jour** (Daylight)

From the suite *Songes* (*Daydreams*), 1891. Lithograph, 210 x 156 mm. New York, The Metropolitan Museum of Art, Rogers Fund, 1920

whose studies of the nude strongly influenced Bonnard, and who valued the "transformation in which your imagination collaborates with your memory," with the result that the artist is "liberated from the tyranny of nature."[20]

The circumstances of his own guarded personal life were always the most compelling material for Bonnard. Even when he stepped out to observe the traffic of the streets or to take in the landscape, he generally did so in such close proximity to his home—whether in the city or the country—that the territory was entirely familiar. In this circumscribed arena, the atmosphere was invariably laden with personal associations and memories, which permeate his carefully focused scenes.[21]

Bonnard's studio window, often seen to frame and to celebrate a familiar vista, became a motif the artist returned to again and again as a source of new possibilities (see figs. 2, 3). It regularly affirmed his commitment to a purely subjective view of reality and testified to his continued unanimity with the doctrines of Symbolism, even long after the Nabis had disbanded. Like the spellbinding dusky prints of Odilon Redon (fig. 15), whom the Nabis considered their spiritual master, Bonnard's picture windows stir the imagination. The older man's uncompromising, highly personal vision was much admired by Bonnard, and the two artists, who were friends, shared an abiding love of evocative poetry.

It may have seemed to Bonnard, as it did to several artists who were his contemporaries, that some of their most novel aims had already been to a certain extent achieved in the colorful prints that began to arrive in France after active trade with Japan started up in 1856 (fig. 16).[22] The exhibition of over one thousand ukiyo-e woodcuts mounted in the spring of 1890 at the Ecole des Beaux-Arts, where Bonnard was enrolled, signaled the height of Japanese prints' popularity in Paris.

"In my youth I was excited by the magnificent gaudiness of Japanese . . . popular art," Bonnard remembered.[23] The artist owned prints by Hiroshige, Toyokuni, Kunisada, and Kuniyoshi, which he tacked to his walls in Paris in the late 1890s and still had on hand at his Mediterranean villa in the 1940s (fig. 17). "I covered the walls of my bedroom with this naive and gaudy imagery. . . . It seemed to me that it was possible to translate light, form, and character with nothing but color, without resorting to shading."[24]

The example of a decorative, nonillusionistic art that ukiyo-e woodcuts presented took a strong hold on Bonnard's imagination at a time when he was sifting his options. In the search for an unpretentious, compactly ordered art with a fresh angle of vision, he embraced these "naive and

16. ANDO HIROSHIGE, **View from a Window**

From the series *One Hundred Famous Views of Edo*, 1856–58. Color woodcut, 333 x 219 mm. New York, The Metropolitan Museum of Art, Rogers Fund, 1914

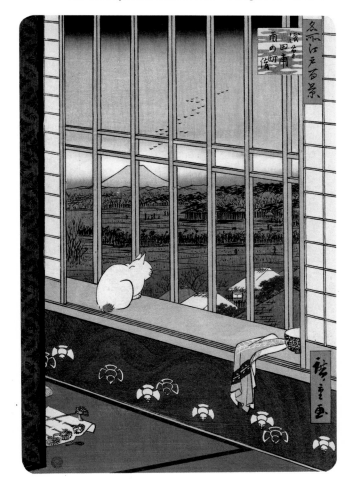

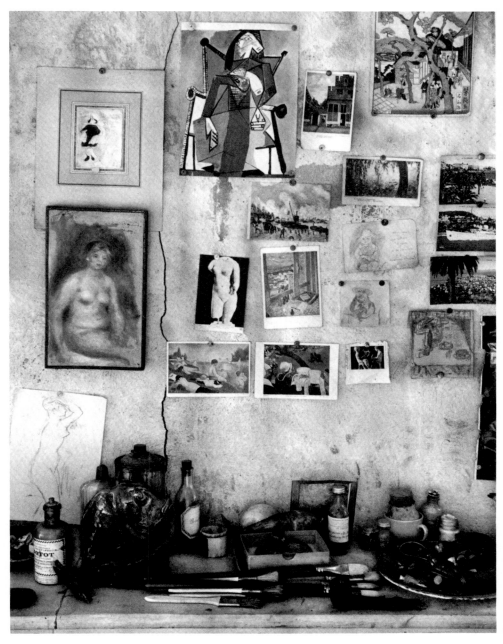

gaudy" images (it would seem more ardently than did the other Nabis) because they represented a view of the world that was sympathetic to his own.[25]

By 1896, the blunt and succinct style that ukiyo-e fostered and that the youthful Bonnard came to favor had mellowed in his hands, as is evident from a comparison of the cover he designed for the 1895 album of prints from the magazine *La Revue blanche* (fig. 18), with his poster produced

17. BRASSAÏ, **Bonnard's Studio, Le Cannet,** 1946

Photograph. Copyright © G. Brassaï, 1989

Among the images Bonnard had on his studio wall just a year before his death were reproductions of works by Hiroshige, Vermeer, Picasso, Renoir, Seurat, and Gauguin, whose *Vision After the Sermon* (see fig. 5) first inspired him in his youth.

An Art for Everyday 15

18. Album de la Revue blanche, 1895

Portfolio cover. Lithograph, 400 x 300 mm. New York, Mr. and Mrs. Herbert D. Schimmel

In 1895 *L'Estampe originale* issued a special edition of the twelve prints that had appeared in the magazine *La Revue blanche* during the previous year. The artists were Bonnard himself, Toulouse-Lautrec, Vuillard, Redon, Vallotton, Denis, Ibels, Cottet, Rippl-Ronaï, Ranson, Roussel, and Sérusier. The cover of the portfolio is fastened with cords.

19. Salon des Cent, 1896

Poster. Color lithograph, 630 x 438 mm. The Art Institute of Chicago, John H. Wrenn Fund, 1960

about two years later for an exhibition of the Salon des Cent (fig. 19). While the subject matter of the two, a dog's training,[26] is basically the same, the rhythm and mood decidedly are not. It is as if sometime after Bonnard depicted the stern mistress who had to scold her frisky pet, the dog learned obedience and the lady dressed for tea. The brisk and unruly silhouettes of the first print, a black-and-white work that uses exaggeration for its effect, were succeeded by softly delineated forms in the second, enhanced with touches of modeling and color. Although Bonnard did not abandon altogether the devices of distortion and abstraction that had helped to establish the style of the Nabis, his adoption of a more relaxed and lyrically sensuous approach did, in fact, coincide with the fraternity's unraveling.

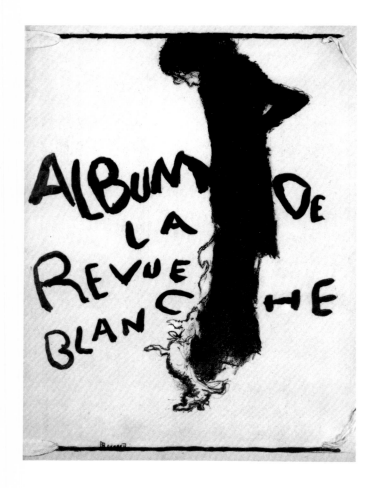

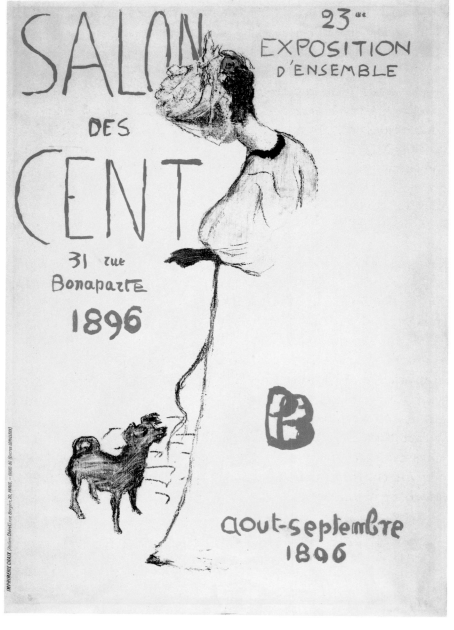

These two illustrated announcements, one advertising an exhibition, the other identifying a portfolio, present an opportunity to examine Bonnard's attentiveness to the harmonious combination of lettering with figural designs. His first poster, commissioned for France-Champagne (see fig. 125), carried its brand name in an undulating parade of type suggesting the giddying effects of the product. Bonnard continued to use a bold, conspicuously handwrought alphabet whenever lettering was called for in his graphic assignments. It was made an integral part of each design, often balancing the asymmetry of a composition and always reinforcing the character of the image he had created. Given a choice, Bonnard obviously preferred to supply any lettering that might be needed with his art, and this remained true right up to 1947, when he designed the cover of an issue of *Verve* devoted entirely to him, which did not appear until seven months after his death.[27]

Bonnard's lithographs are particularly helpful when it comes to tracking his comparatively early artistic development, more so even than his (often undated) paintings, because the prints frequently correspond with specific events, such as exhibitions and theatrical productions, or they were published in periodicals or special editions. His cover for the *Album de la Revue blanche,* for instance, which included a wreath of entwined nudes on the back, was commissioned to wrap around an edition of the twelve prints that had appeared in the monthly issues of the magazine during 1894. *La Revue blanche* was far and away the most significant creative journal of its day, having established a forum for much of the advanced art and literature of the period and numbering among its writers Ibsen, Gide, Mallarmé, Verlaine, Chekhov, and Proust. Under the direction of the Natanson brothers (Alfred, Alexandre, and Thadée), the journal gave strong support to the Nabis, sympathetically reviewing their exhibitions and incidentally providing in its offices a congenial gathering place for authors and artists (fig. 20, center).

Between July 1893 and December 1894, *La Revue blanche* regularly published at the front of each issue lithographs by members of the Nabi group and by their friend Toulouse-Lautrec. Bonnard maintained a fruitful association with the magazine over a period of a decade, contributing two frontispieces (see figs. 144, 145), an advertising poster (see fig. 151), illustrations to its humorous supplement *Nib* (see fig. 137), the album cover of 1895 (see fig. 18), and more than a dozen vignettes by the time the periodical ceased in 1903. His illustrations to Peter Nansen's love story *Marie* (see chapter 4) first appeared in the magazine in 1897, in advance of the book's publication by *La Revue blanche* the following year.[28]

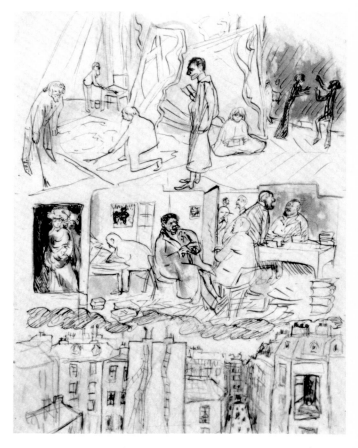

20. The Painter's Life, ca. 1910

Page 2 of a sketchbook. Pen and brown ink with blue wash. France, private collection

Life backstage at the Théâtre de l'Oeuvre, where Bonnard paints sets with his fellow Nabis, while the actor Lugné-Poe stands at center; the offices of *La Revue blanche*, with the directors Thadée and Alexandre Natanson at far right, Misia Natanson entering at left, Félix Fénéon working at a desk, the mustachioed Octave Mirbeau seated in the foreground, and Jules Renard looking in through the doorway; and a view of Paris rooftops from the artist's studio window.

21. Ambroise Vollard, ca. 1924

Etching, 353 x 237 mm. New York, The Brooklyn Museum, Museum Purchase

22. The Painter's Life, ca. 1910

Page 3 of a sketchbook. Pen and brown ink with blue wash. France, private collection

Vollard in his gallery with the artists he represents: Pissarro, seated, and Renoir (left); Degas, seated (far right); and Bonnard himself looking on at the back. Below, Bonnard, seated at the table, makes a puppet at the Théâtre des Pantins, founded by his brother-in-law, composer Claude Terrasse (foreground), and Alfred Jarry (in bicycle pants), the creator of *Ubu roi*, a performance of which was given at the puppet theater in 1898.

Like many artists of his generation, Bonnard discovered France's burgeoning illustrated press to be the most direct route to recognition and a paying career. But he was positively inclined toward popular and utilitarian forms of art for more than just practical purposes, and as his work as an illustrator demonstrates, he readily welcomed opportunities to collaborate with writers and other artists. Thus, in addition to *La Revue blanche*, he helped to enliven the Paris magazines *L'Escarmouche* (see figs. 14, 166), *La Plume*, *L'Omnibus de Corinthe*, and *L'Estampe et l'affiche*, whose subscribers received Bonnard's poster for 1897 as a premium.

During the 1890s quite a substantial number of periodical publications were launched without any literary content, solely as a means of issuing limited editions of prints to subscribers. In some respects this innovation was prompted by the craze for collecting posters that had developed once the new, large-scale, color advertising began to decorate the streets.

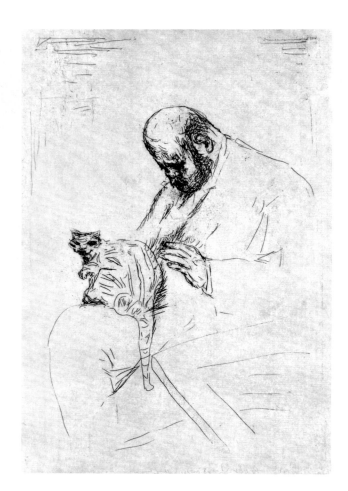

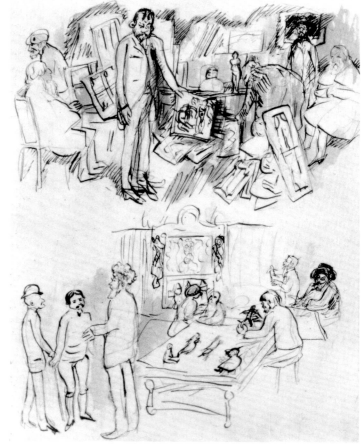

Artists and publishers eager to expand their audience took up print production, leading Camille Pissarro to observe in the spring of 1897: "At the moment prints are the exclusive interest here, it is a mania, the young artists no longer do anything else."[29]

Several of the most memorable works Bonnard created were those he contributed to such special portfolios of prints: the series *L'Estampe originale* (see fig. 62), *L'Epreuve* (see figs. 115, 118), *Germinal* (see fig. 246), and the albums published by the art dealer Ambroise Vollard (fig. 21), who served as the artist's impresario for more than twenty-five years. The two men may have met as early as 1893, about the time Vollard opened his gallery on the rue Laffitte, off the boulevard des Italiens. Denis evidently introduced the Nabis to Vollard, who began showing their work about 1895.[30] Vollard's shop, like the offices of *La Revue blanche*, which were also on the rue Laffitte, became a meeting ground for artists whom the dealer represented, and there Bonnard came in contact with the Impressionists he so much admired: Renoir, Pissarro, and Degas (fig. 22).

It was in 1895 that Vollard announced his grand entry into the realm of print publishing, starting up business where *L'Estampe originale* and *L'Epreuve* had only recently left off, an initiative considered by some to be foolhardy: "Poor Vollard!" Pissarro wrote to his son. "I told him that he was venturing into a field that one has to understand thoroughly, that prints don't sell, the dealers don't know much about them and depend solely on tricks, like posters, color prints, etc."[31] His zeal unimpaired, Vollard went ahead with ambitious plans to issue annual collections of fine prints, which he commissioned from a wide range of contemporary artists. A prospectus survives advertising a publication called *L'Estampe moderne*; Vollard promised this for October 2, 1895, but it never materialized.[32] Instead, the *Album des peintres-graveurs* was brought out by Vollard in 1896: an edition of 100 sets of twenty-two prints, among them works by the Nabis Vuillard and Vallotton and the color lithograph *La Petite Blanchisseuse* (*The Little Laundry Girl*; see fig. 161) by Bonnard, who also designed the poster announcing an exhibition of the prints at Vollard's gallery (fig. 23).[33] Where his earlier prints had been largely monochromatic, Bonnard now embarked on a period of intense activity in color lithography, a medium to which both he and Vollard were attracted for its painterly effects.

In 1897, when Vollard published thirty-two prints in a second portfolio, this one entitled *Album d'estampes originales de la Galerie Vollard*,[34] Bonnard designed the wrapper showing a print-strewn table as a playground for one of Vollard's pet cats (figs. 24, 25). As Pissarro might have

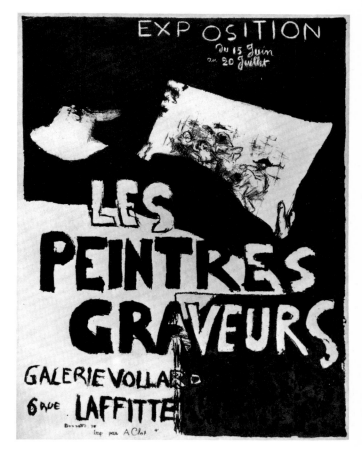

23. Les Peintres-graveurs, 1896

Poster. Color lithograph, 635 x 465 mm. New York, The Museum of Modern Art, Purchase Fund

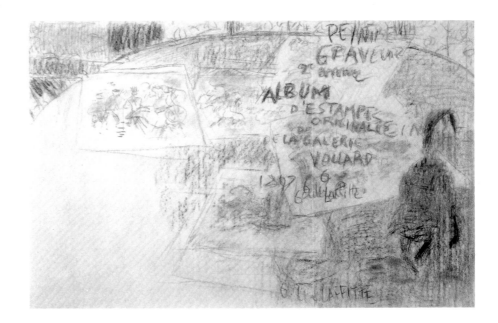

24. Study for **Album d'estampes originales de la Galerie Vollard,** 1897

Charcoal, 584 x 876 mm. New York, The Museum of Modern Art, anonymous gift

predicted, neither this nor the earlier of Vollard's two albums proved a critical or commercial success, and plans to bring out a third album in 1898 were abandoned, even though prints by several artists, including Bonnard's *Child in Lamplight* (see fig. 119), had already, it seems, been commissioned.

As enthusiastic an entrepreneur as he was connoisseur, Vollard thrived on projects that raced ahead of the readily possible, and his habit of embarking on too many endeavors at once was noted by Pissarro with some annoyance: "This blessed Vollard is so *fluttery*, one doesn't know what to believe. He has so many projects that he can hardly carry out everything he has in mind!"[35]

The "vast" number of lithography projects Vollard undertook in a relatively short span of time was remarked upon by André Mellerio in *L'Estampe et l'affiche* (May 15, 1897), and again in his book *La Lithographie originale en couleurs* of the following year, where he mentioned suites of prints by Bonnard, Vuillard, Roussel, and Denis as being then in progress. Vollard apparently also commissioned a number of prints that were never formally presented in editions, although they may have been collected with a view to eventual publication in group or one-man albums. Four of the latter were issued simultaneously by Vollard early in 1899: a suite of six black-and-white lithographs by Fantin-Latour; and suites of twelve color lithographs each by Denis (*Amour*), Vuillard (*Paysages et intérieurs*), and Bonnard (*Quelques Aspects de la vie de Paris*; see chapter 3).[36]

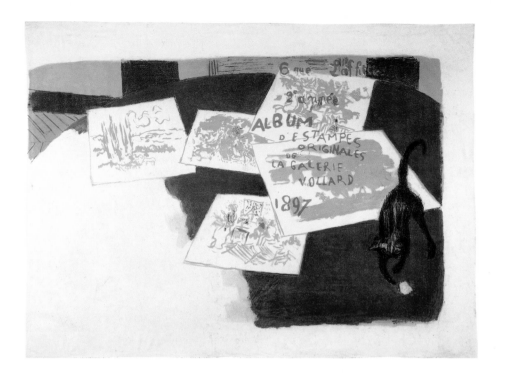

The full extent of Vollard's faith in Bonnard's talents can be judged from the prominent role the artist was assigned in the dealer's first publishing ventures. The year 1897 was a particularly active one in their relationship, marking Bonnard's design of the wrapper, inside covers, and contents page for Vollard's second print album (figs. 26–28), as well as one of the color lithographs within, *Le Canotage* (*Boating*). Bonnard was working at the same time on the prints that would appear in the suite *Quelques Aspects de la vie de Paris* and had also begun sketching on type-set pages of Verlaine's poetry to prepare his illustrations of *Parallèlement*.

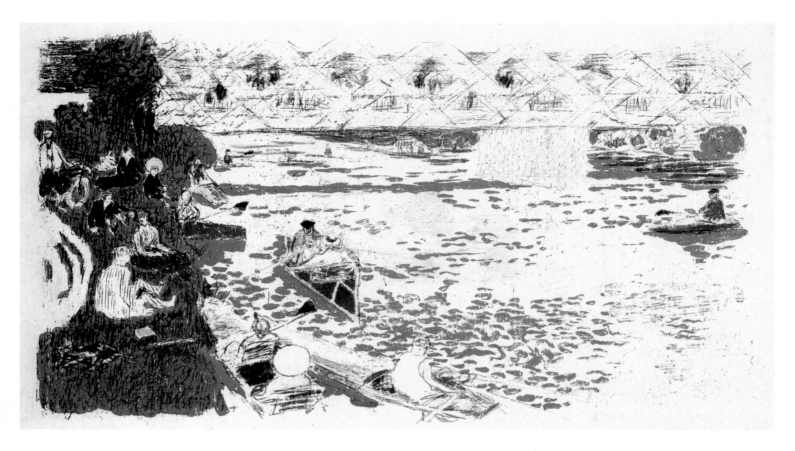

29. Le Canotage (Boating), 1896–97 [cat. 53]

From *Album d'estampes originales de la Galerie Vollard*, 1897. Color lithograph, 270 x 470 mm. New York, The Metropolitan Museum of Art, Harris Brisbane Dick Fund, 1936

Le Canotage (fig. 29), a luminous view of the Sunday outings that took place on and by the Seine at Chatou, just outside Paris, is the first of Bonnard's lithographs to register his newfound enchantment with the imagery and airiness of Impressionism. With its patches of blue and green floating on white china paper it is even more open, atmospheric, and full of light than the painting on which it was based, a small and early exercise in the lessons of Renoir, whose shimmering color came to mean so much to Bonnard (figs. 30, 31). In subject matter and style *Le Canotage* represents a significant departure from the tight planar geometry of *La Petite Blanchisseuse* (see fig. 161), which had appeared in Vollard's album only the year before. In this rare instance when he depended upon a painting as inspiration for a print, Bonnard may have been testing the capacity of lithography to translate freer strokes and convey a more liberated space.[37]

The pleasantly breezy and almost careless look about *Le Canotage* is the seemingly unlabored accomplishment of an artist completely at ease with lithography. Bonnard's relaxed assurance with the complex medium must be credited in some respects to the expertise of Auguste Clot,

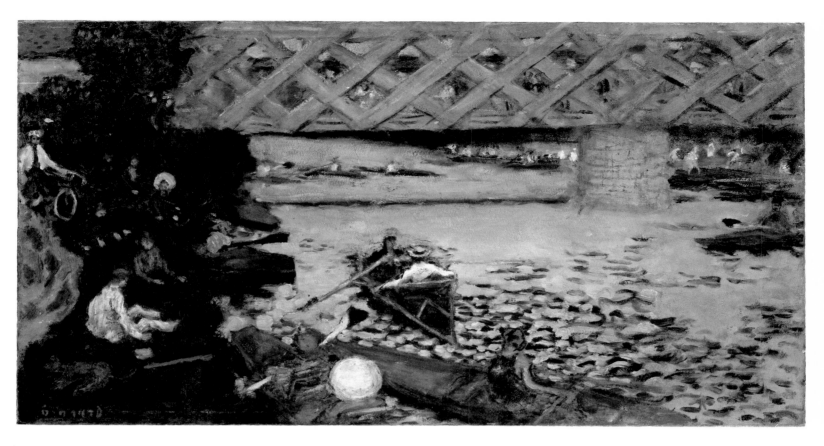

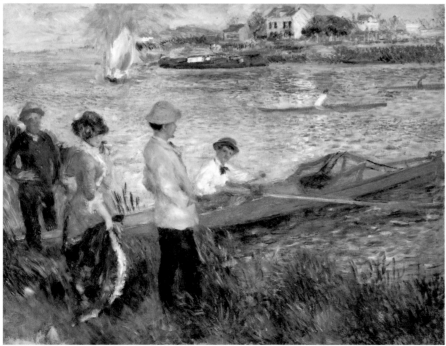

30. Boating at Chatou, 1896 [cat. 52]

Oil on wood, 320 x 595 mm. Private collection

31. AUGUSTE RENOIR, **Oarsmen at Chatou,** 1879

Oil on canvas, 813 x 1003 mm. Washington, D.C.,
National Gallery of Art, Gift of Sam A. Lewisohn

32. The Painter's Life, ca. 1910

Page 4 of a sketchbook. Pen and brown ink. France, private collection

Bonnard shows himself sketching by day in his grandmother's apartment at 8 rue de Parme and, at night, stepping out with Vuillard in Montmartre. Below, he can be seen drawing on a lithographic stone while his printer, Auguste Clot, works the press. Between these scenes of Paris life is the French countryside, to which, after 1900, Bonnard ever more frequently retreated.

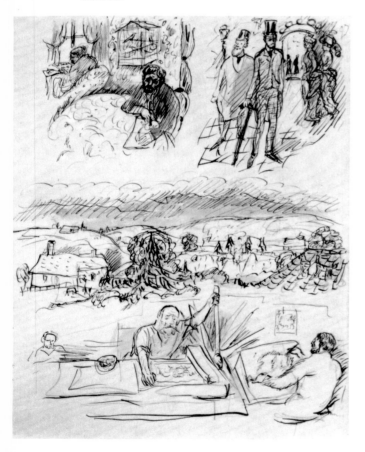

who was the printer of his lithographs for more than thirty years and who figures among Bonnard's autobiographical sketches, energetically working the press (fig. 32).[38]

A former employee of the leading lithographic printer in Paris, the large firm of Lemercier, Clot evidently set up his own atelier about 1895; almost immediately Vollard became a customer and was to remain his most important client for some thirty-five years. During that time Clot printed every lithograph by Bonnard that Vollard published, including the illustrations in the books *Parallèlement*, *Daphnis et Chloé*, and *Sainte Monique*. He also worked with Bonnard on other assignments, such as the sheet-music covers designed for the Théâtre des Pantins and the color print *Place Clichy* (see fig. 197), published in 1922 by Bonnard's dealers, the brothers Bernheim-Jeune.[39] Seventeen surviving notes and letters from Bonnard to Clot talk of making or breaking appointments for the artist to work on lithography stones in the printer's shop, or mention requests for proofs or materials, such as "a stone with a smaller grain." In a typical, undated message, Bonnard writes: "Dear Monsieur Clot, Would you be kind enough to prepare for me two sheets of transfer paper for my last drawings and have them brought to me by your boy as soon as they are ready. It will be no trouble for me to drop by the printshop one of these days."[40] The tone of these short, informal notes is comfortably businesslike, suggesting a healthy working relationship between artist and printer. Recalling their collaboration on *Daphnis et Chloé*, Bonnard gave credit to Clot for facilitating the project by his flexibility.[41]

In the late 1890s the identification of Bonnard's artistic talent with the fortunes of color lithography must have been very strong indeed. Not only did he play a key role in Vollard's publishing operation, as poster and portfolio designer, but he was also Mellerio's choice to create first a poster for his magazine *L'Estampe et l'affiche* (founded by Mellerio and Clément-Janin) in 1897, and then the cover and frontispiece for Mellerio's polemical book of 1898, *La Lithographie originale en couleurs* (fig. 33). It was largely through the efforts of Mellerio, who described Bonnard's "understanding of prints . . . [as] at once personal and distinctive," that color lithography was at last admitted to the French Salon in 1899.[42]

Evaluating the leading lithographic printers of the day, Mellerio singled out Clot as the one "in the forefront," but faulted him for "a tendency to substitute his judgement for that of the artists when their personality is not strong or assertive."[43] The criticism must have been irrelevant where Bonnard was concerned, for it is evident that the latter in-

volved himself regularly in supervising the presswork on his prints, which he initiated by drawing either on stone or on transfer paper. His frequent practice of starting with a design that he had worked on grained paper and then transferred to stone, where he added to it in lithographic crayon and/or ink, resulted in the lively conjunctions of textures, lines, and pools of tone that make up many of the scenes in *Quelques Aspects de la vie de Paris*. Although his compositions sometimes appear to have been rapidly dashed off, certain surviving proofs demonstrate how Bonnard worried over details, reshaping window frames, cart wheels, or the contours of the margins, often precisely for the purpose of reinforcing his pictures' sketchy appearance (figs. 34–36).

The artist's highly tuned sense of color often led to surprising combinations, which, on second thought, might be modulated by subtle additions of gray or blue. Decisions regarding color were generally made in advance of press time and after that changes were rarely made. There are very few impressions of Bonnard's prints whose variations in hue cannot be explained either by fading or by accidental differences in the properties or mixing of the original inks; in some instances, changes of the order in which the stones were used altered the end result.[44] Years after his most intense activity as a lithographer Bonnard recalled the advantages of his experience: "I've learned a lot that applies to painting by doing color lithography. When one has to study relations between tones by playing with only four or five colors that one superimposes or juxtaposes, one discovers a great many things."[45] In one of Bonnard's sketchbooks there is a note that reads "Drawing represents feeling; color, judgment,"[46] a statement suggesting that the artist viewed drawing as a spontaneous means of capturing a personal response, while the application of color was a separate step involving choices that had to be thoughtfully weighed. In that particular respect he remained faithful throughout his life to an important tenet of the Nabis' theories on art. "When my friends and I wanted to pursue the researches of the Impressionists . . . ," Bonnard said, "we sought to surpass them in their naturalistic impressions of color. Art is not nature. . . . There was also much more to be had from color as a means of expression."[47]

Even now, a century later, Bonnard's practice of color lithography remains unsurpassed in its agility and in the variety of its imagery and application. It could be argued, furthermore, that at no other time has a painter's palette been applied to the process with greater sensitivity and success. Bonnard seems to have found lithography perfectly responsive

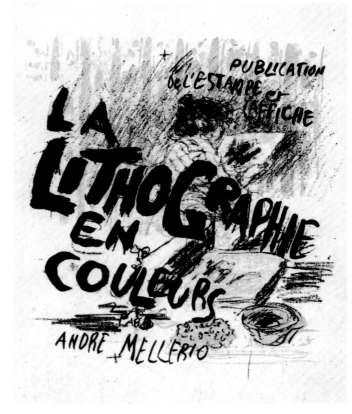

33. La Lithographie en couleurs, 1898

Proof impression of the cover of André Mellerio, *La Lithographie originale en couleurs*, 1898. Color lithograph, 215 x 195 mm. The Fine Arts Museums of San Francisco, Achenbach Foundation for Graphic Arts purchase

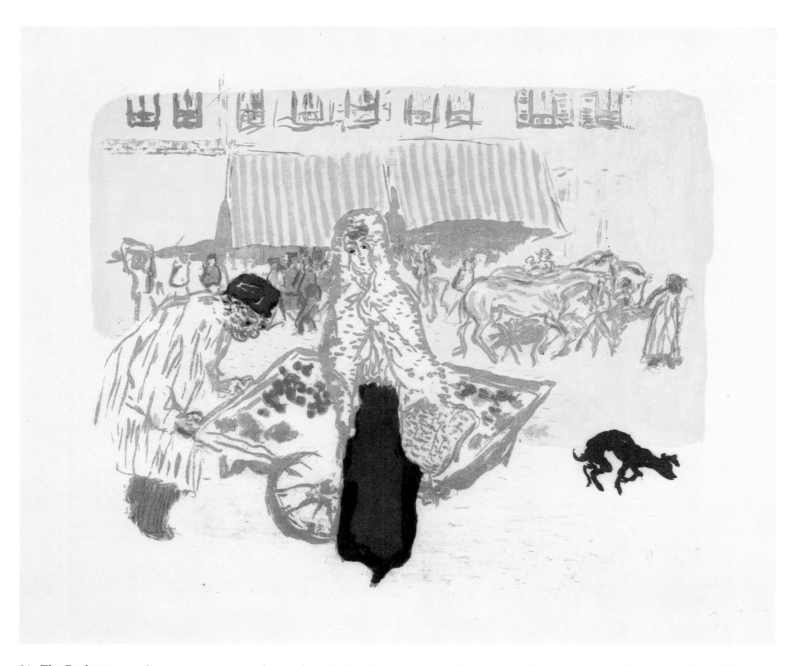

34. The Pushcart, ca. 1897 [cat. 70]

From the suite *Quelques Aspects de la vie de Paris*, 1899.
Color lithograph, 290 x 340 mm. New York, The
Metropolitan Museum of Art, Harris Brisbane Dick
Fund, 1928

to the fluctuations in his style, at first approximating the polished flatness
of Japanese woodcuts with their jigsaw pieces of color, later adopting the
density of painting with its layered strokes, and always conveying the
artist's line, whether jagged or supple, with affecting directness.

It was lithography's special capacity to reproduce his designs without
any loss of their feeling of spontaneity that Bonnard explored in the illus-
tration of books. This, rather than the creation of independent prints,

was to be his principal activity in the graphic arts from 1899 until his death in 1947. Even before it was realized that the fin-de-siècle print market had been glutted and that collectors' portfolios like *Quelques Aspects de la vie de Paris* would not sell, Vollard had begun to consider branching out into *livres de luxe*. A large international book exhibition mounted by Bing in

35, 36. The Pushcart, ca. 1897 [cat. 71]

Working proofs of the print in *Quelques Aspects de la vie de Paris*, 1899. Color lithographs with corrections in colored crayons and chalk: 325 x 535 mm.; 235 x 530 mm. Paris, private collection

These proofs of the lithograph were run off on early trial sheets of the designs for the contents and end pages of *Album d'estampes originales de la Galerie Vollard*, 1897 (see figs. 27, 28).

1896 at his gallery, L'Art Nouveau, revealed the relative backwardness of the French in this area, particularly by comparison with the English private presses and the distinguished achievements in book illustration and production of William Morris, Aubrey Beardsley, Walter Crane, Charles Ricketts, and Charles Shannon.[48] Vollard now undertook to redress the imbalance. In 1896 he invited Camille Pissarro's son Lucien, who illustrated books with Ricketts and Shannon in London, to supply woodcuts

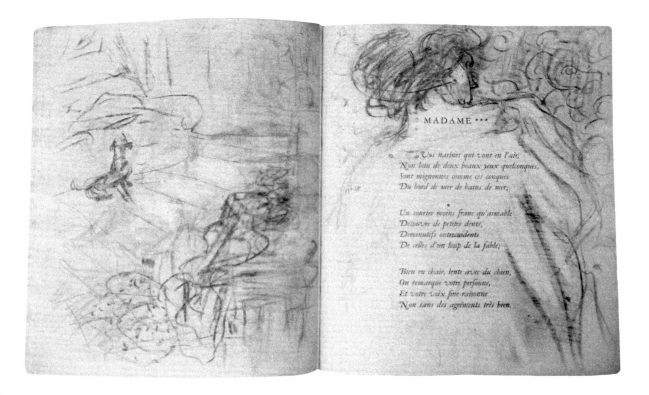

37. A Madame ***

Preparatory drawings for pages 42 and 43 of Paul Verlaine, *Parallèlement*, 1900. Crayon and graphite, page 295 x 241 mm. Upperville, Va., Collection of Mr. and Mrs. Paul Mellon

When type was first set for the text of *Parallèlement*, space was left for an oversize or decorative initial at the beginning of each title. Once Bonnard's drawings filled the pages, such an elaboration must have seemed superfluous, and the missing letters were then inserted in the regular typeface.

for an edition of Verlaine. When Lucien Pissarro declined, Vollard assigned the project to his favorite lithographer, Bonnard, who had only recently completed the illustrations to Peter Nansen's novel *Marie*.[49]

Parallèlement (see chapter 4), which appeared in 1900, was the first of more than twenty deluxe volumes Vollard was to publish that would establish a new aesthetic in books by combining classically printed texts with the freely conceived illustrations of contemporary painters or sculptors. As the first modern *livre de peintre*, Bonnard's *Parallèlement* achieved such a harmonious union of words and images that it is difficult to imagine an artist better suited to the task of illustrating Verlaine's last important collection of verse. Bonnard, like Verlaine, felt profoundly the parallelism of human nature. But unlike the poet, who drowned in wine trying to resolve the conflict between the physical and the spiritual, the painter remained at peace with his own duality, the consistent balancing of his intellectual and sensual impulses giving force to the dynamic at the core of his art. Bonnard rushed to convey Verlaine's lyrical eroticism openly and generously, for the most part skirting the poet's brutishness. But the contemporary critic Clément-Janin dismissed his illustrations as "uncertain . . . stutterings."[50] It was a criticism that the artist might have

taken as a compliment in light of the Symbolist view of illustration as an interpretive rather than a literal rendering of the text. Denis made this point when he wrote in 1890 that illustration was not an "exact correspondence of subject with writing; but rather an embroidery of arabesques on the pages, an accompaniment of expressive lines."[51]

The spirited color Bonnard chose to counterbalance Verlaine's musings on love and *la vie en rose* is an example of his often inspired judgment. Matched to his luxuriant designs the hue immediately signals an ardent mood, at the same time suggesting the Rococo splendor of red-chalk drawings by Boucher and Watteau (figs. 37, 38). Earlier illustrated books, such as Edouard de Beaumont's *Quatre Contes de Perrault* of 1888 and Toulouse-Lautrec's *Yvette Guilbert* of 1894 (see fig. 226), had strewn sketchlike

38. A Madame ✳✳✳ [cat. 84]

Pages 42 and 43 of Paul Verlaine, *Parallèlement*, 1900. Color lithographs, page 292 x 241 mm. Ohio, The Toledo Museum of Art, Gift of Molly and Walter Bareiss

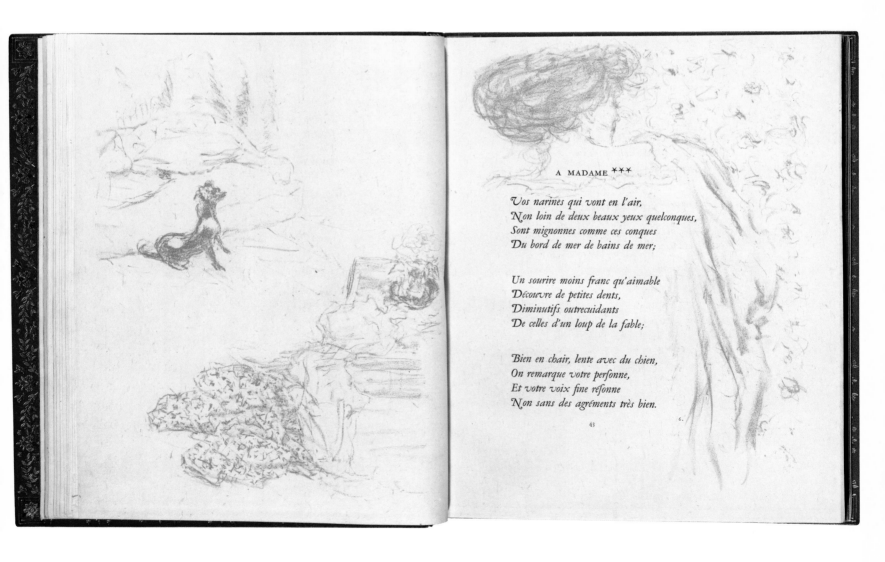

A MADAME ✳✳✳

Vos narines qui vont en l'air,
Non loin de deux beaux yeux quelconques,
Sont mignonnes comme ces conques
Du bord de mer de bains de mer;

Un sourire moins franc qu'aimable
Découvre de petites dents,
Diminutifs outrecuidants
De celles d'un loup de la fable;

Bien en chair, lente avec du chien,
On remarque votre personne,
Et votre voix fine résonne
Non sans des agréments très bien.

43

menèrent leurs bêtes aux champs, mais devant tous Daphnis et Chloé, comme ceux qui servoient eux-mêmes à un bien plus grand pasteur; et d'abord s'en coururent droit aux Nymphes dans la caverne, ensuite à Pan sous le pin, puis sous le chêne, où ils s'assirent en regardant paître leurs troupeaux et s'entrebaisant quant et quant; puis allèrent chercher des fleurs pour en faire des couronnes aux Dieux. Mais les fleurs à peine commençoient d'éclore, par la douceur du petit béat de zéphyre qui les ranimoit et la chaleur du soleil qui les entr'ouvroit. Toutefois encore trouvèrent-ils de la violette, des narcisses, du muguet, et autres telles premières fleurs que produit la saison nouvelle, dont ils firent des chapelets et en couronnèrent les têtes aux images, en leur offrant du lait nouveau de leurs brebis et de leurs chèvres, puis essayèrent à jouer un peu de leurs chalumeaux, comme s'ils eussent voulu provoquer les rossignols à chanter, lesquels leur répondoient de dedans les buissons,

168

commençant petit à petit à lamenter encore Itys et recorder leur ramage, qu'un long silence leur avoit fait oublier.

Et alors aussi les brebis béloient, les agneaux sautoient et se courboient sous le ventre de leur

169 22

39. Daphnis and Chloe [cat. 89]

Pages 168 and 169 of Longus, *Daphnis et Chloé*, 1902. Lithograph illustration, page 292 x 241 mm. New York, The Metropolitan Museum of Art, Harris Brisbane Dick Fund, 1928

designs in color about blocks of text, but Bonnard's response to his author's evocative words was unprecedented in its expansive, ingenious richness, sustained throughout 109 pages. The marriage of word and image achieved in *Parallèlement* set a new standard for deluxe books that proved difficult, if not impossible, to surpass.

By contrast to Bonnard's illustrations in *Parallèlement*, which often sprawl across the page, those he prepared for *Daphnis et Chloé* (see chapter 4), published by Vollard in 1902, contain their rather more innocent sensuality within traditional confines. The text, a translation of the story written by Longus in Greek in the third or fourth century, is a pastoral ro-

mance whose lighthearted feelings Bonnard encapsulated in 151 rectangular black-and-white lithographs.[52] According to Pissarro, Vollard at first planned to issue his edition with woodcuts by Denis.[53] Instead, Bonnard plunged into the project, working "rapidly, with joy . . . with a kind of happy feverishness which carried me along in spite of myself," he recalled.[54] His brisk pace and, most important, his sympathetic involvement with the idyllic story are felt throughout the whole sequence of buoyant drawings. Having envisioned his lover, Marthe, as the modern Marie of Nansen's novel and also as the model for the languorous nudes of *Parallèlement*, Bonnard now entered the picture himself, as Daphnis with his Chloe, in an ideal landscape (fig. 39). Despite the fact that lithography was a costly and seldom-used process for book illustration, since the letterpress had to be printed separately, Vollard spared no expense, even after the largely negative response to *Parallèlement* made it clear that few shared his enthusiasm for coupling formal blocks of type with a painter's freehand allusions.

It must have been close to the time when Bonnard was working on *Daphnis et Chloé* that he made at least twenty-two crayon drawings as illustrations to an edition of Italian fairy tales newly translated into French by Victor Barrucand and intended for publication by *La Revue blanche* (fig. 40). Although they are more tightly compacted and detailed, these drawings resemble the *Daphnis et Chloé* lithographs in their sprightly miniature figures and picturesque scenery. It is assumed that, like the illustrations Bonnard made for *Marie*, published by *La Revue blanche* in 1897 and 1898, the Barrucand designs were always meant to be reproduced photomechanically, which may account for their often broad tonal range. In the end, only seven of them were ever printed: one appeared in an edition of Isabelle Eberhardt's *Notes de route*, published by Fasquelle in 1908; and this was included, along with six others, in Barrucand's *D'un pays plus beau*, published by Floury in 1910.[55]

Beginning with his pictorial music lessons for children in the *Petit Solfège illustré*, Bonnard consistently strove to convey in his illustration of texts a light spirit with a light touch. In *Parallèlement*, and even more purposefully in *Daphnis et Chloé*, he began fracturing outlines into shorter daubs and strokes—the marks of a painter rather than a draughtsman. His illustrations, which allowed more and more white paper to shine through, now conformed to the revised aims of his paintings, which had become charged with luminosity and active brushwork. In the etchings he started around 1915, also on assignment from Vollard, Bonnard tried

40. The Knight in the Forest, ca. 1902–05

Drawing reproduced in Victor Barrucand, *D'un pays plus beau*, 1910. Blue crayon, 140 x 137 mm. Geneva, Galerie Jan Krugier

41. The Death of Dingo [cat. 103]

Illustration on page 189 of Octave Mirbeau, *Dingo*, 1924. Etching, 35 x 175 mm. New York, The Metropolitan Museum of Art, Harris Brisbane Dick Fund, 1928

42. Saint Monica, ca. 1920

Illustration (not included in the book) for Ambroise Vollard, *Sainte Monique*, 1930. Etching, 236 x 176 mm. New York Public Library, Astor, Lenox, and Tilden Foundations, Division of Art, Prints, and Photographs, Print Collection of Miriam and Ira D. Wallach

43. Le Parc Monceau, 1937

Working proof of an illustration in Paul Valéry et al., *Paris 1937*. Etching corrected in pencil, 333 x 259 mm. The Art Institute of Chicago, Print and Drawing Club Fund, 1953

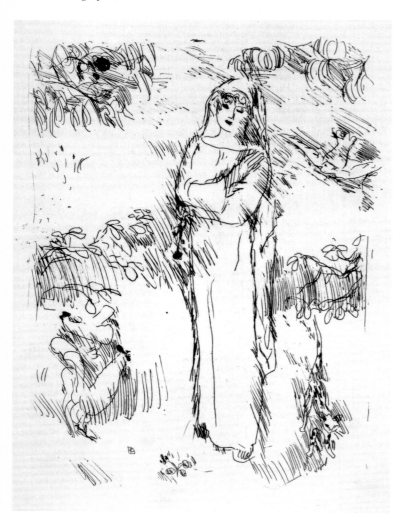

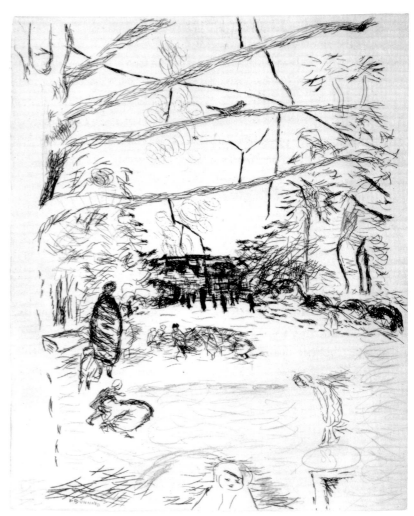

to catch the bright, vibrant light he adored in a net of quivering lines and hatches.

Undeterred by the commercial failures of earlier projects, Vollard renewed his commitment to the *livre de luxe* soon after the doldrums of wartime. Hoping for an invigorated market, he commissioned Bonnard to etch illustrations for Octave Mirbeau's *Dingo* (fig. 41) about 1915, and for his own text *Sainte Monique* (fig. 42) in 1920. But Bonnard found that the etching needle did not follow his thoughts as readily as had the lithography crayon. Work on these two books required a decade, or nearly so, to complete, and Bonnard was still trying to coax etching into compliance when he illustrated one of a collection of essays published under the title *Paris 1937* (fig. 43). In the end, *Sainte Monique* became a hybrid of three techniques—etching, lithography, and wood engraving—displaying the kind of self-conscious extravagance that overtook the production of artist-illustrated books during this era, owing in large part to Vollard's example. His ambitions led eventually to the supremacy of illustrations over text, with the result that some of the greatest artists of the period lavished their talent on unworthy literature.

As the time Bonnard spent each year in Paris diminished rapidly after the turn of the century, and he began to find himself ever more in the thrall of the countryside (fig. 44), such a collaboration as he had earlier maintained with the printer Clot became far less practical. The artist who early on identified himself with the world of magazines, posters, and sheet music continued, nonetheless, to enjoy the useful application of his skills to illustration. But after 1902 his drawings for these assignments were often prepared strictly for photomechanical reproduction. Crisp, black line sketches of the lively sort that Bonnard had been drawing since 1890 became inky accompaniments to numerous articles and books. Having traced the antics of Alfred Jarry's creation, Père Ubu, in almanacs for 1899 and 1901, they brought the hero's adventures up to date in two further "reincarnations" conceived by Vollard: *Le Père Ubu à l'hôpital* (1917) and *Le Père Ubu à l'aviation* (1918). They described life out of doors and on the road with refreshing zest in Jules Renard's *Histoires naturelles* of 1904 (fig. 45), Mirbeau's *La 628-E8* of 1908 (fig. 46), and Léopold Chauveau's *Histoires du petit Renaud* of 1927, where they received the added benefit of stencil coloring (fig. 47).

So scattered in their focus and so irregularly timed were Bonnard's published works during the second half of his life that while the artist was receptive to such projects, the impetus to interrupt his work as a painter must have invariably come from others. There were his dealers, the

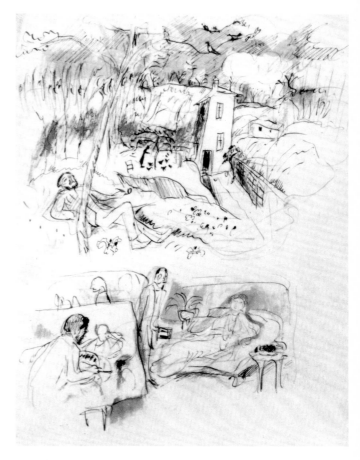

44. The Painter's Life, ca. 1910

Page 5 of a sketchbook. Pen and brown ink with blue wash. France, private collection

In 1900 Bonnard rented the first of what was to be a succession of houses in the Seine Valley and began to spend less time in Paris. There, commissions to paint portraits of the fashionable must have made it possible for him to enjoy the *dolce far niente* of his country retreat.

45. The Image Hunter [cat. 95]

Page 10 of Jules Renard, *Histoires naturelles*, [1904]. Process print, page 186 x 124 mm. New York, The Metropolitan Museum of Art, Gift from The Josefowitz Collection, 1989

46. La 628-E8, 1908

Title page of Octave Mirbeau, *La 628-E8*, 1908. Process print, page 241 x 191 mm. New York, The Metropolitan Museum of Art, The Elisha Whittelsey Collection, The Elisha Whittelsey Fund, 1973

brothers Bernheim-Jeune, for whom he designed invitations for the gallery's exhibitions, a poster, and the limited-edition color lithograph of 1922, *Place Clichy* (see fig. 197); the publishers of the newspaper *Le Figaro* and the magazines *Le Canard sauvage*, *Schéhérazade*, *Les Cahiers d'aujourd'hui*, and *Verve*; the writers André Gide, Victor Barrucand, Elie Faure, and Claude Anet; and authors of articles and books about Bonnard and catalogues of his work, Pierre Laprade, Charles Terrasse, Gustave Coquiot, and Jean Floury.[56]

There was a point, however, at which Bonnard effectively renewed his

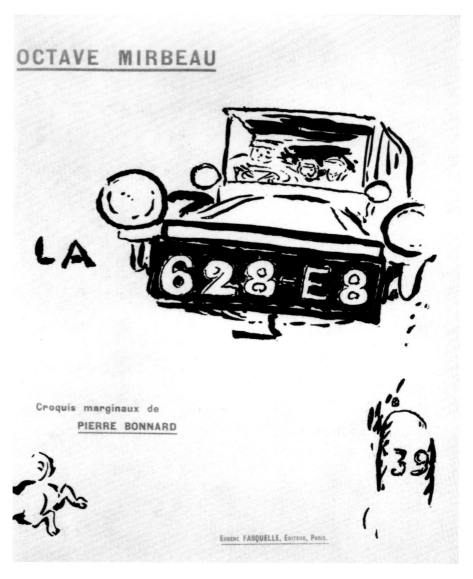

activity as a lithographer, spurred to produce a dozen prints with the encouragement of the publisher and owner of the Paris Galerie des Peintres-Graveurs, Edmond Frapier, who attempted to bring about a renaissance of the lithograph. Bonnard contributed to the first album Frapier published around 1925, which contained a collection of lithographs by contemporary artists, including Aristide Maillol, Maurice Utrillo, and Raoul Dufy, and which was introduced by an essay on the history of French lithography "from Manet to Matisse." Not long afterwards, Frapier persuaded Bonnard to create eleven more prints, four of which were

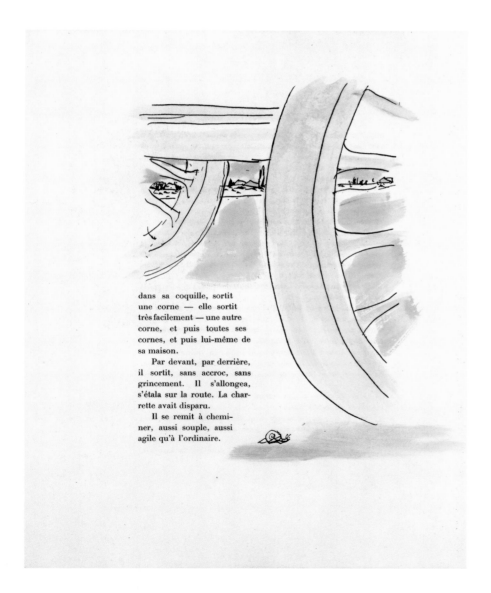

dans sa coquille, sortit
une corne — elle sortit
très facilement — une autre
corne, et puis toutes ses
cornes, et puis lui-même de
sa maison.

Par devant, par derrière,
il sortit, sans accroc, sans
grincement. Il s'allongea,
s'étala sur la route. La char-
rette avait disparu.

Il se remit à chemi-
ner, aussi souple, aussi
agile qu'à l'ordinaire.

47. The Big Snail

Page 16 of Léopold Chauveau, *Les Histoires du petit Renaud* (*Little Renaud's Stories*), 1927. Process print with stenciled coloring, page 283 x 224 mm. New York, The Metropolitan Museum of Art, The Elisha Whittelsey Collection, The Elisha Whittelsey Fund, 1968

48. Paysage du Midi (Landscape in the South of France), 1925 [cat. 111]

From an album in the series *Maîtres et petits maîtres d'aujourd'hui*. Lithograph, 216 x 292 mm. New York, The Metropolitan Museum of Art, Bequest of Dorothy Varian, 1985

issued in 1925 as a set in the series *Maîtres et petits maîtres d'aujourd'hui* (*Masters and Minor Masters of Today*). Bonnard designed the figure studies and landscapes in this group with considerable vigor, working the lithographic crayon to suggest both the tonal and tactile richness of his paintings (figs. 48, 49). The close connection between Bonnard's paintings and these lithographs in terms of their composition and finish underscores the distinction between the seemingly casual and generally sketchy images Bonnard created to accompany a text and the more formal nature of those distributed as single sheets and likely to be framed and mounted.

The ever greater distance Bonnard put between himself and Paris after 1900 made it difficult for him to work as closely with a printer as he once had. Thus, although it was reported in the press in 1943 that he was looking forward to a new engagement with lithography,[57] his involvement with the actual printing of book and magazine illustrations, even when it came to the publication in 1944 of his autobiographical *Correspondances* (*Letters*), remained largely at a remove. He provided the publisher with drawings, which were then sent on to the printer. In 1942, an unusual de-

parture from this procedure was initiated by the dealer and publisher Louis Carré, who suggested that some of the colorful Mediterranean views Bonnard painted in watercolor and gouache should be executed in lithography by the painter-printmaker Jacques Villon. There ensued an exchange of notes between the two artists regarding the production of the prints over a period of two to three years, Villon sending press proofs from Paris to Bonnard's villa at Le Cannet on the Côte d'Azur, and Bonnard returning them with comments and corrections. The eleven color lithographs that resulted from this collaboration, including still lifes and interiors,[58] restate the tradition of teamwork in printmaking that originated in the Renaissance. But as a series of translations and of compromises between two distinct wills, they cannot be said, on the whole, to serve either artist particularly well.

To our eyes lithography appears as a technique remarkably sympathetic to Bonnard's graceful expressions, for it conveyed his wit and finesse lucidly, without much to-do or pretense. But, in truth, all through his life he seems to have welcomed almost any means or opportunity that presented itself to pursue what he defined in his youth as "a popular production with everyday application." Even after he had passed the age of

49. Normandy Landscape, ca. 1926–30

Oil on canvas, 620 x 800 mm. Northampton, Mass., Smith College Museum of Art

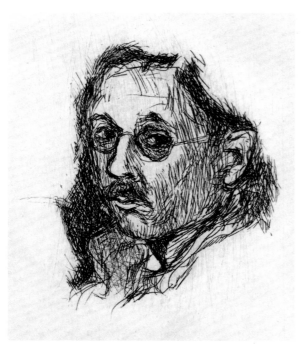

50. Self-Portrait [cat. 103]

Illustration on page 149 of Octave Mirbeau, *Dingo*, 1924. Etching, 89 x 76 mm. New York, The Metropolitan Museum of Art, Harris Brisbane Dick Fund, 1928

seventy-five, Bonnard continued to involve himself with graphic designs, and in the last five years of his life alone, he completed over a dozen projects.

It is clear that Bonnard's art was decisively shaped by his practice of making prints and creating images intended specifically for the press, particularly during the first decade of his career when the graphic arts and popular illustration played an unusually important role. The flat colors, bold forms, and outlines endemic to the Nabi style that he adopted early on found vivid clarification in his printed work, while the lyric delicacy to which he later aspired achieved its first full expression near the end of the century in his lithographs.

In the later years of his life, Bonnard (fig. 50) acquired a mastery of painting that was not only often large in scale but frequently expansive and grand in its vision. All along, however, and especially in his illustrations and color prints, it had been his custom to work quite close to the chest. He pictured what stirred him, for his own sheer pleasure, without any muddle of focus or purpose, and his regard for the common sights and objects of everyday life remained the central inspiration of his work.

As a young man in his twenties, just launching his career, Bonnard was still very much attached to his roots. Scenes of his family gathered about the supper table, in the backyard, or in the halo of affection surrounding a newborn infant injected intimacy and genuine emotion into his earliest pictures. It was not long, however, before the activity of Paris laid claim to his attention, and urban life was supremely his subject from about 1895 to 1900. It was only as his fascination with the city paled that he began the long line of evocative nude studies modeled on the supple figure of Marthe, his principal muse and companion from their meeting in 1893 until her death in 1942. Their quiet life at home and the landscape that surrounded and sheltered them were the focus of Bonnard's art from 1900 on.

2 DOMESTIC SCENES

Helen Giambruni

THE GRAPHIC MEDIA played an important role in Bonnard's artistic development from 1889 to 1902—his Paris years and the first, formative decade of his life as an artist. Domestic scenes featuring parents, children, animals, and the family at table formed a large part of his output. The aesthetic importance he attributed to his commercial art projects, book illustrations, posters, and lithographs is indicated by the very large amount of time and effort he devoted to them. Yet many of these works remain little known and the question of how they fit into the broader art world of the period has only begun to be investigated.

Bonnard was immersed at the time in the aesthetic climate of Symbolism. Closely associated with a Symbolist avant-garde in the visual arts and the theater, he was in touch with a number of the movement's writers and intensely admired the poets Paul Verlaine and Stéphane Mallarmé. The dominant intellectual and artistic current of the period, Symbolism may be defined broadly as a movement away from the naturalist concern for reproducing the physical world and toward a more indirect, a more allusive or "musical" expression, one that reveals the artist's subjective states and expresses content of universal rather than specific import.[1]

Despite his involvement with the Symbolist milieu, Bonnard was long considered to be almost impervious to its aesthetic values. His resistance to the elaborate theorizing of his Nabi friends Paul Sérusier and Maurice Denis is well documented, and he avoided the fantasy, personal metaphor, and overtly symbolic images of so many of his colleagues, persisting in choosing for his subject matter the most ordinary of everyday scenes. Furthermore, the influence on him of Gauguin's Synthetism was believed to be only temporary and superficial. His move away from the near-abstract patterning of his work of the early nineties toward a looser, more atmospheric style reminiscent of his Impressionist predecessors

and more tied to the look of things was viewed as proof of his lack of Symbolist conviction and of a native poetic naturalism. Close study of his content seemed unnecessary.

Art-historical attention was also deflected by the persistent notion that Bonnard's art sprang more directly from an innate sensibility than was usual for painters. Arising from the need to explain the "naive" drawing and seemingly formless structure of his twentieth-century paintings in the context of post-Cubist formalism, this belief made scrutiny of his craft and artistic intentions superfluous, for they disappeared behind ideas of personality and gifts, especially his spontaneity and childlike capacity for pleasure in the world around him. To maintain the consistency of such views it was necessary to ignore equally well founded accounts of a more complex and contradictory character, one that was sophisticated, reflective, and considerably less positive in attitude. Revision of these limiting views has been under way for some years now and important studies have been done on Bonnard's art, but his relationship to Symbolism remains cloudy and most of his work has yet to be subjected to the close formal, iconographical, and contextual scrutiny given to other major artists of his generation. This study will look at Bonnard's graphics of domestic subjects in the broader context of his Symbolist environment, with attention also to the ways in which his work was shaped by characterological imperatives.

Life at Le Clos

Most of Bonnard's early graphics on domestic themes center around life at Le Clos, the country property located on the outskirts of Le Grand-Lemps in the Dauphiné (now Isère) where his family gathered every summer. The place held a profoundly symbolic meaning for Bonnard, stemming from childhood summers of joyous release from living in a *pension* away from home while undergoing the rigors of a classical lycée education—a captivity with which he dealt by cultivating a state of emotional detachment.[2] Le Clos helped shape his way of coping with the world, and its spirit informed his art for the rest of his life.

A small agricultural town with a few winding medieval streets and a central, covered marketplace, Le Grand-Lemps was situated in a poor and sparsely populated area, but its small farms with their assorted domestic animals provided the child from a Parisian suburb with varied and endlessly interesting surroundings.[3] Its location near the foothills of the French Alps meant that spectacular mountains and valleys, forests, lakes

and streams were close enough for an adolescent to explore on foot or on horseback. The long vacations at Le Grand-Lemps developed in the young Bonnard a love of nature and of animals which would be of central importance for his art. His happiness at Le Clos is attested by his habit of returning every year until the property was sold in 1928.

Composed of vineyards, meadows, orchards, barns, and a large but modest house surrounded by lawns and gardens, Le Clos had belonged jointly to the artist's grandfather Michel Bonnard, a local farmer and grain merchant, and Michel's brother, a priest.[4] The property was inherited by Bonnard's father, Eugène, who took much pleasure in its spacious grounds and fruit trees, especially after retiring from his high-level position in the civil service as *chef de bureau* in the War Ministry.

During the 1890s, the decade of Bonnard's greatest activity in the graphic arts, the house was bustling with life, filled with a numerous family together with friends, servants, and pets. His severe but supportive father and his beloved maternal grandmother Mertzdorff, an Alsatian, were still alive in the early years of the decade. Youthful gaiety was provided at first by his sister, Andrée, with her friends and cousins, then, following her marriage in 1890 to Claude Terrasse, by their fast-growing brood of children. For Bonnard, Le Grand-Lemps provided a continuation into adulthood of his childhood family, as Marthe de Méligny, his companion from 1893 on, almost never went there. Always extremely shy, later pathologically so, she found "too many faces there—benevolent perhaps, but strangers nonetheless."[5]

A vivid glimpse of what life at Le Clos meant to Bonnard is provided by a few fictional family letters which he wrote and illustrated for publication toward the end of his life, basing them on his memory of experiences there and on photographs he took in his youth, perhaps also on real letters. The fact of their publication by this almost obsessively private man suggests he believed that they cast light on his art. Centering on the period of the 1890s and purportedly written by himself, his mother, and his grandmother Mertzdorff, several of these letters concern summers in the country. There is talk of family and guests arriving, of children and animals, of homely tasks and amusing episodes, and especially of the bounty of the land. A letter from his grandmother to Pierre reads:

> I'm here installed at Le Clos before everyone else. I feel well in the country. At the moment I'm shelling new peas in the dining room, the dog at my feet and the two cats on the table. I hear breathing, it's the cow who shows her big head at the window. The little maid shouts outside, "Joseph, the calf is loose!" Tell your mother everything is going well and I'm keeping an eye on the kitchen garden.[6]

A letter addressed by Bonnard to his brother, Charles, supposedly doing his army service, reflects scenes from photographs the artist took at Le Clos and some of the paintings he did there:

> Finally I arrived and I hope you'll get leave next Sunday so we can all be together. Terrible heat. The little ones take a dip in the small pool in front of the house, the grown-ups in the *boutasse*. The children in the pool are a charming sight. There are masses of fruits; Maman makes her rounds with her basket every afternoon. And then it's nice to see our cousin up in the big peach tree in among the branches and the blue sky.[7]

For Bonnard, Le Clos seemed to represent an escape to a pastoral Eden, a place where life was simple, peaceful, and savorous, where people performed age-old duties in touch with the earth and their domesticated animals. This Virgilian nostalgia for the universals of human existence and the harmonious life in nature was his sole form of romanticism, and it must be seen in counterpoint to the amused or ironic distance, occasionally verging on misanthropy, that usually colored his view of human beings. Le Clos provided temporary refuge from a broader world that he sometimes found it difficult to cope with, although he was eager enough to get back to it when he had regrouped his forces.

His years in Paris were the most exciting of Bonnard's life. However, if he relished his diverse activities there and the interaction with his fellow artists, and if he was stimulated by the clash of political, literary, and artistic ideas, the imperatives of his own character meant that he also found the experience highly stressful. His central concern for his autonomy, his dread of being influenced against his will, meant that he felt it necessary to remain perpetually and exhaustingly on guard. Uncomfortable with strong emotions and possessed of a capacity for gaiety that showed itself particularly in his youth, Bonnard usually deflected intrusions with jokes and his customary attitude of good-humored nonchalance. But in argument he tended to assume a defensive posture, was sometimes irrationally contradictory, and if pressed too hard could explode in outbursts of almost savage resistance.[8] It is not surprising, then, that he found it necessary to escape periodically from the pressures of his active city life to seclusion in the country and the unthreatening society of his extended family.[9]

Bonnard's romantic response to Le Clos is made clear in the 1892 painting he called *Crépuscule* (*Twilight*)—now usually named *The Croquet Game* —his only painting with explicitly symbolic forms (fig. 51).[10] In the distance, behind the artist's brother-in-law, father, sister, and cousin in the garden at Le Clos, is a vision of joyous innocence, a fantasy circle of

white-clad maidens under a golden sky. Ursula Perucchi-Petri has suggested a convincing connection with an image from one of Paul Verlaine's proto-Symbolist poems:

> On a sudden interlace some forms all white,
> Diaphanous, and by moonlight made
> Opaline amid the green shade of the branches, . . .
> They interlace amid the green shade of the trees . . .
> Then . . .
> Very slowly dance in a ring.[11]

An 1891 watercolor drawing of Andrée with a dog in a garden (fig. 52), one of a number of related subjects dating from the early 1890s, is a somewhat tentative attempt to express related content through primarily formal means, one of the qualities Bonnard and his fellow Nabis associated with an art of "decoration." The suggestion that woman and animal are

51. Crépuscule (Twilight), 1892

Oil on canvas, 130 x 162 mm. Paris, Musée d'Orsay, Gift of M. de Wildenstein through the Société des Amis du Musée d'Orsay

A game of croquet at Le Clos, the Bonnard family's property at Le Grand-Lemps in southeast France. From left, Claude Terrasse (the painter's brother-in-law), Eugène Bonnard (his father), Andrée Terrasse (his sister), and Berthe Schaedlin (his cousin). The figures in the distance are imaginary.

52. Villa Bach: Andrée with Dog, 1891 [cat. 6]

Cover design for a concert program. Watercolor, pencil, and ink, 160 x 257 mm. Switzerland, private collection

53. Villa Bach: Woman in a Landscape, 1891

[cat. 7]

Front cover design for a concert program. Watercolor, pencil, and ink, 160 x 129 mm. Switzerland, private collection

In 1891 Bonnard designed a number of program covers for informal concerts that his sister and brother-in-law, Andrée and Claude Terrasse, planned to hold at the Villa Bach, their home in Arcachon in the Gironde.

integral and somehow related parts of a beneficent nature is made in what would now be called a subliminal fashion by the repetition of the form of the dog's legs and the woman's stance in the same piece of background shrubbery (an echoing device Bonnard learned from Seurat). This suggestion of hidden connections among widely assorted things reflects the Symbolist notion of "correspondences" between human subjective states and the objective world.[12] It may also be seen in a companion drawing where the youthful vitality suggested by the springing arabesque of the young woman's contour is echoed in the tree trunks, a generalizing effect that is reinforced by her obscured face (fig. 53).

Maternity

The birth of her children transformed Bonnard's sister in his art from wood nymph to image of motherhood, one of the universal human conditions to which the Symbolist generation responded. In all Bonnard's works on this subject the mother's attention is completely fixed on her child. Their emotional symbiosis is revealed graphically on the back cover of one of the books he illustrated, *Petit Solfège illustré* (*Little Illustrated Solfeggio*), a picture book of music theory for children. While a preliminary drawing has a realistic environment with details of furnishings and a glimpse of Paris rooftops through the window, in the final version the generalized setting underlines the human relationship (figs. 54, 55). The child is absorbed in the book, the mother in the child, and because the brushstrokes are all of a kind, if varied in size, the figures merge into

their surroundings. With the abstract, curved lines in the background serving to reinforce a sense of enclosure, the scene takes on the feeling of a nest, emphasizing their interdependency.

The devoted mother with infant was a common theme throughout the nineteenth century, an outgrowth of the Enlightenment's focus on the nuclear family rather than on the extended family as an ongoing institution or "house," and of its concern for the needs of the developing child.[13] The belief that maternal love and guidance were not only necessary for successful child-rearing but also emotionally rewarding to the mother was bolstered by nineteenth-century arguments that self-disregarding nurturance of others and domination by instinct rather than reason were natural for women.

54. Mother and Child, 1893 [cat. 24]

Preparatory drawing for back cover, *Petit Solfège illustré,* 1893. Ink over pencil with brown wash, 205 x 282 mm. Cambridge, Mass., The Houghton Library, Harvard University, Department of Printing and Graphic Arts

Andrée Terrasse with her son Jean.

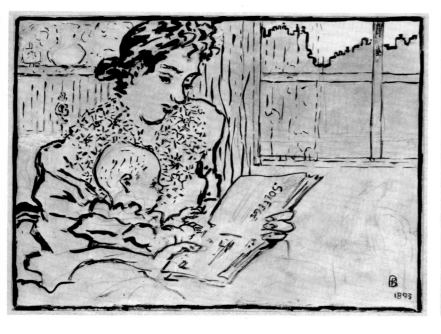

These ideas had been reflected, for example, in Renoir's 1886 paintings of his wife nursing their infant outdoors in a blossoming orchard. But Bonnard's works are less sentimental than those of Renoir and most of his other predecessors. Mary Cassatt's remarkable color etchings on female domesticity (fig. 56), with their combination of realist specificity and a linear abstraction strongly influenced by Japanese prints (fig. 57), were more to his taste. Exhibited at the Galerie Durand-Ruel in 1891, together with a show of Pissarro, they would almost certainly have been seen and appreciated by the *Nabi très japonard,* as his friends, adapting a comment by the critic Félix Fénéon, nicknamed Bonnard. Indeed, Cassatt's prints

55. Mother and Child, 1893 [cat. 19]

Back cover, *Petit Solfège illustré,* 1893. Lithograph, 212 x 278 mm. New York, The Metropolitan Museum of Art, Mary Martin Fund, 1987

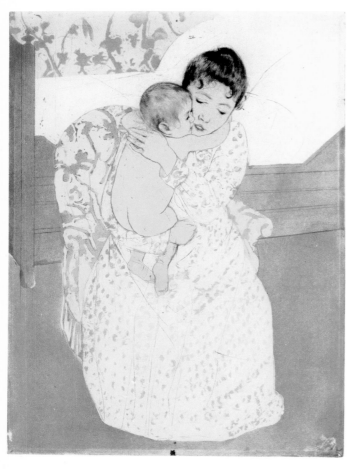

56. MARY CASSATT, **Maternal Caress,** 1891

Drypoint, soft-ground etching, and aquatint, printed in color, 365 x 268 mm. New York, The Metropolitan Museum of Art, Gift of Paul J. Sachs, 1917

facing page

57. KITAGAWA UTAMARO, **Sankatsu and Hanhichi with Their Baby,** ca. 1790

Pillar print. Color woodcut, 622 x 149 mm. New York, The Metropolitan Museum of Art, Rogers Fund, 1919

may have spurred him on to see how far he could push Japanist abstraction in treating similar subjects.

Certainly Bonnard's first lithographic print, *Family Scene* (fig. 58), 1892, carried to a new extreme the art of decoration advocated by Gauguin and the Nabis. For all his initial resistance to the Nabi theorists, Sérusier and Denis, in the end Bonnard had accepted their fundamental ideas, if not their mystical elaborations, and went on to use them as a springboard for his own development. In keeping with the Symbolist emphasis on subjectivity, the Nabis held that it was not the motif itself but the artist's feelings about it that were the real subject of the painting. But a primary obstacle to the communication of an artist's intentions lay in the viewer's preexisting associations with the motif, which were both irrelevant and distracting. Three-dimensional illusionism, it was thought, encouraged such associations through the confusion of image with reality. Therefore illusionism should be rejected and the character of the flat surface and the nature of the materials emphasized, as in mural decoration. In this way the viewer would be forced to recognize the work as a new entity, expressive on its own account as an ensemble of meaning-suffused lines, forms, and colors.[14]

Sérusier held that non-European and past societies uncorrupted by European post-Renaissance illusionism instinctively produced a nonnaturalistic, decorative art with a tendency toward pattern and arbitrary, harmonious color.[15] Such "primitive" arts were therefore admired (the term was invested with positive meanings inherited not only from Gauguin but also from a long French tradition of romanticizing distant, "simple" societies). In Bonnard's case, Japanese woodblock prints provided him with the model he needed for an art at once decorative in the Nabi sense and—equally important—grounded in reality, for he took an unceasing pleasure in observing the world about him and had no taste for the openly symbolic images of Gauguin and several of his fellow Nabis. He explained later of Japanese prints that "Gauguin and Sérusier referred in reality to the past. But there what I had before me was something fully alive and also extremely skillful."[16]

The Japanese also taught him that "it was possible to translate light, form, and character with nothing but color, without resorting to shading."[17] However, in *Family Scene* the negative space of the background assumes far greater significance for the overall pattern than it does in Japanese prints. In this Bonnard pushed much further a tendency already apparent in such paintings as Gauguin's *Vision After the Sermon* (see fig. 5) and Seurat's *La Grande Jatte*, which was to become central in twen-

tieth-century abstraction. This extreme of patterning had been approached only by Vuillard in a somewhat earlier but considerably less resolved work, *Sewing*, of about 1890–91 (fig. 59).

Comparison of a preparatory watercolor drawing for *Family Scene* (fig. 60) with the final print suggests that the lithographic medium itself, with its requirement of a separate stone for each color, encouraged simplification, for in the print only a very limited number of juxtaposed or overlapping areas of flat color define forms and relationships. However, the primary stimulus to Bonnard's formal innovations was the Nabi doctrine of subjective deformation, which held that purposeful simplification and distortion of images and intensification of color were not only permissible but also necessary to the achievement of a "synthesis" of feeling and form. As Denis explained, "The artist, placed before nature or rather before the emotion it inspires in him, must translate it with excess, excluding all that has not struck him, making of it an expressive schema. All lyricism is permitted to him, he must practice metaphor like a poet." [18]

Van Gogh provided a model for such nonillusionist expressiveness. In his *Mme Roulin and Her Baby* (fig. 61), he forced the figures up to the picture plane, set them against a screenlike background, and restricted three-dimensional modeling, while exaggerating color and emphasizing distorted, powerfully expressive linear contours. [19] Several interrelated works by Bonnard done in 1892 and 1893 reveal so many resemblances to van Gogh's painting that it probably served as direct inspiration for them. Compare with the van Gogh the baby's staring impassivity and almond eyes and the placement of the mother's protective hand with its elongated, slightly twisted fingers in the *Family Scene*—both lithograph and preparatory watercolor—discussed above; the mother's profile in the vertical lithograph of the same name (fig. 62); and the infant's wriggling, extended arm in the painting of the same subject (fig. 63).

The feeling conveyed by Bonnard's works is completely different, however, from the crudity and power of van Gogh's confrontational image. Bonnard's sensitivity to nuance and the restraint and subtlety of his color harmonies are more akin to the Japanese prints he admired so much, and serve to counterbalance the daring of his willfully distorted forms and extreme patterning. In fact, the two *Family Scenes* are more insistently Japanese in flavor than any others among Bonnard's lithographs, with their oddly high, oblique, and extremely close-up viewpoints. The narrow, vertical format of the second version is particularly reminiscent of Utamaro's family scenes (see fig. 57), with which Bonnard would certainly have been familiar. [20] Still, they could never be taken for

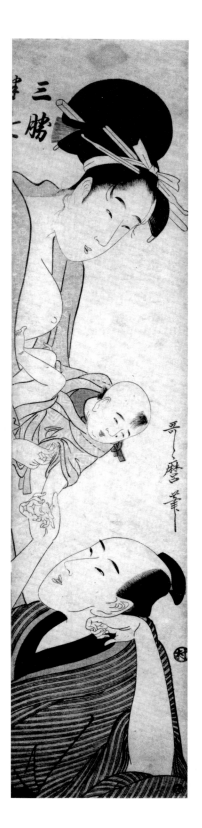

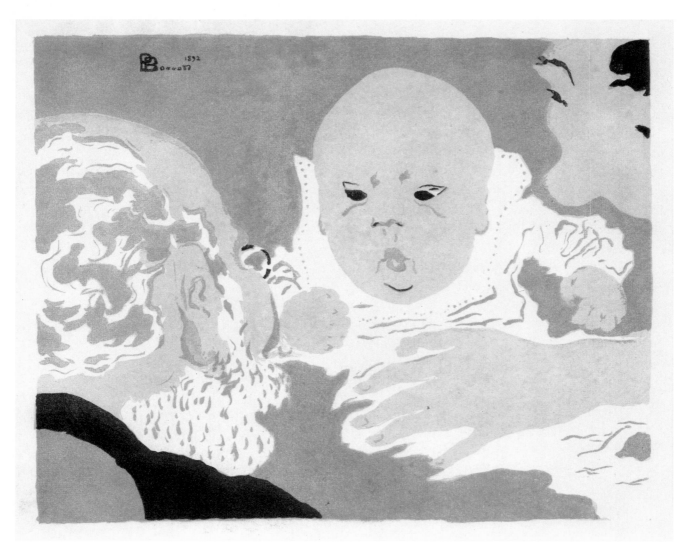

58. Family Scene, 1892 [cat. 13]

Color lithograph, 210 x 260 mm. Switzerland, private collection

Andrée Terrasse presents her baby to his maternal grandfather, Eugène Bonnard.

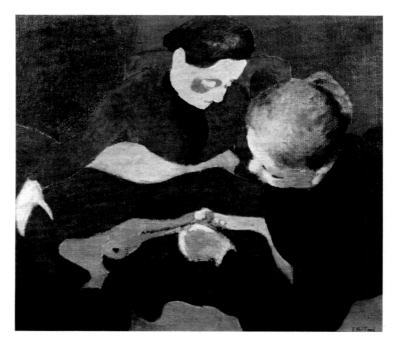

59. EDOUARD VUILLARD, Sewing, ca. 1890–91

Oil on canvas, 480 x 560 mm. Josefowitz Collection

The work is said to be a design for a ceramic tile, which would account for the extreme simplicity of its patterned forms.

Japanese prints or for the work of anyone but Bonnard. Their pungency and humor are unmistakably his. There is none of the somewhat cloying sweetness one sees, for example, in Denis's maternity scenes; sentimentality is ruled out by the peculiarity of Bonnard's forms and the faintly ironic overtones arising from the intensity of attention focused on a tiny and wholly impervious Buddha-figure.

These two lithographs mark the culmination of Bonnard's decorative style. He had pushed the ideas of the Nabis as far as he could take them. Later in 1893 his work began to loosen, and he moved closer to nature and started to explore new means of expression, although he retained a taste for the silhouette, among other formal vestiges of his youth.

60. Family Scene, 1892 [cat. 14]

Preparatory drawing for the lithograph (fig. 58). Watercolor and ink over pencil, 246 x 319 mm. Switzerland, private collection

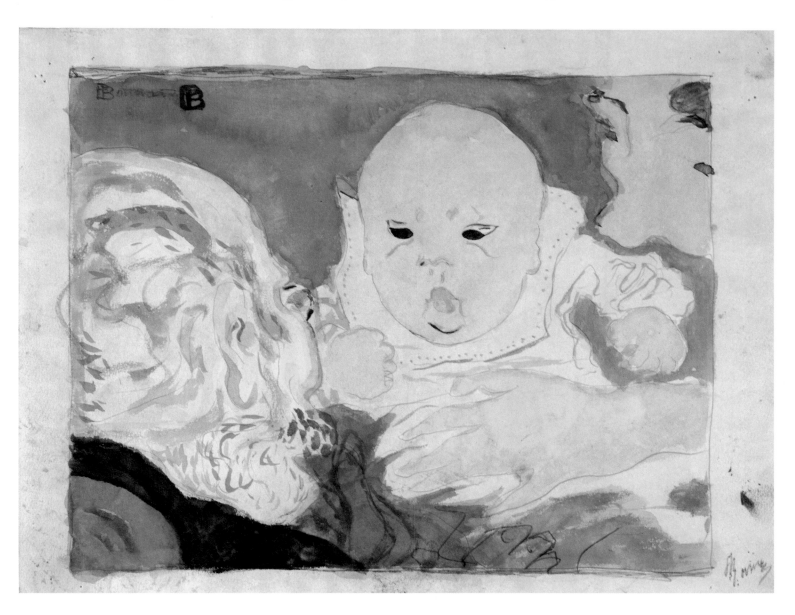

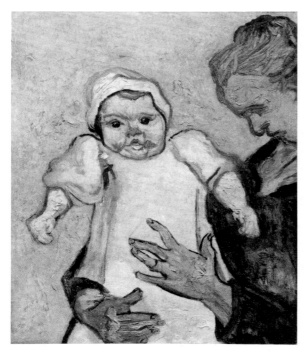

61. VINCENT VAN GOGH, **Mme Roulin and Her Baby,** 1888

Oil on canvas, 635 x 510 mm. New York, The Metropolitan Museum of Art, Robert Lehman Collection, 1975

62. Family Scene, 1893 [cat. 17]

From an album of *L'Estampe originale*. Color lithograph, 312 x 177 mm. New York, The Metropolitan Museum of Art, Rogers Fund, 1922

Andrée Terrasse and Jean, with Bonnard himself in the foreground.

63. Mme Claude Terrasse and Her Son Jean, 1893
 [cat. 18]

Oil on canvas, 370 x 300 mm. New York, Alice Mason Collection

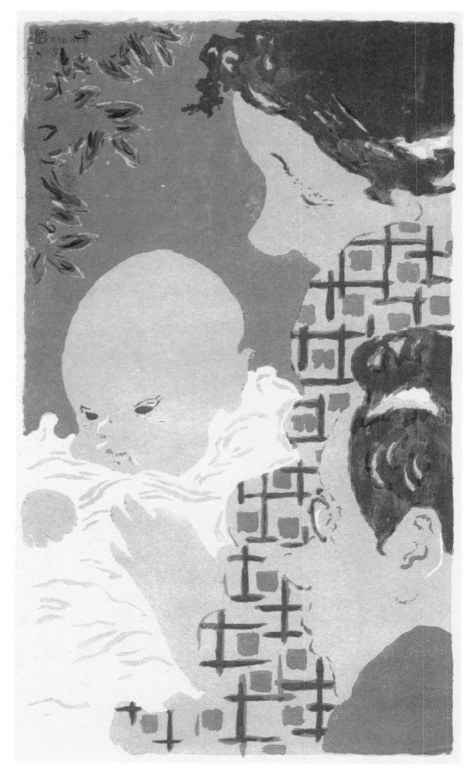

63

Domestic Scenes 51

64. Study for **Petit Solfège illustré,** ca. 1893 [cat. 21]

Watercolor, ink, and wash, 221 x 280 mm. New York,
The Museum of Modern Art, Peter H. Deitsch Bequest

Illustrations for the Family

From 1891 to 1895 Bonnard dedicated a great deal of his time and much serious effort to illustrating Claude Terrasse's primer of music theory for children, *Petit Solfège illustré* (figs. 64, 65), and his collection of sheet music for the family, *Petites Scènes familières* (*Familiar Little Scenes*). These remarkable and little-known works have no real precedents in earlier illustration. Another projected book, "Un Alphabet sentimental" ("An ABC of Sentiments"), was never completed, and we are left with only a few drawings and sketches to suggest how delightful the finished product might have been.

The two music projects were done in collaboration with his brother-in-law, then a piano teacher and later a church organist and successful composer of light music for the theater. Terrasse was a big, deep-voiced man, all bushy hair and mustache and overflowing vitality, to whom Bonnard was deeply attached. He spent time with the Terrasses not only at Le Clos but also in 1891, 1892, and 1893 at the Villa Bach, which they rented at Arcachon, in the Gironde southwest of Bordeaux (fig. 66). In 1891 the Terrasses planned a series of informal concerts in the villa (Andrée was herself a gifted pianist), and Bonnard made a set of drawings for program covers, including the drawings of Andrée in a garden (see figs. 52, 53).[21]

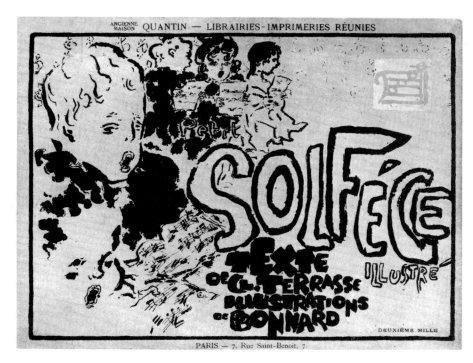

65. Petit Solfège illustré, 1893 [cat. 19]

Front cover of the music primer by Claude Terrasse. Lithograph on brown paper, 213 x 280 mm. New York, The Metropolitan Museum of Art, Mary Martin Fund, 1987

66. UNKNOWN PHOTOGRAPHER, **Andrée and Claude Terrasse,** 1893

Photograph. France, private collection

The photograph was taken at the Villa Bach, the Terrasses' home in Arcachon. Terrasse was a music teacher there before moving to Paris in 1896 as organist of the church of La Trinité.

Later he modeled puppets and painted scenery for the Théâtre des Pantins, the puppet theater founded in 1897 by Alfred Jarry, Terrasse, and Franc-Nohain, which was constructed in the studio of the Terrasses' Paris apartment.

Family feeling and friendship were not the only reasons Bonnard undertook the works for Terrasse, however, for aesthetic concerns certainly spurred him on. While the influence of Japanese prints remained pervasive in his work of this period, in the *Solfège* it shows itself less in specific borrowings than in a relationship to the caricatural spirit of Hokusai, with his feeling for the grotesque and the humorous representation of movement.[22] The heavy, flowing contour lines also have an Asian flavor, but Bonnard's only unequivocal debt to Japan is in the silhouetted figures thrown on a screen in the lesson on compound time (see fig. 78), a common device in ukiyo-e.[23] His more immediate inspiration came from contemporary sources.

English children's book illustration had been of great interest to the Parisian art world since the late 1870s, receiving serious attention from such noted critics as Edmond Duranty, Charles Blanc, J.-K. Huysmans, Alfred de Lostalot, and Louis Gonse.[24] The amusing illustrations of Walter Crane, Randolph Caldecott, and Kate Greenaway, their strongly outlined forms filled with planes of clear color, seemed remarkably fresh and

67. LORENTZ FROELICH, **Grandpapa's Commandments**

Illustration from Pierre Jules Stahl, *Les Commandements du grand-papa*, 1892

68. FRANÇOIS GEORGIN, **The Stages of Life,** 1826

Printed in Epinal (Vosges). Color woodcut, 400 x 638 mm. Paris, Musée National des Arts et Traditions Populaires

Epinal, the center of a thriving printing industry specializing in the production of cheap, popular prints, gave its name to the genre.

69. KATE GREENAWAY, **Waking**

Illustration from Myles B. Foster, *A Day in a Child's Life*, [1881]. Color wood engraving by Edmund Evans, page 244 x 228 mm. New York, The Metropolitan Museum of Art, Rogers Fund, 1921

vital next to contemporary French children's picture books. The latter tended to approach the child as a formless entity to be shaped by admonition and improving examples, or as a vessel to be stuffed with information. Children's illustrations customarily differed from adults' only in subject matter, both being rendered in a complex, elaborately shaded drawing style, rendered inert and homogeneous by the standardized strokes of professional engravers (fig. 67).[25]

Interest in the English illustrators expanded still further in the later 1880s with the advent of pictorial Symbolism. The Symbolists held that line, as a subjective abstraction that does not exist in nature, is a particularly effective carrier of the artist's emotion and therefore should be understood as symbol; and they singled out polychrome graphics combining purposefully simplified and distorted line with areas of unmodulated—that is, unnatural—color as having a special capacity for expressive autonomy. These were precisely the qualities that Gauguin and the Nabis associated with an art of decoration.[26] It is no accident that in Brittany Gauguin was known to have carried around a little storybook by Randolph Caldecott. Beliefs in the symbolic expressiveness of line and polychrome graphics lent new critical and aesthetic respectability to the previously lowbrow commercial media of children's book illustration, magazine illustration, posters, programs, and book and music covers. They also contributed to a new wave of interest in Japanese woodcuts and the crude French popular prints called *images d'Epinal* (fig. 68), encouraged the linear aspects of Art Nouveau, and were instrumental in bringing about the resurgence of color printmaking in the nineties.[27]

Bonnard's juxtaposition of a frontal row of figures and oversized decorative motifs in illustrating the scale recalls Kate Greenaway, although his flowing lines, distorted contours, and impish wit have little connection

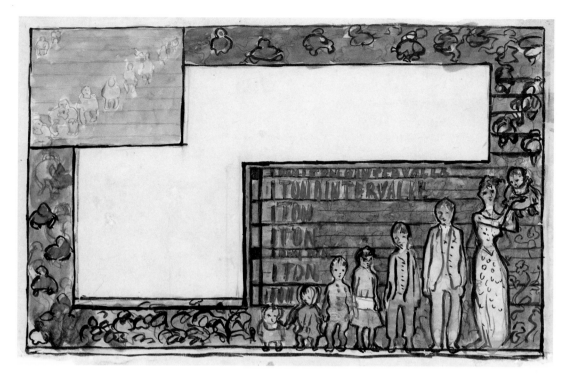

70. Study for **Gamme majeure**
(Major Scale), ca. 1891–93
[cat. 22]

Pencil, ink, and watercolor, 177 x
265 mm. Private collection

71. Gamme majeure, ca. 1891–93
[cat. 19]

Page 8 of *Petit Solfège illustré*, 1893.
Lithograph, 213 x 283 mm. New
York, The Metropolitan Museum
of Art, Mary Martin Fund, 1987

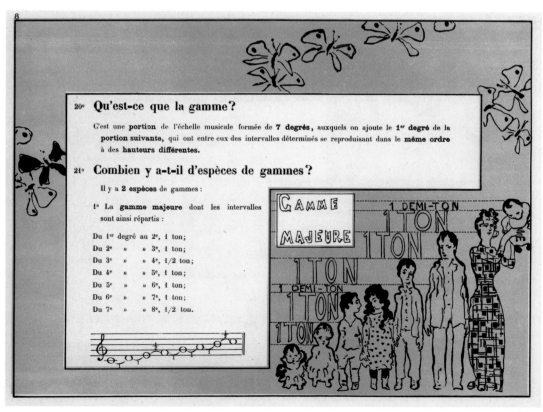

with her controlled, near-saccharine prettiness (figs. 69–71). His irregularly shaped, line-bounded formats clearly stem from the drawings of Walter Crane, either through the first-hand knowledge he almost certainly had or through the Crane-influenced songbooks of Maurice Boutet de Monvel, illustrator of the first French children's books based on English models.[28] A comparison of Boutet's "La Queue leu leu" with Bonnard's "Syncope" ("Syncopation") and "Sol la si do re mi fa sol" suggests that the illustrations by the former for *Vieilles Chansons et rondes pour les petits enfants* (*Old Songs and Rounds for Small Children*) were a direct source (figs. 72–74).[29]

Bonnard's job in the *Petit Solfège illustré* was to keep childish readers amused and interested as they absorbed their lessons—a truly heroic task, for despite Terrasse's personal charm, his text has all the verve of an instruction manual for putting together a ten-speed bicycle. A letter to Edouard Vuillard mailed from the Villa Bach on April 15, 1891, reveals Bonnard's initial anxiety: "I don't know how I'm going to pull something out for my Solfège. I'll have to think of the old-time missal decorators or of the Japanese putting art into encyclopedic dictionaries to give me courage."[30]

Further letters to Vuillard reveal the kind of effort that went into the production of *Petit Solfège illustré*, and the extraordinary practical difficulties Bonnard had to overcome in the process. Contrary to what has always been reported in catalogues of Bonnard's prints, the drawings were lithographed, not reproduced photomechanically.[31] On August 16, 1892, he wrote from Le Grand-Lemps, apparently believing that final proofs were on the way: "Ten days at my brother-in-law's where I went sailing and did some printing—for the latter operation I took myself to Bor-

72. MAURICE BOUTET DE MONVEL, **La Queue leu leu,** ca. 1883

Page 16 of Ch. M. Widor, *Vieilles Chansons et rondes pour les petits enfants*, [1883]. Process print with stenciled coloring, 221 x 258 mm. New York, The Metropolitan Museum of Art, Gift of Mrs. John S. Lamont, 1974

73. **Syncope** (Syncopation), ca. 1891–93 [cat. 19]

Page 23 of *Petit Solfège illustré*, 1893. Lithograph, 213 x 283 mm. New York, The Metropolitan Museum of Art, Mary Martin Fund, 1987

deaux. I'm waiting right now for some proofs, final modifications of those that I obtained at Bordeaux and that were satisfactory. Provided, for God's sake, that they haven't worn them out completely." Perhaps his belief—mistaken, as it turned out—that the work was being satisfactorily printed accounts for what would seem a remarkable equanimity in the face of the misfortune he went on to describe: "I thought I'd be able right away to take it easy. I had reckoned without the railway companies, which have lost my trunk. . . . What annoys me is that in that trunk I have a painting and all the drawings for the Solfège. . . . I've decided— if I don't regain possession of my goods I'll claim a hefty indemnity."[32] Happily, it must be assumed that the trunk was found, since some seventy-two drawings for the book are still in existence.

More than a year later, the work was still not done. On October 15, 1893, Bonnard wrote Vuillard from Le Grand-Lemps complaining that he had just completed twenty-eight days of hard labor on the *Solfège*, which was being printed "right this minute." "Nor can I tell you the vicissitudes that went into the making of this work," he said. "It would take many volumes. Enough to say that my entire vacation was taken up with it and now I still can't return [to Paris] because of this wretched book. In a first attempt, for there were many, my brother-in-law and I were almost at the point of operating the printing press ourselves. However, we have put ourselves in the hands of a very well equipped printer. May heaven help us! So now I'm again turning my hair white in trying to obtain the impossible from the printer."[33] The invoice from this printer, F. Allier Père et Fils of Grenoble, shows that the book was finally delivered in January 1894, nearly three years from the day that Bonnard complained to Vuillard of his difficulties in getting started. A letter accompanying the

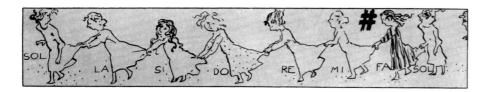

74. Sol la si do re mi fa sol, ca. 1891–93 [cat. 19]

Illustration on page 28 of *Petit Solfège illustré*, 1893. Lithograph, page 213 x 283 mm. New York, The Metropolitan Museum of Art, Mary Martin Fund, 1987

bill suggests that the printer had more exacting clients than he had bargained for; he explains that the original price for the cover had to be raised because a different, heavier paper was requested, but that the price was otherwise maintained "despite all the unforeseen things that happened on this job."[34]

Even then Bonnard's practical difficulties with the book were not over,

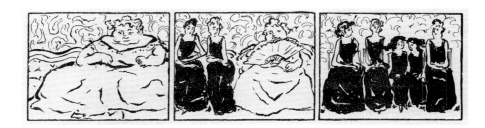

75. Mesure (Measure), ca. 1891–93 [cat. 19]

Illustration on page 15 of *Petit Solfège illustré,* 1893. Lithograph, page 213 x 283 mm. New York, The Metropolitan Museum of Art, Mary Martin Fund, 1987

for it was far from the hoped-for commercial success. He and Terrasse paid only a little over a quarter of the printer's bill when the book was completed, scheduling payment of the balance in three installments beginning a year later, probably in anticipation of profits from sales. However, a good many books were still unsold when the first of these payments came due. A flurry of letters among Allier, Bonnard, and Terrasse written just beforehand reveals that Allier was suspicious and close to insulting, Bonnard both angry and unable to meet his share of the payment. Terrasse, discounting the possibility of a loan given their lack of security, suggested that Bonnard forcefully assert their inability to pay more than half the amount due, but the printer answered Bonnard's letter by insisting on the original terms.[35] The final outcome is not known, but the affair was clearly trying.

Nor were the illustrations themselves easily produced. Existing drawings reveal that Bonnard often developed a number of quite different ideas for a given page, and that even when an idea had been decided upon, several additional drawings might be made. He was undoubtedly collaborating closely with his brother-in-law, adapting and readapting his work to fit Terrasse's pedagogic requirements, for some of the final drawings, if more satisfactory as illustrations of a musical concept, are less imaginative visually than those rejected.[36] Nonetheless, he arrived at some wonderfully ingenious solutions to the problem of illustrating musical theory. He explained measure, for instance, by filling an entire rectangle with one enormous lady (the whole note that makes up the measure) while achieving another whole note by boxing up three skinny women and a couple of teenagers—three quarters and two eighths (fig. 75). His use of an undulating garland of pouncing and yielding dogs to depict syncopation was an imaginative tour de force (see fig. 73): a leaping dog represents the first measure's last beat crossing over the bar line to join the first beat of the next. And in a discarded preparatory sketch with the remarkably unpromising subject "How does one indicate the duration of tones?," he made the notes issuing from a singer's mouth increase in value as they progress around the page, along the way

metamorphosing into raindrops and then into a female audience of mathematically increasing girth (fig. 76).[37]

Bonnard attracted children's interest through such visual puzzles and ambiguous transformations—elsewhere, there are semihidden faces and background lines that may be waves of sound or clouds of hair or ghostly female figures—and especially through caricatural humor, usually at adult expense. He revealed the irreverent truth that grown-ups look funny when they sing, and funnier still when they try to sing and exhibit feeling at the same time.

It is probably not coincidental that French psychologists had been revising traditional views of children's responses in making and looking at art, and that Bonnard's content and style were highly compatible with contemporary theories.[38] The first French book on children's responses to art and poetry was Bernard Perez's *La Psychologie de l'enfant: L'Art et la poésie chez l'enfant*, published in 1888, and it spurred additional studies. Perez held that when looking at art, the child, whose cognition is emotional, not rational, is uninterested in traditional beauty or visual realism: "The *images d'Epinal* will render him wild with delight, and the canvases of a master will say nothing to him."[39] Rather, children respond with sympathy to significant images that offer metaphors for their interior states of feeling.

As for their own drawings and paintings, children are described as paying attention only to what is salient and therefore sufficient, violating perspective and proportion, emphasizing contour, and delighting in

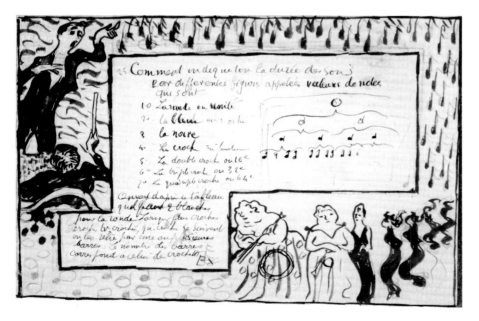

76. Durée des sons (Duration of Tones), ca. 1891–93

Sketch for page 12 of *Petit Solfège illustré*, 1893. Pencil, brush, and ink, 178 x 260 mm. Present location unknown

lively color if it characterizes an object. Not only can this serve as a defini-
tion of caricature, it is a good summary of Gauguin's Symbolist aesthetic
as promulgated by Sérusier and Denis. The latter said of Gauguin, "[He
taught us] that every work of art was a transposition, a caricature, the
passionate equivalent of a received sensation."[40] Significantly, it was in
1888, the year in which Perez's book appeared, that Gauguin and Emile
Bernard began talking of "painting like children."[41] Whether or not Bon-
nard knew specifically of Perez's work, the ideas were in the air in his
own milieu, and his caricatural approach to a book for children surely re-
flects them.

Bonnard has often been accused of not knowing how to draw, and in
later years he sometimes encouraged this belief with statements such as
"I'm awkward. It's true, I really have no skill," perhaps from the real
modesty that was one of his qualities, but perhaps also with the touch of
mockery that often flavored his dealing with critics.[42] In fact, his
draughtsmanship, ranging from highly accurate to gauche in the ex-
treme, is always masterful.

The Nabi theorists held that the expression of individuality necessarily
required that the artist be naive (in the sense of "native" or "natural") and
that the way to preserve this expression of personality was to guard
against the development of facility. The association of artistic naiveté
with sincerity was hardly a new idea, for, as Meyer Schapiro has shown,
it had been common in French art circles since 1850 and had even earlier
roots.[43] Manet, who was always being accused of technical anomalies, ex-
plained to Mallarmé (later the guru of the 1890s) that to retain an original
and exact psychological perception of things the eye should forget all else
it has seen and, while the hand will retain some of its acquired skills, it
should be guided only by the will.[44] Sérusier carried this further, attribut-
ing positive value to distorted form and awkwardness of execution and,
under the rubric of the Nabis' theory of subjective deformation, making
naiveté one of the cornerstones of their art. Comparing draughtsman-
ship to handwriting, he said, "If one pays no special attention to it, it will
become so much the more personal as it is maladroit."[45] Thus, awkward-
ness came to have connotations of emotional truth, whereas facility of ex-
ecution, because it so often arises from unthinking dependence on
artistic formulas, was suspect and likely to be interpreted as a mark of in-
sincerity. To the end of his life Bonnard would retain a horror of "calligra-
phy" in drawing, preferring, as Thadée Natanson said, to stutter rather
than to write too fast or with flourishes.[46]

The early "gaucheries" of the other Nabis, with the exception of Vuil-

lard, tend in practice to seem forced and therefore pointlessly crude (one thinks, for example, of works like Denis's *Catholic Mystery* of 1889 or Sérusier's *Market in Brittany*, 1892). But when Bonnard chose to let his awkwardnesses stand uncorrected they seemed natural and right, always speaking to his emotional point and, as he once said, giving life to the painting.[47] Thus, while the tightly controlled circus horse of "Le Galop" in *Petit Solfège illustré* is realistically proportioned, the race horses that illustrate the tempo *prestissimo* (fig. 77) are grotesquely stretched and elongated, their jockeys subhuman projections, so that the effect of maximum intensification of speed is remarkable.

77. Prestissimo, 1891–93 [cat. 19]

Illustration on page 24 of *Petit Solfège illustré*, 1893. Lithograph, page 213 x 283 mm. New York, The Metropolitan Museum of Art, Mary Martin Fund, 1987

Bonnard's approach to his subjects in *Petit Solfège illustré* is revealing not only of his view of children but also of himself. The children he portrays are no little Victorian angels, so pretty, neatly dressed, and orderly in play as to look stamped from a mold (see fig. 69). Toddlers with wobbly silhouettes stare blankly, children look fidgety and half-formed, teenagers appear lumpish and self-conscious (see figs. 70, 71). All reveal the stamp of their own individuality. The degree of subversion this represented of everything the French bourgeois family wanted for its children can only be seen in context.

By the late nineteenth century the welfare and advancement of the child had become the primary concern of the middle-class French family. But the bourgeoisie placed exacting strictures on the kind of education a child must have (usually a classical lycée education for boys and a restricted convent one for girls, who were also expected to play the piano) and the intricate rules of etiquette that must be inculcated to establish the child as *bien élevé*, well brought up—that all-important mark of class. Establishing class membership, not personal development, was the fundamental goal of education; no amount of intelligence or integrity or diligence could make up for not being *bien élevé*.[48]

The bourgeois ideal was the home as a closed world in which the child could be controlled by perpetual surveillance and, depending on the family, governed either by reason and affection or by authoritarian discipline, for there were different schools of thought on how best to form

character. Constant vigilance protected against undesirable influences. Children should associate only with other family members or with playmates chosen by their parents; school friendships were generally frowned upon.[49] Whether parents were affectionate or harsh, informal or conventional, the characteristic concern of the bourgeois family was to mold the child in accordance with parental expectations. The child's emotional needs or intellectual capabilities were not a matter for consideration. All individuality, any sign of will were to be immediately suppressed.

Consequently, children felt themselves powerless and were often ineffectually resentful. Bonnard, who was always centrally concerned with his own autonomy and perpetually wary of being "tyrannized"—that is, attached or influenced in any way—clearly identified with the child confronting a powerful adult.[50] In the silhouetted figures of a shrinking pupil and a threatening teacher hiding a stick behind his back, he suggested not only the child's helplessness and fear but also the defensive aggression that makes him project large hairy warts onto the teacher's nose and chin (fig. 78). A similar psychology accounts for the tradition of what Jesse R. Pitts has called the "delinquent community" within French schools—peer groups of boys banded together not in friendship but in a purely negative association based on solidarity against the primary au-

78. Leçon sur les mesures composées (Lesson on Compound Time), ca. 1891–93 [cat. 19]

Page 20 of *Petit Solfège illustré*, 1893. Lithograph, 213 x 283 mm. New York, The Metropolitan Museum of Art, Mary Martin Fund, 1987

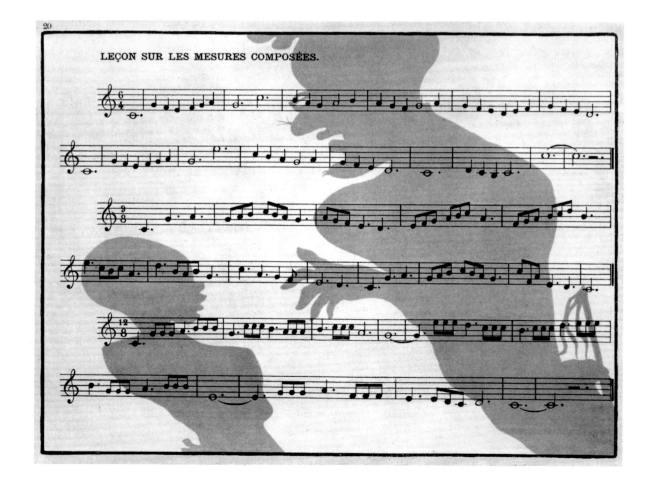

thority figure, the teacher, in an effort to "create for each member a zone of autonomy, of caprice, of creativity."[51] The notorious invention by Bonnard's friend Alfred Jarry and other lycée students of the character of Père Ubu, based on their despised teacher, was the work of just such a delinquent community. (Later, Jarry would develop the character further in his play *Ubu roi*, performed at the Théâtre de l'Oeuvre. Bonnard made sets for that scandalous production and for the puppet version at the Théâtre des Pantins as well.)

The awakening of sexuality was feared by parents above all. Thus, despite its comic approach, "O, Ombre" ("Shadow"), a drawing for his uncompleted ABC book that shows the silhouettes of Andrée and Charles Terrasse kissing behind a screen, suggests that Bonnard enjoyed playing the *provocateur* where parents were concerned (fig. 79). Another unconventional subject for the book is a sketch of a bawling child (fig. 80) illustrating the letter "G" ("Grognon"? "Grimace"?). Bonnard described the project in a letter to his mother dated February 11, 1893: "I have found a patron who, seduced by my drawings for the Solfège, has asked me to do an album for children. I'm going to make an 'Alphabet sentimental.' Isn't the title pretty? To each letter will correspond a word beginning with that letter, signifying a passion or a state of soul, and which I will render by familiar little scenes in which there will be babies, animals, landscapes, etc. . . . It's a question of making beings and things speak."[52] It would be interesting to know whether Bonnard's plans were rejected by his patron or if other reasons account for the book's unfinished state.

In any case, even before all his troubles with *Petit Solfège illustré* were resolved, Bonnard had embarked on his second collaboration with Terrasse, the family album of piano music entitled *Petites Scènes familières*. Bonnard's nineteen lithographed illustrations and a cover were done in brush and black ink, and proofs of the images without the music were printed on loose sheets under his supervision. The date of the album has always been given as 1893, but while work on it was begun in that year, the evidence indicates that it was not published until the spring of 1895.[53] This revised dating makes comprehensible what has previously seemed an unusually abrupt and thoroughgoing change in style from *Petit Solfège illustré*. Many of the drawings for *Petites Scènes familières* are related to the works of 1895 in that they are based more directly on things seen and exhibit less arbitrary composition and more painterly handling than the works of the early 1890s. (The influence of Far Eastern brush paintings has been suggested, but Manet's freely brushed illustrations for Edgar Allan Poe's *The Raven*, published in 1875, may also have been a source.[54])

79. O, Ombre (Shadow), 1893

Design for "Un Alphabet sentimental" ("An ABC of Sentiments"). Pencil, pen, and wash, 184 x 197 mm. Present location unknown

80. G, 1893

Design for "Un Alphabet sentimental." Ink over pencil, 260 x 200 mm. London, private collection

A very faint penciled "G" can be detected beneath the drawing, upside down. The word represented may have been "Grimace" or "Grognon" ("Grouchy").

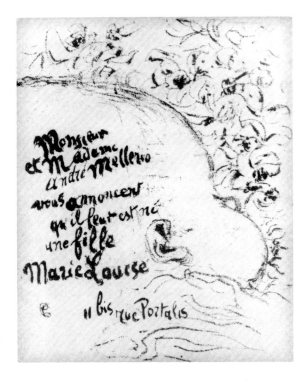

81. Rêverie, ca. 1894

Proof impression of illustration on page 26, *Petites Scènes familières*, 1895. Lithograph, 180 x 130 mm. Boston, Museum of Fine Arts, Lee M. Friedman Fund

The young woman is probably Berthe Schaedlin, Bonnard's cousin.

82. Birth Announcement, 1898 [cat. 57]

Color lithograph, 158 x 120 mm. New York, The Metropolitan Museum of Art, The Elisha Whittelsey Collection, The Elisha Whittelsey Fund, 1950

The father of baby Marie-Louise was André Mellerio, founder and editor of the print journal *L'Estampe et l'affiche*. Bonnard designed a poster for the magazine in 1897 and the cover and frontispiece of a book on contemporary color lithography by Mellerio published the following year (see fig. 33).

The motifs are taken from family life and public activities in a provincial town and were done while Bonnard was visiting the Terrasses in Arcachon—the name of the town is written on one drawing and the local church spire can be identified in two scenes (see fig. 84).[55] The illustrations show a generally positive view of bourgeois life, but the range of intimate feelings portrayed goes beyond conventional limits for childish consumption, including not only tenderness and humor but also reverie, melancholy, and even nightmare.

A new development is the tendency to merge shapes and backgrounds through broken brushstrokes, thereby blurring outlines and erasing distinctions between solids and voids. In "Rêverie" (fig. 81), this technique reinforces the young woman's dream state; a few years later, Bonnard would use a related concept in drawing a sleeping child for a birth announcement (fig. 82). In "Les Heures de la nuit" ("The Night Hours"; fig. 83), the viewer assumes the position of an unseen sleeper and participates in his dream. The darkness teems with images: a lovely, unclothed woman (the features recall those of Bonnard's cousin, Berthe Schaedlin, who figured in a number of his works of the early nineties), a staring female face (resembling Marthe),[56] and advancing nightmare creatures, half-scary, half-funny—a spider, a galloping horse, a skull, a bare bottom. Distorted faces and ambiguous forms emerge and disap-

pear into the darkness: is it a weeping woman on her knees by a grave or a man riding a unicycle? a jumping woman or a lock of hair? a letter dotted with sealing wax or a playing card? What is clearly a companion piece, ''L'Angélus du matin'' (''The Morning Angelus''; fig. 84), reveals the same room in the light of day, stripped of illusion and reduced to a plain bed, a chair, a bare wall, a curtainless window. (It recalls the stripped-down room in one of Manet's illustrations to *The Raven* [fig. 85].) The hand on the bedcovers, a sinewy hand like the artist's own, is not immediately apparent. Given the mixed ages of Terrasse's intended audience, this and the nightmare scene could be interpreted on one level as a sophisticated version of a childhood game—find-the-faces-in-the-picture —and on another as reflecting the Symbolist taste for mystery and the gradual revelation of personally significant content. Mallarmé, whose work Bonnard greatly admired, reading and rereading it all his life, said that ''to *name* an object is to do away with the three-quarters of the enjoyment of the poem that comes from the pleasure of divining it little by little: to *suggest* it, there's the dream.''[57]

83. **Les Heures de la nuit** (The Night Hours), ca. 1893–94 [cat. 42]

Proof impression of illustration on page 16, *Petites Scènes familières*, 1895. Lithograph, 132 x 233 mm. New York, The Metropolitan Museum of Art, The Elisha Whittelsey Collection, The Elisha Whittelsey Fund, 1983

84. **L'Angélus du matin** (The Morning Angelus), ca. 1893–94

Proof impression of illustration on page 34, *Petites Scènes familières*, 1895. Lithograph, 136 x 230 mm. Boston, Museum of Fine Arts, Lee M. Friedman Fund

The spire of the church at Arcachon can be seen through the window. The morning angelus is rung at 6:00 A.M.

85. EDOUARD MANET, **The Raven's Shadow**

Illustration from *Le Corbeau*, Stéphane Mallarmé's translation of *The Raven* by Edgar Allan Poe, 1875. Lithograph, 305 x 280 mm. New York, The Metropolitan Museum of Art, Harris Brisbane Dick Fund, 1924

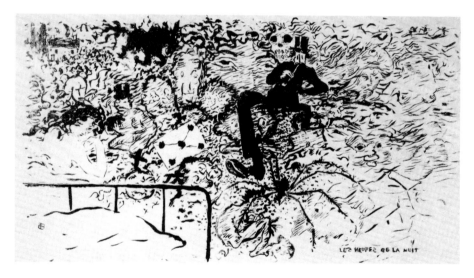

86. Papa, Maman, Ie (Marie), ca. 1895 [cat. 40]

Title page of *Petites Scènes familières*, 1895. Lithograph, 360 x 280 mm. Josefowitz Collection

Claude and Andrée Terrasse, their baby (probably Renée, born in 1894, one of whose names may have been Marie), and Mme Bonnard, the baby's grandmother.

87. Danse, ca. 1893–94 [cat. 43]

Proof impression of illustration on page 28, *Petites Scènes familières*, 1895. Lithograph, 215 x 85 mm. Boston, Museum of Fine Arts, Lee M. Friedman Fund

88. La Chanson du grand-père (Grandfather's Song), ca. 1893–94 [cat. 41]

Proof impression of illustration on page 12, *Petites Scènes familières*, 1895. Lithograph, 226 x 105 mm. New York, The Metropolitan Museum of Art, The Elisha Whittelsey Collection, The Elisha Whittelsey Fund, 1988

Other works are more direct. In "Papa, Maman, Ie (Marie)"(fig. 86), a gurgling infant is the happy cynosure of serious attention on the part of an entire family (the Terrasses and Mme Bonnard); in "Danse" (fig. 87), a teenager (probably Berthe Schaedlin, to whom the music is dedicated, as Bonnard remembered her a few years earlier) prances around with a blissful toddler; in another scene, a couple turns sadly away as a train bearing friends pulls into the distance. Humor is generally less broad than in *Petit Solfège illustré* despite some delightfully rubber-legged dancers (see fig. 136) and a child falling off a donkey. Thus, in "La Chanson du grand-père" ("Grandfather's Song"; fig. 88), the contrast between the coarse-featured, ham-handed man and the delicate, blond infant is more poignant than amusing.

In the latter work, grandfather Terrasse (Claude-Marie Terrasse, to whom the music is dedicated) takes an active role and in a fan-shaped watercolor of about the same period, *The Family* (fig. 89), a not very dignified one. The idea that men should participate in the upbringing of small children was another eighteenth-century development, one that had been given considerable impetus in the later nineteenth century by the publication of the enormously popular book *Monsieur, Madame, et Bébé* by

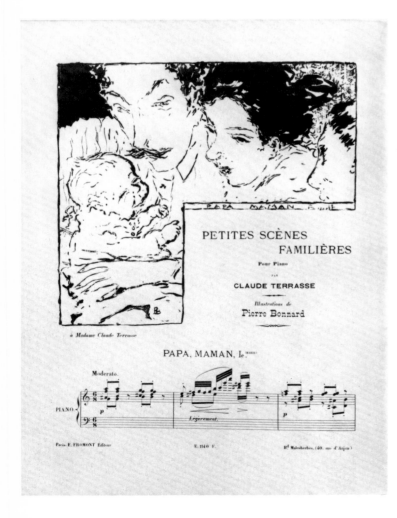

Gustave Droz (it went through 121 editions between 1866 and 1884). Holding that marriage could be strengthened by less inhibited marital sex and by taking pleasure in one's children, Droz actually suggested that fathers roll around on the carpet and play horsie—an astounding idea for the dignified bourgeois of the time.[58] Grandfather aside, photographs of the Terrasse family at play at Le Clos, with naked little boys dancing in a ring and Andrée herself emerging laughing from a dip in the ornamental pool (fig. 90), reveal the Terrasses to have been a remarkably informal and fun-loving group.

These early books reflect the period of Bonnard's closest involvement with his sister and brother-in-law's family. In later years, with his nieces and nephews grown and no children of his own, Bonnard would illustrate only two more books for young readers: *L'Histoire du poisson scie et du poisson marteau* (*The Story of the Sawfish and the Hammerhead*), 1923; and a sequel, *Les Histoires du petit Renaud* (*Little Renaud's Stories*; see figs. 47, 96), 1927. Both projects were commissioned by the author, his friend Léopold Chauveau.[59]

Children and Other Creatures

As with many who are themselves inhibited and find relationships with other adults trying, Bonnard was drawn to beings largely controlled by instinct, innocent of convention and incapable of dissembling—small

89. The Family, 1892 [cat. 15]

Design for a fan. Watercolor and pencil, 267 x 511 mm. Private collection

Bonnard's sister, Andrée, her son Jean, and her father-in-law, Claude-Marie Terrasse. Especially popular since the Japanese craze of the 1870s, fan shapes had been used by Degas and Gauguin among others. Sometimes intended for an actual fan, they were more often considered as providing a challenging format with exotic overtones, suitable for decoration. They were often made as gifts to women.

90. Pool at Le Clos: Andrée and Claude Terrasse with Their Children, 1899

Photograph. Paris, Musée d'Orsay, Promised Gift of the Children of Charles Terrasse

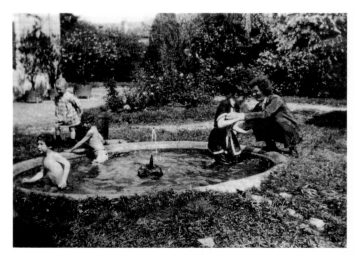

91. Infant on a Cabbage Leaf, ca. 1890–91 [cat. 4]

Ink over pencil, 157 x 130 mm. The Fine Arts Museums of San Francisco, Achenbach Foundation for Graphic Arts, Gift of R. E. Lewis, Inc.

92. Mother and Child, ca. 1892–93 [cat. 16]

Watercolor and ink, 246 x 163 mm. Karlsruhe, Kupferstichkabinett, Staatliche Kunsthalle

children and animals. The gentle, detached amusement with which he regarded children may be seen in what was probably a birth announcement, showing a naked newborn on a cabbage leaf (fig. 91); babies in France are traditionally found under a cabbage, just as in other countries they are brought by a stork. Natanson described the artist's relations with his little nieces and nephews as both affectionate and *laisser-faire*, for he took care never to direct them. If Bonnard had had children, his friend observed, he would have been happy to watch them change every day, but he would never have found the strength to discipline them and would have let them grow up any way they wanted, just as he refused to allow the plants in his garden to be pruned out of their natural inclination.[60]

In fact, it was precisely for their lack of socialization that Bonnard enjoyed children. (For the same reason he was even fonder of animals, and in later life was sometimes drawn to rough and untutored, even brutish adults, to his friends' perplexity.) A drawing of a mother and child dating from about 1893 (fig. 92), in which the small boy's hair is standing on end and his face is smeared all over with what looks like jam, is drawn in a near-caricatural style through which Bonnard showed his amused indulgence of childish irregularities. To Vuillard he had written, after a trip from Bordeaux to Le Grand-Lemps, "I'm a thousand times more struck by my nephew's mug than by all that I've seen in my traveling around."[61]

93. A, Amitié (Friendship), 1893

Design for "Un Alphabet sentimental." Pencil and watercolor, 240 x 298 mm. Paris, Huguette Berès

The cloth below the infant's shoulder creates the look of a winged putto.

94. The Infant Chloe Suckled by a Ewe [cat. 89]

Illustration on page 9 of Longus, *Daphnis et Chloé*, 1902. Lithograph, 154 x 140 mm. New York, The Metropolitan Museum of Art, Harris Brisbane Dick Fund, 1928

One of his semifictional family letters tells the story of his arrival after an absence of three months to find his sister's children at lunch, whereupon little Jean, spoon in hand and heedless of the prescribed greetings in his hurry to announce the great news, cries out, "You know, Ton-ton, the cat has eaten the cream cheese!"[62] As Natanson explained, emotional nakedness could touch him, and besides, animals'—and presumably children's—ways of asking things of him did not put Bonnard on guard as adults' did.[63]

Reflecting these values, he often portrayed small children and animals together in a kind of Golden Age where innocence meets innocence in pleasure and harmony. In "A, Amitié" ("Friendship"; fig. 93), a drawing for the "Alphabet sentimental," the subject is illustrated by a scene of spontaneous sympathy between two such beings—a cherubic infant lying naked on the grass, feet kicking in delight as his face is licked by a small and perky dog. The sympathy between natural beings is made still more explicit in the illustration for Longus's *Daphnis et Chloé*, 1902, of an abandoned infant being nursed by a ewe (fig. 94). Years later Bonnard was still using related themes: in one of the etchings for Octave Mirbeau's *Dingo*, 1924, a child laughs and wriggles his toes as he is licked by the wild dog of the title, while in an illustration for *Les Histoires du petit Renaud*, a small boy is licked by bears (figs. 95, 96).

95. Child and Dingo [cat. 103]

Illustration on page 99 of Octave Mirbeau, *Dingo*, 1924. Etching, 50 x 177 mm. New York, The Metropolitan Museum of Art, Harris Brisbane Dick Fund, 1928

96. The Little Bear

Illustration on page 82 of Léopold Chauveau, *Les Histoires du petit Renaud*, 1927. Process print with stenciled coloring, 140 x 158 mm. New York, The Metropolitan Museum of Art, The Elisha Whittelsey Collection, The Elisha Whittelsey Fund, 1968

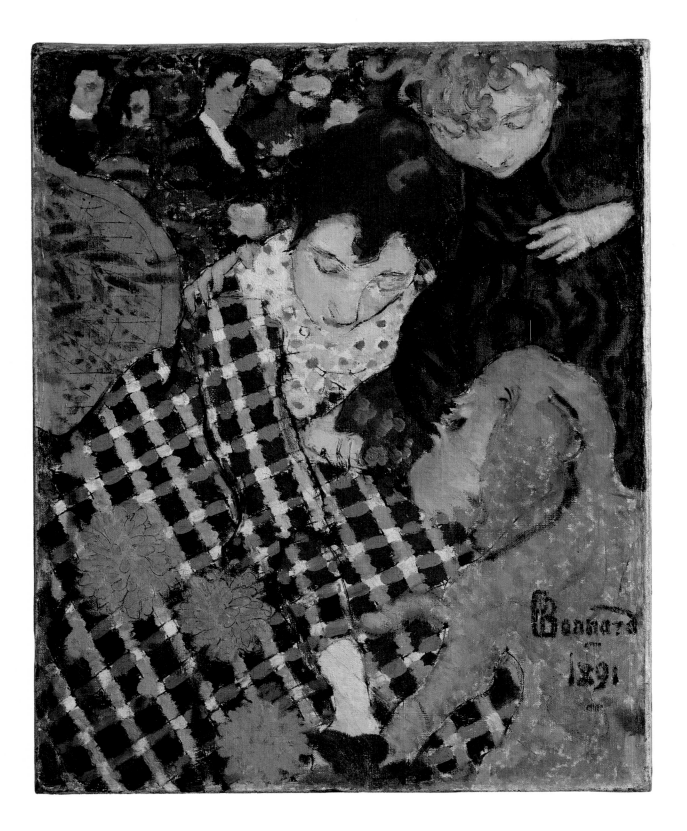

A common subject for Bonnard, especially during the 1890s when he spent so much time at Le Clos, was the interaction of young women or girls with animals, usually pet dogs, as in the painting of his sister, Andrée, and Berthe Schaedlin in the garden, *Women with Dog*, and a related ink drawing, *Andrée with a Dog* (figs. 97, 98). In both works, Bonnard's sister wears a dress in the checkered fabric he enjoyed treating in Japanese fashion, with the spread of pattern ignoring the body underneath. In the drawing, the small dog cavorts in rapture as a calm but attentive Andrée

facing page

97. Women with Dog, 1891 [cat. 8]

Oil on canvas, 406 x 324 mm. Williamstown, Mass., Sterling and Francine Clark Art Institute

The subjects are Andrée Terrasse and her cousin Berthe Schaedlin with Mme Bonnard's dog, Ravajeau.

98. Andrée with a Dog, ca. 1891–92 [cat. 9]

Graphite and ink, 310 x 220 mm. Private collection

bends over it. Bonnard was enchanted by the way young dogs signal their feelings with their entire bodies, especially as they provided an opportunity for active silhouettes and expressive line.

He often portrayed girls or young women other than his sister as he portrayed children—as amusing creatures like small animals themselves (although, unlike children, exempt from caricature). This attitude, which is in marked contrast to his respect for character in older women, reflects in part the upbringing of girls from the prosperous classes in an era when they were supposed to be secluded by convent education and raised until marriage as *oies blanches* (white geese), as carefully guarded from real learning as from the seamier side of life.[64] (This led to much marital dissatisfaction, for while men wanted their brides to be innocent, in the long run they too often found them ignorant, overly pious, and frigid.[65])

Bonnard was particularly taken by the spectacle of one such innocent attempting to discipline another, and a number of drawings and lithographs and at least one painting have this theme (see figs. 18, 19).[66] For the cover of the 1904 edition of Jules Renard's *Histoires naturelles* (*Natural Histories*), Bonnard first drew a young woman petting her adoring dog, then, in the final version, contrasted a hound's long-nosed head and tall, awkward body with the delicate features and coltish grace of an adolescent girl who brings her face up close to the dog and stares at it intently while it looks away, perhaps guiltily, seeming almost to frown (figs. 99, 100). In contrast, a trial plate for Octave Mirbeau's *Dingo* shows a mature woman as a strong figure whose seriousness and preoccupation counter the dog's insinuating play for attention (fig. 101).

99. Study for **Histoires naturelles,** ca. 1904 [cat. 96]

Preliminary design for the front cover of Jules Renard's book. Brush and ink, 307 x 204 mm. Switzerland, private collection

100. Histoires naturelles [cat. 95]

Front cover of Jules Renard, *Histoires naturelles*, [1904]. Process print with stenciled coloring, 186 x 124 mm. New York, The Metropolitan Museum of Art, Gift from The Josefowitz Collection, 1989

101. Lina Lauréal with Dingo [cat. 103]

Illustration, page 162 of Octave Mirbeau, *Dingo*, 1924. Etching, 285 x 224 mm. New York, The Metropolitan Museum of Art, Harris Brisbane Dick Fund, 1928

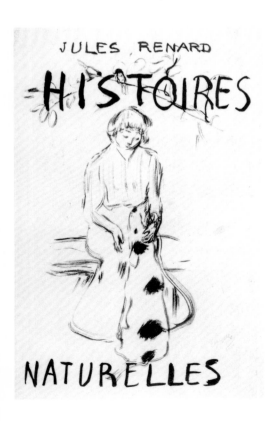

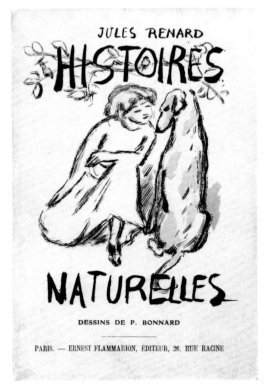

102. Dingo, ca. 1915

 Study for illustration, page 8 of Octave Mirbeau, *Dingo*, 1924. Pen and ink. France, private collection

103. Dingo [cat. 103]

 Illustration, page 8 of Octave Mirbeau, *Dingo*, 1924. Etching and drypoint, 285 x 224 mm. New York, The Metropolitan Museum of Art, Harris Brisbane Dick Fund, 1928

104. The Cat, ca. 1904 [cat. 97]

 Study for illustration on page 75 of Jules Renard, *Histoires naturelles*, [1904]. Brush and ink, 305 x 194 mm. Switzerland, private collection

Interior scenes at Le Clos show cats and dogs as naturally and as often as Bonnard's little nieces and nephews, and the later interiors with Marthe often include a dog and sometimes a cat. In such works, however, interaction was not the point; for Bonnard, animals were simply an essential feature of domestic existence. In his cover for the Galerie Vollard's second album of original prints, 1897, the lithe silhouette of a cat playing with a ball of paper enlivens and establishes a domestic context for a tabletop strewn with prints—animal and art comfortably at home together (see figs. 24, 25).

Bonnard spent a lifetime in the close observation of animals. His acute grasp of their psychology was already clearly revealed in the dogs illustrating syncopation in *Petit Solfège illustré* (see fig. 73). But his fondness was not limited to such small, lively creatures. In fact, his pleasure and acceptance were comprehensive, embracing equally the gangling, flea-scratching, flying-haired, undoubtedly smelly, and thoroughly disreputable Dingo (figs. 102, 103) and the sleek and self-contained cat in a preparatory drawing for Renard's *Histoires naturelles*—a cat, Renard says, who has been playing with a mouse and is now innocently sitting, "head closed tight as a fist" (fig. 104).[67]

Bonnard did sixty-seven drawings in all for the second illustrated edition of this book (his friend Henri de Toulouse-Lautrec had illustrated the 1899 edition). Most were of farm animals, a subject he approached from long and intimate knowledge, since chickens, goats, hogs, cows, and other animals were part of life at Le Clos. As for peacocks, swans,

105. HENRI DE TOULOUSE-LAUTREC, **Le Bouc**
(The Goat), 1897

Plate 18 of Jules Renard, *Histoires naturelles*, 1899. Color lithograph, 310 x 220 mm. New York, The Museum of Modern Art, The Louis E. Stern Collection

106. **The Goat** [cat. 95]

Illustration, page 136 of Jules Renard, *Histoires naturelles*, [1904]. Process print, 186 x 124 mm. New York, The Metropolitan Museum of Art, Gift from The Josefowitz Collection, 1989

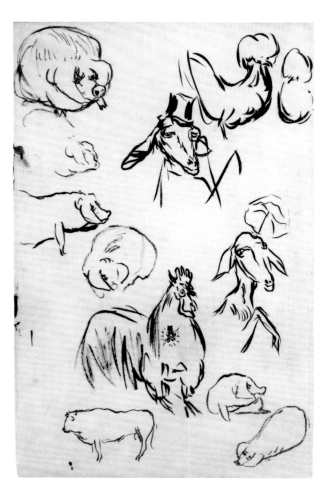

107. **Farmyard Animals,** ca. 1904 [cat. 98]

Studies for Jules Renard, *Histoires naturelles*, [1904]. Ink, 485 x 317 mm. The Art Institute of Chicago, Bequest of William McCormick Blair

and snakes, they held no special significance for him; they were animals like any other. The symbolic freight attached to them by the allegorically inclined Symbolists was as foreign to Bonnard as it was to Toulouse-Lautrec. The two artists differed in other ways, however. Their drawings of goats (figs. 105, 106), for example, reveal that, whereas Toulouse-Lautrec's animals are grand and inaccessible, Bonnard's are familiars, with crotchets that are known and understood, sometimes treated with affectionate amusement. A page of miscellaneous preparatory sketches recalls his capacity for playfulness as, apparently reminded of human types, he gives one goat a cane and top hat and the other a parasol (fig. 107). But the final illustration is pure, unadorned goatishness.

The European tradition of natural histories was an ancient one, stretching from Aesop in antiquity through the medieval bestiaries and carried on in France by the seventeenth-century fables of La Fontaine and by Buffon's monumental efforts at classification in the mid-eighteenth century. Renard's intensely observed descriptions of animals in the French home or countryside, colored by his own wry personality, have an affinity with La Fontaine's lively feeling for the personalities of animals. Doubtless this helped make Renard's book attractive to Bonnard, who numbered La Fontaine among his favorite writers. He enriched a copy of La Fontaine's *Fables* with over one hundred drawings in pencil, pen, and brush, some of them tinted in color (fig. 108).[68]

The Symbolist Interior

The domestic interior as the subject of art had a long and distinguished tradition in France, from the Le Nains and Chardin through the Impressionists. The Nabis built on that tradition, interior scenes playing a major role in their production, but they attempted to renew it in accordance with their ideas about subject matter, form, and expressivity. In their wish to force recognition of the work of art as artifice, the willed creation of an artist rather than a transcription of reality, they experimented in the early 1890s with redirecting attention from the objects depicted to the scene as a whole, especially by making the background carry emotive content.

The shift from figure to ground had been suggested by Gauguin's *Self-Portrait; Les Misérables* (fig. 109) and van Gogh's 1889 *La Berceuse* (*The Nursemaid*), the latter painted in several versions, at least one of which could be seen at Père Tanguy's paint store and gallery in Paris, regularly frequented by the Nabis. Both Gauguin and van Gogh referred to the

108. Conseil tenu par les rats (Council Held by the Rats), ca. 1899

Drawings added to an 1876 edition of La Fontaine's *Fables*. Present location unknown

The story is the famous one about belling the cat.

109. PAUL GAUGUIN, **Self-Portrait: Les Misérables,** 1888

Oil on canvas, 714 x 905 mm. Amsterdam, National Museum Vincent van Gogh, Vincent van Gogh Foundation

On the wall behind Gauguin is a portrait of his friend and colleague Emile Bernard. The painting was made as a gift for van Gogh.

110. MAURICE DENIS, **Mme Ranson with Cat,** ca. 1892

Oil on canvas, 890 x 450 mm. St.-Germain-en-Laye, Musée Départemental du Prieuré

In the Nabis' first years, Paul Ranson was the only one who was married. His wife, France, held open house for his friends, Bonnard among them, and was known as "The Light of the Temple" (the "Temple" being the Ransons' apartment).

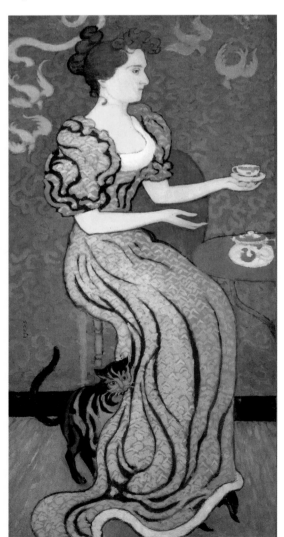

symbolic content of their works, the former explaining his self-portrait as the head of a "bandit," a Jean Valjean, against "a background of chrome yellow strewn with childish bouquets of flowers. The bedroom of a pure young girl. The painter is not yet defiled by the putrid kiss of the Beaux-Arts."[69] Among the Nabis, Paul Ranson and Maurice Denis pushed this emphasis on the background to a new extreme, although without achieving anything like their predecessors' expressive power. In works like *Apple Peelers*, Ranson completely immersed his flattened figures in a meaningless play of Art Nouveau curves. Denis, in *Mme Ranson with Cat*, echoed the curvilinear rhythms of dress folds and cat's tail in the arabesques of the wallpaper to achieve his unvarying mood of serenity (fig. 110). Only Bonnard and Vuillard, who shared a studio during this period and worked closely together, progressed from tentative beginnings toward works of great subtlety and feeling.

One of Bonnard's earliest experiments with the dispersal of expression from object to background can be seen in a cover designed for Claude Terrasse's piano music, done about 1891 in the fluid line of his early drawing style (fig. 111). It shows Andrée Terrasse playing for her husband and Bonnard himself, in the immediate left foreground. The viewer is thereby situated next to the artist and is drawn into his experience of the music by the swirling "wallpaper," resembling notes permeating the atmosphere, and by the rhythmical cascade suggesting a musical score at lower right. Bonnard used a related device, with a more apparent confla-

tion of wallpaper and musical notes, in a preliminary version of the cover for *Petit Solfège illustré* (fig. 112).

If artists like Gauguin and van Gogh had suggested this direction, it was probably the poet Mallarmé who showed the way to further variation and enrichment. In 1891 the Nabis were deeply involved with the avant-garde Symbolist theater, and it was also the period of their most intensive contacts with the Symbolist literary milieu. Mallarmé was the acknowledged master of Symbolism in all its manifestations, and his

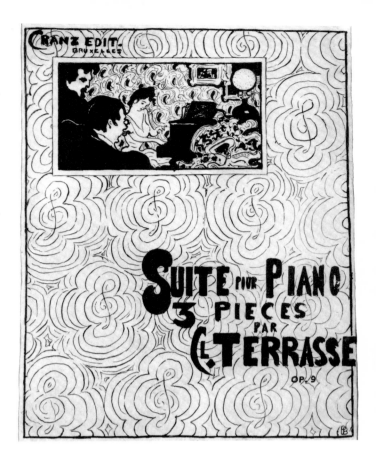

111. Suite pour piano, ca. 1891

> Cover design for piano music by Claude Terrasse. Ink over pencil, 363 x 230 mm. France, private collection

112. Solfège, ca. 1892–93 [cat. 20]

> Preliminary cover design for Claude Terrasse, *Petit Solfège illustré*, 1893. Color lithograph, 216 x 267 mm. New York, The Metropolitan Museum of Art, The Elisha Whittelsey Collection, The Elisha Whittelsey Fund, 1967

> This design owes something to the preceding *Suite pour piano*. It is more complex than the final cover, in which the hand-drawn lettering assumes greater importance (see fig. 65).

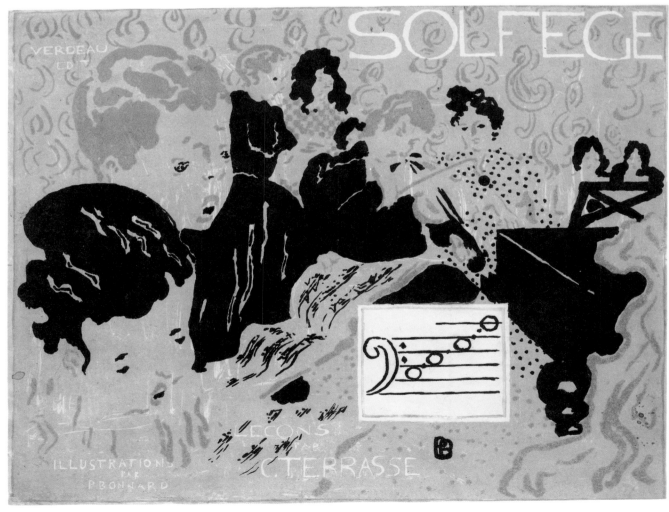

opinions were widely regarded as oracles. So when his famous response to an interview was published early in the year, it was taken very seriously in art circles. In it he said, in part:

> The contemplation of objects, the image taking flight from the reveries awakened by them are the song. . . . to *suggest* [an object], there's the dream. It is the perfect usage of this mystery that constitutes the symbol: to evoke an object little by little so as to show a state of soul or, inversely, to choose an object and disengage from it a state of soul, for a series of decipherings.[70]

Bonnard's painting *Intimacy* (fig. 113), of 1891, probably constituted an attempt to explore Mallarmé's dictum, with the theme derived specifically from the poet's "Toute l'âme résumée":

> All the soul summarized
> When slowly we exhale
> Smoke rings that arise
> And other rings annul.[71]

In the painting, focus is displaced from people to ordinary inanimate objects, which are thereby elevated to singularity and significance. Yet they are so embedded in their environment as to impinge only slowly on the viewer's consciousness. Thus, the artist's own hand holding a pipe is arbitrarily forced up to the immediate foreground, a perspective device which is common in Hiroshige's prints where it is used to achieve a striking silhouette, but which Bonnard adopts only to almost conceal the image against the background. The smoke rising from the woman's cigarette and the men's pipes is echoed in the wallpaper pattern so that the environment itself sustains the silent intimacy of the smokers.

Some of Bonnard's further experiments with expressive grounds and a lost-and-found quality in the definition of form have already been discussed in connection with *Petites Scènes familières*, especially the illustrations for "Rêverie," "Les Heures de la nuit," and "L'Angélus du matin" (see figs. 81, 83, 84). The patent arbitrariness of all these works underlines the fact that they are the product of creative will. In this, too, Bonnard conformed to Mallarmé's practice.

Bonnard took the lead in these developments in the early nineties, but in mid-decade, as he focused more on scenes of city life, it was Vuillard who carried them further in the hermetic interiors, their backgrounds swarming with pattern, for which he is best known (fig. 114).[72] Bonnard, in turn, would draw on Vuillard's achievements in developing his own Intimist paintings of the late 1890s, although he tempered the remarkable density and airlessness of Vuillard's atmosphere and lightened his friend's emotional gravity with unexpected forms.[73]

113. Intimacy, 1891

Oil on canvas, 380 x 360 mm. France, private collection

Bonnard's Intimism

Bonnard, like Vuillard, has often been termed an Intimist because of his predilection for intimate domestic scenes. But he once explained that this label has truth in it only if it refers to artists who have "a taste for everyday spectacles, the faculty for drawing emotion from the most modest acts of life."[74] He did indeed portray "the most modest acts," and very few of those. By far the most common theme in his early years was the family at table (later the bathtub and dressing room would vie with the table). Mother or grandmother feeding a child, the family at dinner, people working or playing around a table in the evening—subject matter varies only slightly from work to work, yet the variety of form and emotional

114. EDOUARD VUILLARD, **Family at Table,** ca. 1897

Oil on board, 483 x 686 mm. New York, private collection

The subjects are Vuillard's sister, Marie (with her back turned), her husband, Ker-Xavier Roussel (Vuillard's friend and fellow Nabi), and Mme Vuillard (the painter's mother), with a servant bringing coffee at left.

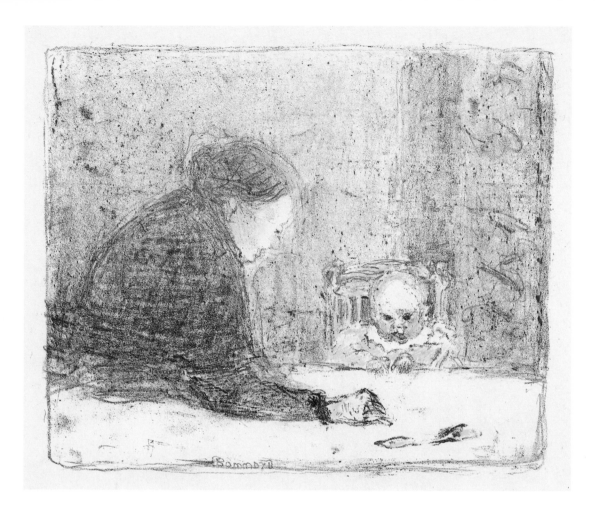

115. The Great-Grandmother, 1895　　[cat. 45]

From an album of *L'Epreuve.* Lithograph printed in brown ink with touches of watercolor, 202 x 230 mm. Houston, Virginia and Ira Jackson Collection

The woman is Mme Mertzdorff, Bonnard's maternal grandmother and the great-grandmother of Andrée Terrasse's baby. In this rare instance Bonnard colored an impression of one of his lithographs by hand.

expression is great. As description was not his intention, the question is how did he go about "drawing emotion" from these simple scenes?

From about 1895 to 1897 Bonnard experimented with reducing interiors to a bare minimum of elements. Thus, in the lithograph and painting *The Great-Grandmother* and the lithograph *Card Game by Lamplight* (figs. 115, 116, 118) there is no drama or anecdote, no movement, and only scant documentation of costume or setting. The lithographs are printed in a somber monotone of gray-green or brown. In *Card Game by Lamplight* even the faces are obscured.

There were precedents for a minimalist approach to domestic interiors. In the later eighties, van Gogh, Munch, Ensor, Hodler, and Carrière had all moved away from the detailed realism of their earlier domestic genre paintings toward a more generalized handling that served to heighten meaning.[75] In Bonnard's immediate circle, the Nabi Félix Vallotton had for some years been reducing forms to simple, dramatic, and expressive silhouettes, especially in his woodcuts, although Vallotton's work was not only sharper and less tonal than Bonnard's,

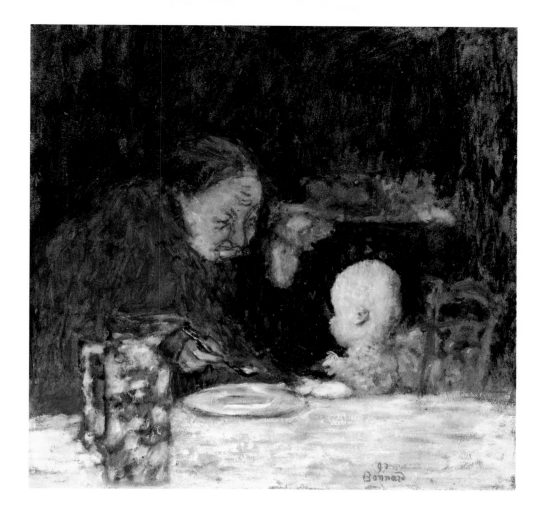

116. The Great-Grandmother, 1897

Oil on cardboard, 396 x 390 mm. Paris,
Huguette Berès

even at his most "Japanese," it was also anecdotal in approach and sardonic in expression, notably in the series *Intimités* (*Intimacies*; fig. 117).

Bonnard's Intimist interiors are closer in feeling to the Symbolist aesthetic of Verlaine, while their form reveals a debt to the Impressionists. The famous "Art poétique" of the poet whom he once termed "our master"[76] advised:

> You must have music first of all,
> and for that a rhythm uneven is best,
> vague in the air and soluble,
> with nothing heavy and nothing at rest.
>
> You must not scorn to do some wrong
> in choosing the words to fit your lines:
> nothing more dear than the tipsy song
> where the Undefined and Exact combine.
>
> Never the Color, always the Shade,
> always the nuance is supreme!
> Only by shade is the trothal made
> between flute and horn, of dream with dream![77]

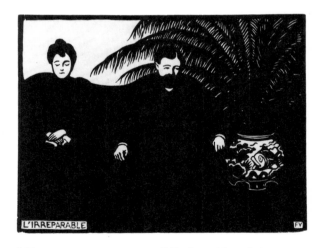

117. FELIX VALLOTTON, **L'Irréparable,** 1898

From the series *Intimités*, 1898. Woodcut, 178 x 223 mm. Lausanne, Galerie Paul Vallotton

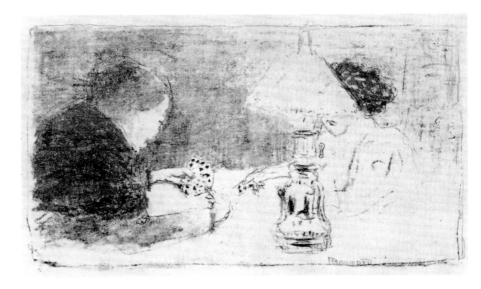

118. Card Game by Lamplight, 1895 [cat. 44]

From an album of *L'Epreuve*. Lithograph, 133 x 236 mm. New York, The Metropolitan Museum of Art, Gift of Mrs. Maurice E. Blin, 1977

Verlaine's insistence on "music first of all" implies that the nonverbal aspects of poetry (rhythm, sound, line) have intrinsic expressive possibilities. Not surprisingly, the analogy with music was also widespread among Symbolist painters interested in synesthesia: the idea that line, form, color, and composition—like the data from other senses—possess autonomous expressive power, independent of what is being represented.[78] Gauguin, for example, regularly used musical analogies. But it is Verlaine's taste for the vague and the "soluble," the shade over the color, the nuance above all that is suggested by these lithographs of interiors by Bonnard.

Impressionist influence is apparent in the deeper space, the loosened handling, the broken brushstroke, and the scattered light. Bonnard once told an interviewer that when he and his friends finally discovered Impressionism (for they had gone directly from academic art to Gauguin's Synthetism), "it came as a new enthusiasm, a sense of revelation and liberation . . . Impressionism brought us freedom."[79] Still, he held to a more arbitrary approach and his works recorded a memory rather than a moment of visual perception. As he said much later, "we sought to surpass [the Impressionists'] naturalistic impressions of color. Art is not nature. We were more severe as to composition. There was also much more to be had from color as a means of expression."[80]

Bonnard also subtly infused his works with more abstract meanings. In the lithograph *The Great-Grandmother* (see fig. 115), his grandmother Mertzdorff sits at a table beside a baby in a high chair. She has laid down the spoon with which she has been feeding the child and sits with her

head slightly bowed, staring inwardly. However, it is not her face but her hand, lying heavy and inert in the center of the image, that gives the work its poignancy, speaking of age and fatigue and resignation. The lithograph has another level of meaning as an allegory of the stages of life. Bonnard also took up this ancient theme in paintings of the nineties, always expressing it in a similarly indirect fashion (see fig. 116).[81] The cyclical nature of human life was then an attractive subject for many artists, part of the universalizing tendency that characterized the Symbolist era. Gauguin's *Where Do We Come From? What Are We? Where Are We Going?* is a famous example that, unlike Bonnard's work, is overtly symbolic. The popularity of this subject is sometimes seen as a reflection of fin-de-siècle pessimism, but it also carries positive overtones, as in *The Great-Grandmother*, in that the cycle brings renewal as well as death.

During the 1890s, Bonnard often used lamplight to suggest the home as a source of emotional and physical sustenance. French family life after dark during the 1890s tended to be concentrated about a round table lit by

119. Child in Lamplight, ca. 1897 [cat. 54]

Color lithograph (preliminary state), 330 x 455 mm. Paris, private collection

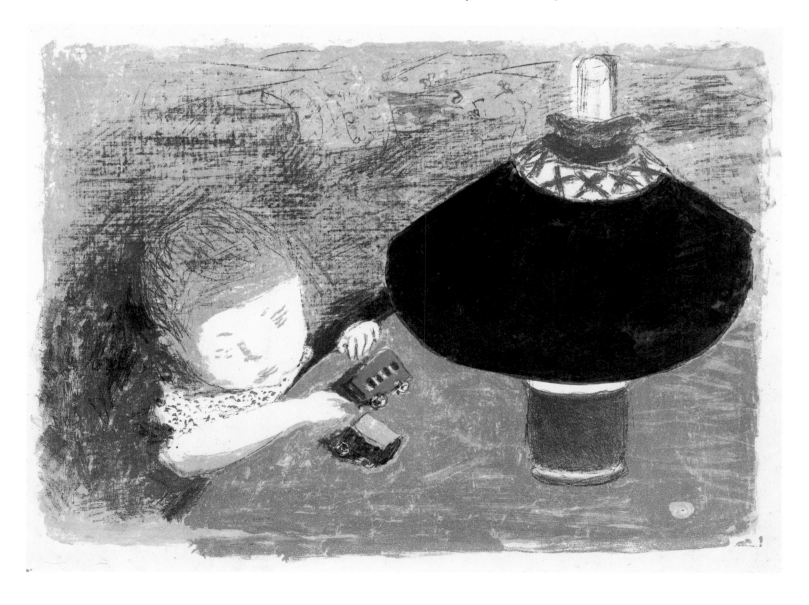

an oil or kerosene lamp and used not only for dining but also for other activities: sewing, studying, reading, or the playing of games as pictured in *Card Game by Lamplight* and *Child in Lamplight* (figs. 118, 119). Beyond the circle of light the rest of the room, like the world, receded into shadow. It is not surprising, then, that the lamp increasingly assumed symbolic resonance. By the 1880s it had become ubiquitous in advertising and popular imagery as a sign of home, so that in taking up this theme, Bonnard was setting himself the problem of giving a hackneyed motif new life and meaning. *Child in Lamplight* reveals the startling apparition of a small round head with features blanched by the light rising like a moon over the rim of a table, its focus on the toy railway cars suggesting the childish capacity for total absorption in imaginative play. In *Card Game by Lamplight*, by placing the lamp in the foreground and obscuring the faces, Bonnard disperses attention to the scene as a whole so that the silent atmosphere becomes the true subject.

In that it acts as a barrier to the viewer's participation, the lamp in *Card Game* places the scene at a remove and makes the act of looking more self-conscious. It is no doubt relevant in this regard that a number of plays done by the avant-garde Théâtre de l'Oeuvre (for which Bonnard and the other Nabis, especially Vuillard, produced sets and programs) used a similarly gray, imprecise stage setting with only a lamplit table and chairs for props, and that the ordinary everyday conversation around such a table was thought to conceal beneath its surface undercurrents of meaning of which not even the principals were wholly aware. L'Oeuvre interpreted Ibsen's plays in this way, for example, but the idea originated with Maurice Maeterlinck, whose early plays centered around the conception of unspoken meanings.[82]

Maeterlinck's *Intérieur* was given at L'Oeuvre on March 15, 1895, one of its more successful performances. In this play a group of watchers stand outside in the dark and look through a window at a family seated around a table under a lamp, unaware that they are observed and that the observers will shortly bring them the tragic news that a daughter has killed herself. The watchers procrastinate, dreading to shatter this apparent contentment, but a wise old man points out that it may itself be illusory:

> We cannot see into the soul as we see into that room. They are all like that. They only say trite things; and no one suspects aught. . . . They look like motionless dolls, and, oh, the events that take place in their souls! They do not know themselves what they are! She would have lived as the rest live. She would have said up to her death, "Monsieur, Madame, we shall have rain this morning."[83]

If in Bonnard's Intimist works he used food and light and shadow to suggest the home as a source of shelter and sustenance, like Maeterlinck he also conveyed more ambivalent undertones: home may provide the only security, yet, except between parents and very small children, genuine communication is rare in even the warmest of families. Individuals remain, in the end, alone. Thus, interaction among adults is almost nonexistent in these works. Bonnard's atmosphere is one of silence and inwardness, sometimes of unspoken intimacy, more often of separateness, and occasionally, when the figure is alone, of downright melancholy. His foreground still lifes not only divert attention from the figures to the rest of the work and provide emotional distance for the viewer— *The Lamp* (cat. 78) is an early example—but as symbols of nurturance they point up the less positive human feelings. This may also be seen in the much later lithograph *The Menu*, of about 1925, in which Marthe checks over a menu while her cook stands behind her, arms forming a self-protective circle suggestive of anxiety, and in a preparatory drawing for the lithograph, in which Marthe's averted position implies separation (figs. 120, 121). In *Before Dinner*, a closely related painting, psychological alienation is emphasized even more strongly by the trough of space dividing the cook from Marthe, who faces away from her, pushed to the edge of the picture and partly out of it (fig. 122).

Bonnard's mature working methods underlined such expressive, nonrealist ends. In his old age he told a reviewer that for him the absolutely central problem in painting was holding to the initial, creative vision of the work experienced before nature—a sort of epiphany, accompanied by a surge of emotion he called the "seduction."[84] He believed that only through communicating this initial subjective experience could the artist attain to universal expression. "If this seduction, this first idea is erased," he said, "there is nothing left but the motif, the object, which invades and dominates the painter. From that moment on he is no longer in charge of his own painting."[85] His way of coping with the danger of being distracted by visual incident was the procedure he learned in his youth and never abandoned: he worked from memory. Never without a sketchbook, he would set down his first, subjective impression on the spot, capturing a stance or movement in a few rapid strokes or a range of color values in some blotches of color; he would then construct an image in the studio from memory, with only an occasional reference to his notes.

Henri Bergson's work on the data of consciousness, *Essai sur les données immédiates de la conscience*, published in 1889 and read assiduously by the Nabis, and the well-attended lectures on which his *Matière et mémoire*

(*Matter and Memory*) of 1896 was based probably played a determining role in the development of these methods.[86] Bergson, whose great success is now attributed less to originality than to a gift for synthesizing current ideas, was then universally considered the foremost philosopher of his day. Interest in his ideas among the Nabis and the writers of the *Revue blanche* with whom they associated is well documented.[87] His emphases on subjectivity and intuition were congenial, especially because he related them to the arts (he was a friend of Mallarmé's, who may well have influenced his thinking on aesthetics). And his ideas were all the more attractive in that he drew on contemporary (and not so contemporary) science in an effort to integrate mind and matter with scientific coherence and practical applicability. Most important for Bonnard, Bergson gave central place to the critical, transforming function of memory for the human perception of the world.

Bergson emphasized that our consciousness is always fluid, always becoming, always dependent on emotional states, so that there is no one perceptual reality. Not only is our immediate experience permeated and colored by the memory of emotions attendant upon related previous experiences, but every succeeding experience will be different still, for

120. Marthe and the Maid, ca. 1924–25 [cat. 108]

Preparatory drawing for *The Menu*, ca. 1924–25. Pen and ink over pencil, 137 x 105 mm. Switzerland, private collection

121. The Menu, ca. 1924–25 [cat. 107]

Lithograph, 309 x 167 mm. New York, The Metropolitan Museum of Art, The Elisha Whittelsey Collection, The Elisha Whittelsey Fund, 1988

tomorrow's memories will be modified by today's psychological and physiological states.[88] The *truth* of one's own experience in what Bergson called "duration" is therefore too fluid and complex to be grasped by reason. Only sudden intuition can give us access to memories of past experiences stored in the unconscious. Those memories that spring back to consciousness must have some peculiar value as "symbols for the fundamental truths of that internal world of our consciousness which is all we know of reality," as Edmund Wilson said of Proust, also deeply influenced by Bergson.[89]

Concerned with a new definition of free will, Bergson declared that only in those rare moments when we are connected with the fundamental self can we act freely. He advocated introspection and also immersing oneself in the stream of life and movement, not passively but with an attention that actively seeks past feelings and sudden intuitions. Failing such attention, the mind will lazily substitute habitual concepts for authentic experience.

The practical consequences of these ideas for art were clear: if artists aim to capture subjective feelings truthfully, they must choose motifs of which they have had long, attentive experience, and of which they

122. Before Dinner, 1924

Oil on canvas, 902 x 1067 mm. New York, The Metropolitan Museum of Art, Robert Lehman Collection, 1975

continue to have intensive experience. Thus, Bergson not only provided Bonnard with a rationale for confining his subjects to the everyday world he knew best but also suggested a practical method of tapping his response to the motif, a method that would serve him for a lifetime, supplementing the vague Nabi theory of subjective deformation.

Bergson's prescriptions fit Bonnard exactly. He confined himself to long-familiar motifs selected on the basis of a sudden emotional response (he once said of a beautiful pastry, "I haven't lived long enough with this object to succeed,"[90]), and those who knew him, from his early manhood to old age, described him as deeply meditative or reflective. It was also his lifelong custom to walk at length every day, whatever the weather, and to observe closely; several witnesses spoke of the intensity of his gaze, which could be unnerving until one understood that it was habitual. Further, Bergson's conception of the importance of acting from free will, and the consequent dangers of habit and allowing oneself to be influenced against one's true feelings, must have struck a powerful if not decisive chord with Bonnard, given the central importance those very ideas had in his life.[91]

Thus, a number of intellectual sources contributed to the development of emotional content in Bonnard's Intimist subjects. But if Mallarmé, Maeterlinck, and Bergson suggested the means, it is Bonnard's own peculiar sensibility, his pictorial imagination, his irony and tenderness, his wit that are communicated to the viewer.

Because most of Bonnard's graphics on domestic subjects date from the 1890s, his sister's family and life at Le Clos have assumed central importance in this discussion. An early painting, *Crépuscule* (see fig. 51), encapsulated the aura of nostalgia and romanticism that colored Bonnard's experience of the place. But his great painting from just after the end of the decade, *L'Après-midi bourgeoise* (*The Bourgeois Afternoon*; fig. 123), is more complex and contradictory in feeling. Claude and Andrée Terrasse are seated on the lawn outside the family house at Le Clos, together with one of their sons and the appropriately named M. and Mme Prudhomme, visiting relatives, while other children are scattered about, as are dogs, cats, and, in the distant background, chickens. A nursemaid kneels in front with a child and Mme Bonnard disappears into the house with a grandchild. There is a table with wine and fruit. It is a superb summer afternoon. Everything Bonnard loved about Le Clos is in evidence, yet suggestions of disenchantment underlie the ostensibly idyllic scene.

Andrée toys desultorily with a kitten; her husband can barely stay awake and his disproportionately stretched-out body betrays his flaccid-

88　PIERRE BONNARD

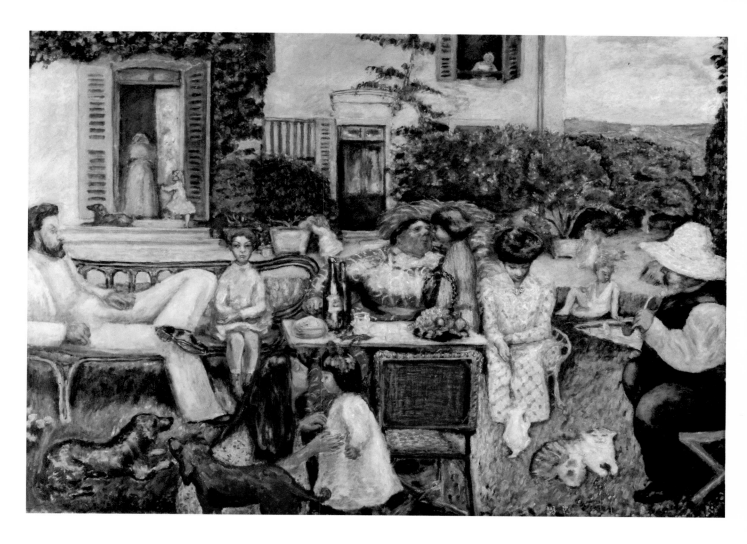

ity; their son is in a state of near-paralysis. Only the stuffy Prudhommes are enjoying themselves. The rigidity of the group's physical arrangement, all lined up in a row and isolated one from the other in the midst of nature in flower, underlines the contrast between social propriety and inner feeling. Propriety was not the custom at Le Clos and they can barely tolerate its strictures. Bonnard's comic sense, not often seen in the later years, is here again in evidence but he avoids the truly grotesque, making his humor just pointed enough to give an unexpected edge to the scene.

Changes can also be seen in Bonnard's style: bodies have a new roundness and the play of light over surfaces is emphasized. There is less flat pattern, too, although it is occasionally used, as in the foreground figures, for its disconcerting or enlivening effect. The painting marked the culmination of an important stage in Bonnard's art, the only one in which the graphic arts played a crucial role in his development, and the beginning of another, in which painting would rule almost uncontested. In his personal life, too, it marked the end of an era. As he spent less and less

123. L'Après-midi bourgeoise (The Bourgeois Afternoon), 1900

Oil on canvas, 1390 x 2120 mm. Paris, Musée d'Orsay

time in Paris and more in the country, in rented houses, hotel rooms, or the houses he eventually bought in Normandy and the Midi, Marthe replaced his sister's family at the center of his Intimist imagination.

Bonnard's Domestic Scenes and the Climate of Symbolism

One of the problems in assessing the influence of Symbolism has been the difficulty of assigning clear meanings to that most elusive of literary-artistic movements. From the beginning, among visual artists, there were two distinct, very different formal strains, as well as a few individualists like Redon who could not be made to fit comfortably in either. One strain, typified by the Belgian Symbolists, turned to fantastic or mystical subjects and the novel use of existing symbols while retaining relatively conventional form. The second, typified by Gauguin, avoided narrative content while distorting form and altering or heightening color in an attempt to communicate personal symbols and feelings. This has led to much confusion. If, say, the elaborately sensuous fantasies of a Jean Delville are Symbolist, then how can we classify Denis's *Mme Ranson with Cat* as part of the same movement? And how could one possibly apply the term to Bonnard's quiet little interiors? In fact, Symbolism as a whole can only be grasped as a complex of widely differing styles which have little or nothing in common but the fundamental assumption that art should be not a transcription of reality but a subjective expression, to some degree indirect or mysterious and carrying universal meanings; these ideas were usually combined with a belief in the heightened emotive powers of color and, even more important, of line.[92]

Thus, the intensity of Bonnard's early involvement with graphic art and the variety and extent of his projects in commercial graphics may be explained by the significance the Symbolists attributed to line, especially when paired with arbitrary color. It was responsible not only for this serious young artist's eagerness to devote himself primarily to commercial art between 1889 and 1890, but also for the strength of his subsequent interest in illustrations for children and in lithography, particularly color lithography, then relatively new and untraditional.

Color lithography was well suited to the Nabi aesthetic of the decorative, which aimed to suggest the artist's impelling emotion by formal means and to focus attention on the willful artifice of the creative act by reducing illusionism and emphasizing material substance. Japanese prints provided a model for nonillusionist art. This approach, seen at its

most evolved in the two lithographs entitled *Family Scene* (see figs. 58, 62), required the purposeful manipulation and distortion of line, form, and color for the sake of an expressive, harmonious whole. Thus, despite its radical aspects, the Nabi movement was in some ways a return to more classical ordering after a period of naturalist disorder. Denis recognized this when he labeled the movement "Neo-Traditionism." Bonnard himself later characterized Gauguin, the Nabis' mentor, as "a classic, almost a traditionalist." [93]

Around 1893, however, Bonnard began to move away from decorative formalism toward a more somber, indirect, and allusive kind of expression related to the Symbolist aesthetics of Verlaine and Mallarmé and making use of certain aspects of Impressionist style. It was the ideas of Mallarmé and the Symbolist playwright Maeterlinck that encouraged Bonnard's and Vuillard's interest in domestic interiors. Mallarmé's aesthetic goal was a "mysterious sense of the aspects of existence," [94] obtained by shifting the focus from human beings to objects in their environment, by the gradual disclosure of content, and by multiple layers of meaning. It was expanded by Maeterlinck's notion of another, more significant reality—the unformulated emotional undercurrents existing beneath the banal surface of everyday human interactions—and the inevitable separateness of adult human beings, unable to grasp that reality. Further, the philosopher Bergson, in his analyses of the workings of memory and emotive intuition, suggested a rationale for the choice of only long-familiar subjects and a working method for the retrieval of significant emotional experience.

The Intimist paintings of Bonnard and Vuillard dating from the late 1890s should in fact be seen as constituting a new, more poetic strain of late Symbolism. They conform to the general characteristics of Nabi Symbolism as outlined by George Mauner (the avoidance of action and high emotion, the wish to express universal human truths, and a heightened dependence on formal means to communicate them[95]), yet their mysterious indirection, their muffled atmosphere suggestive of volatile, unexpressed feelings and hidden meanings bring them closer to the Symbolist literature of Mallarmé and Maeterlinck, perhaps also to Proust, than to their Nabi friends. Together with the paintings of Gauguin and the drawings of Redon, they represent the finest flowering of the Symbolist movement in the visual arts and not, as has been said, a last, fading bloom of the "Impressionist mode." [96]

And what of Bonnard's later work? In the end, no one, I think, would call him a Symbolist. He moved too far in new directions. Shortly after the

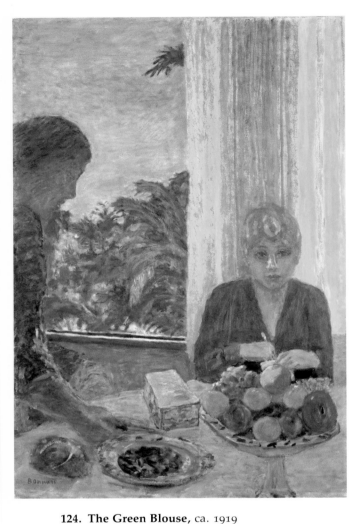

124. The Green Blouse, ca. 1919

Oil on canvas, 1019 x 683 mm. New York, The Metropolitan Museum of Art, The Mr. and Mrs. Henry Ittleson, Jr. Purchase Fund, 1963

turn of the century, his work took on almost classical solidity through modeling in light and shade, and his later explorations suggest he was not so immune to developments in the broader art world as has usually been thought.[97] Toward the end of his life, color, light, and brushstroke seemed to take on an independent existence, so that some of his latest paintings became almost abstract. On the other hand, he held unchanged his conception of painting as the expression of a subjective response to the familiar, supported by his practice of working from memory.

A painting of 1919, *The Green Blouse* (fig. 124), reveals both how much Bonnard had changed by that date and how much he still retained from his years in Paris. If the early domestic scenes referred beyond specific people and events to timeless relationships and universal conditions of humankind—mother and child, the family, the stages of life, symbols of home, relationships of human and animal, the pastoral experience in contrast with the city—here the domestic environment has become a self-referring world, more detailed and specific than before, yet bathed in a dreamlike atmosphere, poeticized through a veil of memory. The almost pantheistic unification of interior and exterior and the significance given the landscape are in total opposition to the dim, Mallarméan seclusion of the earlier interiors.

But if the hedonistic brilliance and sumptuousness of the color, the scintillating light, the proliferating brushstrokes are new, they nonetheless interweave to form a unified, almost abstract surface, a harmonious, decorative ensemble that is cousin to the flat, allover patterning of the *Family Scene* lithographs of 1892 and 1893. There is even a silhouetted figure. And like the earlier interiors, *The Green Blouse* is distanced through indirection, the focus on inanimate objects. We see again the lack of human interaction, a certain purposeful awkwardness of drawing, and we sense some ambiguous, underlying significance. Bonnard said in his old age, "I float between 'intimism' and decoration; one does not make oneself over."[98]

3 CITY LIFE

Public Entertainment

THE COLORFUL SIGHTS that enlivened Parisian nightclubs, theaters, ice rinks, circuses, and racecourses often inspired the young Bonnard, as they did a great many artists during the 1890s, for never before had the city offered such a glittering array of public amusements. Cafés, cabarets, dance halls, and music halls abounded in Paris, especially in the neighborhood of Montmartre where Bonnard lived. Although evidence suggests that the rather shy artist remained more a beholder than a participant, his keen eye was ever alert to an appealing gesture, a witty posture, and the most succinct alignments of scenery and human activity.

Bonnard's first memorable work—a print, not a painting—was commissioned in 1889 to advertise Debray's France-Champagne (fig. 125).[1] The poster, which launched Bonnard's professional career, is remarkably good for a first try, demonstrating the artist's precocious ability to capture high spirits in a stringent and compelling design. Bonnard's starry-eyed reveler, who raises a toast above a great wave of bubbling foam, symbolizes the most alluring and intoxicating aspects of Parisian nightlife, while vividly celebrating the year that inaugurated both the Exposition Universelle and the Eiffel Tower.

Following the example of the Exposition's Gold Medal winner, Jules Chéret, who had become the leading commercial artist of his day (fig. 126), Bonnard put his product in the hands of an exuberant, curvaceous female. But he exceeded the usual posing and parading of the hackneyed *chérette* to convey in a few joyful colors and lines the very essence of ebullience. His emblematic design is energetically lean, rippling with his enthusiasm for the bold color woodcuts of the Japanese and his admiration for the art of Gauguin, to which he had been introduced by Paul Sérusier only a year before.

Colta Ives

The exhibition in June 1889 of the Groupe Impressionniste et Synthétiste at the Café Volpini, across from the press pavilion at the Exposition Universelle, gave Bonnard an opportunity to study at first hand both Gauguin's paintings and his recent zincographs printed on canary yellow paper (fig. 127). The flat, unmodeled forms in these prints, sinuously outlined in black, mingled naiveté and sophistication in a way that strongly affected Bonnard, who later said he had been "fired with enthusiasm" by the "magnificent example of Gauguin."[2] Adopting Gauguin's emotive color and revolutionary abstract style, Bonnard raised his France-Champagne poster above the level of trite description. Aiming for greater subtlety and the evocation of a particular mood, he realized the Nabis' principal ideal, publicly defined by Maurice Denis in 1890, which required a work of art to appeal to the beholder through "the ability of its lines and colors to explain themselves."[3]

It is little short of astounding that Bonnard created this tour de force when he was but twenty-two years old and only lately graduated from law school. The 100-franc commission was a special victory for him, since it demonstrated that an artist's living was not beyond his reach, and thereby purchased his freedom from the civil-service career his father had envisioned. It was not until late in March 1891 that the poster actually appeared on the streets of Paris (its production probably delayed by the

126. JULES CHERET, **Le Pays des fées** (Fairyland), 1889

Poster. Color lithograph, 740 x 550 mm. New York, Park South Gallery at Carnegie Hall

Chéret's poster advertised an amusement park —the Enchanted Garden—at the Paris Exposition Universelle of 1889.

127. PAUL GAUGUIN, **Leda,** 1889

Design for a plate applied to the cover of *Dessins lithographiques*, a portfolio of prints. Hand-colored zincograph, diam. 205 mm. New York, The Metropolitan Museum of Art, Rogers Fund, 1922

facing page

125. France-Champagne, 1889–91 [cat. 1]

Poster, 1891. Color lithograph, 780 x 500 mm. New Brunswick, Rutgers, The State University of New Jersey, The Jane Voorhees Zimmerli Art Museum, Gift of Ralph and Barbara Voorhees

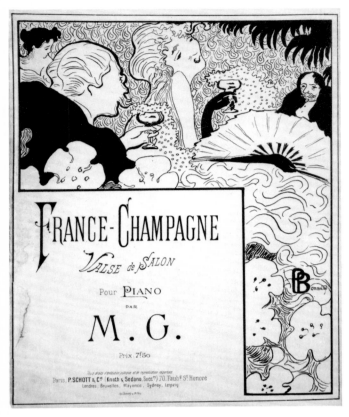

128. France-Champagne, Valse de Salon (France-Champagne Waltz), 1891

Sheet-music cover. Zincograph, 350 x 280 mm. France, private collection

artist's military duty).[4] The public response was such that by June Félix Fénéon referred to the lithograph in the magazine *Le Chat noir* as "that celebrated poster."[5] Young Henri de Toulouse-Lautrec was so impressed with Bonnard's bold design that he went in search of its creator. As told by Thadée Natanson, who knew both men well, "Bonnard took the little Lautrec by the hand . . . to lead him to the printer Ancourt," thus helping to launch the graphic career of an artist with whom he would often be in contact during the 1890s on assignments to produce posters, book covers, theater programs, color prints, and magazine illustrations.[6]

In May 1891 Bonnard proudly reported to his mother, "Everyone's asking for my poster." He added, "I have also designed the cover of a book of music for the gentleman of the Champagne poster for which he has paid me 40 francs!"[7] In his cover decoration for the France-Champagne waltz (fig. 128) Bonnard alluded to his poster, but he abandoned its eye-catching simplicity in favor of a broader, more descriptive scene filled with lines that loop and roil inside an inverted L-shaped frame. The female figures who are the embodiment of ecstasy in both of these commercial designs seem to have been arrived at after trial and error, as preliminary sketches attest (figs. 129, 130).[8] The artist's model was his cousin, the curly-haired Berthe Schaedlin, whose serpentine poses—like an arabesque borrowed from the Japanese—figure in many of Bonnard's paintings around 1891.

The year 1889 marks both the official start of Bonnard's career as an artist and the beginning of his interest in commercial graphic projects, through which he hoped not only to support himself but also to explore the avant-garde ideas of the Nabis. That summer, when he visited his family's country house at Le Grand-Lemps, he was full of ideas for posters and illustrations, and he continued to devote himself to inventing speculative commercial designs right through 1892.[9] Gustave Coquiot, Bonnard's biographer, remembered seeing hundreds of projects from this period for sheet-music covers, advertisements, theater programs, and the like.[10] But these projects were seldom realized, and very few of the preparatory designs have survived.

Among the drawings for projects that apparently never reached the publication stage are program or poster designs for the operas *Le Cid* by Massenet and *Hamlet* by Ambroise Thomas.[11] Bonnard also made charming sketches for sheet-music covers to piano pieces composed by his sister Andrée's piano teacher, Francis Thomé, and by the young composer Andrée married in 1890, Claude Terrasse.[12] A watercolor design for the

129, 130. Studies for **France-Champagne,** ca. 1889 [cat. 2]

Pencil and ink (recto and verso), 190 x 323 mm. Houston, Virginia and Ira Jackson Collection

131. Théâtre Libre: At the Theater, 1890

Front cover design for a theater program. Ink and watercolor, 317 x 218 mm. Present location unknown

cover of the song *La Petite qui tousse* (*The Girl with a Cough*; see fig. 7), Jean Richepin's poem set to music by Terrasse, is closely related to the France-Champagne poster and may even have preceded its completion in 1891.[13] The sanguine, inventive frame of mind that is conveyed through these aspiring designs at last found an outlet in the publication in 1893 of Terrasse's music primer for children, *Petit Solfège illustré* (*Little Illustrated Solfeggio*), and later, in 1895, of his collection of nineteen piano pieces, *Petites Scènes familières* (*Familiar Little Scenes*), both of which are brimful of Bonnard's cogent and witty illustrations (see chapter 2).

One of the activities that Bonnard found most compelling during the 1890s was his participation, with others of the Nabis' circle, in Symbolist theater productions.[14] He was often involved in painting mood-creating backdrops for dramas, and he occasionally worked on costumes as well. But seldom, it is surprising to note, did his designs appear in theater programs. The actor Aurélien Lugné-Poe encouraged him to submit ideas to André Antoine, director of the Théâtre Libre, but although both Bonnard and his friend Edouard Vuillard came up with suggestions (fig. 131), only Vuillard received a single commission.[15]

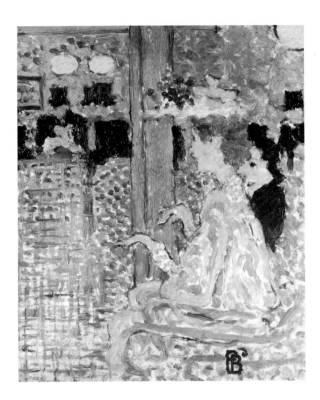

132. At the Bar, ca. 1892

Oil on cardboard, 240 x 200 mm. Private collection

133. Moulin Rouge, 1891 [cat. 5]

Design for a poster. Pencil, crayon, ink, watercolor, and pastel, 365 x 325 mm. Private collection

The Symbolist Théâtre d'Art founded in 1891 by Paul Fort soon succeeded the realist Théâtre Libre, attracting Lugné-Poe and with him the Nabis. Here Bonnard not only designed stage decor but also produced the cover illustration for the first program of the 1891–92 season, *La Geste du roy*.[16] In October 1893 Lugné-Poe established his own theater, the Théâtre de l'Oeuvre; it became the leading avant-garde theater of its time, with performances of Symbolist dramas by Ibsen, Maeterlinck, Mallarmé, and Verlaine. Lithographed program covers were commissioned from the most advanced contemporary artists, among them Toulouse-Lautrec, Vallotton, Sérusier, Denis, and Vuillard. In 1896 Bonnard designed the cover of the program for a triple bill at the Théâtre de l'Oeuvre that included Maxime Gray's *La Dernière Croisade*, Pierre Quillard's *L'Errante*, and a one-act play translated from the Chinese, *La Fleur enlevée* (see fig. 217).[17]

In many of Bonnard's scenes of cafés and music halls there is a young woman in the immediate foreground who seems to serve as the viewer's escort into the world she overlooks. This appealing creature is the emotional and decorative focus of innumerable works, such as the small canvas *At the Bar* (fig. 132), which demonstrates the special attraction Bonnard felt for Seurat's broken brushstrokes and his lucid arrangements of doll-like figures. (A large retrospective of Seurat's paintings was mounted at the Salon des Indépendants in the spring of 1892.)

It was not long after his poster for France-Champagne had been publicly displayed on the walls of Paris that Bonnard became engaged in another advertising project, this time to help revitalize attendance at the brassiest night spot in his neighborhood, the Moulin Rouge. The music hall, which stood on the boulevard de Clichy a few blocks from his studio, had opened only two years before with a bogus windmill erected just as the genuine old mills were disappearing one by one from the Butte Montmartre. A group of drawings survives to show Bonnard's ideas for this project (figs. 133, 134), on which he was at work in June 1891.[18] Like Toulouse-Lautrec's now famous poster (fig. 135), which evidently won the commission at stake, Bonnard's designs revolved around the nightly floor show, where the principal attractions were the high kicks of La Goulue and the gyrations of Valentin ''the boneless.'' Here, as in the earlier

134. Moulin Rouge, 1891

Design for a poster. Ink and pastel, 220 x 175 mm. Present location unknown

135. HENRI DE TOULOUSE-LAUTREC, **Moulin Rouge, La Goulue,** 1891

Poster. Color lithograph, 1910 x 1170 mm. The Art Institute of Chicago, The Mr. and Mrs. Carter H. Harrison Collection

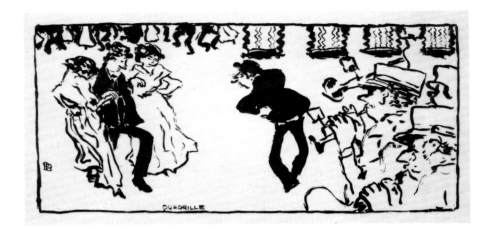

136. Quadrille

Proof impression of illustration on page 55 of *Petites Scènes familières*, 1895. Lithograph, 218 x 350 mm. Boston, Museum of Fine Arts, Lee M. Friedman Fund

advertisement for champagne, dynamically fluid lines sweep pictorial elements together into a giddying spin. For all its daring, Lautrec's design, his first foray into poster art, remains a more realistic rendering of the ballroom scene than Bonnard's intensely concentrated vision, a reason perhaps for its success with the client.

Particularly entertaining in Bonnard's designs is the humorous awkwardness of the figures, with their rubbery arms and legs, jutting elbows and knees. Highly popular marionette and shadow theaters, in which puppets with unusual bulges and distended limbs were common, provided immediate suggestions for such expressive possibilities.[19] Henri Rivière's shadow plays, performed at the cabaret *Le Chat noir* during the late 1880s, regularly offered entertaining projections of cutout zinc silhouettes, which interested many contemporary artists, including the Nabis.[20] Both Hokusai's and Daumier's nimble exaggerations of human postures must also have inspired these comic creatures, for as the Nabi spokesman, Denis, submitted: "The syntheses of the Japanese decorators were not enough to sustain our need for simplification. Primitive and Far Eastern idols, Breton calvaries, *images d'Epinal* . . . were all combined with recollections of Daumier."[21] Like the great French caricaturist, Bonnard transcended differences between specific Parisian types—lawyers or bakers, landlords or bluestockings—in order to present everyman in a high-stepping mood.

As distortion and awkwardness were viewed positively by the Nabis, who, on the basis of Gauguin's theories, extolled a *gaucherie d'exécution*, the almost caricatural simplification of form was discovered as a powerful vehicle of emotion.[22] Thus it is that Bonnard's light-footed dancers from street fairs and carnival processions, with whom he embellished sheet

music and a comic magazine supplement (figs. 136, 137), appear to be carelessly drawn and childish. Nonetheless, or rather, perhaps, for that very reason, they project highly animated spirits.

Bonnard's backstage involvement with theater life, which continued throughout much of the 1890s, culminated in his collaboration in the marionette productions of the Théâtre des Pantins, which had been founded by his brother-in-law, Terrasse, with Franc-Nohain and Alfred Jarry. Bonnard decorated the auditorium, carved puppets, and even worked the strings for the 1898 marionette revival of Jarry's absurd *Ubu roi*, which he had helped to stage earlier, in 1896, by painting the scenery for it at the Théâtre de l'Oeuvre.[23] When Terrasse published a group of songs he had composed for the puppet theater, Bonnard illustrated the sheet-music covers.[24]

Bonnard's graphic designs of the early 1890s only rarely depict the staged performances that were central to Paris's nighttime entertainment, and then mainly for commercial reasons; his own attendance as a member of the audience seems to have been infrequent. Since he took greater pleasure in what was informal and unrehearsed, Bonnard's attention at theatrical performances probably wandered. But the roving path of his exploration of the picturesque at public events usually produced discoveries, as is revealed in a letter to his elder brother, Charles, giving news of the Cirque Médrano:

> Yes, it still exists. I often go, it is very near my new place. I always enjoy the circus, and for one who goes alone, it has the invaluable advantage of having entertaining intermissions, whereas at the theater they are detestable. One goes to the bar where the clowns do their drinking. There is a way into the stable to say hello to the horses and other beasts.[25]

Compared to Toulouse-Lautrec, for instance, Bonnard appears to have been much more comfortable at some remove from the spectacle; even his paintings of the ballet and concert hall in the mid-1890s show the stage at a considerable distance from his seat. Like Daumier and Degas, he often preferred to portray sights seen over the shoulders of theatergoers or café customers (fig. 138), a vantage point to which he was especially attached. It was the audience settled into the plush seats of a darkened theater that became his focus around 1898, as is seen in the frontispiece to André Mellerio's book *La Lithographie originale en couleurs* and in the color lithograph *At the Theater* in the suite of prints *Quelques Aspects de la vie de Paris* (*Some Aspects of Paris Life*; fig. 139). Bonnard's interest had turned from the performers onstage to the expectant observers like himself, who were seated in wait.

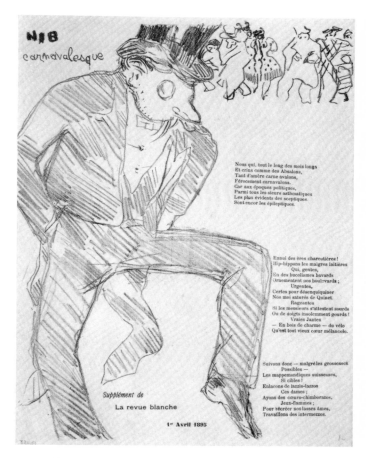

137. Nib carnavalesque, 1895

Page from the supplement to *La Revue blanche*, April 1, 1895. Lithograph, 328 x 250 mm. New York, The Museum of Modern Art, Abby Aldrich Rockefeller Fund

It was without regret that, after 1900, Bonnard withdrew almost entirely from the nightlife of Paris. He came to associate it with the days of his youth, before he became absorbed in the countryside. There were, however, a few occasions when his attention turned again to the theater. He designed sets for Nijinsky's staging of the ballet *Jeux* in 1920, and was commissioned by the French state (with Vuillard, Denis, and Ker-Xavier Roussel) to paint panels for the new Théâtre de Chaillot, one of the showpieces of the Exposition Universelle of 1937. Of the five poster assignments he accepted after the turn of the century, one was addressed to a theater audience. This was the nearly life-size announcement in 1914 of Léonide Massine's starring role in the Ballets Russes (fig. 140), a design which bows to the dance posters of Léon Bakst and Jean Cocteau, even as it closes the most public-oriented portion of Bonnard's career. Several preparatory drawings for the lithograph survive, showing the artist's ex-

138. The Moulin Rouge, 1896

Central panel of a triptych. Oil on panel, 610 x 400 mm. Collection of Wright S. Ludington

Bonnard observed Paris by night from his table in a café in the Place Blanche, just across from the Moulin Rouge.

139. At the Theater, ca. 1897–98 [cat. 73]

From the suite *Quelques Aspects de la vie de Paris*, 1899. Color lithograph, 210 x 400 mm. New York, The Metropolitan Museum of Art, Harris Brisbane Dick Fund, 1928

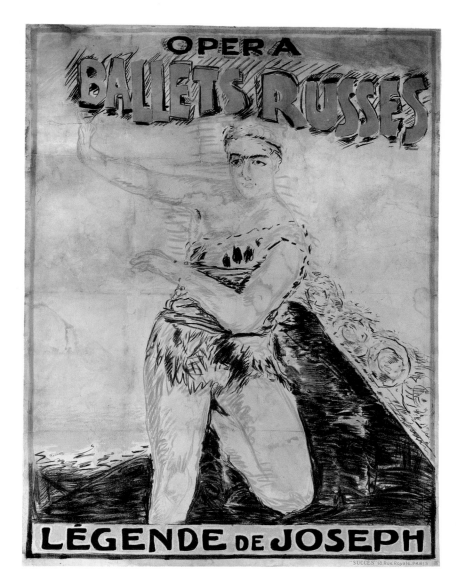

treme care in selecting colors and in establishing the dancer's pose (fig. 141).[26] The color scheme is virtually the same as that of Bonnard's first published poster (see fig. 125), but his early impulse in favor of the decorative and abstract has been almost entirely abandoned. Bonnard's concerns were by this time directed toward a new approach to sculptural realism and the revelation of light.

The Parisienne

The earliest evidence we have of Bonnard's lifelong fascination with the ever-changing parade of Parisians along their boulevards and streets dates from 1889, when his first sidewalk scenes were created. Bonnard was twenty-two at the time and particularly alert to the charms of the feminine passerby. The few dated works that survive from this period

140. **Légende de Joseph** (The Story of Joseph), 1914

Poster for the Ballets Russes. Color lithograph, 1600 x 1200 mm. Paris, Bibliothèque Nationale

141. Study for **Légende de Joseph**, 1914

Crayon and pastel, 286 x 303 mm. Paris, Musée du Louvre (Orsay), Cabinet des Dessins

142. The Parisienne, 1889

Ink and watercolor, 140 x 51 mm. Present location unknown

often have as their focus a young woman who makes her way somewhat gingerly along the city streets. *The Parisienne* (fig. 142) announces the subject that was to become central to Bonnard's Paris scenes of the 1890s, where a fragile-looking figure, her small face nearly swallowed by a hat and cape, trips along the pavement, with an umbrella in hand and a child or dog at her side. The strength of Bonnard's attachment to this theme is no less remarkable than is his repeated success in varying both its arrangement and its impact (fig. 143). For Bonnard, as for us, the Parisienne glimpsed in her passage from here to there against a backdrop of curbstones, cabs, and shop windows symbolizes the activity at the heart of the city.

Two prints Bonnard made very early in his career as illustrations to the literary and art journal *La Revue blanche* capture this aspect of the urban woman. His *Parisiennes* (fig. 144), first published in December 1893, has the spontaneity of a snapshot and seems to have been worked rapidly to describe a flurry of young shoppers. *Woman with an Umbrella* (fig. 145), printed almost a year later, in September 1894, strikes rather a different note, presenting a single animated silhouette. These lively prints appear to reflect characteristics of Parisiennes who were close to Bonnard: one, the open-faced, coquettish Berthe Schaedlin, the cousin who appears in portraits and family scenes of the early 1890s and who was the model for his France-Champagne poster (see fig. 125); the other, the timid florist's assistant, Marthe de Méligny, whom Bonnard met late in 1893 and with whom he was to share most of his life. Marthe, who became the dominant female presence in Bonnard's pictures from 1894 on, was remembered as having a curiously birdlike air, "a skipping step on heels as high and thin as a bird's feet," that made her seem forever on the brink of flight.[27]

The wasp-waisted figure in Bonnard's print, although it seems to have been hastily sketched, was, like so many of his apparently spontaneous essays, the result of labors that involved repeated drawings and tracings through which the perfectly balanced silhouette was progressively refined (figs. 146–148).[28] Such work was the outcome of Bonnard's exercise of important Nabi tenets: the stringent shaping of a subject to summarize personal observations and sentiments, combined with a deliberate naïveté. His witty slip of a Parisienne owes more to caricature than to any attempt at realism and thus breaks from the throng of ladies who stroll through the fashion plates of the era and the paintings by Béraud, Boutet, Caillebotte, and Tissot (fig. 149). It was not particularly surprising to find a figure of such artless simplicity in the popular press; more remarkable

143. Woman on a Windy Day, ca. 1891–92 [cat. 10]

Pencil, ink, and wash, 325 x 258 mm. Private collection

144. Parisiennes, 1893 [cat. 30]

From *La Revue blanche*, December 1893. Lithograph, 216 x 137 mm. Houston, Virginia and Ira Jackson Collection

was the fact that Bonnard began to people his full-color lithographs and paintings with creatures who were similarly flimsy and fanciful (fig. 150).[29]

One of Bonnard's most audacious graphic designs depends upon just such a singular creature. His poster of 1894 for *La Revue blanche* (fig. 151) is a memorable record of his long and friendly association with this important monthly, its publishers, the Natanson brothers, and its brilliant

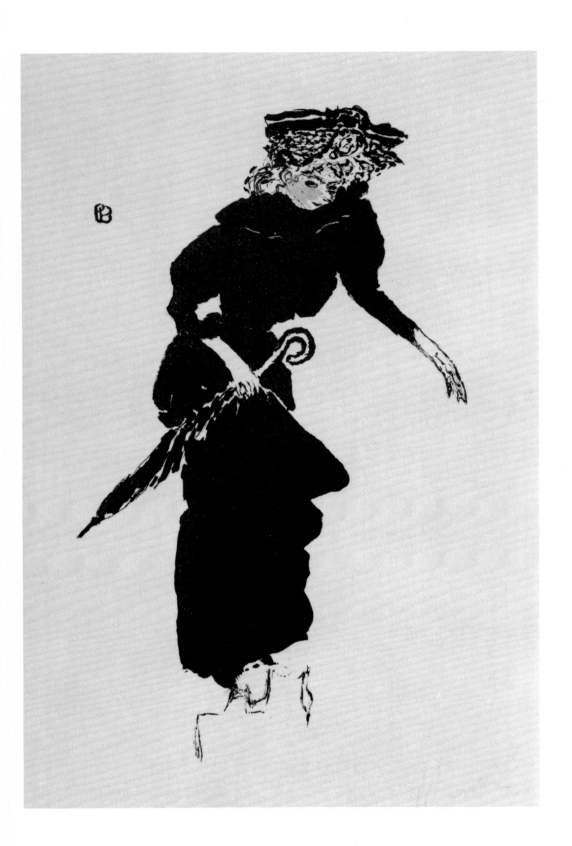

145. Woman with an Umbrella, 1894
[cat. 31]

From *Album de la Revue blanche*, 1895; initially published in the magazine, September 1894. Color lithograph, 220 x 127 mm. Boston, Museum of Fine Arts, Bequest of Betty Bartlett McAndrews

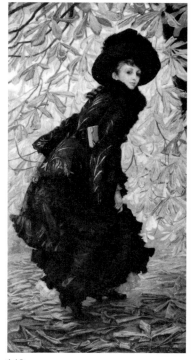

147 148 149

146. Studies for **Woman with an Umbrella,** 1894
[cat. 32]

Graphite, ink, and wash with touches of watercolor,
310 x 198 mm. The Art Institute of Chicago, Gift from
the Estate of Grant J. Pick, 1963

147, 148. Studies for **Woman with an Umbrella,** 1894

Lithographic crayon, ink, and wash (recto and verso),
310 x 205 mm. Switzerland, private collection

149. JAMES-JACQUES-JOSEPH TISSOT, **October,**
1877

Oil on canvas, 2165 x 1095 mm. The Montreal Museum of Fine Arts, Gift of Lord Strathcona and
Family

150. Street Scene, ca. 1895

Oil on canvas, 350 x 270 mm. Jacques and Natasha
Gelman Collection

band of contributing artists and authors. Between 1893 and 1903 Bonnard produced more than thirty-five images for the journal.[30]

It was Thadée Natanson, the Nabis' principal champion on the magazine and Bonnard's lifelong friend and biographer, who commissioned the poster, and probably Thadée's young bride, Misia, whom he married in 1893, who gave the advertisement its particular allure. A daring abstract image in unexpectedly somber tones, the lithograph presents a beguiling, sloe-eyed Parisienne who holds a copy of the magazine in one hand and, in the other, an umbrella which slots through an *a* and rests in the *v* of the title.

By any standards, even those of Bonnard's own painting of the same time, the graphic work is exceptionally bold. Like the artist's earlier advertisement for champagne, it turns two-dimensionality to notable effect, restating the flatness of the image in the compressed space of the

facing page

151. **La Revue blanche,** 1894 [cat. 33]

Poster. Color lithograph, 800 x 630 mm. New York, The Metropolitan Museum of Art, Purchase, Gift of Joy E. Feinberg of Berkeley, California, 1986

152. Study for **La Revue blanche,** 1894 [cat. 34]

Ink, charcoal, watercolor, and chalk, 794 x 597 mm. New Orleans Museum of Art, Gift of Mr. and Mrs. Frederick Stafford

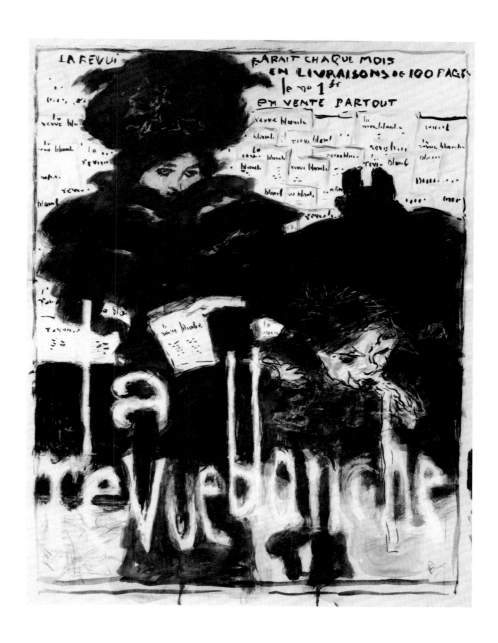

153. UTAGAWA KUNISADA, **Nakamura Utaemon in a Kabuki Scene,** before 1861

Color woodcut. France, private collection

This Japanese print filled with bold, colored shapes was once in Bonnard's own collection.

narrow sidewalk and in the striking silhouettes. Large, dark shapes like these had been used by Toulouse-Lautrec to form the figures of Jane Avril and Aristide Bruant in his posters printed only the year before. But rather than explore, as Lautrec did, the obviously broad range of possibilities offered by color lithography, Bonnard chose instead the not-quite-monochromatic, vaguely moody scale of tones he and Vuillard found evocative and in which he had executed his preparatory drawing (fig. 152). In keeping with the Japanese masters whose woodcuts he admired and collected (fig. 153), he directed his energy toward creating dynamic shapes and articulated patterns within a relatively simple planar composition, a habit formed during the early 1890s when Fénéon, who functioned as the editor in chief of *La Revue blanche*, found reason to call him "Bonnard très japonard." [31]

Bonnard's images, like those of Vuillard, Roussel, and others of the Nabis, are sometimes difficult to decipher. That his poster for *La Revue blanche* carries a message beyond its intrinsic decorative appeal is announced by its neckerchiefed newsboy, invented as a foil to the winsome lady and as contrast to the indeterminate top-hatted figure bent over the newsstand behind him. Darkly silhouetted gentlemen routinely accompanied *chérettes* in posters of the period. Here, however, the woman is partnered by an impertinent lad who shouts to passersby while cocking a thumb at the magazine in her hand—an upstart who projects the coarse, even demonic humor that sometimes marks the works of Félix Vallotton (fig. 154), the Swiss artist who entered the Nabi circle in 1892. A master of daring inventions in black and white, Vallotton, like Toulouse-Lautrec, surely sparked Bonnard's genius, although both he and Lautrec were on the whole much sharper realists.

Bonnard's mastery of the exquisitely constructed image peaked at this time with his creation of a four-panel folding screen that effectively brought the Paris street into the domestic interior. Created first in distemper (fig. 155) and soon afterwards recast in color lithography (fig. 156), *Promenade* is one of at least five screens that Bonnard is known to have worked on between 1890 and about 1919. [32]

Although the folding screen had been a popular piece of furniture in Europe since the eighteenth century, it was not until the second half of the nineteenth century that Western painters began to embrace it as a form of household decoration. The two-panel screen Whistler painted in 1872 with a view of Old Battersea Bridge in London is the first important

example of the genre to be created in imitation of the Japanese screens that began to enter Europe in quantity during the 1860s.[33]

Among the Nabis, both Vuillard and Denis painted folding screens, but it was Bonnard, with his special attraction to the decorative Japanese style, who was the first of his group to attempt and fully assimilate the principles of such a design. In 1891, at the Salon des Indépendants, he exhibited four panel paintings showing women in a garden at different seasons of the year.[34] The paintings matched in size and shape, but each was composed as an individual entity. The later *Promenade*, by contrast, united its four panels in one extended design, which floated Oriental-style across the entire surface of the screen.

His firm belief in art as a form of decoration, which he held in common with others of the Nabi circle, prompted Bonnard to apply his art to a variety of practical objects, including theater scenery, fans, and stained glass. Although he was less active in the area of interior design than Denis, for instance, who created a completely furnished model bedroom for Siegfried Bing's store, L'Art Nouveau, he nonetheless showed an active interest in such enterprises by submitting plans for the decoration and furniture of a dining room to a competition organized in 1891 by the Union Centrale des Arts Décoratifs.[35]

Bonnard's superb adaptation of his painted screen to a lithographed one was an undertaking that appears to be without precedent. The impetus for a project of this nature may have come from the large color posters of the period by Chéret, Grasset, and others, which made their way from the streets into private houses as part of a fad for collecting and mounting such prints on folding screens. Among other possible stimuli are the large prints Levilly made to be mounted as fire screens and the mural panels ("simili-frescoes") Chéret lithographed for the firm of Maison Pattey in 1891, which were hailed as important new developments in interior decoration. Bonnard and the publisher of his screen, Molines, the director of the Galerie Laffitte, where Bonnard exhibited several of his prints in the spring of 1895, may have noted with uncommon interest the printer and publisher Charles Verneau's founding in 1894 of *L'Estampe murale* for the distinct purpose of distributing large-scale prints for the home.[36]

Bonnard executed his painted version of the *Promenade* in the medium he often used for theater flats, distemper. Its matte finish made for visual unity with the unprimed canvas, much of which Bonnard left

154. FELIX VALLOTTON, **Le Plan commode de Paris**, 1892

Poster illustrated in *Le Livre et l'image*, March–July 1893. New York, The Metropolitan Museum of Art, Thomas J. Watson Library, Presented by Pierre L. LeBrun, 1922

Vallotton's shop-window placard illustrated the advantages of a pocketbook guide to the streets of the city and its omnibus and tram routes, as opposed to the unwieldy folding plan.

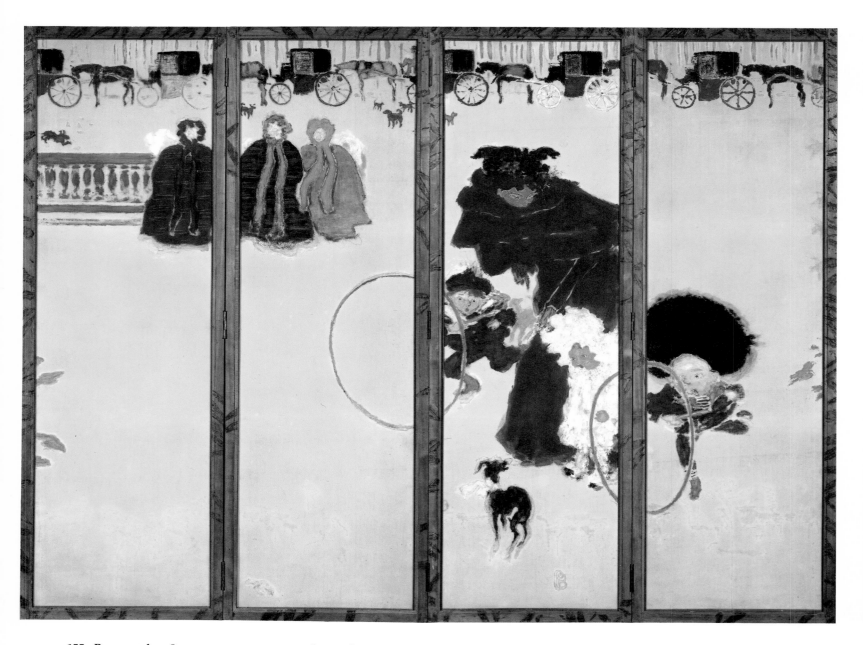

155. Promenade, 1894 [cat. 35]

Four-panel folding screen. Distemper (pigment in
glue) on canvas with carved wood frame, each panel
1470 x 450 mm. Private collection

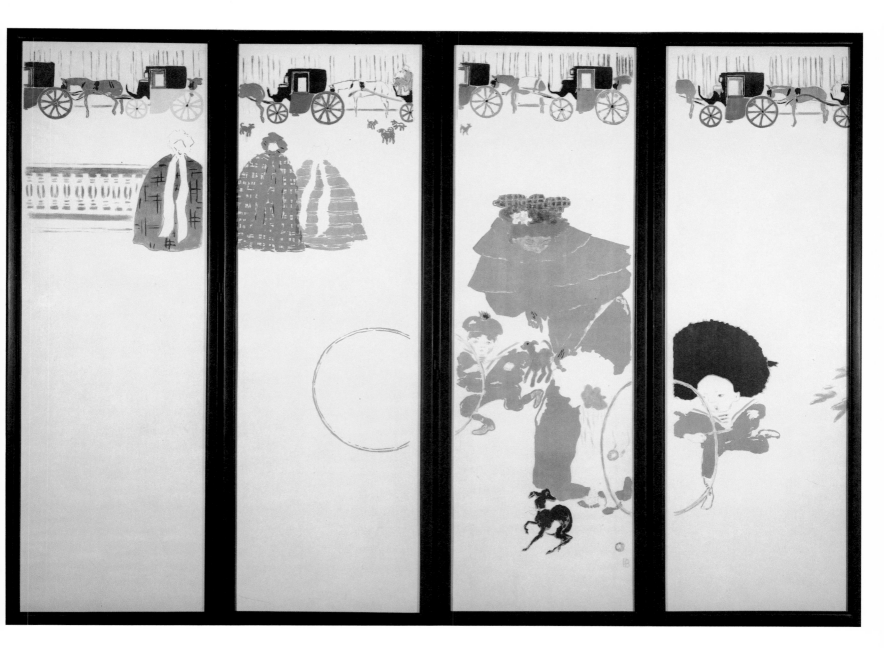

156. Promenade, 1895 [cat. 36]

Four-panel folding screen. Color lithographs, each (sight) 1499 x 479 mm. Houston, Virginia and Ira Jackson Collection

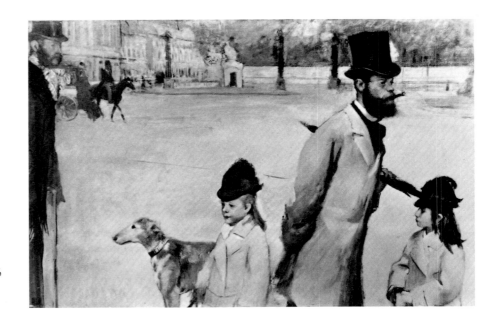

157. EDGAR DEGAS, **Place de la Concorde,** ca. 1876

Oil on canvas, 790 x 1180 mm. Destroyed during
World War II. © Document Archives Durand-Ruel

entirely bare. The large, open areas of the composition provided a back-drop for the animated group that is seen crossing the Place de la Concorde (perhaps heading home from the Tuileries),[37] rather like the ensemble Degas pictured in his 1876 painting showing the vicomte Lepic with his daughters and dog (fig. 157).

The subject of children and adults in public parks and gardens had been taken up regularly by the Impressionists Manet, Renoir, and Monet in the 1870s and 1880s, as a means of examining contemporary life in the open air. It was given unusually extensive treatment in 1894 by Vuillard, who decorated the dining room of Alexandre Natanson (Thadée's older brother) with nine painted panels of scenes in the Tuileries gardens and the Bois de Boulogne (fig. 158). Bonnard was in almost daily contact with Vuillard during the 1890s, since the two for a while shared a work space and then had neighboring studios on the rue Pigalle, and he could not have failed to be impressed by his friend's ambitious murals, which featured expansive foregrounds and charmingly anecdotal outdoor scenes. But because he differed from Vuillard in almost always settling upon a specific focus for his interest, Bonnard gave great importance in *Promenade* to demonstrating a hierarchy of points of emphasis. Much more than Vuillard's atmospheric tableaux or Degas's candid, camera-stopped scene, his composition is a consciously decorative arrangement centered, as are so many of his graphic works in 1894–96, on the animated figure defined in an eye-catching silhouette.[38] In an organization based

on Japanese design principles, Bonnard counterbalanced the asymmetrically placed cluster of hurrying figures with a stationed rank of horse cabs and a row of beribboned nannies.[39]

In the five-color lithographed version of *Promenade*, which Bonnard must have completed late in 1895, the year after his painting, he adjusted and consequently clarified the composition by lowering the principal figural ensemble, remodeling the stylish whippet, and emphasizing striped and checked patterns throughout. Greater lightness was achieved by additions of white and by the elimination of certain details, including many of the autumn leaves that appear to drift into Bonnard's painting from its carved frame.[40] The precise manner in which Bonnard mounted his four large prints when they were displayed under the title "Paravent" at his

158. EDOUARD VUILLARD, **The Public Garden,** 1894

Three panels (from a series of nine). Distemper on canvas, 2120 x 3042 mm. Paris, Musée d'Orsay

first one-man show, at the Galeries Durand-Ruel in January 1896, is unfortunately not known.[41] Announcements of their publication and sale by Molines offered the edition of 110 sets in either loose sheets (40 francs) or mounted (60 francs).[42] Their material and size must have made the prints especially vulnerable, and no more than a quarter of the edition seems to have survived.[43]

Bonnard's persistent fascination with the compression of figural subjects into tall, narrow formats, like the upright panels of a screen, is exemplified in numerous other works, including *The Schoolgirl's Return* (figs. 159, 160), which assembles again the favored subjects: a Parisienne, a child, and a little dog.[44] Here, as in so many of Bonnard's compositions (even those made very late in life), a statuesque woman is shown beside an open door, its square-cornered construction in rigid contrast to the curvaceous feminine form. Although he began to depict the human figure with greater sculptural realism after 1896, Bonnard's earliest compositions consistently stress a highly caricatural treatment such as is seen here, particularly in the comically distorted child teetering under a load of schoolbooks.

The spectacle of babies, children, and dogs regularly stirred Bonnard, who evidently admired the naive, unfettered spirits of these small creatures and was amused by their naturally awkward behavior. His paintings and prints of the 1890s are full of Parisian schoolchildren, whose black-stockinged legs and clumsy feet scurry along the stone-paved streets. Since elementary education had been made compulsory and free in the 1880s, this nonadult population of the city had become a common sight.[45] But although he was alert to the picturesque in daily life, Bonnard generally did not concern himself with social realism, even while there were artists close to his immediate circle, such as Steinlen, Ibels, and Hermann-Paul, for whom it was a major theme, and in the nearby cabarets of Montmartre, Aristide Bruant's songs commiserated with the tattered, the homeless, and the exploited working masses.

Bonnard's little laundry girl (fig. 161), shown trudging along a deserted

159. Study for **The Schoolgirl's Return,** ca. 1895 [cat. 39]

Pencil, ink, pastel, and watercolor, 273 x 115 mm. Houston, Virginia and Ira Jackson Collection

back street with her basket load of linens, is a figure both comic and touching, revealing Bonnard's sympathetic eye for strays of every breed. At the same time, she represents a witty inversion of a common fin-de-siècle theme, that of the fashionable lady out walking her dog. In this case, girl and dog meet head-on in the street, more or less on equal footing, equal ground.

By midcentury the laundry industry was employing over one-fifth of the population of Paris and its environs. All over the city women and girls could be seen collecting and delivering their clients' laundry, which had to be transported to the local washhouses.[46] Images of the ubiquitous laundresses, the women who did the ironing, and the young delivery girls are plentiful in contemporary illustrations and in paintings by Daumier, Degas, Toulouse-Lautrec, and others. Bonnard's essay on this theme is unusual in its extreme spareness and abstraction. In keeping with the Nabis' theory that subjects must be re-formed, or deformed, to express their most telling qualities, the artist pared down his composition to essentials, progressing through a series of steps to distill the scene (figs. 162–164).[47] Like Degas, Caillebotte, and the Impressionists, who studied the aerial perspective and oblique organization of Japanese prints, Bonnard projected his figures against the tilted plane of the street, so that the ground fills the picture and compresses its space.

Bonnard's affection for the irregularly shaped silhouette of the fugitive Parisienne, which makes itself apparent so very early in his work (fig. 165), is most succinctly expressed in this print. Probably started in 1895, perhaps for the portfolio *L'Estampe moderne*, which the art dealer Ambroise Vollard had hoped to put out in October of that year, *La Petite Blanchisseuse* (*The Little Laundry Girl*) made its debut in the *Album des peintres-graveurs*, published by Vollard in 1896 and exhibited at his gallery in June and July.[48] One of Bonnard's last explorations of Japonisme, and perhaps his finest, *La Petite Blanchisseuse* was the first of his color prints commissioned by Vollard. It thus heralded the start of a new and intensely active stage in his printmaking career.

160. The Schoolgirl's Return, ca. 1895 [cat. 38]

Color lithograph, 260 x 130 mm. Houston, Virginia and Ira Jackson Collection

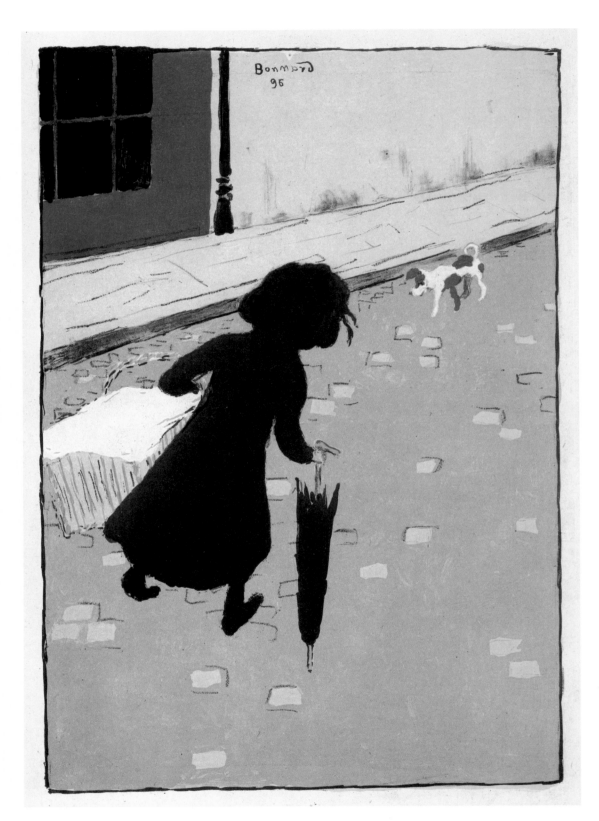

161. La Petite Blanchisseuse
(The Little Laundry Girl),
1895–96 [cat. 48]

Color lithograph, 294 x 200 mm.
New York, The Metropolitan Museum of Art, Harris Brisbane Dick
Fund, 1939

162

163

162. Study for **La Petite Blanchisseuse,** 1895–96 [cat. 50]

Crayon, 305 x 195 mm. Paris, private collection

163. Study for **La Petite Blanchisseuse,** 1895–96 [cat. 51]

Lithographic crayon, 312 x 210 mm. New York, The Metropolitan Museum of Art, The Elisha Whittelsey Collection, The Elisha Whittelsey Fund, 1988

164. Study for **La Petite Blanchisseuse,** 1895–96

Ink and watercolor, 275 x 205 mm. Paris, private collection

165. Parisienne in the Rain, 1889

Pencil, 315 x 140 mm. London, private collection

164

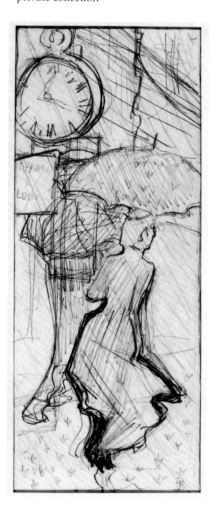

The Animated Street

For more than fifty years Bonnard maintained a studio near Montmartre. His addresses changed over time, and after 1900 his absences from Paris became longer and more frequent, but he continued to keep a work space there, never more than a few blocks from the Place de Clichy. Bonnard was deeply attached to this neighborhood, and the routine sights of its boulevards and narrow streets, which so inspired the art of his youth, reappeared again and again in works he made during periodic returns to the city.

It is Bonnard's affection for familiar things, the people, places, and objects close at hand, that empowers his art. The delight he took in his sister's children, in the household pets, and in games played on the lawn of the family's country retreat at Le Grand-Lemps was also to be found in the local life of Paris. There, too, the commonplace could be reinvented and restaged so as to focus and enlarge upon small points of drama. Thus, an extraordinary consistency informs Bonnard's choice of subject matter and his concentrated vision, overriding the shifts in style that occurred between the compact, tightly organized works of his youth and the looser, more spacious paintings of later years.

166. Les Chiens (The Dogs), 1893 [cat. 25]

Published by the magazine *L'Escarmouche*. Lithograph, 370 x 270 mm. New York, The Metropolitan Museum of Art, Purchase, Mr. and Mrs. Dave H. Williams Gift, 1988

167. Dingo in the Town Square [cat. 104]

Illustration facing page 46 of Octave Mirbeau, *Dingo*, 1924. Etching and drypoint, 286 x 225 mm. Houston, Virginia and Ira Jackson Collection

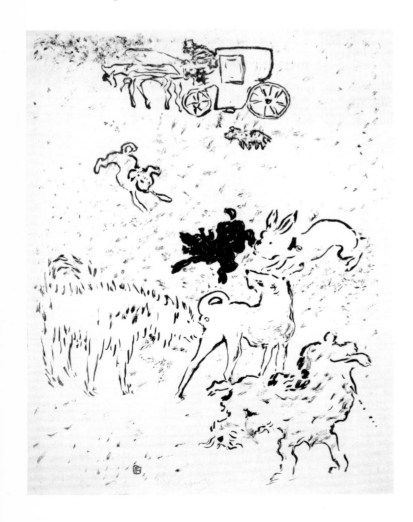

The lithograph *Les Chiens* (*The Dogs*; fig. 166), one of four prints Bonnard made in 1893 for the short-lived weekly *L'Escarmouche*, demonstrates the young artist's attitude toward the city, which he viewed as if it were his own backyard: an arena of activity he treated with humor and a kind of jaunty grace. Bonnard's picture of stray dogs disporting themselves is one of his most skillful creations of high caricature, and it brings to mind not only the dazzling energy of Daumier but also Manet's best work in black and white, such as his bold and impudent *Cats' Rendezvous* of 1868. Bonnard's graphic design, like Manet's, benefited from the inspiration of ukiyo-e woodcut prints, in which the facts of animal behavior were rendered succinctly and with wit.[49]

It is not often that we encounter emphatic actions in Bonnard's work. The stray in the foreground of *Les Chiens* and the raucous newsboy touting *La Revue blanche* in the poster done just a year later (see fig. 151) are two notably aggressive efforts to engage the audience's attention. Usually, the street life in his Paris scenes remains at a polite remove. Bonnard's vantage point, his sentiments, and his artistic style changed over the years, progressing toward greater realism in the modeling of forms and a broader definition of space, but his pictures nonetheless retained a scattered appearance, a scribbly texture, and quite often the sharp accent of a dark silhouette, as progressively later essays on the same theme attest (fig. 167).

A remarkable number of Bonnard's most inventive compositions are included in the splendid group of twelve color lithographs that was issued by Ambroise Vollard early in 1899 under the title *Quelques Aspects de la vie de Paris*.[50] The suite of prints was displayed for the first time at Vollard's gallery in March 1899, along with other series of lithographs that had been commissioned from the painters Henri Fantin-Latour, Denis, Odilon Redon, Roussel, and Vuillard.[51]

Although an early proof of Bonnard's title page for his Vollard suite bears the date 1898 (fig. 168), close study of the prints themselves, which vary greatly in compositional emphasis and in the style of draughtsmanship, reveals that they represent work accomplished over a period of at least three years. The name of the series went through several changes: from "Croquis Parisiens," to "Quelques Aspects de Paris," and then to the final version, with its overlooked repetition—QUELQUES ASPECTS DE DE LA VIE DE PARIS—in the lettering on the title page, where traces of the earlier, erased titles remain faintly visible.[52]

Among Bonnard's twelve views of Parisian life, only four appear to have been systematically numbered and signed (figs. 169, 175, 179,

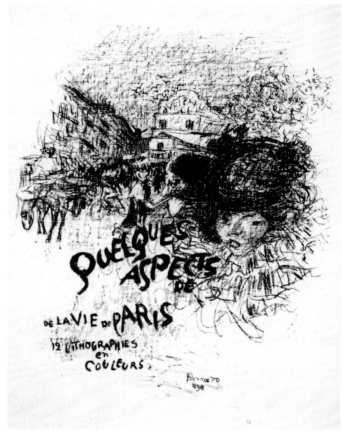

168. Quelques Aspects de la vie de Paris
(Some Aspects of Paris Life), 1898

Title page of the suite published in 1899. Lithograph (first state), 410 x 333 mm. Williamstown, Mass., Sterling and Francine Clark Art Institute

The scene is set in the Place Blanche in Montmartre.

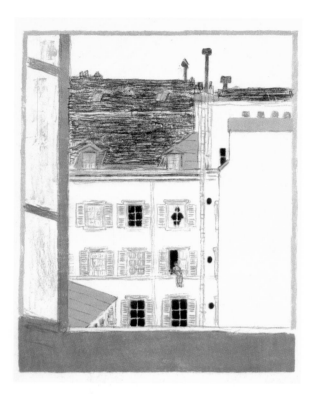

169. Houses in the Courtyard, 1895–96

[cat. 60, fig. 2]

From the suite *Quelques Aspects de la vie de Paris*, 1899. Color lithograph, 345 x 257 mm. New York, The Metropolitan Museum of Art, Harris Brisbane Dick Fund, 1928

181).[53] These four are also the most precisely composed and tightly contained of all the images, suggesting their relatively early conception within the set, which, on the whole, may be said to display a stylistic evolution toward broader spaces, looser lines, and an airier, more light-infused atmosphere. All four of these early signed lithographs describe rather narrow, compressed spaces, which are restricted in depth. Bonnard's experience in painting theater sets may have influenced him to re-create the closed shape of a proscenium; in these prints the buildings and streets of Paris are the artist's stage.

The scene of the lithograph *Houses in the Courtyard* (fig. 169) represents the view from the artist's studio,[54] a vista that obviously pleased Bonnard, for he repeatedly depicted its conjunction of stuccoed walls and sooty roofs, and the orderly march of shuttered windows and chimney pots. In a painting dated 1900, probably completed not long after he had installed himself on the rue de Douai, Bonnard seems to have bade farewell to his old window (fig. 170). Although it framed a scene that was common in Paris and not particularly distinguished, the view from it had nonetheless proven regularly inspiring.

The faithfulness with which Bonnard portrayed this view can be

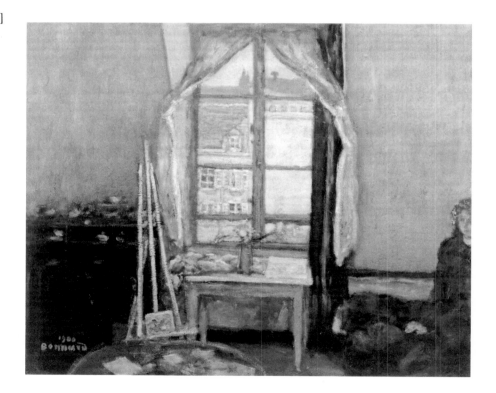

170. The Studio, 1900

Oil on canvas, 615 x 762 mm. Upperville, Va., Collection of Mr. and Mrs. Paul Mellon

171. Study for **Houses in the Courtyard,** 1895–96
[cat. 61]

Pastel, 397 x 311 mm. Boston, Museum of Fine Arts, Jesse H. Wilkinson Fund

172. Rooftops, ca. 1895 [cat. 46]

Oil on cardboard, 343 x 368 mm. Northampton, Mass., Smith College Museum of Art, Gift of Adele R. Levy Fund, Inc., 1962

judged from several fairly uniform depictions made from the same vantage point between about 1895 and 1900. The pastel drawing done in preparation for the color lithograph (fig. 171) contains all the essentials of his print, evidencing some hesitancy only in the angle of the open studio window and in the details of drains and roof tiles. The single element of human animation in the picture, a woman shaking out linens, is there from the first. *Rooftops* (fig. 172), a more closely focused study of the scene painted at about the same time, gives greater importance to the attic roof

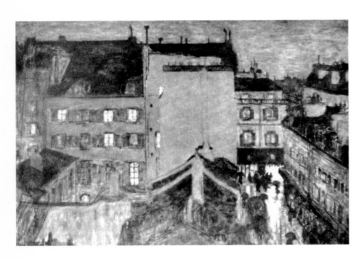

173. Montmartre in the Rain, ca. 1897

Oil on board, 700 x 920 mm. Present location unknown

facing page

174. Narrow Street in Paris, 1896–97 [cat. 67]

Oil on cardboard, 371 x 196 mm. Washington, D.C., The Phillips Collection

175. Narrow Street Viewed from Above, 1896–97 [cat. 66]

From the suite *Quelques Aspects de la vie de Paris,* 1899. Color lithograph, 368 x 210 mm. New York, The Metropolitan Museum of Art, Harris Brisbane Dick Fund, 1928

and chimneys, adding a bouquet and a bird cage to a garret windowsill as tokens of the life within.

Bonnard returned repeatedly to the theme of the window view over a period of more than fifty years, establishing his sight lines from a succession of frames that looked out on the traffic of the Place de Clichy, the boulevard des Batignolles, and the rue Molitor, or that opened onto lush vistas outside the artist's house in the Seine Valley and his Mediterranean villa (see fig. 3). Bonnard found windows eloquent with promise, marking the boundary between private and public life, between the alluring mystery of the out-of-doors and the more predictable order of the domestic interior.[55] The subject, which appealed also to Redon (see fig. 15),[56] was one perfectly allied with the aims of Symbolist poetry, for its enjoyment was based almost purely on memories and associations evoked, as Stéphane Mallarmé suggested they be, "little by little."[57]

Bonnard often used his window in Paris as a way to focus his vision and to structure his pictures, for within the armature of the window frame the humble verities of everyday life were spread before him as if on one plane. The broad panorama to be seen from his studio took in not only the flat walls and windows opposite but also a more distant perspective that dipped down into the street (fig. 173). There, below, was a block-long stretch of pavement dotted with shoppers and tradesmen— another complete unit of urban activity which absorbed Bonnard's attention both in paintings and in prints (figs. 174, 175).[58]

The aerial view was to remain one of Bonnard's favorite perspectives on the streets of Paris, beginning with his pictorial celebration of Bastille Day on the rue de Parme, where he had taken lodgings with his grandmother during his student days (fig. 176). The vertiginous bird's-eye view began to appear regularly in French art about the time that narrow, upright landscapes and cityscapes by Hiroshige and other Japanese printmakers started infiltrating Paris in the 1860s and 1870s. Bonnard himself owned woodcuts by Hiroshige, whose masterful print suite *One Hundred Famous Views of Edo* (fig. 177) embraced aspects of everyday life in the city of Tokyo with a breadth and inventiveness that both amused and inspired.[59]

The elevated vantage point so often found in ukiyo-e woodcut prints suggested to French artists a perspective that was particularly well suited to the expansive display of Paris's wide and recently modernized boulevards, which Monet, Renoir, and others glorified as the parade grounds of the bourgeoisie (fig. 178). By the time Bonnard came of age, the sight of

174

175

176. Paris, Rue de Parme on Bastille Day, 1889

Oil on canvas, 794 x 400 mm. Upperville, Va., Collection of Mr. and Mrs. Paul Mellon

shoppers swarming along the main department-store routes was no longer novel, and the young artist turned his eyes instead to familiar sights close at hand, which he strove to present as if they were extraordinary and new. During the early 1890s, when he discovered a fresh appreciation for the subtle shapes and patterns of street activity, Bonnard depicted Paris not so much as the grand metropolis of two and a half million inhabitants into which it had grown as a few pockets of neighborhood life.

On the whole, therefore, Bonnard concerned himself rather little with the city's chic modernity. Like the popular illustrators of his day who supplied picture books for children and souvenirs for the tourist trade, he concentrated on anecdotal, everyday occurrences that put Paris on a more manageable and intimate human basis. Although his palette and use of abstraction were avant-garde, Bonnard's subject matter, it must be emphasized, was entirely traditional and stemmed from a long line of Paris street views that took in merchants, shoppers, and assorted pedestrians; such views went back to the seventeenth century with the prints of Callot, Bosse, Bouchardon, and a host of other French pictorial journalists.

To be sure, nineteenth-century Paris, with its expanding boundaries, its rapidly growing population, and its increasing prosperity, offered untold new sights. A keen urban consciousness arose, which took in everyone from ragpickers to elegants, and which treated the physiognomy of the modernized city itself as the backdrop for dining, riding, shopping, dancing, strolling, and countless other activities that could be enjoyed almost as well by onlookers as by participants.

Connoisseurship in observation developed as the special talent of the *flâneur*, that stroller of the city streets who became the sensitive viewer of movements and events. Victor Fournel, who in 1858 was among the first to outline the pursuits of the modern *flâneur* in his book *Ce qu'on voit dans les rues de Paris* (*What Is to Be Seen in the Streets of Paris*), declared that the "aesthetic observer" animated all that he saw and was not so much a spectator as a collector of the city's sensations.[60]

In 1863 Baudelaire defined the painter of modern life as a passionate spectator with "an aim loftier than that of a mere *flâneur*, an aim more general, something other than the fugitive pleasure of circumstance. He is looking for that quality which you must allow me to call 'modernity'; . . . He makes it his business to extract from fashion whatever element it may contain of poetry within history, to distill the eternal from the transitory."[61]

Compared to the "dandy-*flâneur*" Constantin Guys, whom Baudelaire had selected as his ideal, Bonnard showed himself distinctly uninterested in what was fashionable, but sought instead to describe in a general way the arresting incidents of the everyday. Certainly, as the range of his observations broadened, the acuity of his vision strengthened. "He has the gift for picking out and quickly seizing the picturesque in every spectacle," said the critic Roger Marx in 1893, praising an ability to capture "momentary attitudes" and "unconscious gestures" where he had earlier emphasized Bonnard's talent for decoration.[62]

Bonnard's ritual morning promenades regularly presented him with fresh experiences of the city's patterns of movement and a changing array of human silhouettes.[63] But the artist, although his habits of observation were keen and intense, nonetheless limited the extent to which he worked directly before his subject, preferring to re-create a scene later in the studio, guided by the dynamics of memory. His street views are

177. ANDO HIROSHIGE, **Suruga-cho** (Suruga District)

From the series *One Hundred Famous Views of Edo*, 1856–58. Color woodcut, 340 x 222 mm. New York, The Brooklyn Museum

178. CLAUDE MONET, **Boulevard des Capucines, Paris,** 1873–74

Oil on canvas, 794 x 591 mm. Kansas City, Mo., The Nelson-Atkins Museum of Art, Kenneth A. and Helen F. Spencer Foundation Acquisition Fund

179. Boulevard, ca. 1896 [cat. 62]

From the suite *Quelques Aspects de la vie de Paris*, 1899. Color lithograph, 173 x 435 mm. New York, The Metropolitan Museum of Art, Harris Brisbane Dick Fund, 1928

The boulevard de Clichy, with its islands of plane trees and benches, is not much changed since Bonnard's day, although now, near the Moulin Rouge, souvenir shops and peep shows have supplanted pastry shops, dairies, and wine merchants.

therefore selective reconstructions of reality, spiced with the haphazard occurrences and incongruities that enliven the routine. His prints, even more than his paintings, demonstrate an extraordinarily concise structuring. Perhaps because the many working steps necessary to their creation gave Bonnard opportunities to refine, distill, and recompose, he managed to translate a moment in the heavily trafficked life of the street into a composition with something of the enduring power of a classical frieze (fig. 179).

It is evident from contemporary photographs that Bonnard was in many ways true to life in portraying his subjects (fig. 180). Yet photography's even-handed, unprejudiced field of vision emphasizes by contrast Bonnard's selectivity and his careful staging of activity within a tightly held space. Pedestrians, carriages, even rivulets of light are all pressed to conform to the artist's directions. *Street at Evening in the Rain*

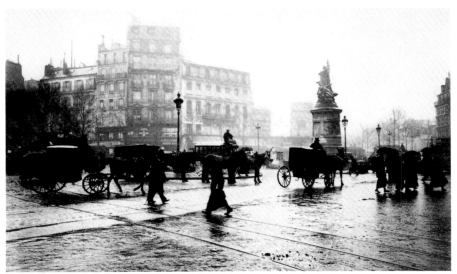

180. EMILE ZOLA, **Place Clichy,** ca. 1895–1900

Photograph. Paris, Collection François Emile-Zola

The author of the Rougon-Macquart novels took up photography with enthusiasm during the last seven years of his life (1895–1902), producing family portraits and Paris views—this was taken from the corner of the rue Amsterdam—which he developed and printed in his own darkroom.

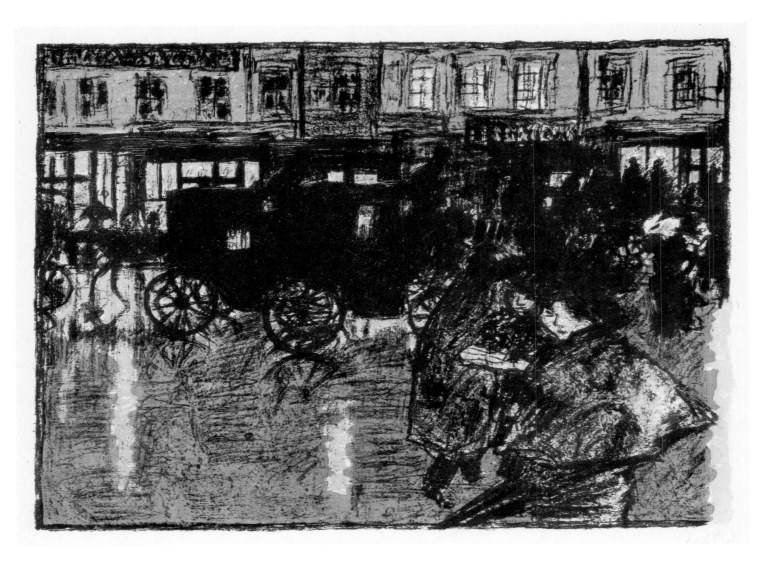

181. Street at Evening in the Rain, 1896–97 [cat. 64]

From the suite *Quelques Aspects de la vie de Paris,* 1899.
Color lithograph, 257 x 355 mm. New York, The
Metropolitan Museum of Art, Harris Brisbane Dick
Fund, 1928

(figs. 181, 182) is for Bonnard a relatively rare treatment of a night scene, a subject for which he later confessed little sympathy,[64] but which in the late 1890s he may have found compelling in its contemporaneity inasmuch as electric lights and large plate-glass windows had only recently extended the pleasures of shopping after dark.[65] The interplay between the shadowy crowd and spots of light was both novel and arresting, especially as played out against a stretch of rain-slick street. It is true, too, that just as the darkened domestic interior had been given mystic significance by the Nabis, so had the urban night, which during the late 1880s and 1890s inspired the works of Degas, Pissarro, van Gogh, Vuillard, Anquetin, and scores of illustrators, including Rivière, Steinlen, Buhot, and Lepère.[66]

A passing shopper or a cab horse was introduced into the foregrounds of such scenes to invite a sense of spatial interaction (fig. 183). Their cropping at the picture's edge suggests their movement into or out of the field of vision, rather like the crowds of people who wandered into and out of the range of Louis Lumière's early movie cameras, which produced the first cinema shows in Paris in 1895.[67]

Sketches that experimented in lending greater density and dynamic to the planar street scene (figs. 184, 185) seem to have led Bonnard toward a more pronounced asymmetry and, eventually, a highly expressive rein-

182. Study for **Street at Evening in the Rain,**
 1896–97 [cat. 65]

Pastel, 275 x 375 mm. Paris, Bibliothèque Nationale, Cabinet des Estampes

183. **The Cab Horse,** ca. 1896

Oil on wood, 300 x 400 mm. Washington, D.C., National Gallery of Art, Ailsa Mellon Bruce Collection, 1970

terpretation of rush-hour traffic as an alienating experience, in which the individual may feel isolated and even be in distress (figs. 186–188). It is at this very moment in Bonnard's career, late in the 1890s, that his own restlessness and anxiety about living in the city began to surface, motivating ever more frequent retreats to the suburbs and country.

Since Nicolas Perelle's etching suites of the mid-1600s, sets of Paris views usually presented a program of well-known sites. However, Bonnard's *Quelques Aspects de la vie de Paris* steers intentionally clear of famous landmarks and vistas to focus instead on one man's personal vision. The windmill known as the Moulin de la Galette perched past the top of the rue Lepic helps to identify the Place Blanche at its base as the setting for Bonnard's title page (see figs. 168, 195).[68] But the mill and

184. Street Scene, ca. 1896

Crayon. Present location unknown

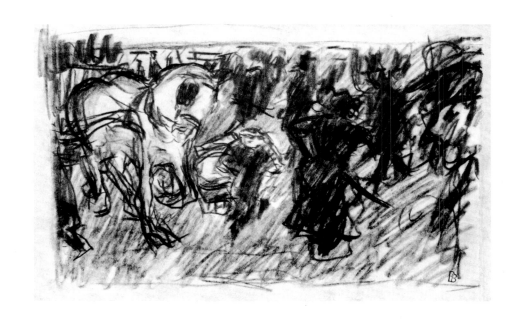

185. Street at Evening, ca. 1897

Charcoal and pastel, 223 x 341 mm. Cologne, Wallraf-Richartz-Museum, Strecker Collection

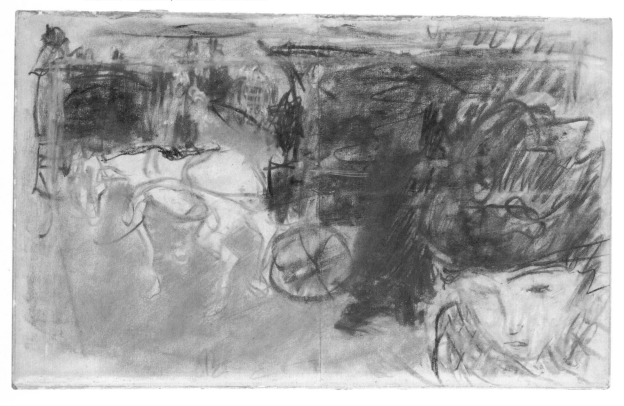

facing page

186. The Square at Evening, ca. 1897–98 [cat. 74]

From the suite *Quelques Aspects de la vie de Paris*, 1899. Color lithograph, 170 x 430 mm. New York, The Metropolitan Museum of Art, Harris Brisbane Dick Fund, 1928

187. Study for **The Square at Evening,** ca. 1897–98

Watercolor, pastel, and ink, 255 x 375 mm. Private collection

188. Study for **The Square at Evening,** ca. 1897–98 [cat. 75]

Charcoal, 310 x 198 mm. Paris, Musée du Louvre (Orsay), Cabinet des Dessins

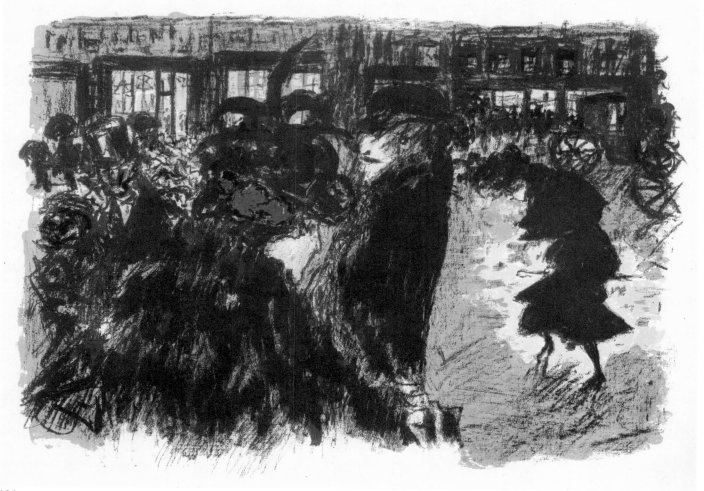

186

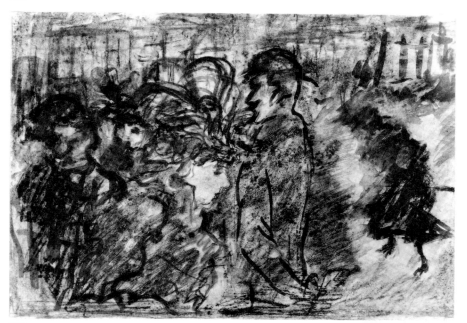

187

188

the Arc de Triomphe glimpsed at the far end of the avenue du Bois de Boulogne (see fig. 193) are the only identifiable sights in the entire portfolio of Bonnard's Paris views. It is also true that almost nowhere in his work do we see Doublemard's monument to Maréchal Moncey, which stands at the hub of the Place de Clichy (see fig. 180), although Bonnard repeatedly pictured the traffic that circled around it.[69]

It is a wonder that Bonnard's set of Paris prints displays such appealing originality and freshness, for the artist could very easily have been jaded by the flood of city views that began in the 1870s to broadcast news of Haussmann's urban renovations. Tourism reached a peak during the Exposition Universelle of 1889, and there ensued a vast outpouring of illustrations of Paris in newspapers, journals, books, and albums that continued right up to World War I. One anonymous writer in *Le Livre et l'image* in 1893 seemed to sigh at the thought of another season's crop of picture books: in the springtime, he said, "it rains albums."[70]

The nineteenth century's last decade was indeed flooded with printed images of Paris. A sample of such publications might include Maximilian Luce's album *Coins de Paris* (1890), Auguste Lepère's illustrations in *Paysages parisiens* (1892), Vallotton's series *Paris intense* (1894), Théophile-Alexandre Steinlen's *Chansons de Montmartre* (1898), and Henri Rivière's *Paysages parisiens* (1900).[71] Much less common were albums of lithographs of rural landscapes, such as Charles-Marie Dulac's *Suite de paysages* (1892–93) and Rivière's *Les Aspects de la nature* (1897–99); the latter may have influenced Bonnard's choice of title for his own set of views. A flourishing market for print suites was thus well established, but it had probably peaked by 1899, when Vollard announced his publication of albums by the Nabi painters Bonnard, Vuillard, Roussel, and Denis. The portfolios, which together included domestic, rural, and urban scenes, did not sell well, in part perhaps because the lithographs looked disconcertingly unfinished and sketchier than the color prints then in vogue. Their studious avoidance of realism also set them apart. The world they showed was purposefully distorted, its verities filtered through the artists' own personal recollections and emotions. Thus Bonnard's views of Paris were not everyone's, but decidedly and uniquely his.

Around 1897, as he moved to dissolve the spatial and formal restrictions that had kept his Paris pictures confined to limited sections of the street, Bonnard opened up their space to greater air and brighter light. The atmosphere he created with a new, looser line and luminous, transparent tints made his cityscapes seem more than ever dreamlike. In *The*

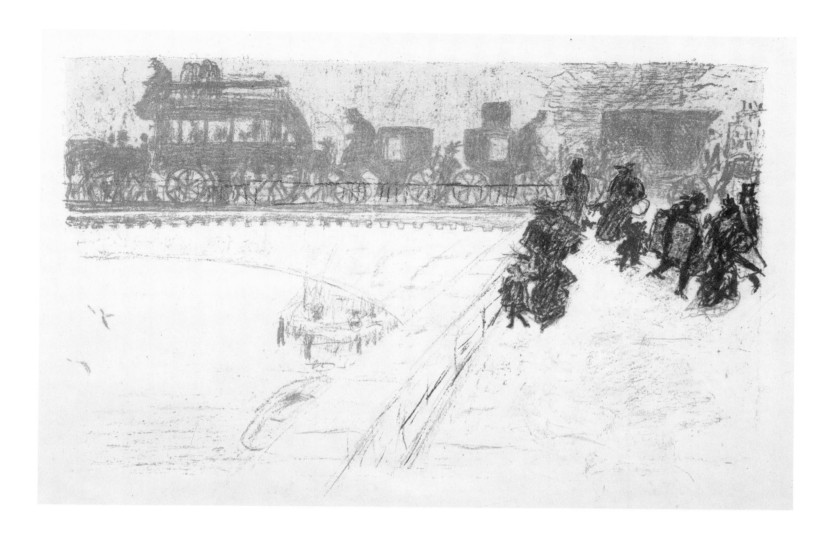

Bridge (fig. 189), the processions of carriages moving behind a veil of light snow or fog have a mysterious aura, while figures that pass through the background of *Street Corner* (fig. 190) disintegrate like ghosts. We are denied any clues that might help us to identify these particular sites; even the bridge which spills pedestrians onto the quay is too summarily drawn to be named.[72]

In works such as these Bonnard revealed his continued delight in the decorative arrangements that had charmed him in Japanese prints. But his growing appreciation for Impressionism soon compelled him to infuse flat and airless designs with enlarged space, broken outlines, and forms that shimmer in light. His *Street Seen from Above* (fig. 191) dives down a Montmartre street, taking in a much deeper perspective while

189. The Bridge, 1896–97 [cat. 68]

From the suite *Quelques Aspects de la vie de Paris,* 1899. Color lithograph, 270 x 410 mm. New York, The Metropolitan Museum of Art, Harris Brisbane Dick Fund, 1928

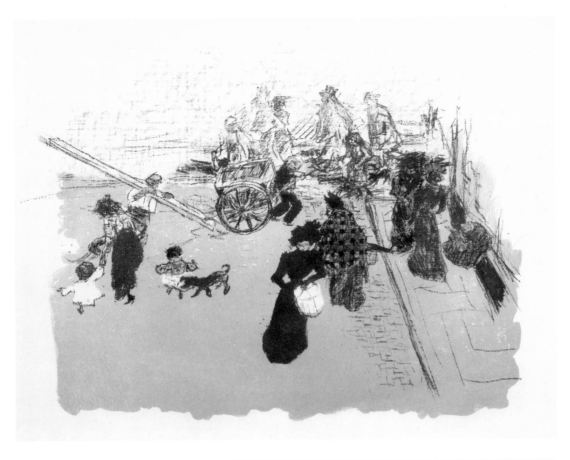

190. Street Corner, ca. 1897
[cat. 69]

From the suite *Quelques Aspects de la vie de Paris*, 1899. Color lithograph, 270 x 355 mm. New York, The Metropolitan Museum of Art, Harris Brisbane Dick Fund, 1928

191. Street Seen from Above, ca. 1897 [cat. 72]

From the suite *Quelques Aspects de la vie de Paris*, 1899. Color lithograph, 370 x 225 mm. New York, The Metropolitan Museum of Art, Harris Brisbane Dick Fund, 1928

also suggesting the state of the weather. The same may be said of the *Avenue du Bois de Boulogne* (fig. 192), in which the autumn sun sets on an expanded horizon. The sharply silhouetted figure is here less prominent than before and now steps into alignment with the picture's dramatically receding space.

Like Renoir, Monet, and other painter-*flâneurs*, Bonnard discovered the joy of walks in the open air on the city's wide, tree-lined avenues. Paris's renovated parks and broadened roads, such as the avenue du Bois de Boulogne (now the avenue Foch), which ran from the Arc de Triomphe to the Bois de Boulogne, were recognized as modern marvels. For many well-to-do Parisians, an outing to the Bois de Boulogne was the main event of the day. The fashionable time for horseback riding was late

192. Avenue du Bois de Boulogne, ca. 1898 [cat. 76]

From the suite *Quelques Aspects de la vie de Paris*, 1899. Color lithograph, 310 x 460 mm. New York, The Metropolitan Museum of Art, Harris Brisbane Dick Fund, 1928

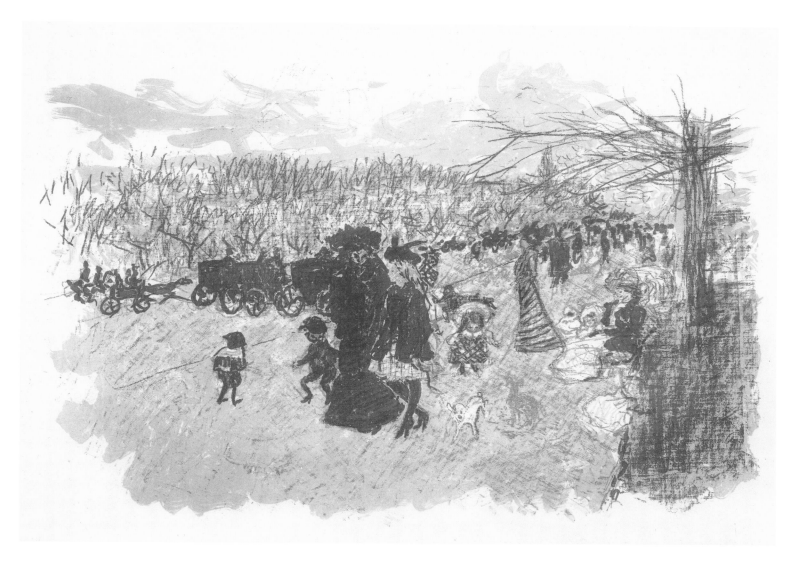

193. **Arc de Triomphe,** ca.
1898 [cat. 77]

From the suite *Quelques Aspects de la vie de Paris*, 1899. Color lithograph, 310 x 465 mm. New York, The Metropolitan Museum of Art, Harris Brisbane Dick Fund, 1928

194. CAMILLE PISSARRO, **Avenue de l'Opéra,** 1898

Oil on canvas, 730 x 920 mm. Reims, Musée de St.-Denis

in the morning,[73] and Bonnard rendered the brightness of the hour in a tremulous, almost ethereal light (fig. 193).

His newfound delight in plunging the eye into great wedges of space seems to have been shared at this time by Toulouse-Lautrec and Vuillard, both of whom depicted sharply receding stretches of roadway in color lithographs dating from 1897, the year Vollard commissioned Vuillard's print suite *Paysages et intérieurs* (*Landscapes and Interiors*). Bonnard's scenes are distinguished, however, by their increased painterliness, suggesting strong similarities with Pissarro's late views of the avenue de l'Opéra, painted from a rented room in the Hôtel du Louvre (fig. 194). But Pissarro's panorama is a relatively formal, elegant view of the city, unlike Bonnard's quirky vision of returning equestrians attracted, as if magnetically, toward a distant landmark. The atmospheric luminosity of *Arc de Triomphe* would have appealed to Pissarro, who, having declared Bonnard's first one-man show in 1896 "a complete fiasco," later revised his opinion, predicting in 1899, "This young artist will go far, for he has a painter's eye."[74]

Like a new convert, Bonnard seemed, around the turn of the century, to find fresh life in his discovery of Impressionism's unguarded realism

and shattered forms. It was as if his art had experienced an awakening, for it filled with almost palpable light and an urgency conveyed in masses of eager lines. The title page for the Vollard suite, executed in 1898 (fig. 195), demonstrates quite vividly Bonnard's Impressionist style, picturing passersby in the busy intersection of the Place Blanche with an off-handed instantaneity that goes far beyond his own earlier renditions of the Parisienne and that seems to owe something to the enchanted world of his new friend Renoir (fig. 196).[75]

Although it was the title page to his portfolio of views of Paris, this design served as Bonnard's bittersweet salute to the city, from which he was thenceforth to distance himself more and more. His lighthearted intimacy with the streets of Paris rarely reappears. Around 1900 Bonnard adopted a vagabond's life, pulling up stakes with each change of season

195. Quelques Aspects de la vie de Paris, ca. 1898
[cat. 59]

Title page of the suite, published by Vollard in 1899. Color lithograph, 410 x 333 mm. New York, The Metropolitan Museum of Art, Harris Brisbane Dick Fund, 1928

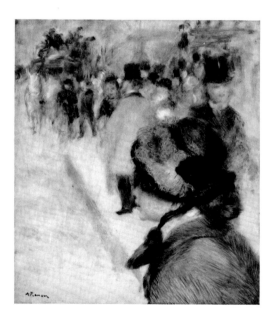

196. AUGUSTE RENOIR, **Place Clichy,** ca. 1880

Oil on canvas, 650 x 540 mm. Cambridge, Fitzwilliam Museum

197. Place Clichy, 1922 [cat. 101]

Color lithograph, 470 x 635 mm. New York, The Metropolitan Museum of Art, Purchase, Mr. and Mrs. Derald H. Ruttenberg Gift, 1987

Bonnard observed the Place de Clichy after dark from one of the sidewalk tables at the café Au Petit Poucet—still in existence—in sight of passing green-and-white buses.

in order to move on to a new locale. He would leave Paris every spring to work in the valley of the Seine (purchasing in 1912 a house at Vernon called Ma Roulotte [My Gypsy Wagon]), then spend the summer and early autumn in the family home at Le Grand-Lemps in the Dauphiné. His travels took him to Belgium, Holland, England, Spain, Algeria, Tunisia, Germany, and Italy. After 1909 there were many extended stays in the South of France, in St.-Tropez and Le Cannet; finally, in 1925, he purchased Le Bosquet (The Grove) in Le Cannet, which, like Ma Roulotte, commanded its own luxuriant vista. As Bonnard became engrossed in painting country rooms bathed in light and the landscapes viewed from his own terrace, his art, like his life, grew increasingly private. Commissions for illustrations and prints became sporadic, and Bonnard himself took less interest in the graphic arts, so absorbed had he become in the process of painting.

Not until 1922 did Bonnard again produce a view of Paris in a color lithograph. Commissioned by his dealers, the brothers Bernheim-Jeune,

198. Place Clichy, 1922 [cat. 102]

Pastel, 450 x 810 mm. Paris, private collection

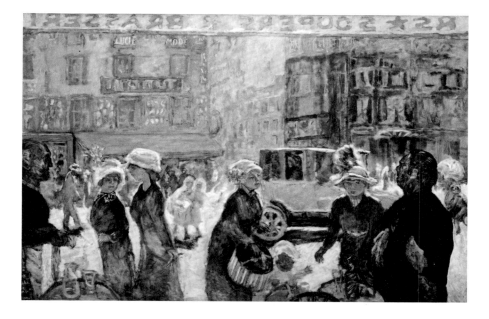

199. Place Clichy, 1912

Oil on canvas, 1380 x 2030 mm. Besançon, Musée des Beaux-Arts

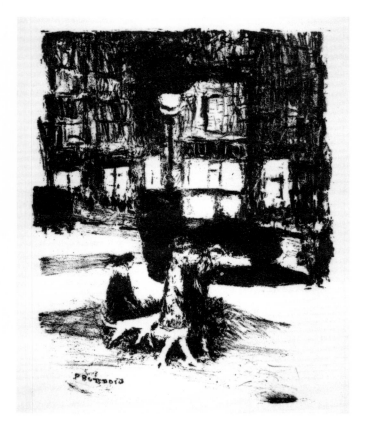

Place Clichy (figs. 197, 198), as it is always known, both details and summarizes the artist's repeated attempts to capture in oil the clarity and intimacy of his earliest recorded urban encounters. In carefully framed images composed from a comfortable table in the Wepler brasserie, Bonnard sorted out the Place de Clichy's hectic traffic (fig. 199). But it was clear that the rhythms and patterns of Paris, so greatly altered by the advent of the automobile, had by now assumed a different beat, and in the fashionable, streamlined attire of the passersby there is an awkward stiffness that Bonnard probably shared as he fended off the physical and social pressures of the city; in the country he was free to be himself. The marked difference in feeling between Bonnard's rural and urban subjects had been noted as early as 1896, when Mellerio commented in his book *Le Mouvement idéaliste en peinture* on "the simplicity" and "calm" of the one and the "tenuous and nervous" acuity of the other.[76]

200. The Street, ca. 1927

Frontispiece of Paul Valéry et al., *Tableaux de Paris,* 1927. Lithograph, 240 x 180 mm. Houston, Virginia and Ira Jackson Collection

201. Dingo in Paris [cat. 103]

Illustration on page 159 of Octave Mirbeau, *Dingo,* 1924. Etching, 32 x 176 mm. New York, The Metropolitan Museum of Art, Harris Brisbane Dick Fund, 1928

In 1933, when he was interviewed by Pierre Courthion, Bonnard confessed his uneasiness in the city: "I don't spend much more than two months in the year in Paris. I come back in order to keep in touch, to compare my paintings with other paintings; in Paris, I am a critic, I cannot work there: too much noise, too many distractions. I know that many painters get used to that life. For myself, it was always difficult."[77]

Bonnard's prints and illustrations after 1920 often show a city that is fragmented, disconcertingly blurred, and difficult to grasp (fig. 200). In the small sketches with which Bonnard ornamented the text of Octave Mirbeau's *Dingo,* Paris appears vague and remote (fig. 201). The Australian wild dog of the book's title is miserable in the city: "In Paris, Dingo became sad again. He no longer knew what to do. Too many people, too many houses, crowded streets, not enough space and sky."[78]

Whatever the discomforts he felt there, Bonnard made regular pilgrimages back to Paris until the year of his death, as if to reassure himself that his sensitivity to the poetry of the streets still remained keen. In 1946 he took a room, as he had earlier, in the Hôtel Terminus at the Gare St.-Lazare, which was not very far from his studio on the rue Tourlaque.

Looking out on the view from his hotel window, which probably faced the Place du Havre (fig. 202), Bonnard explained why he stayed in a hotel for commercial travelers and why he continued to find enchantment in the patterns of urban life:

> I take great pleasure in staying at establishments like this. They are palpitating with life, it's a continuation of the movement of the trains. Look at this picture. What a charming spectacle it is to see this world of workers escaping from the station, like bees from a hive. They run to make their living, they're going to search for their fodder.
>
> For an elderly man like myself these goings and comings become touching, they assume a certain grandeur. From the height of my balcony they are no bigger than insects, they are depersonalized, yet represent a symbol of the work force. I see them in the morning, they flow like a swarm of ants, to return in the evening in long processions. I can imagine that they are carrying home to the cells of their honeycombs the spoils of their day. Brave little people, I love them with all my heart.[79]

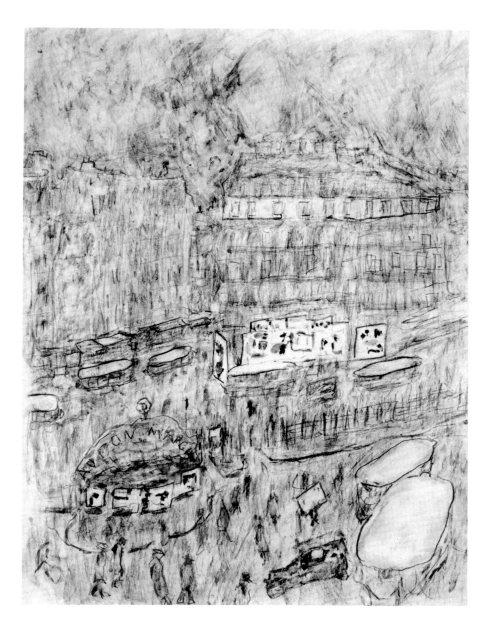

202. Place du Havre, ca. 1946

From *Verve* 5:17–18, August 1947. Reproduction of a drawing in pencil, charcoal, and wash, 350 x 264 mm. New York, The Metropolitan Museum of Art, Rogers Fund, 1949

Bonnard selected illustrations and designed the cover and frontispiece for an issue of *Verve* magazine devoted entirely to his work. It was published seven months after his death.

4 NUDES AND LANDSCAPES

Sasha M. Newman

PIERRE BONNARD'S VISION of the world is a blissfully but deceptively simple one. Women bathe, dogs cavort, doors and windows open onto the eternal blaze of a Provençal garden. Critics throughout the twentieth century have tendered thanks for the existence of this honey-voiced purveyor of an idyllic Proustian reverie, celebrating the delights of the French table and the French toilette in an era of ever-decreasing attention to such niceties.[1] What has been excluded from this carefully cultivated view is that Bonnard's vision was complex and contradictory. He was a magician of a language of covert signs—stylistic, social, and personal—a language directly connected to the reassessment of the French tradition that was such a potent aspect of his age.

This essay will survey Bonnard's transformation of tradition in the two subjects with which he became preoccupied in the late 1890s, the nude and the repopulated landscape, culminating in his illustrations for the books *Parallèlement* and *Daphnis et Chloé*. Using as touchstones the Rococo and antique sculpture, traditions around which there was an active dialogue in the 1890s, Bonnard transformed stylistic and iconographic conventions through the liberating use of Japanese popular art, contemporary caricature, informal photography, and ultimately Impressionism. Moreover, the graphic process and the graphic arts themselves played an essential role in Bonnard's ability to transform Western traditions and their accepted codes of meaning. In all of his graphic work at the turn of the century Bonnard's hand appears to scurry along the surface, leaving no image intact. This emanation of process, which seems simultaneously to give birth to new images as it destroys others, results in a visual language that never becomes formulaic, making possible an elaborate layering of imagery that traverses different historical moments as it links conscious and unconscious thought.

La Grande Tradition française: *1871–1914*

Educated during the early years of the Third Republic, Bonnard matured during a profoundly self-conscious period of French history.[2] France's struggle to define herself in the aftermath of her defeat by the Prussians in 1871, the invasion of the capital, and the specter of civil war are by now elements of a familiar story. What resulted was a huge investment in the identification of those national qualities considered particularly and immutably French, often accomplished by contrasting French strengths and values with those of her German victor.[3] *La grande tradition française*, the great French tradition, was both resuscitated and reinvented.[4]

Bonnard absorbed from his earliest school primers a sense of the weight of history and the potency of tradition.[5] In the lycées the positivist Hippolyte Taine was the philosopher of preference. The Tainean link between artistic styles and politics—between style and political destiny—was explicit, and style was a subject that fascinated both reactionary and progressive circles.[6] Bonnard and his entire generation—Nabis, Neo-Impressionists, and society portraitists alike—were acutely aware of the representational power of different styles to reflect the myths of diverse cultures and historical moments, as well as the future of France herself.[7] Moreover, the language of style was no longer the exclusive domain of the artist in the academy but was equally accessible to the shopper in the Bon Marché, eager to decorate a new apartment.[8] It was a time when nostalgia for the past was concomitant with aspirations for the future.

The pantheon of French tradition was being constantly refined and reformed in the period between 1871 and 1914. From 1880 to 1905 the rage was for the Rococo as the new republic of the bourgeoisie, in an ironic inversion, embraced the style and iconography of the prerevolutionary monarchic period for both fashionable applied art and consumer goods.[9] The advertisements of Jules Chéret, for example, are emblematic of the Third Republic's burgeoning consumer class, promoting everything from perfume to Dubonnet to cold remedies. Without using specific Rococo sources Chéret managed, through his similar subject matter and elegant, vivacious handling, to evoke Watteau's *Fêtes galantes* and Boucher's rosy shepherdesses.[10] Chéret's embrace of Watteau and the fact that his work had "un certain air de voyage à Cythère" did not go unnoticed by his contemporaries.[11] The Rococo world of Chéret's posters, like that of Albert Besnard's portraits and decorations,[12] captured the contemporary yearning toward a collective fantasy ideal—a Golden Age of the imagina-

tion, where innumerable free-spirited young ladies were available for a plethora of leisured activities and where traditions of French gaiety and humor were actively rehabilitated.[13]

After 1905, the mood and the aesthetic shifted as France shouldered her responsibilities and prepared ideologically, with a somber and measured classicism, for a war that seemed more and more inevitable.[14] *Hommages à Poussin* replaced the eighteenth-century pastiches that had previously filled the two national salons—a change in emphasis also evident in the more progressive Salon des Indépendants and the newly established Salon d'Automne. Attitudes toward the eighteenth century changed, and the imperial grandeur of Louis XIV and Versailles was considered a more suitable model than the frivolous age of Marie-Antoinette. What in the 1890s had been seen as a joyous reclamation of the French spirit came to be increasingly identified with the dangers of individualism—a corrupting influence perceived not only in certain aspects of the Enlightenment but also in the unfinished excesses of Delacroix and the explorations of Impressionism. Ultimately the question as to how Impressionism, admittedly the most recent manifestation of French artistic originality yet dangerously independent and ahistorical, could be integrated into the constantly evolving French pantheon was not easily solved.[15]

Bonnard's sensitivity to this system of styles and this shifting stylistic hierarchy embedded in every aspect of the rhetoric of the early Third Republic—in its educational system, in its advertising, in the program of the Ecole des Beaux-Arts—is an essential aspect of his work and of the Symbolist milieu in general. Moreover, while recent definitions of Symbolism have affirmed the importance of contemporary psychological theory to doctrines of symbolic perception and symbolic representation, such discussions have nonetheless neglected the relevance of the manipulations of tradition stimulated by those theories of memory and correspondences which were at the center of experimental psychology in the 1880s and 1890s, and which were reinforced by contemporary historical attitudes.[16] At this time memory, as described in the work of Henri Bergson, was the locus of philosophic and popular reflection.[17] When explored in literary autobiography, it manifested obsessive attention to the re-creation of personal history; at the collective level the new republican government ransacked the past for clues and guideposts to encourage a present style worthy of France's former glory. New traditions were created—festivals, monuments, coins—and old ones were restructured.[18]

Bonnard both manipulated the stylistic languages he inherited and acknowledged the existence of newly minted traditions, often through their subversion, just as writers like Félix Fénéon upturned linguistic systems by means of neologisms and punning. Elitist and erudite, replete with multilayered jesting, Bonnard's Symbolist vision was also leveling in its disruption of established tautologies. In exploring nonlogical linkages and unconscious drives (often sexual in nature), in insisting on the material aspect of the personal or the intimate, and in attempting to portray the constant invasion of the present into the past, Bonnard undermined Tainean determinist hierarchies, embracing a notion of personal and historical time both synchronic and anachronistic. Ultimately, Bonnard's use of mythology, antique art, Japanese popular imagery,[19] Old Masters, and poetry was not a nostalgic hymning or re-creation of the past, but instead a way of connecting this past with the future through the simple immediacy of process.

From France-Champagne *to* Parallèlement

Bonnard's nudes are his most inventive and evocative images. His attitude toward this essential subject was informed until the end of his life by the experimentations he pursued in the 1890s, a decade in which his portrayals of women took a variety of forms—a passerby in the streets, a cocotte trying on a new hat, a woman reclining in the boudoir. Yet all of these enriched his developing vision of the modern nude. Often reverberating with a disturbing erotic charge that functions on several levels simultaneously—autobiographical, social, and historical—Bonnard's women have an integral connection with the issues of his era. Bonnard is at his most astute in his representation of the female figure and most wicked in his description of the relationship between the sexes. In *Parallèlement* his interest in expressing the modern woman (this time the modern nude), an interest which had its roots in his earliest public commission, reached fruition.

Bonnard's first poster, *France-Champagne* (fig. 203), demonstrates his remarkable ability to assimilate and transform a popular type—the *chérette*, or poster girl of Jules Chéret (see fig. 126)—a type itself predicated on Chéret's effective use of the Rococo then so in vogue. Chéret had developed an astonishingly adept commercial formula that traded on the aristocratic aspirations of France's new reigning middle class—a formula that, not incidentally, effectively masked sexual suggestion with histori-

cal inflection. Like an airbrushed centerfold, the *chérette*'s Rococo allusions eschewed the visceral tactility, the irrationality of sexuality. While sex was perhaps a marketable commodity, contemporary sexuality was a hidden menace.[20]

Bonnard's poster and the posters of Chéret share a comedic aspect, and it is important to recognize that humor was cultivated throughout the 1880s and 1890s as a distinguishing characteristic of the French tradition (as opposed to the Prussian), often linked, as in Chéret's posters, with the Rococo in explorations of erotic or suggestive subject matter.[21] However, in *France-Champagne* Chéret's neo-Rococo exuberance of line, Bonnard's starting point, becomes flatter and more sinuous, and Chéret's lighthearted good-time girl becomes more available and more dangerous. Through a daring use of distortion and caricature, particularly as derived from non-Western precedents, Bonnard modified the homogeneous illustrative quality of Chéret's poster designs.[22] Rather than a pastel-sweet neo-Fragonard dainty offering a drink as a covert pretext for sex, Bonnard's inebriated cocotte, turning complicitously toward the viewer/consumer as she waves a glass of champagne, offers the sex up front. In overthrowing a canon of beauty that reinforced Third Republic notions of sexual stability, of normalcy in and out of marriage, and in revealing the potential fetish of sexual obsession, Bonnard transformed Chéret's use of the Rococo and initiated his attack on the positivist world of the middle class.

In *France-Champagne* Rococo illusions no longer provide a historical cover-up for the lure of sexuality. The critic Félix Fénéon[23] was quick to recognize the erotic edge implicit in *France-Champagne* as that which distinguished this wine-company advertisement from similar commissions executed by Chéret and Eugène Grasset, the most popular poster artists of the moment. Welcoming the appearance of Bonnard's poster, Fénéon noted, in his typically witty and acerbic language, that there would be images of a "serpentine and cruel eroticism" on the streets of Paris if "after Chéret and his masks of lyric joy, Bonnard were commissioned to publicize Cirques, Elysées, Jardins, Moulins."[24]

Fénéon's use of the word "serpentine," with its dual meanings of abstract arabesque of line and actual serpent creature, is a powerful comment on Bonnard's own abilities to transform and reinvent. Bonnard's style was one of layering and metamorphosis, his art about something that began as one thing and became, through a slight movement of line, something else. Alternately sweet and demonically exuberant, the lovely

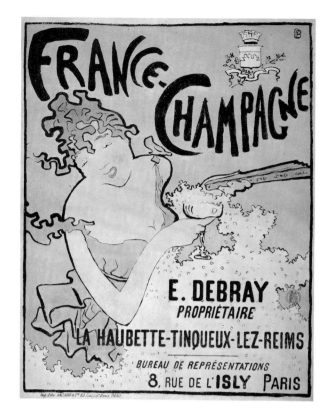

203. France-Champagne, 1889–91 [cat. 1, fig. 125]

Poster, 1891. Color lithograph, 780 x 500 mm. New Brunswick, Rutgers, The State University of New Jersey, The Jane Voorhees Zimmerli Art Museum, Gift of Ralph and Barbara Voorhees

204. Reine de joie (Queen of Joy), 1892

Cover for Victor Joze, *Reine de joie: Moeurs du demi-monde* (*Ways of the Demimonde*), 1892. Color lithograph (trial proof), 190 x 260 mm. Josefowitz Collection

In its final state the cover showed the publisher's name and address on the front at lower right. The poster for the book was designed by Toulouse-Lautrec.

bit of froufrou in *France-Champagne*, whose drapery blows from her shoulder as the champagne bubbles pour into her lap, is, despite her relation to the more antiseptically alluring *chérette* and her eighteenth-century ancestors, sexual and female. Eyes closed, mouth opened in inebriation or excitement, arm languidly extended in a gesture of provocative acceptance, she is subtly animal—an antidote to the *chérette*'s high-pitched gaiety.

Bonnard clearly understood what and how the Chéret style sold and upped the ante just a bit so that the edge of "cruel eroticism" transforms the Rococo mask of the Chéret type. This erotic edge appears often in Bonnard's trade commissions of the 1890s. We see it at its most extreme in his book cover for *Reine de joie* (*Queen of Joy*; fig. 204), grotesquely caricatural here, this prostitute with her grimacing teeth and avaricious gaze.[25] We even see it in the charming portrait of Misia Natanson in the poster for *La Revue blanche* (see fig. 151), her pointed face so like the cats that Bonnard loved to draw. The animality is more hidden here, feline rather than serpent, but it lurks in the cast of her eyes, in her sharp nose, and in the set of her chin within the ruff formed by the many capes of her coat. This correspondence between human and animal amused Bonnard. Like his friends Fénéon and Alfred Jarry, he was entranced by the transformation of matter, by language—whether in poetry or painting—that created associations and shapes never before conceived.[26] Such a process de-

manded a specific interaction between work and audience, even a complicitous one, as well as the artist's hypersensitivity to his personal experience and sensations, and to his milieu.

There is, after all, a significant subtext to all of Bonnard's images of women in the 1890s. The "woman question" was a central issue in French discourse during the Third Republic. The repeal of censorship laws after the fall of the Second Empire allowed for an enormous increase in feminist literature. Discussion of woman's position within and without the family structure escalated the dialogue about her status, and increasingly challenged male supremacy. Perception of the changing relations and power balance between the sexes focused attention on issues of eroticism and sexuality.[27] And while a relaxation of censorship laws allowed for a greater freedom in the feminist press, demonstrations against pornography and anything considered to be an overt display of sexuality were engineered with ever-increasing fervor by Senator René Berger and his notorious morality police. The animal in woman was considered just as dangerous to the established order as the worker, the crowd, the foreigner, or the Jew.[28] Yet both for fervent upholders of the moral order of the Republic, like Senator Berger, and for Montmartre's subculture (in which Bonnard played a part), sexuality was identified as the locus of female power.

Whatever Bonnard's opinion of French feminism may have been, it is evident that he was increasingly fascinated by contemporary explorations of sexuality. It is also evident from his collaborations with Jarry—among them the two illustrated almanacs of Père Ubu, published in 1899 and 1901, and *Soleil de printemps* (*Spring Sun*), which appeared in the satirical weekly *Le Canard sauvage* for March 21–28, 1903[29]—that he enjoyed spoofing the sexual hypocrisy of the bourgeoisie in general, and specifically those contemporary theories that conflated racial inferiority with sexual degeneration.[30] *Soleil de printemps*, the last appearance in print of Bonnard and Jarry together, was a direct hit at middle-class morality and its double standards, charting the effect of the spring sun on the libido. Bourgeois, priests, cats, dogs—all succumb to the influence of the satyr, the "Repopulator" who "enters without knocking."

Bonnard's earliest lithographs of women nude and seminude, *The Tub* and *Dans l'intimité* (*In Private*), predate his explorations of similiar subjects in paint. Like *France-Champagne*, these images oscillate between the erotically provocative and the chastely sweet, and share with all of Bonnard's portrayals of women in the 1890s an identifiably animal quality. *The Tub* (fig. 205) was produced for the catalogue of the exhibition

205. The Tub, 1894

From the catalogue of the exhibition sponsored by the newspaper *La Dépêche de Toulouse,* May 1894. Lithograph, 185 x 136 mm. New York, The Metropolitan Museum of Art, The Elisha Whittelsey Collection, The Elisha Whittelsey Fund, 1963

206. Dans l'intimité (In Private), 1893 [cat. 27]

For the magazine *L'Escarmouche*. Lithograph, 288 x
127 mm. Washington, D.C., National Gallery of Art,
Ailsa Mellon Bruce Fund

sponsored by *La Dépêche de Toulouse* in 1894, a catalogue ornamented with
sixteen additional lithographs by Henri de Toulouse-Lautrec, Maurice
Denis, Ker-Xavier Roussel, Henri-Gabriel Ibels, Louis Anquetin, and
others. The print shows a naked woman crouching in a round basin set
on the floor, while someone out of sight on the left pours water over her.
This bent and foreshortened creature certainly reflects, rather academi-
cally, Bonnard's assimilation of Japanese prints and of caricature. The
subject of the nude bathing or in the boudoir, as will be demonstrated in
the following discussion of *Dans l'intimité*, also engages with contempo-
rary commentary provoked by the first comprehensive showing of
Degas's nude bathers at the eighth Impressionist exhibition in 1886, a dia-
logue that continued through the 1890s.[31]

Dans l'intimité (fig. 206), a transfer lithograph that appeared in the mag-
azine *L'Escarmouche* on January 14, 1894, expands the sense of social am-
biguity implicit in the subject of *The Tub*—is it a prostitute or a young
bourgeoise depicted?—but is a significantly more complex and sophisti-
cated image. *L'Escarmouche*, like many magazines at this time, was a fero-
cious and short-lived review (its first issue was dated November 12, 1893,
and its last January 14, 1894), with a pointed and acerbic text, heavily il-
lustrated by Toulouse-Lautrec, Anquetin, Félix Vallotton, and Bonnard.
The editor, Georges Darien, a professed anarchist in Fénéon's circle, was
the author of novels that were the preferred fare of Fénéon and Jarry.[32]
Through his work for *L'Escarmouche*, Bonnard cemented his relation-
ships with Fénéon and Jarry, and began producing the kind of litho-
graphic work that he would continue for Fénéon and Natanson at *La
Revue blanche*. Darien wrote of the contributors to his review: ''The illus-
trators of *L'Escarmouche* are people of bizarre and independent taste and
claim to do exactly what they please.''[33] Bonnard made three lithographs
for this journal besides *Dans l'intimité*, including *Les Chiens* (*The Dogs*; see
fig. 166) of December 10, 1893, and *Conversation* (see fig. 14). All reflect
the avowed purpose of *L'Escarmouche* to act as a *provocateur* against
bourgeois culture.

Bonnard addressed the issue in a typically subtle and witty fashion. As
capable of transformation as the *France-Champagne* cocotte, the woman of
Dans l'intimité in her raised chemise and black stockings is simulta-
neously an adorable young girl in a state of undress and a disheveled slat-
tern just risen from bed. With her tousled hair and pointed face, she
avoids old formulas of the chaste and idealized nude and is, despite
Bonnard's light touch, a contemporary female—sexuality overt.[34] Drawn

with a deft and agile hand, the print abandons the assured and sinuous arabesque refined in *France-Champagne*. Instead, Bonnard cultivates the awkward and the mobile—the primitive drawing of children that Paul Sérusier encouraged in his *ABC de la peinture*, to which Bonnard would turn with increasing commitment.[35] The language of caricature allows for the exploration of this woman's animality. Even a related sketchbook page (fig. 207), which has a direct link with Hokusai's *manga*, also manifests Bonnard's implicit parodic edge; this tiny creature going about a succession of daily activities could be cat, bird, or insect.[36] The preparatory drawing for *Dans l'intimité* (fig. 208) is somewhat more explicit than the final version and more aggressively rendered. Less delicate of face and line, this figure lacks the other's air of ambiguous sweetness and insidious mischief. Ultimately, it is its increased emphasis on ambiguity and contrast that makes the final print so successful.

207. Figure Studies, ca. 1893 [cat. 29]

Page of a sketchbook. Ink, 313 x 196 mm. Budapest, Szépmüvészeti Múzeum

208. Study for **Dans l'intimité,** 1893 [cat. 28]

Ink and wash, 305 x 187 mm. New York, Mr. and Mrs. Eugene V. Thaw

209. Young Woman in Black Stockings, 1893
Oil on cardboard, 170 x 240 mm. Private collection

In all of these related works, including a small painting completed after the lithograph (fig. 209), the black stockings are the central compositional element. Nowhere is this more obvious or provocative than in the lithograph, whose light, airy, decorative upper segment is in stark contrast to the dense black slash of the stockings below. They seem to brand the young woman as clearly as any product logo or advertising sign—but brand her as what? Black stockings certainly played a role in the work of artists such as Degas and Félicien Rops, for example, as details that might distinguish scenes of brothels from those of "innocent" women at their toilettes.[37] Yet, for the contemporary chronicler Octave Uzanne, whose book on the Parisienne was published in 1894, the wearing of black stockings as an article of fashion by the ubiquitous modern woman and their inclusion in current renditions of the nude were instances of the dangerous breakdown of social hierarchies and systems of social identification:

> The modern nude, as Heine would have said, has broken with the tradition of an impassive and chaste idealism. Following Félicien Rops and Rodin, a "sensualist" movement arose, about twenty-five or thirty years ago, which to-day has almost reached its climax. Art and literature have never before been so profoundly absorbed by the consideration of woman as at this present day, with the culture of her body, the study of her nerves, of her caprices, her desires. Woman does not only inspire the artist of today: she dominates him.

She is no longer merely the Muse, she is the Succubus. She has ceased to pose with a halo of splendour and perfection; rather she invites her votaries to an orgy of the senses; she lives and palpitates as if possessed with a demon of luxury. This modern nude figure peeps at us everywhere, her leg marked at the knee by the sharp contrast of the black stocking fastened with the eccentric garter. In books, in newspapers, at the annual Salon she springs up; she announces herself in magazine illustrations and on posters.[38]

In "Marie Putting On Her Stockings" (fig. 210) and related sketches the stocking, while provocative and fashionable, has a certain domestic ease, and its appearance is mitigated by other areas of darkness in the composition. In *Dans l'intimité* the black stockings are the only solid area (Bonnard's initials apart) in the whole lithograph. Their insistent presence calls attention to the young woman's disarray and the crumpled bedclothes behind her. If the stockings are no longer a specific sign of prostitution, as the most obvious aspect of the composition they point instead to the subtext of sexual activity.

In its potential to obliterate the distinction between good women and bad (bad women who had sex for money and good women who had sex to procreate)—a distinction that was becoming increasingly difficult to make—sexuality posited a serious disruption of the social order.[39] As Uzanne wrote of prostitution:

> Many do not see it even when it is at their elbows, for one's powers of observation must be sharpened by long residence in Paris and by an innate curiosity in these matters before one can be certain, so deceptive are the appearances which this culpable trade assumes. . . . all those who love the streets of Paris for the sake of the women they meet there, the amateurs of fresh faces and alluring curves, are never deceived, for daily exercise in the chase keeps every sense alert. They divine everywhere the discreet invitation, the mere insinuation of an advance, and it is rarely indeed that they are mistaken. . . . I am not speaking, observe, of obvious harlots. I take merely those whose bearing is modest, whose manner is virtuous, and whose composure is all but middle-class.[40]

The blurring of women's status was not the only issue. Another was that of sexual identity. Uzanne's text, like a myriad others from the period, reveals the fear that appearances and reality do not correspond, and that subtle clues are all that exists to tell the true story. Sex was, at this time, more and more a game of potential power and probable deceit, in which the individual had to be ever vigilant to avoid being blinded by a superficial "reality" that had, in effect, little or no relationship to what was actually going on. A bathing woman might be prostitute or bourgeoise, a black-stockinged girl a *montmartroise* or a young matron. Sexual

210. Marie Putting On Her Stockings [cat. 58]

Illustration on page 29 of Peter Nansen, *Marie*, 1898. Process print, page 185 x 116 mm. New York, The Metropolitan Museum of Art, The Elisha Whittelsey Collection, The Elisha Whittelsey Fund, 1969

identities were also often in doubt. Critics like Fénéon and poets like Rimbaud took on female personas.[41] Sexual inversion and lesbianism became subjects of intense fascination and lesbianism a subgenre in literature.[42]

Intrigued by the ambiguity of good and bad (so plainly presented in *Dans l'intimité*), Bonnard was equally interested in exploring the exchange of sexual identities. He would pose for photographs naked with his model and mistress, Marthe—he taking photographs of her and she taking some of him—and then transform those compositions of which he had been the subject into nude portrayals of her. Moreover, one of his most extraordinary paintings of the nude, *Siesta* (fig. 211), a high point of the work that revolved around *Parallèlement* at the end of the century, has the issue of sexual ambiguity at its very center. The languorous reclining

211. Siesta, ca. 1899

Oil on canvas, 1090 x 1320 mm. Melbourne, National Gallery of Victoria

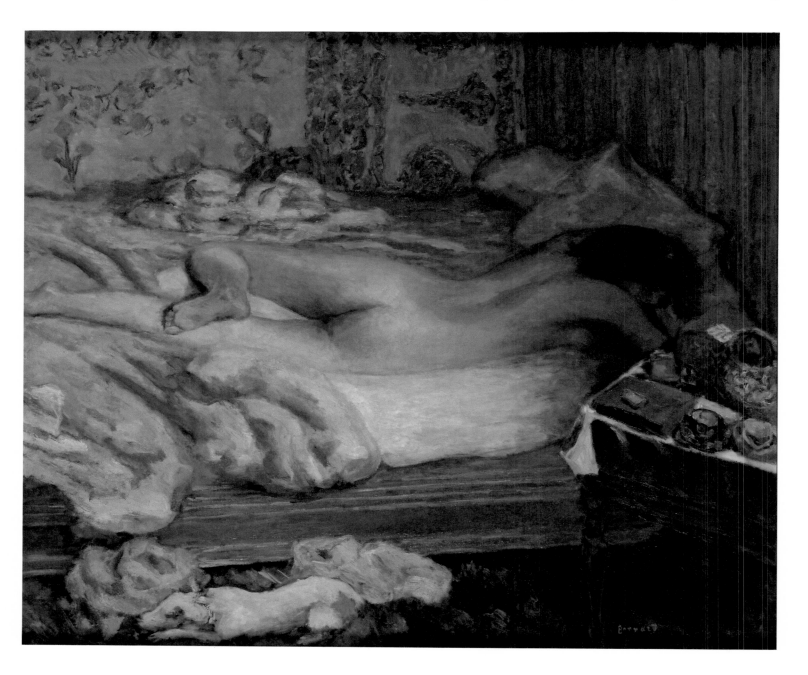

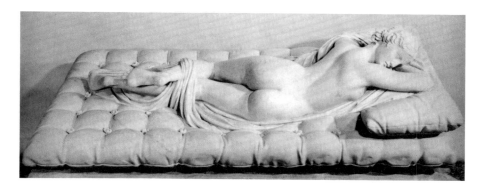

woman in *Siesta* is, despite the painting's naturalism and immediacy, based directly on an antique sculpture in the Louvre, *The Sleeping Hermaphrodite* (fig. 212).[43] The witty relationship between antique source and contemporary model exemplifies Bonnard's delight in layering a work of art with levels of humor and historical meaning, here provoked by a change of context. The hermaphrodite is, of course, simultaneously man and woman, and Bonnard's allusion to the sculpture frames a contemporary joke about the eroticism of sexual ambiguity. Moreover, in French discourse of the 1890s, the concept of the hermaphrodite can be related to the notion of the *hommesse* (man-woman) that made its appearance, alongside the *femme nouvelle*, in the popular literature of the period. Both *hommesse* and hermaphrodite refer to a conflation and potential inversion of gender, but while the hermaphrodite is a polymorphously perverse creature of sexual delectation, the *hommesse* is resolutely androgynous and asexual—the liberated woman spoofed wearing pants, riding bicycles, no longer a potentially primitive creature of sexual abandon. In quoting the *Sleeping Hermaphrodite* in this portrait of his mistress in a pose of postcoital languor, Bonnard's trope is an ironic nod to, and refutation of, the modern *hommesse*. Bonnard's view seems disturbingly like that of Victor Joze, the social commentator for whose book *Reine de joie* Bonnard had designed the cover: "Let woman remain what nature has made her: an ideal female, man's companion and lover, mistress of the home or bacchante. Let her not pose as a virago, the role does not become her. . . . No eunuchs, no androgynes!"[44]

Bonnard's attitude toward feminism seems to have been similar to that of his closest colleagues, Jarry and Fénéon, dismissive, ironic, and insistent on an emphasis on the animal, the childlike, and the irrational in women. Further examination of this issue lies outside the present survey. However, Bonnard's persistent exploration of the potential for erotic

213. Marie Sleeping [cat. 58]

Cover illustration (repeated from page 177) of Peter Nansen, *Marie*, 1898. Process print, page 185 x 116 mm. New York, The Metropolitan Museum of Art, The Elisha Whittelsey Collection, The Elisha Whittelsey Fund, 1969

214. Marie Putting On Her Hat [cat. 58]

Illustration on page 9 of Peter Nansen, *Marie*, 1898. Process print, page 185 x 116 mm. New York, The Metropolitan Museum of Art, The Elisha Whittelsey Collection, The Elisha Whittelsey Fund, 1969

inversion and his concomitant pursuit of the representation of female sexuality are central to an understanding of all his work of the 1890s, culminating in *Parallèlement*. Undoubtedly an attack on the hypocrisies of the bourgeoisie in the Third Republic, who sanctioned prostitution while continuing to deny women their rights and whose crusades for moral sanctity belied the overt corruption at all levels of the political hierarchy, Bonnard's focus on the modern nude was also related to his intensifying involvement with Marthe de Méligny, the young woman who became his lifelong companion sometime in 1893.

In his association with Marthe, whom Bonnard met on the streets of Paris, the artist showed himself firmly attached to the preoccupations of his time. Marthe was the type of woman who made her appearance in novels and plays. For many she was symptomatic of the social dissolution that seemed imminent as the twentieth century approached. Hiding her past and her origins, Marthe entered Bonnard's life in 1893 and was to remain at the center of his art thereafter. Biographical information about her is sketchy. She was most probably a midinette or *trottin*, a young seamstress or errand girl—not a milliner (who had a high position in the fashion hierarchy) but one of a legion of young women working for appalling wages in the Paris dress trade. Her real name was Maria Boursin. In choosing Marthe de Méligny, she affected the kind of name associated with a conspicuous class of demimondaines, the most famous of whom promoted themselves through the use of assumed, aristocratic-sounding names—Liane de Cougy, Laure de Rubempré, Alice de Korrigan—and had their exploits recounted in lurid detail in the popular press. Their pseudonyms were calculated to satisfy the vanity of their clients and ensure an elevated profile in the society they frequented. Bonnard evidently enjoyed this game, and Marthe de Méligny Maria remained.

Bonnard did not impose on his models; rather he required that they impose on him, creating the ultimate collusion of fiction and reality. The relationship between Marthe and Pierre became a complex one, and it

has been treated in discussions of the artist with a good deal of circumspection over the years.[45] Throughout the decade of the 1890s, however, Bonnard exploited the relationship to transform and liberate his art. Alternately rosy eighteenth-century animal, demurely girlish, and overwhelmingly sexual, Marthe was his inspiration in an extraordinary series of nudes. She was the perfect vehicle through which he commented on the sexual hypocrisies of his own bourgeois class and developed his feminine ideal.

In 1897, using Marthe as model, Bonnard illustrated a full-length novel for the first time—*Marie*, translated into French from a work by the Danish author Peter Nansen. The story of Marie, a young and impressionable midinette in love with a member of the upper classes who avails himself of her charms and then spurns her, was one that had great personal appeal for Bonnard. The conclusion of the tale, in which the young woman, rejected and sick, is reunited with her chastened lover, promotes the notion that love conquers all, even class. Initially serialized in *La Revue blanche* between May 1 and June 17, 1897, *Marie* had enough popular success to warrant republication in book form under the magazine's imprint in 1898.[46] Renoir took the trouble to write the young artist a note: "I am sending this letter by Vollard to tell you that I find your drawings in *La Revue blanche* absolutely exquisite. Good for you. Keep this art."[47]

Bonnard's drawings have an intimate charm, yet their illustrative quality reflects a retrenchment from the more pointed satire of the *Escarmouche* lithographs. They propose a simple narrative trajectory: Marie sleeping (fig. 213); Marie putting on her hat (fig. 214); Marie in a state of undress, her black stockings recalling those so vividly depicted earlier in *Dans l'intimité* (see figs. 210, 206), but in this context no longer so ambiguously provocative. Marie is most often portrayed alone, and, with one or two exceptions (fig. 215), Bonnard avoids the overtly sexual and shows a modern Parisienne going about the business of her daily life, without picturing the less savory details of her fall and despair. *Marie* provides an interesting comparison with other Bonnard projects involving sex and the sexes. The delicacy and courtliness of the drawings are a far cry from the scatological and sexual jokes in the *Almanach du Père Ubu* created just a year later. Even in its format *Marie* was related to traditional illustration and lacked the experimental quality of earlier designs for program covers (fig. 216) or musical scores.

Bonnard the satirist of contemporary mores and Bonnard the gentle sensualist, chronicler of private life, are both in evidence on a program cover he devised for a production at Lugné-Poe's Théâtre de l'Oeuvre in

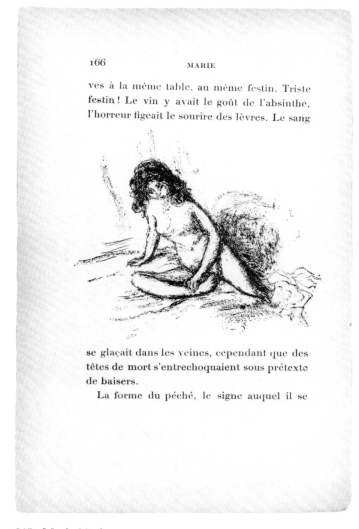

215. Marie Nude [cat. 58]

Page 166 of Peter Nansen, *Marie*, 1898. Process print, 185 x 116 mm. New York, The Metropolitan Museum of Art, The Elisha Whittelsey Collection, The Elisha Whittelsey Fund, 1969

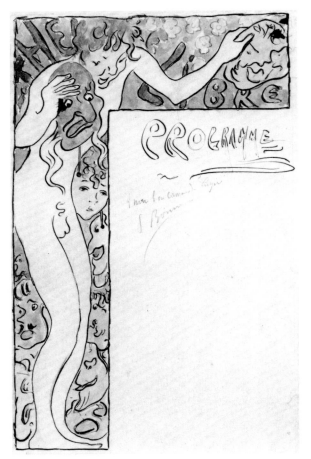

216. Théâtre Libre: Tragedy and Comedy, 1890

Front cover design for a theater program. Inscribed: *A mon bon camarade Lugné / P Bonnard*. Watercolor, 315 x 198 mm. Washington, D.C., Atlas Foundation

The "good comrade" to whom the work is inscribed was Aurélien Lugné-Poe, then an actor at the Théâtre Libre, who founded the Symbolist-oriented Théâtre de l'Oeuvre in 1893.

April 1896 (fig. 217).[48] The production, a triple bill, had as its main feature a play by Maxime Gray, *La Dernière Croisade*. The plot revolves around the conversion of a Jewish banker, Baron Gugenfeld (played by Lugné-Poe himself), whose Catholic wife uses the time he spends on this religious epiphany to more easily see her lover, the marquis de Maltaux. The front cover of the program depicts the betrayed baron in profile (his large nose and curly hair sure signs of his race in the popularized visual language of

the time); his deceitful but fashionable wife (related to all of Bonnard's pointy-faced, feline Parisiennes and modeled on Misia Natanson) behind him; and the natty, mustachioed marquis in the background.

The image on the back cover, representing one of the other plays on the program, defies these modish and anecdotal flourishes in favor of a pair of youthful, nude lovers, he a French Apollo, she a long-haired siren of a type popular in the Symbolist lexicon and related to Edvard Munch's contemporaneous lithograph (fig. 218). Munch, who was also designing for the Théâtre de l'Oeuvre at this time, was an important figure in *Revue blanche* circles, and his work, particularly in evidence in Paris between 1893 and 1897, had a significant impact on Bonnard's nudes in the 1890s.[49]

The naked lovers on the program, idealized forerunners of the couple in *Daphnis et Chloé*, are also related to Bonnard's intensely focused portrait of himself and Marthe in an interior, *Man and Woman* (fig. 219)—revealing once again Bonnard's mingling of autobiographical and literary

sources. In the years between 1894 and 1900 Bonnard's obsession with the nude is realized entirely through Marthe; their coupling becomes the subject of his art. The erotic charge of the great paintings from these years —*Siesta*, *Indolence*, *Young Woman in Black Stockings*, *Man and Woman* among them—has an undeniably self-referential basis, which Bonnard tapped as a way of achieving the essential in painting, mingling personal incident with a wealth of other sources so that the works are themselves an extraordinary account of the layering and melding of disparate memories and experiences.

219. Man and Woman, ca. 1899

Oil on canvas, 1150 x 720 mm. Paris, Musée d'Orsay

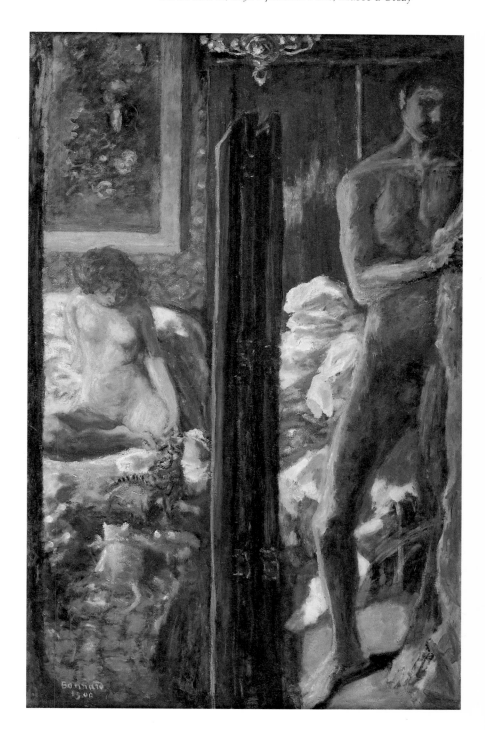

facing page

217. Théâtre de l'Oeuvre: La Dernière Croisade (The Last Crusade), 1896

Cover for a theater program. Lithograph, first state, 300 x 490 mm. Private collection

In its final state, the cover listed the cast of *La Dernière Croisade* in the center box and displayed an advertisement for the illustrated weekly *La Revue encyclopédique* on the front at lower right.

218. EDVARD MUNCH, **Madonna,** 1895

Color lithograph and woodcut, 605 x 442 mm. New York, Collection of Nelson Blitz, Jr.

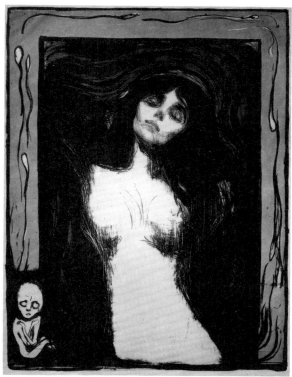

Parallèlement

Parallèlement was Ambroise Vollard's first production of an *édition de luxe* for what he hoped was a new generation of bibliophiles ready to embrace the notion of a painter's book with interpretive images, rather than an illustrator's book that paid literal attention to the text.[50] Vollard's own account of the evolution of *Parallèlement* may not have been completely factual, but it is revelatory in terms of the intent behind his creation of a new form of book.[51] According to Vollard, who was already achieving success as a dealer in pictures and lithographs, he went one day to the Imprimerie Nationale in the Hôtel Soubise de Rohan to see the Salon des Singes. There, in the midst of that monument to Rococo decoration, he admired a page printed in Garamond, a typeface developed for François I at the height of the French Renaissance, and resolved to use its italic font to print the work of a poet. By chance, he saw Verlaine soon after and fixed his choice on him. More likely, Vollard was stimulated not by the sight of Verlaine but by the news of Verlaine's death (in 1896), and thought he might just have a hit on his hands.

Bonnard's drawings for *Marie* (completed although not published at the time of Vollard's commission) had established him as one of the most appealing contemporary painters of the nude, capable of creating images of a sweet but voluptuous eroticism. In its resonant and magical transformation of eighteenth-century types, Bonnard's vocabulary seemed sympathetic to the *édition de luxe* in general and to Verlaine's text in particular, and Vollard asked him to undertake the illustrations. Rather surprisingly, the authorities at the Imprimerie Nationale agreed to do the printing of the letterpress, although they are said to have thought it "a queer idea, to put a book on Geometry into verse!" Upon publication, however, the Minister of Justice found it indecent that "the official Minerva"—referring to the Imprimerie's vignette on the title page—should act as the patron of such free manners (a book of geometry indeed!) and declared that "Minerva must therefore be dethroned, or rather the title page and cover must be changed."[52] Using the character of Ubu, a portly symbol of the French state, Bonnard and Jarry later mocked both the initial misconception and this belated recognition of the true, profane nature of the project (figs. 220, 221).

Parallèlement, first published in 1889, was Verlaine's last important collection of poetry, imbued with a nostalgia for the Rococo dream and its promise of transient happiness. The eighteenth-century spirit of many of

220. Parallèlement

Cartoon on page 22 of Alfred Jarry, *Almanach illustré du Père Ubu*, 1901. Lithograph, page 200 x 285 mm. France, private collection

An as yet blissfully unaware Ubu examines a painting of some "parallel" lines suggesting the geometry book the Imprimerie Nationale assumed *Parallèlement* to be.

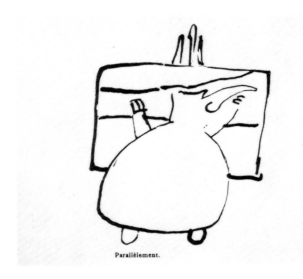

Parallèlement.

the verses, and their relationship to the rarefied milieu of the Goncourts as well as to an earlier Verlaine collection entitled *Fêtes galantes* (1869), appealed to Vollard, who was after a book with a prerevolutionary perfume that would sell to a new class of collectors in thrall to the aristocratic days gone by.

However, *Parallèlement* was also concerned with Verlaine's exploration of his dual nature, specifically the conflict between the religious and the sensual sides of his being and between hetero- and homosexual love. Verlaine's sexual indiscretions and appetites were notorious. While not as explicit as *Femmes*, the volume of poems that followed, *Parallèlement* is undeniably erotic and purposefully (sometimes adolescently) titillating. Verlaine described it to his editor, Vanier, in 1888: "I'll be publishing in a few months a book entitled *Parallèlement*, of an extreme and as it were ingenuous sensuality, which will be a contrast to the very severe Catholic mysticism of *Sagesse* and of another volume, *Amour*."[53] *Parallèlement* resumes the spirit of the Parnassian school of poets, a group which included Mallarmé, Théodore de Banville, Baudelaire, Leconte de Lisle, and Heredia, as well as Verlaine, and which emphasized the ideals of Greek paganism rather than medieval or Renaissance Christianity as the essential force in their art. The liberal hedonism of *Parallèlement* was infinitely more suited to Bonnard's temperament than the medievalized religiosity of *Sagesse* would have been,[54] and his art expanded to meet the challenge of Verlaine's verses.

These verses leap back and forth between past and present, between eighteenth-century follies and decadent Parisian dinners, between lesbian intimacy and heterosexual passion. The first section, "Les Amies," reprints six lesbian sonnets written in 1867; the second, "Filles," is a rather more lighthearted treatment of whores in a brothel.[55] The next part, "Révérence de parler," refers to Verlaine's prison years, and the conclusion, "Lunes," takes as its theme the parallelism between normal and abnormal love. This is the most successful section, yet all of *Parallèlement* is a testament to Verlaine's ability to express a scabrous subject with elegant allusiveness—a skill brilliantly paralleled in Bonnard's designs for the illustrated edition. When Jarry reviewed this for *La Revue blanche*, he commented that never before had illustrations been so perfectly adapted to a book of verse.[56]

Parallèlement took Bonnard two years to complete. The first drawings, which display a number of differences from the final versions, are on proofs of the text typeset between March 24 and April 13, 1897, and the

221. Parallèlement (fin)

Cartoon on page 23 of Alfred Jarry, *Almanach illustré du Père Ubu*, 1901. Lithograph, page 200 x 285 mm. France, private collection

The denouement: Ubu is literally bowled over by his belated discovery, in the presence of the artist, of the real nature of *Parallèlement*.

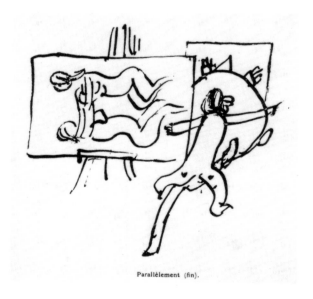

Parallèlement (fin).

222. Sappho, 1897–98

Preparatory drawings for pages 18 and 19 of Paul Verlaine, *Parallèlement*, 1900. Crayon and graphite, page 295 x 241 mm. Upperville, Va., Collection of Mr. and Mrs. Paul Mellon

223. Sappho, ca. 1897–99 [cat. 82]

Pages 18 and 19 of Paul Verlaine, *Parallèlement*, 1900. Color lithographs, 305 x 250 mm. New York, The Metropolitan Museum of Art, The Elisha Whittelsey Collection, The Elisha Whittelsey Fund, 1970

« Elle a, ta chair, le charme sombre
Des maturités eſtivales,
Elle en a l'ambre, elle en a l'ombre;

« Ta voix tonne dans les rafales,
Et ta chevelure sanglante
Fuit brusquement dans la nuit lente.»

SAPPHO.

Furieuſe, les yeux caves & les seins roides,
Sappho, que la langueur de son déſir irrite,
Comme une louve court le long des grèves froides;

Elle songe à Phaon, oublieuſe du Rite,
Et, voyant à ce point ses larmes dédaignées,
Arrache ses cheveux immenſes par poignées;

Puis elle évoque, en des remords sans accalmies,
Ces temps où rayonnait, pure, la jeune gloire
De ses amours chantés en vers que la mémoire
De l'âme va redire aux vierges endormies :

19 3.

book appeared in 1900, although it was already being discussed in the periodical *L'Estampe et l'affiche* in 1899.[57] Bonnard worked directly on page proofs from the Imprimerie Nationale, creating a free and sensuous series of drawings that have an extraordinary flow and immediacy. These preparatory designs have a visceral intensity, a sensuality which is diminished in the final version in favor of overall consistency of line. Density of touch and linear gesture change from page to page, from text to text. A woman's back curves away in shadow; next to her another nude, fleet of line and foot, races toward the poem "Sappho" (figs. 222–224). Other nudes belie this classical solidity and burrow like small animals in a tumble of bedclothes. A delicately drawn landscape descends the page like rivulets from a stream of water (fig. 225).

The completed volume, with 109 lithographs in rose-sanguine and adorned on almost every page, is a masterpiece of marginal illustration.

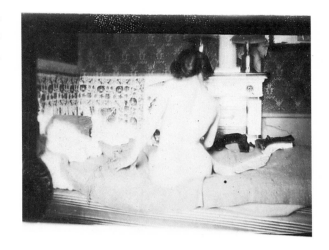

224. Marthe, ca. 1897–98 [cat. 56]

Photograph. Original contact print, 38 x 55 mm.
Paris, Musée d'Orsay, Promised Gift of the Children
of Charles Terrasse

225. Allégorie, ca. 1897–99 [cat. 83]

Pages 4 and 5 of Paul Verlaine, *Parallèlement*, 1900. Color lithographs, 305 x 250 mm.
New York Public Library, Astor, Lenox, and Tilden Foundations, Division of Art,
Prints, and Photographs, The Spencer Collection

ALLÉGORIE.

Un très vieux temple antique s'écroulant
Sur le sommet indécis d'un mont jaune,
Ainsi qu'un roi déchu pleurant son trône
Se mire, pâle, au tain d'un fleuve lent;

4

Grâce endormie & regard somnolent,
Une naïade âgée, auprès d'un aulne,
Avec un brin de saule agace un faune
Qui lui sourit, bucolique & galant.

Sujet naïf & fade qui m'attristes,
Dis, quel poète entre tous les artistes,
Quel ouvrier morose t'opéra,

5

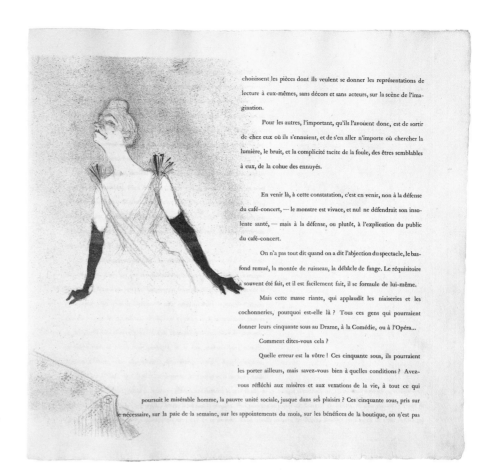

choisissent les pièces dont ils veulent se donner les représentations de
lecture à eux-mêmes, sans décors et sans acteurs, sur la scène de l'ima-
gination.

Pour les autres, l'important, qu'ils l'avouent donc, est de sortir
de chez eux où ils s'ennuient, et de s'en aller n'importe où chercher la
lumière, le bruit, et la complicité tacite de la foule, des êtres semblables
à eux, de la cohue des ennuyés.

En venir là, à cette constatation, c'est en venir, non à la défense
du café-concert, — le monstre est vivace, et nul ne défendrait son inso-
lente santé, — mais à la défense, ou plutôt, à l'explication du public
du café-concert.

On n'a pas tout dit quand on a dit l'abjection du spectacle, le bas-
fond remué, la montée de ruisseau, la débâcle de fange. Le réquisitoire
a souvent été fait, et il est facilement fait, il se formule de lui-même.

Mais cette masse riante, qui applaudit les niaiseries et les
cochonneries, pourquoi est-elle là ? Tous ces gens qui pourraient
donner leurs cinquante sous au Drame, à la Comédie, ou à l'Opéra...
Comment dites-vous cela ?

Quelle erreur est la vôtre ! Ces cinquante sous, ils pourraient
les porter ailleurs, mais savez-vous bien à quelles conditions ? Avez-
vous réfléchi aux misères et aux vexations de la vie, à tout ce qui
poursuit le misérable homme, la pauvre unité sociale, jusque dans ses plaisirs ? Ces cinquante sous, pris sur
le nécessaire, sur la paie de la semaine, sur les appointements du mois, sur les bénéfices de la boutique, on n'est pas

226. HENRI DE TOULOUSE-LAUTREC, **Yvette Guilbert,** 1894

Page 4 of Gustave Geffroy, *Yvette Guilbert,* 1894. Color lithograph, 380 x 380 mm. New York Public Library, Astor, Lenox, and Tilden Foundations, Division of Art, Prints, and Photographs, The Spencer Collection

An earlier example of the genre is Toulouse-Lautrec's *Yvette Guilbert* of 1894, in which the illustrations were printed in green (fig. 226), conferring upon them the freshness and immediacy of crayon—a precedent for Bonnard's use of color in *Parallèlement*. But although *Parallèlement* is now considered one of the greatest *livres de peintre* of the twentieth century, it was not a success in its own day. When it was reviewed by Clément-Janin for the *Almanach du bibliophile*, there was a general feeling of excess, of things gone too far, a desire for the standard illustrated volume, not for this painter's book with its freedom, even anarchy.[58]

And Bonnard had gone very far indeed. His extraordinary transitions from painterly to linear, from empty space to rich ornamentation, had more textual precedents than visual ones. Mallarmé, who called his poems bibelots, carved out with his words a similar feeling for ornament and void, inviting the reader's participation by the framing and mirroring of words and images to create additive compositions replete with historical and mythical associations. So Bonnard in *Parallèlement* invites the viewer to engage in a rarefied form of free association that calls to mind

fragments of memories from the subconscious, images of past art, everything that in the Nabis' thinking modifies "la vision moderne." [59]

In *Parallèlement* women's faces, looming above the text in the crude language of caricature (fig. 227), coexist with landscapes that breathe the gentle air of Fragonard. On other pages a modern nude, a contemporary woman, lies splayed in a position of sexual satisfaction or offering, with no palliating reference to classical sculpture (figs. 228–231). *Parallèlement* was the project that distilled Bonnard's theory of the 1890s, and the nude was his vehicle. When he had said at age twenty-four, "I am of no school. I am looking only to do something personal," [60] Bonnard was not, as has generally been insinuated, looking for a new and independent style to make his mark on the history of art. Instead, he sought a subject that would liberate the development of his inner core, his subconscious—what Bergson and Fénéon called *intuition*—in order to tap his memories, sharpening and layering his perception.

Bonnard and Vuillard both agonized over this search for a subject that would be genuine and true to their own feelings, allowing them to mediate between the reality of matter and the reality of the spirit. [61] Denis

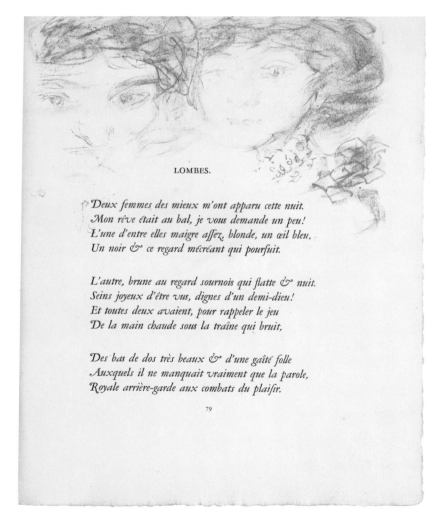

LOMBES.

Deux femmes des mieux m'ont apparu cette nuit.
Mon rêve était au bal, je vous demande un peu!
L'une d'entre elles maigre assez, blonde, un œil bleu,
Un noir & ce regard mécréant qui poursuit.

L'autre, brune au regard sournois qui flatte & nuit.
Seins joyeux d'être vus, dignes d'un demi-dieu!
Et toutes deux avaient, pour rappeler le jeu
De la main chaude sous la traîne qui bruit,

Des bas de dos très beaux & d'une gaîté folle
Auxquels il ne manquait vraiment que la parole,
Royale arrière-garde aux combats du plaisir.

79

227. **Lombes** (Loins), ca. 1897–99 [cat. 82]

Page 79 of Paul Verlaine, *Parallèlement*, 1900. Color lithograph, 305 x 250 mm. New York, The Metropolitan Museum of Art, The Elisha Whittelsey Collection, The Elisha Whittelsey Fund, 1970

228. Séguidille, 1897–99 [cat. 82]

Page 27 of Paul Verlaine, *Parallèlement*, 1900. Color lithograph, 305 x 250 mm. New York, The Metropolitan Museum of Art, The Elisha Whittelsey Collection, The Elisha Whittelsey Fund, 1970

The title refers to the verse form, whose rapid tempo suggests the *seguidilla*, a Spanish dance and its accompanying music.

229. Le Sonnet de l'homme au sable (The Sonnet of the Sandman), ca. 1897–98

Study for page 100 of Paul Verlaine, *Parallèlement*, 1900. Crayon and graphite, 295 x 241 mm. Upperville, Va., Collection of Mr. and Mrs. Paul Mellon

230. Le Sonnet de l'homme au sable, ca. 1897–98

Rejected version of page 100 of Paul Verlaine, *Parallèlement*, 1900. Color lithograph, 292 x 241 mm. Upperville, Va., Collection of Mr. and Mrs. Paul Mellon

Another pose was in the end used for "Le Sonnet de l'homme au sable" (fig. 231), and this one was adapted for "Séguidille" (fig. 228).

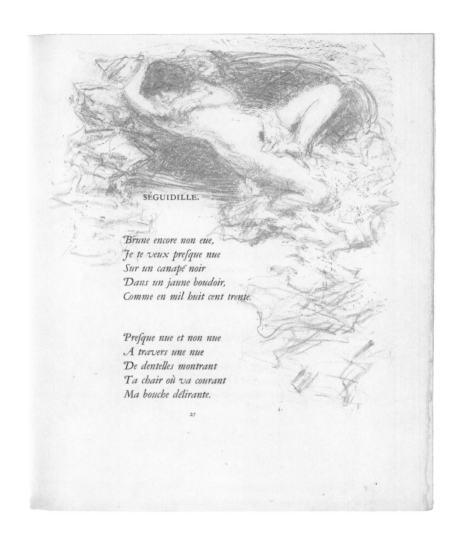

SÉGUIDILLE.

Brune encore non eue,
Je te veux presque nue
Sur un canapé noir
Dans un jaune boudoir,
Comme en mil huit cent trente.

Presque nue et non nue
A travers une nue
De dentelles montrant
Ta chair où va courant
Ma bouche délirante.

27

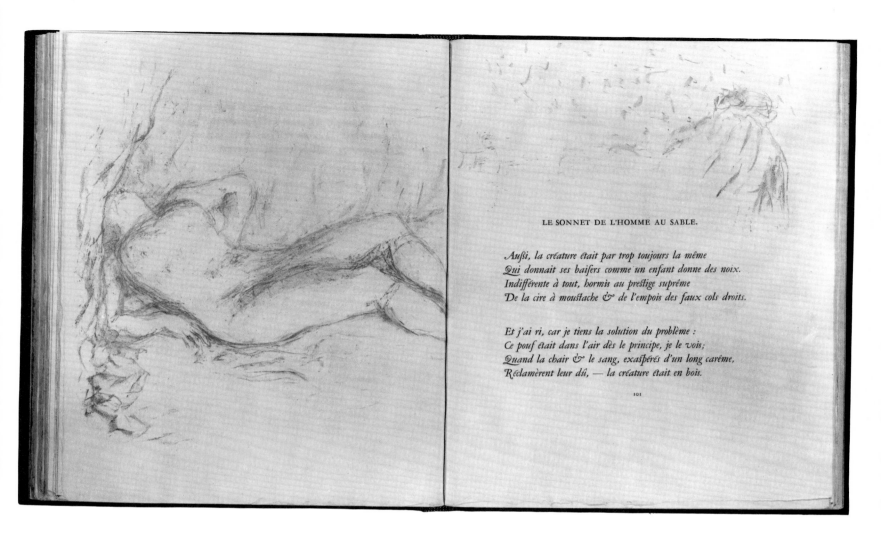

LE SONNET DE L'HOMME AU SABLE.

Aussi, la créature était par trop toujours la même
Qui donnait ses baisers comme un enfant donne des noix.
Indifférente à tout, hormis au prestige suprême
De la cire à moustache & de l'empois des faux cols droits.

Et j'ai ri, car je tiens la solution du problème :
Ce pouf était dans l'air dès le principe, je le vois;
Quand la chair & le sang, exaspérés d'un long carême,
Réclamèrent leur dû, — la créature était en bois.

101

proposed, in "Définition du néo-traditionnisme," that it was foolish to look for originality, for new subjects and new visions, because they seduced the artist with novelty and with trompe l'oeil, coming between the emotion sustained and the work produced. Moreover, according to Denis, one brings to any work of art and to any motif personal associations and preconceptions that often arise in fragmented disorder—disconnections that are part of the process of perception and creation.[62]

Thadée Natanson later described Bonnard as having succeeded in combining aspects of Greek sculpture and the art of Raphael, which he had come to admire, perfectly fusing them into an everyday event.[63] In his nudes of the 1890s Bonnard achieved this fusion, not only in the layering of sources and traditions but also in the layering of the process itself. The designs prepared for *Parallèlement* are seen again and again in paintings of the period; motifs appear and reappear. Bonnard worked from photographs, on paper, on small canvases, everywhere that he could

231. Le Sonnet de l'homme au sable, ca. 1897–99
[cat. 82]

Pages 100 and 101 of Paul Verlaine, *Parallèlement*, 1900. Color lithographs, 305 x 250 mm. New York, The Metropolitan Museum of Art, The Elisha Whittelsey Collection, The Elisha Whittelsey Fund, 1970

The Sandman of the title alludes to a story by the German writer and composer E. T. A. Hoffmann, which was later used by Offenbach in his opera *The Tales of Hoffmann*. The protagonist of the story is infatuated with the beautiful Olimpia, only to discover that she is not a real woman but a mechanical doll.

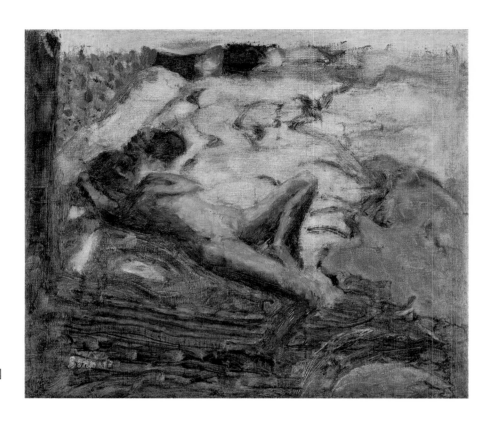

232. Study for **Indolence,** ca. 1897–98 [cat. 55]

Oil on canvas, 240 x 270 mm. Private collection

begin to re-create, in the process of image making, the process of his own memory and creativity. *Indolence* (fig. 232), a small oil sketch painted with a vital directness, brushed with the artist's finger, seems a spontaneous record of that small moment of epiphany Bonnard sought to remember and document. The nude lies on the bed, one hand behind her head, the other across her breast, one foot raised, the other resting on the floor. Sated, content, she appears boneless, animal, part of the surrounding tumble of sheets and bedclothes. The work has a tremendous immediacy and candor. There is nothing coy about the exposed sprawl of the nude, the touch of white paint on her crotch and between her legs. These and other touches of paint—the red of the pillow, the blue bow of the pet curled up beside the woman—are aids to Bonnard's memory. The gesture of painting is a way of reconnecting with sensation.[64] The bed is a large expanse of white, an empty space that hints at Bonnard's preoccupation with lithography and the relevance of this picture to the image in *Parallèlement* (see fig. 228), which it clearly preceded. After the lithograph came two other versions in paint—the first in the Josefowitz Collection (fig. 233) and the second in the Musée d'Orsay; dark and brooding, they are lost in penumbra, without the same sense of closed and open. Bon-

nard made many such oil sketches for *Parallèlement*, but *Indolence* is the only one he transformed into two full-scale paintings. It was the only time in his career that he devoted such concentrated attention to a single motif.

Parallèlement is in many ways the ultimate Symbolist work. Often autobiographical, sometimes related to the social milieu, sometimes to the stylistic, the illustrations reach deep into the artist and the viewer in an effort to capture the actual experience of reading Verlaine's text rather than the material reality of any given image. The forms are themselves a revelation of hidden mysteries and take on shapes according to the individual's vision and point of view. The nude becomes the physical manifestation of sensation, the epiphany itself—modern woman, feline, antique sculpture, and eighteenth-century nymph within the same moment of perception.

Parallèlement was not the commercial success for which Vollard and Bonnard must have hoped. Vollard had recognized the potential for an *édition de luxe* in lithography, and he had also seen in Bonnard's sensitivity to Verlaine's poems and in his clever use of the Rococo a marketable commodity. But these nudes were not sufficiently in disguise. They were

233. Indolence, ca. 1899

Oil on canvas, 960 x 1050 mm. Josefowitz Collection

too provocative, too direct, and were not even restrained by the formal conventions expected of illustrations in a book. Moreover, Bonnard used the leveling quality of caricature, as well as the elevating style of the Rococo, to express and redefine sexual experience.

Parallèlement was the culmination of Bonnard's Paris period with Marthe at its center. His illustrations for this book would haunt all of the work that followed.

Daphnis et Chloé

Despite *Parallèlement*'s lack of success, or perhaps because of it, Vollard promptly commissioned another book from Bonnard, *Daphnis et Chloé*, which was completed very quickly and published at the end of 1902. The letterpress was again printed by the Imprimerie Nationale, but this time there would be no trouble.

Daphnis et Chloé was a canny choice after *Parallèlement* and for reasons of subject matter and format had rather more success. The text, a Greek romance of the third century A.D. by the pastoral writer Longus, had the tone and immediacy of a modern novel and afforded Bonnard the opportunity to produce an illustrated book "of a more classical inspiration." [65] Bonnard's 151 lithographs for *Daphnis et Chloé*, printed by Auguste Clot in black ink to match the text, provided a satisfying contrast with the straightforward, rather naive Grandjean typeface chosen for the letterpress. Abandoning the free and daring disposition of images throughout the margin area that in *Parallèlement* had proved anathema to contemporary bibliophiles, Bonnard restricted his *Daphnis et Chloé* illustrations for the most part to an unvaried rectangular format underscored by five lines of text—text, moreover, that generally referred directly to the image above.

The reviews by Clément-Janin in the *Almanach du bibliophile* give a sense of how differently the two books were received. According to Clément-Janin, *Parallèlement* was not only a compositional failure; it was also a project that mocked the serious bibliophile. [66] He was critical of the indecision and uncertainty of Bonnard's lines, critical of Vollard's use of the Garamond typeface, whose nobility he felt contrasted unpleasantly with Verlaine's sentiments, critical of a relationship of image to page that ignored rules of proportion and reflected a complete absence of taste, even critical of the rose-sanguine color—the "red-currant tone"—of the lithographs themselves. [67] Clément-Janin found *Daphnis et Chloé* to be a more

serious and appealing venture, one that showed itself sensitive to the traditions of book illustration, despite its continued use of the lithographic medium. He reviewed with approbation the Longus text, the color of the ink, the typography, the balanced compositions, and the fact that the margins had been left intact, although he was still uncomfortable with the unfinished, sketchlike quality of many of Bonnard's images.[68] As he wrote: "*Daphnis* is an advance on *Parallèlement*, even from the point of view of the book. . . . You see that M. Vollard learns wisdom and that, unlike many of his colleagues, he is not afraid to evolve."[69] Certainly, the modifications of design noted in *Daphnis*, as well as the choice of a text to illustrate that already had an established bibliographic history in the French literary tradition, were quite intentional, perhaps a strategy aimed at improving upon the dismal reception of *Parallèlement*.[70]

First translated into French in 1559 by the humanist Jacques Amyot, later bishop of Auxerre, a protégé of François I and tutor to both the future Charles IX and Henri III, *Daphnis et Chloé* had long been a popular romance. Amyot's version was completed and edited in 1810 by Paul-Louis Courier, a soldier turned scholar and pamphleteer, who preserved the freshness and candor so apparent in the Vollard-Bonnard edition. An edition of *Daphnis et Chloé* illustrated by Pierre-Paul Prud'hon and François Gérard, with three and six plates respectively, had enjoyed considerable success in the early years of the First Empire. Owing largely to Edmond de Goncourt's publication of a catalogue raisonné of Prud'hon's work in 1876, interest in Prud'hon revived during the last two decades of the nineteenth century.[71] Certain illustrations in Bonnard's *Daphnis et Chloé* refer rather slyly to the Prud'hon model (figs. 234, 235), although Bonnard's sketchy and aggressively deforming technique, with its relationship to caricature and to children's art, was the antithesis of Prud'hon's rigorous, Neoclassical closure—positing a joke about the devolution of style.

Such references to the past were not lost on an audience anxious to resuscitate *la grande tradition française* and to recognize allusions to it whenever and wherever possible. As Thadée Natanson noted: "In his *Daphnis* Bonnard appears to me to come close to the translations of the ancients made by the writers of the seventeenth century."[72] In 1917 René Jean commented favorably upon Bonnard's relationship with Prud'hon, describing both artists as eloquent interpreters of the "sensibility and emotions of a race."[73] By 1931, on the occasion of an exhibition of Vollard editions at the Galerie du Portique, Claude Roger-Marx was able to refer

Disant ces mots, il mit la pomme au giron de
Chloé, et elle, comme il s'approcha, le baisa si
soevement qu'il n'eut point de regret d'être monté
si haut pour un baiser qui valoit mieux à son gré
que les pommes d'or.

215

234. Daphnis and Chloe
[cat. 89]

Page 215 of Longus, *Daphnis et Chloé*, 1902. Lithograph, 292 x 241 mm. New York, The Metropolitan Museum of Art, Harris Brisbane Dick Fund, 1928

"Saying these words, he placed the apple on Chloe's lap, and she, as he drew nearer, kissed him so sweetly that he did not regret having climbed so high for a kiss that was worth more to him than the golden apples."

offhandedly to *Daphnis* as the most beautiful illustrated book since the eighteenth century, one that confirmed the vitality of the French tradition by its timeless ability to be at the same time Greek and modern.[74]

Daphnis et Chloé celebrates the innocent love of a young goatherd and shepherdess on the idyllic island of Lesbos. Abandoned as babies, their parentage unknown, Daphnis and Chloe are taken in by goatherds and shepherds respectively, and learn to love one another as adolescents. After adventures and separations, their love ends in marriage and in the recognition of the couple by their noble parents. Longus's romance is a tale of pastoral bliss in which sex is as natural as the passage of the seasons.[75] Throughout the story pagan myths mingle freely with the details of Arcadian life, and Bonnard's lithographs address these dual sources in a light-handed but direct way. Scenes of mythological inspiration (fig. 236) coexist with informal landscapes (fig. 237)—topographically identifiable as set in the Ile de France—and with figural compositions of a much more monumental and classical derivation (fig. 238).

Daphnis et Chloé was an opportunity for Bonnard to develop his own "repopulated landscape," in which an idiosyncratic, often northern countryside was activated by figures with pastoral or mythological attributes. This kind of landscape, which proliferated during the years 1895–1915, proposed a bridge between the classical and the contemporary.[76] Alternatives were sought to the informal, ahistorical disorder of the Impressionist landscape, where the inclusion of figures was considered accidental and haphazard.[77] In *Daphnis et Chloé*, and in paintings of the period, Bonnard sought to imbue Impressionist technique (and its concomitant associations of individual liberty) with the integrity and solidity of the classic French canons. Bonnard said of his discovery of Impressionism in the 1890s: "I remember very well that at that time I knew nothing about Impressionism; and the work of Gauguin made us enthusiastic for itself, not against something. Indeed, when a little later we discovered Impressionism, it was a new enthusiasm, a sensation of discovery and liberation, because Gauguin is a classic, almost a traditionalist, and Impressionism brought us liberty."[78]

Although Bonnard discovered in Impressionism a newfound liberty, he also resisted Impressionism's ultimate message—the temptation of nature and trompe l'oeil. Bonnard, and with him Roussel and Vuillard, wanted to create the *tableau*, the composed painting, out of the perceptual immediacy of Impressionism.[79] Bonnard said of this implicit tension: "When my friends and I wanted to pursue the researches of the

235. PIERRE-PAUL PRUD'HON, **Daphnis Removing a Cicada from Chloe's Breast**

Illustration facing page 16 of Longus, *Daphnis et Chloé*, the P. Didot L'Aîné edition, 1800. Etching and engraving by B. Roger, 190 x 145 mm. New York, The Metropolitan Museum of Art, Harris Brisbane Dick Fund, 1929

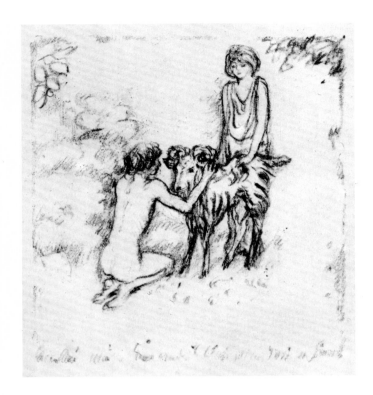

236. Daphnis Currying His Goat [cat. 91]

Illustration for page 225 of Longus, *Daphnis et Chloé*, 1902. Lithograph (proof impression without text), 105 x 140 mm. Cambridge, Mass., The Houghton Library, Harvard University, Department of Printing and Graphic Arts

237. Daphnis and Lycoenium [cat. 89]

Illustration on page 179 of Longus, *Daphnis et Chloé*, 1902. Lithograph, 155 x 140 mm. New York, The Metropolitan Museum of Art, Harris Brisbane Dick Fund, 1928

Impressionists and to try to develop them, we sought to surpass them in their naturalistic impressions of color. Art is not nature. We were more severe as to composition." [80]

Artists were increasingly in search of a subject and a style that would have inherent in it a universality, a classicism confirming links with tradition. As Elie Faure said in his introduction to the catalogue of the Salon d'Automne in 1905: "The revolutionary of today is the classic of tomorrow." [81] The affirmation of the continuity of history became increasingly popular. Arcadian subjects with modern attributes proliferated. Nymphs and bathers were the motifs of choice for avant-garde and conservative artists alike. For the latter, a return to the iconography of the Golden Age reflected the desire to create an Arcadia that was distinctly Catholic and replete with monarchic references. For other artists, particularly the Neo-Impressionists, mythological subjects engaged with a liberated Utopian future. [82]

Bonnard's concerns ran parallel with those of the Neo-Impressionists, with whom he became increasingly friendly in the 1890s as his relationship with Fénéon deepened. Significantly less interested in the stylistic or humorous inversions of his earlier Paris-based work, Bonnard began

in the years preceding World War I to engage more directly with the French tradition, while maintaining a continued, if variable, will to subvert it. The Neo-Impressionist Henri-Edmond Cross played an important role in the development of Utopian iconography and was, with Paul Signac, particularly influential in Bonnard's assimilation of Neo-Impressionist landscape ideology and iconography.[83] Cross had installed himself in the Midi in 1891, and between then and 1900 he became involved with several of the Nabi group, particularly with Bonnard, Maillol, and Roussel. Cross's subject matter and that of his Nabi friends increasingly depicted female nudes and bathers, vacillating between fidelity to nature and monumental decorative aspirations. During the period between 1895 and 1910 both Nabi and Neo-Impressionist artists traveled, haunting the museums of Europe, often in each other's company. The continuity of themes among the images on the picture postcards they sent one another reflects undeniable interest in one subject to the exclusion of practically all else—the monumental figured landscape.[84]

At this time, Bonnard began to emphasize mythological subject matter in his painting, although the flat space and puppetlike figures of *Daphnis et Chloé* cleverly subvert the bombast of a more ideologically conservative and reactionary classical inspiration. Roussel also began to paint mythological landscapes to the exclusion of all else, and Cross and Signac, among others, created visions of a pastoral Utopia populated by both clothed and nude figures engaged in such timeless activities as a grape harvest by the sea. Wrote Fénéon of a Signac exhibition in 1890: "Exemplary specimens of a highly developed decorative art, which sacrifices anecdote to arabesque, nomenclature to synthesis, fugitive to permanent and . . . confers on Nature—weary at last of its precarious reality —an authentic Reality."[85]

The Fugitive Made Permanent: Photography and Beyond

Bonnard struggled in his landscapes of the 1890s with this notion of a balance between the fugitive and permanent, a struggle that paralleled his evolving attitude toward uses of tradition. The process of photography became essential to this exploration. The Kodak hand-held camera was made available to the public in 1888 and Bonnard soon began using one.[86] He always developed his own negatives (or oversaw their development) to achieve not a single print but a succession of small, related images on a

238. Daphnis and Chloe [cat. 90]

Illustration for page 173 of Longus, *Daphnis et Chloé*, 1902. Color lithograph without text from an extra suite printed in blue, 150 x 140 mm. Josefowitz Collection

239. Chloe Bathing [cat. 92]

Illustration for page 69 of Longus, *Daphnis et Chloé*, 1902. Lithograph (proof impression without text), 150 x 140 mm. New York, The Metropolitan Museum of Art, Purchase, E. Powis Jones Gift, 1988

240. Marthe, 1900–1901 [cat. 88]

Photograph. Original contact print, 38 x 55 mm. Paris, Musée d'Orsay, Promised Gift of the Children of Charles Terrasse

strip of film, a montage of serialized moments, like the work of Eadweard Muybridge.[87] Photography encouraged Bonnard's evolving notion of art as symbolic representation. As with the successive realities of Mallarmé's poems created through the devices of mirrors and windows, Bonnard used the medium to create framed images that stylized the ephemeral aspects of daily life, raising them to another level of narrative reality. The camera helped Bonnard capture the fugitive instants of vision and experience—those elusive moments of recognition, perception, and emotion —that he said one must seize and note as quickly as possible.[88] In freezing the momentary perception, the photograph became an immutable record of the transient, an artifact through which memory could be decanted and savored.

Inevitably, then, Bonnard's photography was not the idle recording of scenic views, nor even a notation of trips taken and friends seen. Instead he focused upon the most intimate aspects of his personal existence, using the medium as an essential step in the transformation of life into art. The series of photographs he took during the creation of *Daphnis et Chloé* around 1900, as distinct from those which informed *Parallèlement* (see fig. 224) and which seem to date from 1897–98, are paradigmatic of this process.

241. Chloe Garlanding Daphnis [cat. 89]

Illustration on page 185 of Longus, *Daphnis et Chloé*, 1902. Lithograph, 153 x 140 mm. New York, The Metropolitan Museum of Art, Harris Brisbane Dick Fund, 1928

242. MARTHE DE MELIGNY, **Bonnard,** 1900–1901

Photograph. Original contact print, 36 x 53 mm. Paris, Musée d'Orsay, Promised Gift of the Children of Charles Terrasse

In 1900 Bonnard rented the first of what was to be a succession of country houses in the Seine Valley.[89] He chose Montval, a small village halfway between Marly-le-Roi and Mareil, close to Roussel at L'Etang-la-Ville, Denis at St.-Germain-en-Laye, and Maillol, whose studio in Marly he visited frequently between 1900 and 1902. In the garden at Montval, bordered by chestnut trees and dappled by the light filtering through the leaves, Bonnard took a series of photographs directly related to *Daphnis et Chloé*. Marthe, who had enacted the heroine of *Marie* and had inspired the intensely sensual passages of *Parallèlement*, was now metamorphosed into a shy, adolescent Chloe. Standing under the bough of a sheltering tree, legs apart, eyes downcast, she is a delightfully modest girl whose nudity is entirely natural, unutterably chaste (figs. 239, 240). Bonnard plays Daphnis to her Chloe (figs. 241, 242). Sitting under the same tree, back to the camera, head turned from our view, he is centuries away from the contemporary Parisian in his urban interior portrayed in *Man and Woman* (see fig. 219). Bonnard willfully created a pastoral Eden in the Ile-de-France, and it was the camera, ostensible purveyor of truth, that contributed to the lie of his art. Clearly, he exulted in the innocent, hedonistic freedoms of Longus's tale, as well as in the poignant correlations he orchestrated between the garden at Montval and an antique Arcadia.

Nudes and Landscapes 179

243. Picking Fruit, ca. 1899–1900

Photograph. Negative 38 x 55 mm. Paris, Musée d'Orsay, Promised Gift of the Children of Charles Terrasse

244. Picking Plums, ca. 1892–93 [cat. 12]

Pencil, ink, and watercolor, 184 x 114 mm. Switzerland, private collection

Photography, an essentially fugitive process that paradoxically creates the illusion of classical stasis and harmony, brought Bonnard closer to realizing large-scale decorative compositions—works in which the figures engaged in activities with antique or mythological connections, or in which contemporary activities were raised to mythological status. Children swimming in a pool at Le Clos (see fig. 90) metamorphose into nymphs frolicking in a fountain; the gathering of fruit becomes a timeless episode, resonant with Virgilian overtones (figs. 243–245). Evocations of the family orchard are further explorations of stasis and incident: within their carefully structured landscape, the children and dog are stilled for a second in play, and the profile of the woman to their right has the noble silhouette of antique statuary (fig. 246); yet the trees and shrubbery all bespeak a particular moment in a particular season (fig. 247).

245. In the Garden, Picking Fruit, ca. 1899 [cat. 80]

Oil on canvas, 340 x 480 mm. New York, The Family of Mr. and Mrs. Derald H. Ruttenberg

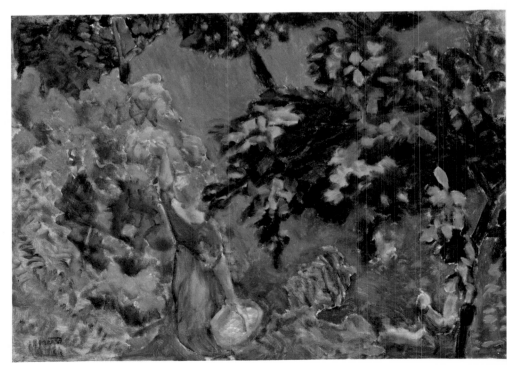

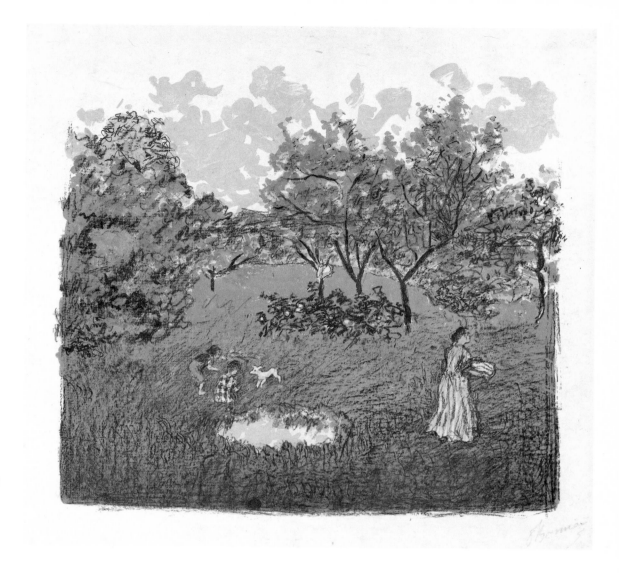

246. The Orchard, 1899 [cat. 79]

 From the album *Germinal*. Color
 lithograph, 330 x 350 mm. North-
 ampton, Mass., Smith College Mu-
 seum of Art, Selma Erving Gift

247. The Orchard, 1895 [cat. 47]

 Oil on canvas, 410 x 590 mm. Rodés
 Collection

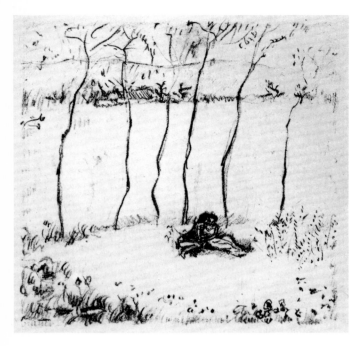

248. Daphnis and Chloe [cat. 93]

Illustration for page 171 of Longus, *Daphnis et Chloé*, 1902. Lithograph (proof impression without text), 135 x 140 mm. New York, The Metropolitan Museum of Art, The Elisha Whittelsey Collection, The Elisha Whittelsey Fund, 1985

249. Fruits of Vine and Orchard [cat. 89]

Illustration on page 221 of Longus, *Daphnis et Chloé*, 1902. Lithograph, 150 x 140 mm. New York, The Metropolitan Museum of Art, Harris Brisbane Dick Fund, 1928

L'Après-midi bourgeoise (*The Bourgeois Afternoon*; see fig. 123), a major painting of the 1890s, reflects these fundamental concerns of temporality versus timelessness. Photographs taken by Bonnard of members of his family during the summers at Le Clos contributed to this picture. Directly associated with Seurat's *La Grande Jatte*, *L'Après-midi bourgeoise* was purposefully and resolutely located in history. Hieratic and serene, the sitters are nonetheless identified by specific details of fashion and attitude, simultaneously timeless and time-bound.[90] Following his Seurat/Neo-Impressionist model, Bonnard here sought to infuse the idiosyncratic, temporal quality of one family's Sunday activities with the immutability of the grand-scale decorative tradition, establishing a tension between classical attitudes of a serene timelessness and contemporary incident.

Bonnard's elaboration of the Impressionist touch, however, and the conscious lack of finish in his drawing and painting style differ markedly from the pointillist dot and manifest his burgeoning interest in a reworking of Impressionism in a manner different from, if related to, the Neo-Impressionist precedent. The potential disarray and the delightfully intimate and familiar quality of the *Orchard* landscapes, even of *L'Après-midi bourgeoise*, are evident throughout *Daphnis et Chloé*. Lauded for its seamless mix of the antique and the contemporary, *Daphnis et Chloé* achieved for the first time in the artist's work a lyric universality.[91] Bonnard was clearly struggling to define his place within *la grande tradition française*.

The tension varies from plate to plate in *Daphnis et Chloé*, as it does in paintings of the period. Certain figures may have stepped from an antique frieze, yet they also convey a sense of freedom and modernity. In other plates figures more monumentally conceived fill the entire rectangle, their forms suggesting relationships with antique sculpture, with Prud'hon's Neoclassical illustrations, even with contemporary renditions of Greek types in the work of Maillol and Renoir.[92] The book's innocent sensuality was as far removed from the fin-de-siècle smolder of *Parallèlement* as its regularized format was from the lawless, insinuating spread of illustrations in the earlier volume. Bonnard's visions of a carefree, pagan life on the island of Lesbos reflect an increasingly active embrace of the Greco-Roman, Western traditions, as opposed to the interest in the popular arts of Japan and in caricature so apparent in his earlier work.

Despite this ever-increasing involvement with the world of Greece and Rome, Impressionism remained for Bonnard a weapon against the sterility of hard-edged classicism and imitation that filled the salons. The de-

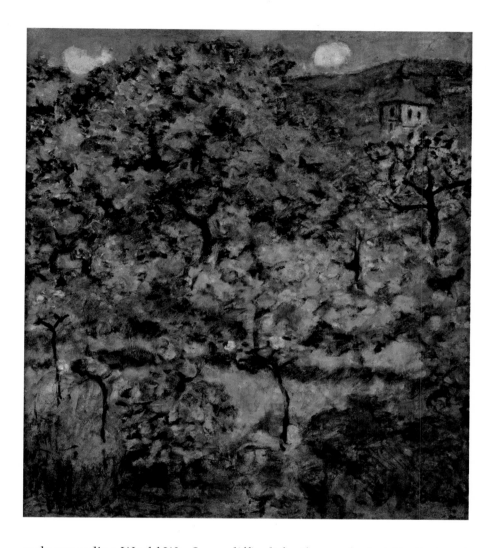

250. Landscape at Le Grand-Lemps, ca. 1897–99
[cat. 81]

Oil on cardboard, 480 x 430 mm. Private collection

cade preceding World War I was difficult for those who held to that part of the French heritage embodied in the Enlightenment, in Delacroix, and in Impressionism itself. As early as 1903, Impressionism, equated with liberty and individualism, was considered dangerous. Described as "febrile" and "invertebrate" (words applied to Bonnard on several occasions between 1905 and 1910), Impressionism fell into disgrace. So, too, did Monet, one of its greatest proponents, who could not be incorporated into the great French tradition as readily as Cézanne and Renoir, in large part because of their embrace of the figured landscape.[93] Impressionism became symptomatic of the anarchy and chaos that troubled France from the Franco-Prussian War through the next conflagration with Germany, which was itself a poignant reminder of that earlier painful defeat and occupation.

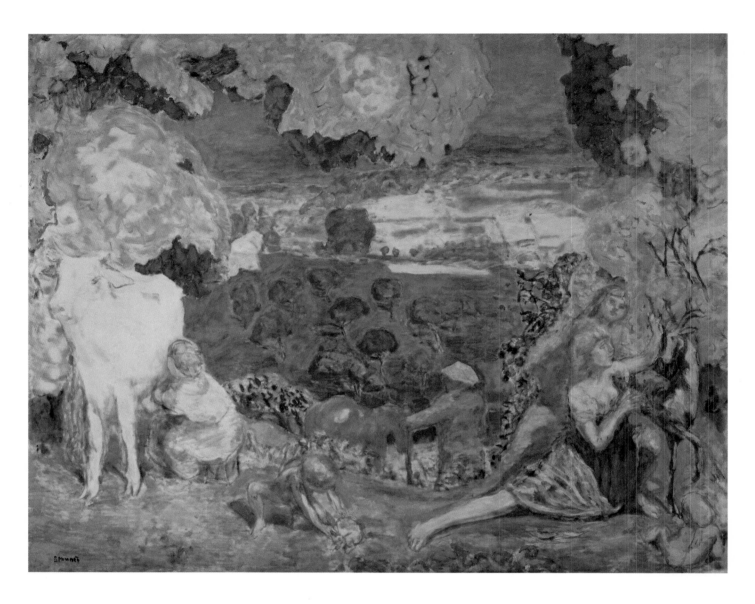

251. Pastoral Symphony, ca. 1920

Oil on canvas, 1300 x 1600 mm. Paris,
Bernheim-Jeune

More regularized and stylistically consistent than *Parallèlement*, *Daphnis et Chloé* reflects, nonetheless, a full range of experiments in landscape formulas. Bonnard's touch throughout the book is active and unfinished. Certain plates are almost entirely landscape, sometimes densely foliated, sometimes open, with only a thin row of trees (fig. 248). Often the wild profusion of the landscape has full rein (fig. 249). Occasionally small figures nestle in the shrubbery or cavort behind a tree, barely distinguishable from the foliage that surrounds them. Certain paintings of the period manifest a similar hide-and-seek relationship be-

tween figure and landscape. Others, unusual in being landscapes without figures, show the same closely observed, yet highly stylized forms that appear in *Daphnis et Chloé* (fig. 250). This landscape is recognizably and familiarly northern, taken either from the Seine Valley or from the Dauphiné of the Bonnard family's country home. As Claude Roger-Marx described it:

> Bonnard has found in the Dauphiné or near Paris the atmosphere of those happy times when the gods and demigods were still around; . . . life has always the same limits, desire follows the same paths, the seasons run the same course; and Chloe's girdle is untied in the Ile-de-France as on the island of Mytilene.[94]

In *Daphnis et Chloé* the northern landscape of Impressionism coexists with Bonnard's interests in meridional, classical decoration.

Daphnis et Chloé, which marked the end of Bonnard's Paris period, played a central role in the development of his style. Not only was it the genesis of a number of paintings with mythological content, but it also contributed to the large-scale decorative commissions undertaken for Misia Sert, the Russian collector Ivan Morosov, and others in the prewar decade.[95] The four panels Bonnard completed between 1915 and 1919 for the Bernheim-Jeune villa in Normandy, with their north-south dialogue (fig. 251), are the culmination of interests that he addressed for the first time in his illustrations of the Longus text.[96]

North and South

After 1910 Bonnard spent less and less time in Paris. Perhaps because of disappointment with the reception of his two greatest series of book illustrations, his involvement with lithography also declined. Of the two books he illustrated for Octave Mirbeau, the first, *La 628-E8*, published in 1908, was the record of a car trip through France and the Low Countries. The second, *Dingo*, which first appeared in 1912, was issued by Vollard in 1924 in a deluxe edition with etchings by Bonnard. This was the story of a wild Australian dog that was never truly able to understand or assimilate the expectations of "civilized" society. In both books the landscape is an essential element. In *La 628-E8* the regional terrain of France, identified and noted, is a leitmotiv (fig. 252). The car itself, license plate 628-E8, is in many ways a metaphor for Bonnard's own peripatetic existence. He kept his studio in Paris until the end of his life, and retained his house in the

252. The Fauna of the Roads

Illustration on page 35 of Octave Mirbeau, *La 628-E8*, 1908. Process print, page 68 x 154 mm. New York, The Metropolitan Museum of Art, The Elisha Whittelsey Collection, The Elisha Whittelsey Fund, 1973

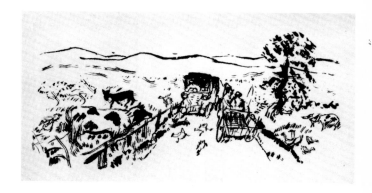

Ile-de-France even after moving to the Midi. At the same time he traveled. Bonnard seemed to be always on the road. Grasse, La Baule, Arcachon, Bénerville, Trouville, Deauville—Bonnard visited, and noted, all of France's regional variety. His later landscapes reflect this sensitivity to place: the cool vegetation of the Seine Valley, the wide beaches and the pine trees of Arcachon, the brilliant and exotic light of the south, the spare, snow-covered Dauphiné of his childhood (fig. 253).

In *Dingo* Bonnard was less engaged by a landscape of place or region than by a landscape of familiarity—a favorite tree rendered again and again (fig. 254), or the terrace of his home, Ma Roulotte (fig. 255). This was a small house at Vernonnet, near Vernon, that Bonnard bought in

253. Winter Landscape, ca. 1910–20 [cat. 100]

Pencil and watercolor, 283 x 227 mm. Switzerland, private collection

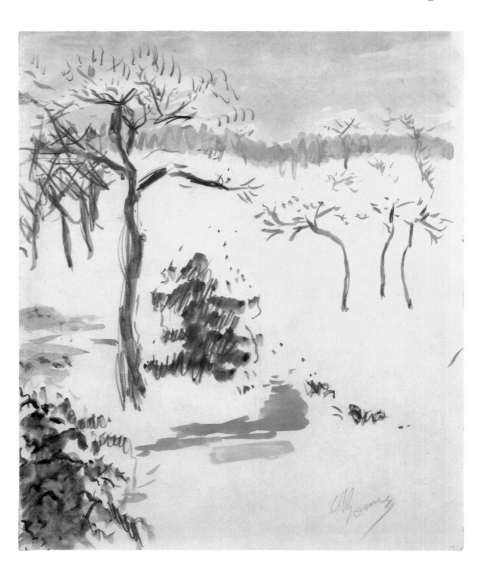

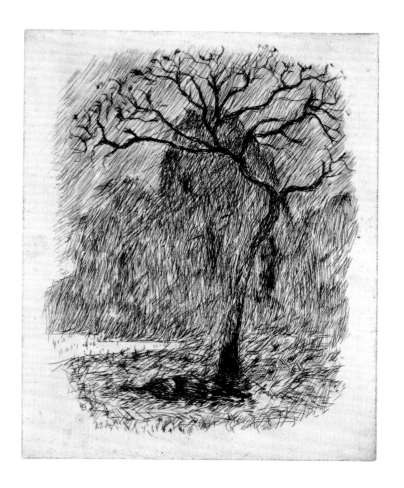
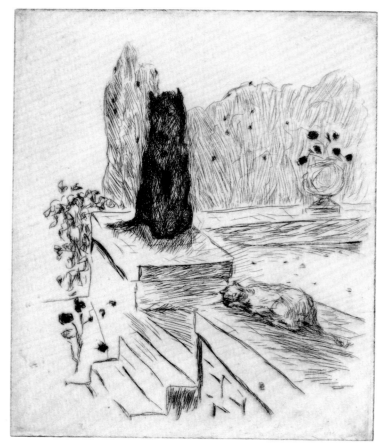

1912, and where he painted his great Seine Valley landscapes. During these years he became close friends with Monet, Giverny lying just across the river from Vernon, and Monet was a frequent visitor at Ma Roulotte. Bonnard's retreat to the country and his feeling for the cycles of nature parallel Monet's earlier withdrawal from urban life. The conflict in Bonnard's art, however, was not so much between city and country as between the contemporary and the timeless. Bonnard, who in the 1890s was a painter of Paris, moved more and more toward the creation—the re-creation—of his own private world.

The ultimate expression of this private world is in the body of work created at Le Bosquet, Bonnard's house in Le Cannet in the South of France, which he bought in 1923 and which increasingly became the focus of his art. In the years following World War I Bonnard distanced himself more and more from the valley of the Seine, the setting for *Daphnis et Chloé* and his earliest decorative commissions. This commitment to the south came

254. Dingo Under the Mountain Ash [cat. 106]

Trial proof of illustration facing page 140 of Octave Mirbeau, *Dingo*, 1924. Etching and drypoint, 288 x 227 mm. New York, The Museum of Modern Art, The Louis E. Stern Collection

255. Dingo and Miche on the Terrace [cat. 105]

Proof impression of illustration facing page 130 of Octave Mirbeau, *Dingo*, 1924. Etching and drypoint, 288 x 231 mm. Cambridge, Mass., Fogg Art Museum, Harvard University, William M. Prichard Fund

256. Last Light, ca. 1927–28 [cat. 112]

Lithograph (trial proof), 240 x 320 cm. New York, The
Metropolitan Museum of Art, The Elisha Whittelsey
Collection, The Elisha Whittelsey Fund, 1985

at a particularly difficult period of Bonnard's life, just following the sui-
cide of his model Renée Monchaty in Rome,[97] and it represented for him
the final withdrawal from his Parisian youth.

Bonnard's treatment of landscape became rather obviously bifurcated,
continuing the different approaches noted in his two Mirbeau projects—
La 628-E8 and *Dingo*. In general, his graphic work grew distinctly less per-
sonal, more illustrative, less concerned with touch and with process. A
lithograph like *Last Light* (fig. 256) represents, in formulaic fashion, the at-
tributes of a Midi landscape with the deadpan vision of a tourist postcard.

Small paintings of northern and southern landscapes often reflect this
same descriptive attitude, becoming a catalogue of places, of terrain, of
the morphology of specific hills and valleys (fig. 257). When personal in-
cident does emerge, it is in the persistence of certain motifs, like the ob-
sessively remembered terrace at Vernon, which appears again in the
graphic work for Vollard's *Sainte Monique* (fig. 258), published in 1930,
and in an important series of decorative panels from the same period.
Here the northern landscape appears as the ghost of places barely re-
called. Yet this is, in fact, no longer a concentration on landscape or a top-
ographical re-creation but another set from Bonnard's memory theater:
motifs and visions and monuments that appear again and again, achiev-
ing the quality of personal myth acquired after a long distillation.

The richness of Bonnard's vision and its connection to his early explo-
rations in Paris continue in his interiors—especially his great late paint-

ings of nudes at their toilettes—and in his hermetically sealed views of the terrace at Vernon. Here he achieved the culmination of the ambitions first signaled in *Parallèlement*, where the graphic process itself was central to Bonnard's manipulation and transformation of tradition. Perhaps as a result of Bonnard's work in sculpture and his examination of gesture in a nongraphic medium at the time of *Daphnis et Chloé*, the process of painting became his primary concern. *Parallèlement* preceded and stimulated the great nudes of the 1890s; it was the fountainhead. After 1915, with the nude as Bonnard's central and most evocative subject, the graphic work had a much more tangential relationship to his method. Drawing remained essential (fig. 259), yet the lithographs of the nude that were produced followed the paintings and did not inform them (figs. 260–262).

257. The Côte d'Azur, ca. 1923

Oil on canvas, 787 x 762 mm. Washington, D.C., The Phillips Collection

Many of Bonnard's later landscapes were based on vistas seen in the course of daily walks near his house at Le Cannet, in the hills above the Bay of Cannes.

258. The Tiger-Cat in the Garden [cat. 113]

Illustration following page 106 of Ambroise Vollard, *Sainte Monique*, 1930. Lithograph, 280 x 207 mm. New York, The Museum of Modern Art, The Louis E. Stern Collection

The setting, one Bonnard used in many contexts over the years, is the terrace of Ma Roulotte, his country house at Vernon, in Normandy.

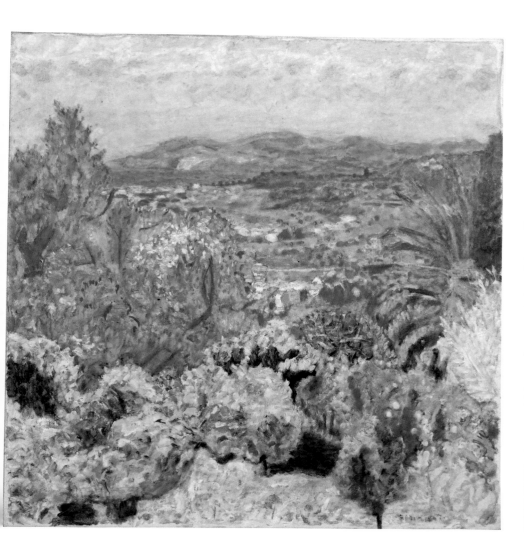

However, in all of Bonnard's nudes and interiors fragments of past art would emerge, like phrases half-remembered from a now-inaccessible text. The most ambitious of Bonnard's works encouraged this collision of past and present, with the continued examination of persistent traditions learned in the studio or at the Louvre, and then deliberately forgotten. These fragments of the past appear with the same insistence as the suppressed autobiographical details, submerged under the obsessively worked surfaces but insinuating themselves just the same. For example, in *The Terrace at Vernon*, on which Bonnard worked from around 1920 to 1939, a woman with her arm raised recalls the *Dying Niobid*, a statue which Bonnard loved and of which he owned a cast. Repeatedly painted, the figure of Marthe floating in the tub recalls a medieval tomb effigy, or perhaps the dead body of Renée Monchaty in a bathtub in Rome.

259. Nude with Peignoir, ca. 1916–17 [cat. 99]

Pencil and charcoal, 325 x 255 mm. Switzerland, private collection

260. Standing Nude, ca. 1925 [cat. 110]

Color lithograph, 290 x 165 mm. New York, The Metropolitan Museum of Art, The Elisha Whittelsey Collection, The Elisha Whittelsey Fund, 1988

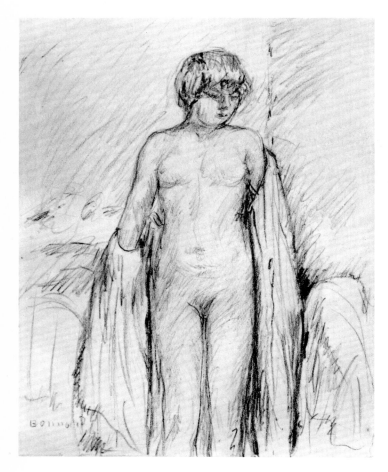

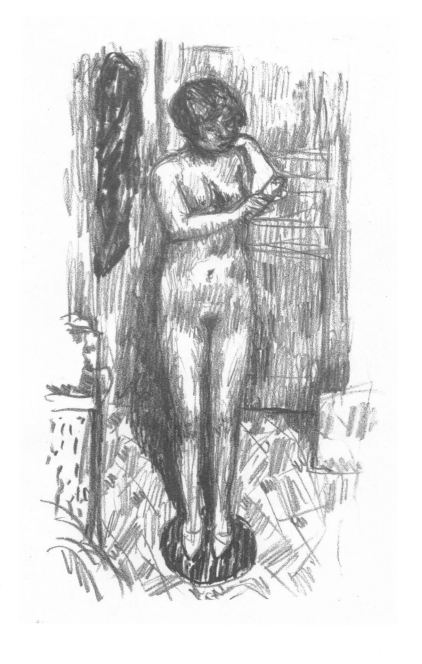

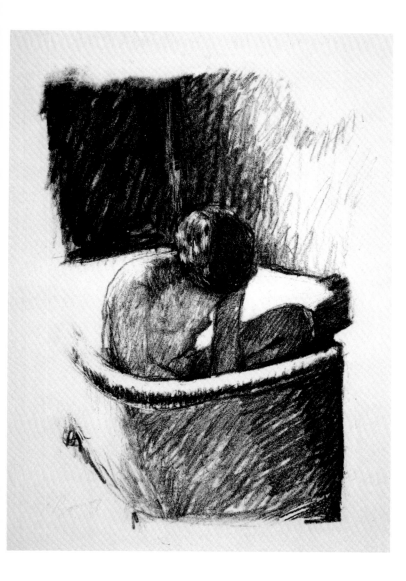

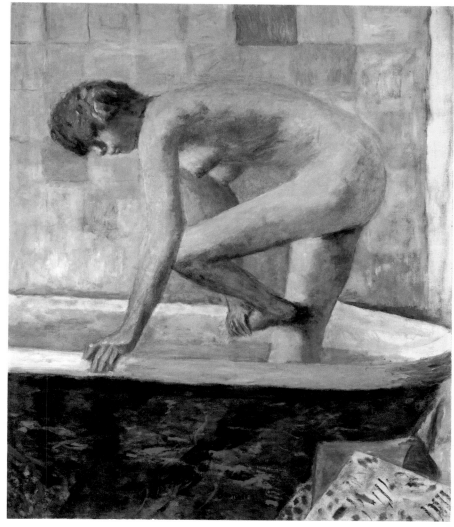

Bonnard's earliest exploration of the potency of memories and traditions stored away only to emerge later in different and more provocative and disrupted contexts, so acutely reflected in *Parallèlement* and *Daphnis et Chloé*, acquired even greater significance. Increasingly Bonnard's concern for tradition, and for how to forget it or subvert it in the creation of his own multilayered Symbolist vision, became ever more obsessive. In revealing the interaction of his own personal history with the input of the viewer of a subsequent age who brings to any monument the thoughts and needs of his own era, Bonnard rejected positivist historicism and accepted and embraced the complicated fate of the work of art after its moment of creation.

261. Le Bain (The Bath), ca. 1925 [cat. 109]

From the album *Les Peintres-lithographes de Manet à Matisse*. Lithograph, 330 x 225 mm. New York, The Brooklyn Museum

262. Nude in the Bathtub, ca. 1924

Oil on canvas, 1060 x 960 mm. Private collection

APPENDIX

Alfred Jarry on *Parallèlement*, in *La Revue blanche* 24 (1901)

Il n'y a que deux manières de savourer comme il convient de très beaux vers qui chantent des joies très infâmes: il faut se les faire lire par une adolescente, vierge s'il se peut et de préférence fille d'anciens rois; ou bien, si l'on n'a pas à sa disposition de lectrice vierge née d'une dynastie immémoriale, on peut méditer seul les poèmes, à même un exemplaire de grand format, imprimé avec des caractères neufs, fondus dans des matrices vénérables. Il est indispensable que ces caractères soient amples, et imposent l'idée d'une stabilité immuable, comme d'une architecture. Les poinçons gravés par Garamond sur l'ordre de François Ier répondent à ces exigences, et font la typographie de *Parallèlement* aussi définitive qu'une inscription sur une porte d'enfer. Ils permettent de lire comme on déguste ou plutôt comme on digère, en passant avec toute la temporisation requise au long de la caresse de chacune de leurs courbes.

Et comme il est dans l'ordre naturel qu'après avoir fixé quelque figure nette, l'oeil reste obsédé de contours identiques quoique de couleur complémentaire, il est impossible de s'interrompre de suivre les arabesques voluptueuses du texte pour se fourvoyer vers le blanc des marges, sans être poursuivi, agréablement d'ailleurs, par des imaginations de choses arrondies: de petites femmes et de petites filles, de chairs blondes et de boucles noires, de joues, de ventres, de seins et de cuisses… Mais nulles rêveries, fussent-elles d'un bibliophile, ne suggéreraient la beauté et la grâce que réalisent les lithographies de Pierre Bonnard. Ses crayonnages légers dans les marges semblent les propres fantômes qui s'évoquent des rythmes à mesure de la lecture, assez diaphanes pour ne point empêcher de lire. C'est la première illustration que l'on publie, qui soit tout à fait adaptée à un livre de vers. Pierre Bonnard est le peintre de la grâce, des femmes frileuses, des petits enfants, quoiqu'il construise, quand il lui plaît, le beau ou le grotesque, cette autre forme du gracieux. Avec une légèreté admirable, il a mollement culbuté sur les draps candides des pages ces êtres, féminins ou enfantins, ou ces jeunes animaux, les petites Amies qui jouent à la grande Sappho.

Clément-Janin on *Parallèlement*, in *Almanach du bibliophile* (1901)

Dirai-je que je n'aime guère de *Parallèlement*, que le caractère choisi, de l'italique de Garamond, bien que sa noblesse ne s'accorde que de très loin avec le

sentiment de Verlaine. Soit! Mais, que dirai-je des incertaines illustrations de
M. P. Bonnard, qui ne paraît pas s'être rendu compte que "l'indécis" en lit-
térature et "l'indécis" en dessin sont deux choses bien différentes, et que si
"l'indécis" poétique se rachète par la musique des mots, "l'indécis" plas-
tique se rachète uniquement par la couleur. Couleur, musique, sentiment,
c'est tout un. Mais l'incertitude des lignes à elle seule ne donne que l'impres-
sion de l'inexistant, et telle est bien celle que l'on éprouve devant la plupart
des balbutiements de M. Bonnard. Ajoutons que le procédé employé est la
lithographie et que si une préoccupation typographique se voit dans le mé-
nagement des blancs, par contre la mise en pages révèle la plus ingénue igno-
rance des proportions, des conditions inéluctables du livre, et, ce qui est non
moins grave, la plus complète aberration du goût. Je n'en veux pour preuve
que le ton groseille des lithographies, et leur fuite générale vers la couture du
volume ou vers son sommet. Que n'ont-elles fui davantage? *Parallèlement* eût
été fort acceptable avec son texte seul.

Clément-Janin on *Daphnis et Chloé,* in *Almanach du bibliophile* (1902)

M. Bonnard, après le Régent, Gérard, Prudhon, Raph. Collin, E. Lévy, etc., a
entrepris d'illustrer ce chef-d'oeuvre immortel et de se mesurer, à son tour,
avec les descriptions très précises de Longus, colorées encore par la langue
du "bon Amyot."

De la couleur, M. Bonnard en a, il faut le reconnaître. Ses lithographies
parcourent avec légèreté la gamme du noir au blanc, sachant appuyer où il
faut, glisser où cela convient mieux. Du dessin, l'artiste en a moins, il se con-
tente trop souvent d'un croquis sommaire, parfois insignifiant et à ce point
quelconque, qu'on pourrait l'employer dans n'importe quel ouvrage. C'est
de l'illustration *interchangeable*, renouveau d'usages que l'on croyait périmés.
Néanmoins, nombre de croquis ont un intérêt et un charme menus. Tel por-
trait de Chloé, telle scène où les deux innocents se baisent sur la bouche, telle
attitude, tel geste, exactement notés et fins, révèlent l'émotion artiste, la
seule chose qui compte en art. Mais des croquis, toujours des croquis, est-ce
suffisant? On sent,—ici et ailleurs,—que M. Bonnard est incapable d'aller au
delà, de donner à sa pensée une formulation plus complète.

Daphnis est en progrès sur *Parallèlement,* même au point de vue du livre.
Bien que le procédé soit la lithographie, un grand souci est manifesté de la
rendre typographique par l'exclusion des teintes. Notons encore que les
compositions sont équilibrées, les marges respectées, qu'il n'y a pas de pages
vides et que le volume est composé en Grandjean. Vous voyez que M. Vol-
lard s'assagit et qu'à l'encontre de beaucoup de ses confrères, il ne craint pas
d'évoluer.

NOTES

1 AN ART FOR EVERYDAY

1. The principal catalogues of Bonnard's prints and illustrations are by Jean Floury (in C. Terrasse 1927), Claude Roger-Marx (1952), Francis Bouvet (1981), and Antoine Terrasse (1989).

2. "Quand on est jeune, on s'enthousiasme pour un endroit, pour un motif, pour la chose de rencontre. . . . Plus tard on travaille autrement, guidé par le besoin d'exprimer un sentiment." Hedy Hahnloser-Bühler, *Félix Vallotton et ses amis* (Paris, 1936) pp. 93–94; trans. in Rewald 1948, p. 56.

3. Quoted in Raymond Cogniat, *Bonnard*, trans. Anne Ross (New York, [1968]) p. 16.

4. See Charles Terrasse, "Bonnard: An Intimate Memoir of the Man and Artist Revealed by His Nephew," *Art News Annual* 28 (1959) pp. 87–107; noted by Helen E. Giambruni, "Bonnard's Lithographs," M.A. thesis (University of California, Berkeley, 1966) p. 3.

5. Exhibition records indicate that Bonnard showed prints as follows:
La Libre Esthétique, Brussels, February 17, 1894: *Family Scene*, 1893, among prints from *L'Estampe originale*;
Le Barc de Boutteville, 47 rue Le Peletier, Paris, "Sixième Exposition des Peintres Impressionnistes et Symbolistes," March 2, 1894, no. 15: "Estampe en couleur";
Galerie Laffitte, 20 rue Laffitte, Paris, May 10–June 10, 1895: the posters for France-Champagne and *La Revue blanche*; *Petit Solfège illustré*; and *Petites Scènes familières*;
"Centenaire de la Lithographie," Paris, September 1895, nos. 1012, 1013: ten lithographs from *Petites Scènes familières*;
Galeries Durand-Ruel, 11 rue Le Peletier and/or 16 rue Laffitte, Paris, "Exposition P. Bonnard," January 6–22, 1896, nos. 50–54: the posters for France-Champagne and *La Revue blanche*; *Petit Solfège illustré*; the folding screen *Promenade* as "Paravent"; and "Deux Cadres de lithographies" (probably proofs from *Petites Scènes familières*);
Galerie Vollard, 6 rue Laffitte, Paris, "Les Peintres-Graveurs," June 15–July 20, 1896: *La Petite Blanchisseuse*;
La Libre Esthétique, Brussels, February 25–April 1, 1897: the folding screen *Promenade*;
Galerie Vollard, 6 rue Laffitte, Paris, March 1899: *Quelques Aspects de la vie de Paris*.

6. Maurice Denis, "Pierre Bonnard," *Le Point* 4:24 (1943) p. 4.

7. See Burhan 1979, p. 231: "There is, in fact, every reason to believe that the title was chosen by these young painters as a reference to Islamic traditions, since whenever Sérusier signed a canvas 'Nabi,' . . . he wrote the word out in Arabic script."

8. See Bradford Ray Collins, Jr., "Jules Chéret and the Nineteenth-Century French Poster," Ph.D. diss. (Yale University, 1980).

9. The history of this enterprise and the commissioning of works by the Nabis (including Bonnard's creation of a design for a stained-glass window executed by Louis Comfort Tiffany) are traced in Gabriel P. Weisberg, *Art Nouveau Bing; Paris Style 1900*, exh. cat. (New York, 1986).

10. Douglas Druick and Peter Zegers, *La Pierre Parle: Lithography in France, 1848–1900*, exh. cat. (Ottawa, 1981) p. 101.

11. Quoted in A. Terrasse 1967, p. 23: "Notre génération a toujours cherché les rapports de l'art avec la vie." Letter from Bonnard to Claude Roger-Marx, January 7, 1923 (Roger-Marx, p. 11): "A cette époque, j'avais personnellement l'idée d'une production populaire et d'application usuelle: gravures, meubles, éventails, paravents, etc." Translations unless otherwise attributed are by the author and the editor.

12. Charles Rearick, *Pleasures of the Belle Epoque: Entertainment and Festivity in Turn-of-the-Century France* (New Haven/London, 1985) p. 75.

13. Two of Richepin's lines are quoted (among others) in Boyer 1988, p. 20: "Her nose and her fingers are pincushions for the needles of the cold winds. What is that dark and trembling creature, sobbing on the white sidewalk?"

14. In a letter to his actor friend Lugné-Poe, who was doing his military service toward the end of 1890, Bonnard wrote, "I may go with Vuillard to see a music publisher, but I do not expect any success as yet in that direction." From Aurélien Lugné-Poe, *La Parade: I. Le Sot du tremplin: Souvenirs et impressions du théâtre* (Paris, 1930) pp. 242–243; quoted in Rewald 1948, p. 17.

15. Seventy-two drawings for *Petit Solfège illustré* were auctioned at the Hôtel Drouot, Paris, on May 10, 1962, lot 29, when they were purchased by New York dealers Peter Deitsch and Lucien Goldschmidt.

16. Another example is Bonnard's double-sided study of a woman putting on her stockings, a preparatory drawing for an illustration in Peter Nansen's novel *Marie* (1897), in the collection of E. W. Kornfeld, Bern.

17. Quoted in J. Daurelle, "Chez les jeunes peintres," *Echo de Paris* (December 28, 1891), p. 2; cited in Giambruni 1983, pp. 300–301 n. 76: "Je ne suis d'aucune école. Je cherche uniquement à faire quelque chose de personnel."

18. Natanson 1948, p. 320: "Mallarmé fut l'admiration profonde de la maturité de Bonnard et jusqu'à la vieillesse il l'a lu, relu, vers à vers, ligne à ligne."

19. Angèle Lamotte, "Le Bouquet de roses; Propos de Pierre Bonnard recueillis en 1943," *Verve* 5:17–18 (1947) pp. [75–77]; quoted in Rewald 1948, p. 40.

20. Quoted in Roy McMullen, *Degas: His Life, Times, and Works* (Boston, 1984) p. 35.

21. References to contemporary studies of associative phenomena and the science of aesthetics are given in Burhan 1979, pp. 95–113.

22. See Colta Feller Ives, *The Great Wave: The Influence of Japanese Woodcuts on French Prints* (New York, 1974).

23. Letter of January 4, 1946, to Mme Hedy Hahnloser, quoted in Annette Vaillant, *Bonnard*, trans. David Britt (Greenwich, Conn., 1966) p. 182.

24. Quoted in A. Terrasse 1967, p. 24: "Je remplis les murs de ma chambre de cette imagerie naïve et criarde" (Bonnard to Gaston Diehl); and ibid., p. 10: "Il m'apparut qu'il était possible de traduire lumière, formes et caractère rien qu'avec la couleur, sans faire appel aux valeurs."

25. The aspect of Japanese influence is

effectively explored in Perucchi-Petri 1976, pp. 29–96.

26. Ker-Xavier Roussel's color lithograph on this theme, *L'Education du chien*, was published in *L'Estampe originale* in 1893. See Donna M. Stein and Donald H. Karshan, *L'Estampe originale: A Catalogue Raisonné*, exh. cat. (New York, 1970) no. 76, pl. 7.

27. A. Terrasse 1989, 59. Bonnard had already designed a cover for *Verve*, in 1938 (ibid., 52).

28. Bonnard's contributions are listed in the two principal works regarding the publications of *La Revue blanche*: Fritz Hermann, *Die Revue blanche und die Nabis* (Munich, 1959) pp. 571–572, 582; and A. B. Jackson, *La Revue blanche (1889–1903): Origine, influence, bibliographie* (Paris, 1960) pp. 176, 281–282. See also Bouvet 30–34 and A. Terrasse 1989, 8, 11, 13–15.

29. Letter dated April 13, 1897, in Rewald 1943, p. 311.

30. Robert T. Wang, "The Graphic Art of the Nabis, 1888–1890," Ph.D. diss. (University of Pittsburgh, 1974) p. 210.

31. Letter dated September 4, 1896, in Rewald 1943, p. 294.

32. Pat Gilmour, "Cher Monsieur Clot... Auguste Clot and His Role as a Colour Lithographer," in *Lasting Impressions: Lithography as Art*, ed. Pat Gilmour (Philadelphia, 1988) p. 133.

33. The dates Bonnard inscribed on the lithography stones of *La Petite Blanchisseuse* and on the Galerie Vollard poster were evidently altered from 95 to 96. It is likely, therefore, that both works were begun in 1895, and they may have originated with plans for the aforementioned publication, *L'Estampe moderne*. The poster design seems to derive from Eugène Grasset's 1887 poster for *Librairie romantique*, which is illustrated in Anne Murray-Robertson, *Grasset, pionnier de l'Art Nouveau* (Paris/Lausanne, 1981) p. 106.

34. The change of title was probably to avoid confusion with the Société de Peintres-Graveurs Français, the sixth of whose intermittent exhibitions was mounted in April 1897.

35. Pissarro to his son Lucien (July 1, 1896) in Rewald 1943, p. 291.

36. Una E. Johnson, *Ambroise Vollard, Editeur: Prints, Books, Bronzes*, exh. cat. (New York, 1977) p. 20: "He [Vollard] thought nothing of holding individual prints for such time as they might be fitted into an album. This practice is reflected in the extensive Vollard archives at Winterthur, which contain prints that were never published in editions." Although, according to notices in *L'Estampe et l'affiche* (April 15,

1899), Vollard included color lithographs by Roussel in his March 1899 exhibition, he never published Roussel's set of twelve prints in an edition.

37. Natanson 1948, p. 321. See chapter 3 below, note 75.

38. Clot is also pictured in a snapshot Bonnard took around 1900. See Heilbrun and Néagu 158.

39. The most complete source of information regarding Clot's activity is Gilmour, "Cher Monsieur Clot," pp. 129–182, 382–391. According to Pat Gilmour (letter to the author), in the later stages André Clot, Auguste's son, is likely to have been more involved in the printing.

40. Unpublished letter, no. 39 Ab (undated), among those from Bonnard to Clot owned by the printer's grandson, Dr. Guy Georges, copies of which were kindly provided by Pat Gilmour: "Cher Monsieur Clot, Seriez vous assez gentil pour me préparer 2 feuilles de papier report pour mes derniers dessins et de me les faire porter par votre boy dès qu'elles seront prêtes. Cela ne m'occupera pas de passer un de ces jours à l'imprimerie. à vous. Bonnard."

41. Letter from Bonnard to Claude Roger-Marx, January 7, 1923 (Roger-Marx, p. 11): "J'ai travaillé avec Clot qui facilitait beaucoup l'exécution par sa souplesse." There is a note from Bonnard to Clot which contains a diagram correcting the placement of the frontispiece in *Daphnis et Chloé* (see Gilmour, "Cher Monsieur Clot," p. 146).

42. See Phillip Dennis Cate and Sinclair Hamilton Hitchings, *The Color Revolution: Color Lithography in France, 1890–1900*, exh. cat. (New Brunswick, N.J., 1978), which contains Margaret Needham's translation of Mellerio's essay, pp. 77–97.

43. Ibid., p. 91.

44. There is, for example, an unusually acidic green impression of *Le Canotage* in the Fogg Art Museum, Cambridge, Mass., and an unusually beige impression of *Houses in the Courtyard* in the National Gallery, Washington, D.C. (cf. figs. 29, 2).

45. Quoted in A. Terrasse 1967, p. 44: "J'ai beaucoup appris au point de vue peinture en faisant de la lithographie en couleurs. Quand on doit étudier les rapports de tons en jouant de quatre ou cinq couleurs seulement qu'on superpose ou qu'on rapproche, on découvre beaucoup de choses."

46. Antoine Terrasse, "Bonnard's Notes," in Newman 1984, p. 52.

47. Quoted in A. Terrasse 1967, p. 94: "Quand mes amis et moi voulûmes poursuivre les recherches des Impressionnistes et tenter de les développer, nous cherchâmes à les dépasser dans leurs impres-

sions naturalistes de la couleur. L'art n'est pas la nature. . . . Il y avait aussi beaucoup plus à tirer de la couleur comme moyen d'expression."

48. See Eleanor M. Garvey, "Art Nouveau and the French Book of the Eighteen-Nineties," *Harvard Library Bulletin* 12 (1958) pp. 375–391. Acknowledging the important role of the English designers as models for the French, Garvey points to Denis's innovative illustrations for Verlaine's *Sagesse* (executed in 1889 but not published until 1911).

49. Camille Pissarro wrote to Lucien on July 1, 1896 (Rewald 1943, p. 291): "Vollard also asked me whether you would do a book by Verlaine for him. He intends to write to you about this himself when the time comes." The invitation is discussed by Una E. Johnson, *Ambroise Vollard, Editeur, 1867–1939: An Appreciation and Catalogue* (New York, 1944) pp. 18–19.

50. Clément-Janin, review of *Parallèlement* in "Les Editions de bibliophile," *Almanach du bibliophile* (1901) pp. 245–246. The text of this review is given in the Appendix following chapter 4.

51. Denis 1920, p. 11 (quoted in Garvey, "Art Nouveau," p. 382): "L'illustration, c'est la décoration d'un livre . . . sans servitude du texte, sans exacte correspondance de sujet avec l'écriture; mais plutôt une broderie d'arabesques sur les pages, un accompagnement de lignes expressives."

52. The edition of 250 copies was printed entirely in black ink. Additional suites of the illustrations were printed in color—10 in rose and 40 in blue—and distributed with the first 50 numbered volumes.

53. Camille Pissarro to his son Lucien, March 3, 1900 (Rewald 1943, p. 339): "Yesterday Vollard showed me a galley for a volume of Verlaine . . . illustrated by Bonnard (a young artist). . . . Denis (the painter) is going to do *Daphnis and Chloe* with woodcuts." An English edition of the book illustrated with woodcuts by Charles Shannon and Charles Ricketts had been published in London in 1893.

54. Quoted in Marguette Bouvier, "Pierre Bonnard revient à la litho...," *Comoedia* 82 (January 23, 1943) p. 1: "Je travaillai rapidement, avec joie. . . . avec une sorte de fièvre heureuse qui m'emportait malgré moi."

55. Nicolas Rauch, *Les Peintres et le livre, 1867–1957* (Geneva, 1957) pp. 34–36. One of these drawings was auctioned at the Hôtel Drouot, Paris, in the sale of December 15, 1978, lot 57. Six others were sold at Christie's, London, April 4, 1989, lots 318A–323. See also A. Terrasse 1989, pp. 156–161. In an undated letter (presumably ca. 1909–10) in the archives of Hubert Prouté, Paris, Bonnard writes to Barrucand regretting that he

cannot supply another drawing to match the style of those done earlier: "Mon cher Barrucand, Je n'avais pas compris que le tirage était si près de se faire. J'aurais écrit plus tôt. Servez vous de mes dessins suivant votre idée. Mais je ne serais pas capable d'en faire un nouveau qui s'accorde avec les anciens. Cela n'irait pas. Tout à vous. Bonnard."

56. These commissions are listed in Bouvet and A. Terrasse 1989. In 1945 Bonnard prepared a drawing in lithographic crayon on transfer paper as a frontispiece to the revised catalogue of his prints by Marcel Guérin and J. R. Thomé that Jean Floury, his nephew by marriage, planned to publish. The drawing, which shows a child near a doorway, is now in the collection of Virginia and Ira Jackson, Houston, along with correspondence relating to the catalogue project, which foundered after Guérin's death in 1948.

57. Quoted in Bouvier, "Pierre Bonnard revient à la litho," p. 1: "Voilà dix ans que j'ai lâché la gravure et la pierre lithographique. C'est avec plaisir que j'envisage de les reprendre." In 1944 Bonnard prepared a group of lithographs on zinc for an unpublished text by André Beucler; see Bouvet 129, and Gaston Diehl, "Fidélité de Bonnard," Comoedia (April 15, 1944). In 1946 twenty-four transfer lithographs appeared as illustrations for Le Crépuscule des nymphes by Pierre Louÿs, published by Editions Pierre Tisné, Paris (Bouvet 128).

58. Bouvet 116–126. The preliminary gouache drawings are dispersed. Working proofs of two of the prints are now in the New York Public Library.

2 DOMESTIC SCENES

1. On the Symbolist movement in general see A. G. Lehmann, The Symbolist Aesthetic in France, 1885–1895 (Oxford, 1950); and Burhan 1979. On Symbolist art see Robert Goldwater, Symbolism (New York, 1979); H. K. Rookmaaker, Gauguin and Nineteenth Century Art Theory (Amsterdam, 1972); and Sven Loevgren, The Genesis of Modernism: Seurat, Gauguin, Van Gogh and French Symbolism in the 1880's, rev. ed. (Bloomington/London, 1971).

2. Gustave Coquiot, Bonnard (Paris, 1922) p. 8, based on an interview with the artist; and C. Terrasse 1927, p. 16. Bonnard first attended the Lycée de Vanves, then the Lycée Charlemagne in Paris, followed by the Lycée Louis-le-Grand for a brief period, then back to Charlemagne, from which he obtained his baccalauréat in about 1886. A

statement from the archivist of Louis-le-Grand dated August 24, 1980, indicates that Bonnard attended that ancient and exclusive Parisian institution only from January 1, 1884, to the end of June 1884. Enrolled in the philosophy class, he had middling grades. His address was listed as 94 boulevard d'Enfert—probably a pension; the tradition of boarding most pupils either at the lycées themselves or in pensions was a long one, although a rapid movement toward a predominance of day pupils was then under way. In Bonnard's time, despite some amelioration of conditions, lycées were still places of harsh discipline and long hours of silent, sedentary work. Louis-le-Grand abandoned Napoleonic military discipline and punishment by solitary confinement in a prison cell only in 1890, after Bonnard had left. See Philippe Ariès, Centuries of Childhood: A Social History of Family Life, trans. Robert Baldick (New York, 1962) pp. 266–267, 280–285.

3. On economic and political conditions in Le Grand-Lemps and the surrounding area see Pierre Barral, Le Département de l'Isère sous la Troisième République, 1870–1940: Histoire sociale et politique, Cahiers de la fondation nationale des sciences politiques 115 (Paris, 1962) pp. 40–42, 46, 65, 130–131, 503. Barral reports that until 1870 much of Isère was greatly isolated, reachable only by mule, and that deep poverty and "very bad" material conditions remained common in the area until about 1900. Between 1851 and 1936 Le Grand-Lemps lost about 24 percent of its population.

4. Information provided by the mayor of Le Grand-Lemps from the town archives: "La propriété 'Le Clos' appartenait à la famille Bonnard au XIXe siècle. On trouve: Michel Bonnard, marchand de grains, en 1850, grand-père de Pierre, et François Bonnard, prêtre, tous deux propriétaires."

5. Natanson 1951, p. 28. Marthe de Méligny was an assumed name; her legal name, then unknown to Bonnard, was Maria Boursin.

6. Pierre Bonnard, Correspondances (Paris, 1944) p. 7: "Me voici installée au clos devançant tout le monde. Je me trouve bien à la campagne. Pour le moment j'écosse des petits pois nouveaux dans la salle à manger le chien à mes pieds et les deux chats sur la table. J'entends souffler, c'est la vache qui montre sa grosse tête à la fenêtre. La petite bonne crie au dehors 'Joseph le veau qu'est détaché.' // Dis à ta mère que tout va bien et que je surveille le potager." Translations not otherwise attributed are by the author. Handwritten letters are sometimes difficult to decipher and punctuation is often missing or eccentric. I am grateful to Catherine Gillot and Mary Laing for their advice.

7. Bonnard, Correspondances, p. 77: "Enfin

je suis arrivé et j'espère que dimanche prochain tu auras ta permission et que nous serons tous réunis. Chaleur formidable—on fait trempette les petits dans le bassin devant la maison et les grands dans la boutasse. C'est charmant le bain des gosses. Des fruits il y en a des masses. Maman fait son tour toutes les après-midi avec son panier. C'est gentil aussi de voir la cousine dans le grand pêcher au milieu des branches et du ciel bleu." According to Heilbrun and Néagu, p. 117, there were nine small pools on the grounds of Le Clos, one of them—in the kitchen garden—called the boutasse.

8. On Bonnard's need for autonomy see René-Marie [Francis Jourdain], "Bonnard et son époque," Le Point 4:24 (1943) p. 23; and Natanson 1948, pp. 323–325. On his responses in argument see Maurice Denis, "L'Epoque du symbolisme," Gazette des Beaux-Arts, 6th ser., 11 (1934) p. 178; Maurice Denis, "Pierre Bonnard," Le Point 4:24 (1943) p. 5; André Fontainas, Mes Souvenirs du symbolisme (Paris, 1928) p. 104; Natanson 1948, p. 320; and Natanson 1951, pp. 19–21, 32, 51. Thadée Natanson, director and art critic of La Revue blanche, one of Bonnard's first collectors and a friend for over fifty years, was the most sensitive and reliable witness to the complexities of the artist's personality.

9. In Pierre Courthion, "Impromptus: Pierre Bonnard," Les Nouvelles littéraires (June 24, 1933); photograph of article reproduced in A. Terrasse 1967, p. 205. Bonnard told an interviewer that he could no longer work in Paris because of the noise and distractions, and that he had always found life there difficult.

10. The painting was first shown at the exhibition of Les Indépendants in 1892, where it was entitled Crépuscule; see Gustave Geffroy, "Les Indépendants" (March 29, 1892) in idem, La Vie artistique (Paris, 1893) II, pp. 372–373: "M. Bonnard . . . expose un Crépuscule où des femmes ondulent en une danse délicieuse, sur une pelouse, au fond d'un paysage de lumière presque éteinte." In a group show at the Galeries Bernheim-Jeune in 1899 the work was again shown under the name Crépuscule. The origin of the later title is unknown. As the work remained in Bonnard's private collection until his death, perhaps it was the choice of his executors.

11. Perucchi-Petri 1976, p. 69. Paul Verlaine, "Nuit du Walpurgis classique," Choix de poésies (Paris, 1961) p. 25: "S'entrelacent soudain des formes toutes blanches, / Diaphanes, et que le clair de lune fait / Opalines parmi l'ombre verte des branches, / S'entrelacent parmi l'ombre verte des arbres / . . . Puis . . . / Très lentement dansent en rond."

12. The theory of correspondences or

"equivalents," referring to the associational process known as "synesthesia," has been seen as deriving from the Romantics and Baudelaire (see Rookmaaker, *Gauguin*, pp. 19–26; and Lehmann, *Symbolist Aesthetic*, pp. 207–215, 260–271). However, a more immediate founding of such beliefs in the instruction in psychology given by contemporary lycées is suggested in Burhan 1979, pp. 57–171. I am grateful to Sasha Newman for bringing this work to my attention.

13. See Ariès, *Centuries of Childhood*, pp. 128–133, 398–404; Priscilla Robertson, "Home as a Nest: Middle Class Childhood in Nineteenth Century Europe," in Lloyd deMause, ed., *The History of Childhood* (New York, 1974) pp. 407–431; and Carol Duncan, "Happy Mothers and Other New Ideas in French Art," *Art Bulletin* 55 (1973) pp. 570–583.

14. Maurice Denis, "Préface de la IXe exposition des peintres impressionnistes et symbolistes," in Denis 1920, pp. 28–29; and idem, "Définition du néo-traditionnisme," sec. 20 in ibid., pp. 9–10. See also the critic-advocate of Gauguin and the Nabis, G.-Albert Aurier, "Les Peintres symbolistes," *La Revue encyclopédique* (April 1892), reprinted in idem, *Oeuvres posthumes* (Paris, 1893) p. 303. For an analysis of these ideas see Giambruni 1983, pp. 40–60, 263–270.

15. Undated letter to Maurice Denis, in Paul Sérusier, *L'ABC de la peinture, suivi d'une correspondance inédite recueillie par Mme Paul Sérusier et annotée par Mlle Henriette Boutaric* (Paris, 1950) pp. 43–44. (Difficult to date precisely, the letter is most often thought to have been written in the summer of 1889.)

16. Bonnard to Gaston Diehl, quoted in A. Terrasse 1967, p. 24: "Gauguin, Sérusier se référèrent en fait au passé. Mais là ce que j'avais devant moi c'était quelque chose de bien vivant, d'extrêmement savant."

17. Ibid.: "il était possible de traduire lumière, formes et caractère rien qu'avec la couleur, sans faire appel aux valeurs."

18. Maurice Denis, "Pour l'art sacré," 1918 lecture, reprinted in idem, *Nouvelles Théories sur l'art moderne et sur l'art sacré, 1914–1921* (Paris, 1922) p. 179: "L'artiste, placé devant la nature ou plutôt devant l'émotion qu'elle lui fournit, doit la traduire avec excès à l'exclusion de tout ce qui ne l'a pas frappé, en faire un schéma expressif. Tout lyrisme lui est permis: il doit pratiquer la métaphore comme un poète."

19. This painting, which reveals Gauguin's influence, was done while Gauguin was visiting van Gogh in Arles.

20. The definitive study of Japanese influence on Bonnard's work is Perucchi-Petri 1976, pp. 29–96. See also Galeries nationales du Grand Palais, *Le Japonisme*, exh. cat.

(Paris, 1988) pp. 40–41, 205, 210–211; Gabriel P. Weisberg et al., *Japonisme: Japanese Influence on French Art, 1854–1910*, exh. cat. (Cleveland, Ohio, 1975) pp. 53–156; Colta Feller Ives, *The Great Wave: The Influence of Japanese Woodcuts on French Prints* (New York, 1974) pp. 56–78; Siegfried Wichmann in Haus der Kunst, *World Cultures and Modern Art*, exh. cat. (Munich, 1972) pp. 91–143; and Chisaburoh F. Yamada in ibid., pp. 143–148.

21. The set contains 22 drawings, 6 in watercolor and 16 in ink. Two drawings are accompanied by printed programs bearing the dates February 3, 1891, and March 21, 1891. See Carlton Lake, *Baudelaire to Beckett: A Century of French Art and Literature. A Catalogue of Books, Manuscripts, and Related Material Drawn from The Collections of the Humanities Research Center* (Austin, 1976) p. 35, no. 52.

22. See Perucchi-Petri 1976, pp. 79–80.

23. Perucchi-Petri 1976, pp. 88–89, compares this work to a print by Utagawa Kuniyoshi that was previously in the collection of Maurice Denis.

24. Duranty wrote in *La Chronique des arts* in January 1879 that Walter Crane's drawings were "incomparable in their field" (quoted in Alfred de Lostalot, "Les Livres en couleur publiés en Angleterre, pour l'enfance," *Gazette des Beaux-Arts*, 2nd ser., 25 [1882] p. 72). See also J.-K. Huysmans, "Le Salon officiel de 1881," in idem, *L'Art moderne* (Paris, 1883) pp. 190–210; Charles Blanc, chapter on children's albums in idem, *Grammaire des arts décoratifs* (Paris, 1882); and Louis Gonse, "Les Livres en couleurs," *Gazette des Beaux-Arts*, 2nd ser., 29 (1884) pp. 87–88.

25. On children's book illustration see Rolf Söderborg, *French Book Illustration, 1880–1905*, trans. Roger Tanner (Stockholm, 1977) pp. 77–80; Isobel Spencer, *Walter Crane* (New York, 1975) pp. 181–191; and Marion Durand and Gérard Bertrand, *L'Image dans le livre pour enfants* (Paris, 1975) pp. 24–30.

26. An influential pre-Symbolist discussion of line and color as meaningful abstraction in a context of decoration may be found in Ogden N. Rood, *Théorie scientifique des couleurs* (Paris, 1881) pp. 264–265, 269–271 (orig. publ. as *Modern Chromatics* [New York, 1879]). Rood differentiated between the goal of painting, which he saw as naturalistic representation, and decoration, in which color is its own end and the ornamented surface is not the representation of an absent object but is itself the beautiful object; decided contour lines, he said, not only emphasize decoration's nonrealistic intent, they also form a separate and potentially expressive decorative element. Related ideas were later expressed in Félix Bracque-

mond, *Du dessin et de la couleur* (Paris, 1885); Charles Henry, *Introduction à une esthétique scientifique* (Paris, 1885), and idem, *Cercle chromatique* (Paris, 1888); Téodor de Wyzewa, "L'Art wagnérien: II. La Peinture," *La Revue wagnérienne* (May 1886) pp. 10–24; and Edouard Dujardin, "Le Cloisonnisme," *La Revue indépendante* 6 (March 1888) pp. 487–492.

27. See Giambruni 1983, chap. 3, "Line and Color: Commercial Graphics and Early Lithographs," pp. 77–97.

28. According to Spencer, *Walter Crane, 1975*, p. 181, Crane's Toy Books were published in France by Hachette. Hachette also published numerous books by Greenaway in French translation, beginning in 1863 and continuing into the 1890s.

29. Charles M. Widor, *Vieilles Chansons et rondes pour les petits enfants* (Paris, [1883–84]). This first children's book illustrated by Boutet de Monvel is usually dated to 1884, but as Gonse referred to it in January 1884 (see note 24), it was probably published in 1883. J.-B. Weckerlin, *Chansons de France pour les petits français* (Paris, n.d.), is another, slightly later book with illustrations by Boutet de Monvel that suggest Bonnard's.

30. Letter from a private collection: "Je ne sais pas comment je tire quelque chose de mon Solfège. Il faut que je pense aux décorateurs de missel des temps passés ou bien aux japonais mettant de l'art dans des dictionnaires encyclopédiques pour me donner du courage." I am grateful to Sasha Newman for acquainting me with this and other letters and for making them available to me.

31. Although these illustrations have never been included among Bonnard's lithographs, the printer's invoice states that the drawings were lithographed and the text done in "typo:litho," while an accompanying letter mentions that the stones had been effaced; for reproductions of the invoice and letter see A. Terrasse 1989, p. 24.

32. Letter from a private collection: "Dix jours chez mon beau frère où j'ai fait du canotage à voile et de l'imprimerie pour cette dernière opération je me transportais à Bordeaux. J'en attends à l'heure qu'il est des épreuves dernières modifications de celles que j'ai obtenues à Bordeaux et qui étaient satisfaisantes. Pourvu mon dieu qu'ils n'aient pas tout éreinté. . . . Je croyais pouvoir commencer de suite la grande flemme. J'avais compté sans les compagnies de chemin de fer qui m'ont perdu ma malle. . . . Ce qui m'ennuie c'est que j'ai dans cette malle une peinture et tous les dessins du Solfège. Aussi je suis décidé—si je ne rentre pas en possession de mon bien à réclamer une indemnité sérieuse." See chapter 1, note 15.

33. Letter from a private collection: "Je ne peux pas non plus vous raconter les péripéties de la confection de cet ouvrage il en tiendrait plusieurs volumes. Ce qu'il y a de [sûr?] c'est que toutes mes vacances y ont passé et à l'heure qu'il est je ne peux pas encore rentrer à cause de ce malheureux bouquin. Dans une première tentative—car il y en a plusieurs nous avons été jusqu'à faire fonctionner nous mêmes mon beau frère et moi la machine à imprimer malheureusement nous en sommes revenu à nous confier à un imprimeur très bien outillé. Que le ciel nous soit en aide! Donc encore maintenant je blanchis mes cheveux à obtenir l'impossible de l'imprimeur."

34. Letter reproduced in A. Terrasse 1989, p. 24.

35. Letters from a private collection: Claude Terrasse to Pierre Bonnard, November 2, 1894, November 9, 1894, and [December 27, 1894?]; Allier to Bonnard, January 4, 1895. Bonnard's letters, if they still exist, have not been made available, but their general tenor may be deduced in part from the above.

36. "Qu'est-ce que battre la mesure?" ("What is beating time?") on page 18 combines elements from at least two, much livelier, preliminary drawings: "Comment marque-t-on le temps?" ("How does one mark time?") and "Chapitre de la mesure" ("Chapter on Measure"). Also, for all its charm and its undoubtedly greater clarity of content, "Durée des sons" ("Duration of Tones") on page 12 is less successful as an imaginative composition than its surviving sketch (see fig. 76).

37. Boyer 1988, pp. 24, 26, suggests convincingly that Bonnard drew on an illustration from the popular magazine La Caricature for the contorted female silhouettes in this work.

38. I rely in this discussion on the section "Late Nineteenth Century Theories About the Aesthetic Production of Children and Primitive Man" in Burhan 1979, pp. 237–259.

39. Quoted in Burhan 1979, p. 250: "Les images d'Epinal le rendront fou de joie, et les toiles d'un maître ne lui diront rien."

40. Maurice Denis, "L'Influence de Paul Gauguin," in Denis 1920, p. 162: "que toute oeuvre d'art était une transposition, une caricature, l'équivalent passionné d'une sensation reçue."

41. Van Gogh reported this in a letter to his brother. See Vincent van Gogh, The Complete Letters of Vincent van Gogh (Greenwich, Conn., 1958) III, letter 527, p. 20.

42. Daniel Théote, "Pierre Bonnard," Tricolor 1:1 (April 1944) p. 89.

43. Meyer Schapiro, "Courbet and Popular Imagery," Journal of the Warburg and Courtauld Institutes 4 (1941), reprinted in idem, Modern Art: Nineteenth and Twentieth Centuries (New York, 1978) pp. 46–65.

44. Stéphane Mallarmé, "The Impressionists and Edouard Manet," Art Monthly Review and Photographic Portfolio (September 30, 1876), as quoted and discussed in Seymour Howard, "Manet, 'The Absinthe Drinker,' 1859: Foundations of Anti-illusion and Unconscious Image Formation in Modern Painting," in Seymour Howard, ed., The Counterpoint to Likeness: Essays on Imitation and Imagination in Western Painting (Davis, Calif., 1977) pp. 39–40, n. 20.

45. Letter to Maurice Denis (written from Pouldu, [1889]), in Sérusier, ABC de la peinture, suivi d'une correspondance inédite, pp. 44–45: "si on néglige de s'en occuper spécialement elle deviendra d'autant plus personnelle qu'elle sera maladroite." See also Maurice Denis, "Aristide Maillol," in Denis 1920, p. 242: "J'appelle gaucherie cette sorte de maladroite affirmation par quoi se traduit, en dehors de formules admises, l'émotion personnelle d'un artiste."

46. Natanson 1951, p. 200.

47. Galerie Beyeler Bâle, Bonnard, exh. cat. (Basel, 1966) n.p.: "Les défauts sont quelquefois ce qui donne la vie à un tableau." The quotation is from the artist's notebook.

48. On upbringing and education as a measure of class see Jean-Baptiste Duroselle, La France et les français, 1900–1914 (Paris, 1972) pp. 67–75.

49. For the different schools of thought in childrearing see Louis Delzons, La Famille française et son évolution (Paris, 1913) pp. 110–124 (Delzons, despite a stated preference for earlier mores, is evenhanded in describing late nineteenth-century family life); Maurice Crubellier, L'Enfance et la jeunesse dans la société française, 1800–1950 (Paris, 1979) pp. 52–53, 68–71; and Theodore Zeldin, France, 1848–1945: Ambition and Love (Oxford, 1979) pp. 215–342.

50. Natanson 1951, p. 51. See also René-Marie, "Bonnard et son époque," pp. 22–23.

51. Jesse R. Pitts, "Continuity and Change in Bourgeois France," in Stanley Hoffmann et al., In Search of France (Cambridge, Mass., 1963) p. 259.

52. See French ed. of A. Terrasse 1989, Bonnard illustrateur (Paris, 1988) p. 312 : "J'ai trouvé un commanditaire qui, séduit par mes dessins du Solfège, m'a demandé un Album pour enfants. Je vais faire un 'Alphabet sentimental.' N'est-ce pas que le titre est joli? A chaque lettre correspondra un mot commençant par cette lettre, signifiant une passion un état d'âme, et que je rendrai par de petites scènes familières où il y aura des bébés, des bêtes, des paysages, etc. . . . Il s'agira de faire parler les êtres et les choses." Additional drawings include a rabbit illustrating "T, Timidité" and a little girl smelling a flower as a grandmother looks on for the otherwise untitled "B" ("Bonté"? "Bienveillance"?).

53. The letter from Terrasse to Bonnard dated November 9, 1894 (see note 35), reveals that printing of Petites Scènes familières had not yet started. He urges Bonnard to talk to the printer and get production under way immediately, because he assumes the work will take three months to complete and it would be best to publish toward the end of February [1895]—if later, the music season would be too far advanced: "Il faudra te mettre à l'ouvrage de suite. En admettant que tout se passe bien, je présume qu'il faut 3 mois pour qu'il soit terminé. S'il pouvait être mis en vente vers la fin février ce serait très bien, plus tard ça n'irait plus, l'année musicale serait déjà trop avancée." Whether or not Terrasse's deadline was successfully met, prints from Petites Scènes familières were exhibited at the Galerie Laffitte from May 10 to June 10, 1895, and according to Antoine Terrasse (verbal communication, Colta Ives), the album was advertised in the issue of La Revue blanche dated May 1, 1895.

54. Perucchi-Petri 1976, pp. 73–75. Edouard Manet did six illustrations for Le Corbeau, the bilingual edition of Edgar Allan Poe's The Raven with French trans. by Stéphane Mallarmé (Paris, 1875). Unappreciated by collectors and critics at publication, these black-and-white lithographs were done with a freedom and directness, a lack of "finish," that made them extremely radical for their time and interesting to later artists. They were exhibited in Manet's retrospective at the Galeries Durand-Ruel, April 1893, just as Bonnard was beginning Petites Scènes familières.

55. See also "Dimanche matin" (Bouvet 19); I am grateful to Colta Ives for this observation and for suggestions as to the interpretation of "Les Heures de la nuit."

56. Compare two contemporary paintings of Marthe (Dauberville 01753, 01754).

57. Stéphane Mallarmé in Jules Huret, Enquête sur l'évolution littéraire, orig. publ. L'Echo de Paris (March 3–5, 1891), notes and preface by D. Grojnowski (Vanves, 1984) p. 77: "Nommer un objet, c'est supprimer les trois quarts de la jouissance du poème qui est faite du bonheur de deviner peu à peu; le suggérer, voilà le rêve."

58. Gustave Droz, Monsieur, Madame, and Bébé, first French ed. 1866 (New York, 1910) p. 230.

59. Léopold Chauveau, L'Histoire du poisson scie et du poisson marteau (Paris, 1923),

and idem, *Les Histoires du petit Renaud* (Paris, 1927). Chauveau was something of a polymath—surgeon, painter, sculptor, and writer and illustrator of children's books.

60. Natanson 1948, pp. 324–325.

61. Letter written from Le Grand-Lemps, August 16, 1892 (private collection): "Je suis mille fois plus épaté par la frimousse de mon neveu que par tout ce que j'ai vu dans mes pérégrinations."

62. Bonnard, *Correspondances*, p. 77.

63. Natanson 1951, pp. 54, 65, 100–101.

64. Delzons, *La Famille française*, pp. 40–43; Crubellier, *L'Enfance et la jeunesse*, p. 71; and Eugen Weber, *France, Fin de Siècle* (Cambridge, Mass., 1986) p. 92.

65. Zeldin, *France, 1848–1945*, pp. 285–307. Droz, *Monsieur, Madame, and Bébé*, pp. 74–75, blames male infidelity on female "prejudices and principles" and, without suggesting changes in the education of women, urges married women not to be content with "virtue" but to make themselves attractive to their husbands.

66. Dauberville 101.

67. Jules Renard, *Natural Histories*, trans. Richard Howard (New York, 1966) p. 81.

68. Claude Roger-Marx, "Bonnard, illustrateur de La Fontaine," *Le Portique* 5 (1947) pp. 42–50. These drawings have been assigned dates ranging from 1907 to 1927, but their affinities with the illustrations in *Parallèlement* suggest that they were done about 1899.

69. Gauguin, letter to E. Schuffenecker, October 8, 1888, quoted in Wladyslawa Jaworska, *Gauguin and the Pont-Aven School*, trans. Patrick Evans (Greenwich, Conn., [1972]) p. 68. See also van Gogh, *Letters*, III, letter 574, p. 129.

70. Mallarmé in Huret, *Enquête*, p. 77: "La contemplation des objets, l'image s'envolant des rêveries suscitées par eux, sont le chant. . . . le *suggérer* [un objet], voilà le rêve. C'est le parfait usage de ce mystère qui constitue le symbole: évoquer petit à petit un objet pour montrer un état d'âme, ou, inversement, choisir un objet et en dégager un état d'âme, pour une série de déchiffrements."

71. Stéphane Mallarmé, *Poems*, trans. C. F. MacIntyre (Berkeley/Los Angeles, 1957) pp. 98–99: "Toute l'âme résumée / Quand lente nous l'expirons / Dans plusieurs ronds de fumée / Abolis en autres ronds."

72. On Vuillard and Mallarmé see André Chastel, "Vuillard et Mallarmé," *Le Nef* 26 (1947) pp. 13–25. On Vuillard, Bonnard, and Mallarmé see Giambruni 1983, pp. 218–229.

73. See, e.g., *Le Déjeuner*, 1899, and *Jeune Femme à la lampe*, ca. 1898 (Dauberville 216, 176).

74. Pierre Bonnard in "Hommage à Maurice Denis," *L'Art sacré* 3:25 (1937) p. 156: "Cette étiquette a quelque chose de juste si elle annonce chez ces artistes le goût des spectacles journaliers, la faculté de tirer de l'émotion des actes de la vie les plus modestes."

75. Robert Goldwater, "Symbolic Form: Symbolic Content," in *Problems of the 19th and 20th Centuries: Acts of the XX International Congress of the History of Art* (Princeton, N.J., 1963) IV, pp. 111–121; and Mark Roskill, *Van Gogh, Gauguin, and the Impressionist Circle* (Greenwich, Conn., 1970) pp. 207–245.

76. Letter from Bonnard to Lugné-Poe, n.d. [between December 1890 and February 1891] in Aurélien Lugné-Poe, *La Parade*: I. *Le Sot du tremplin: Souvenirs et impressions du théâtre* (Paris, 1930) p. 243.

77. Paul Verlaine, "Art poétique," *Jadis et naguère*, first publ. 1884, in idem, *Selected Poems*, trans. C. F. MacIntyre (Berkeley/Los Angeles, 1961) pp. 180–181: "De la musique avant toute chose, / Et pour cela préfère l'Impair / Plus vague et plus soluble dans l'air, / Sans rien en lui qui pèse ou qui pose. // Il faut aussi que tu n'ailles point / Choisir tes mots sans quelque méprise: / Rien de plus cher que la chanson grise / Où l'Indécis au Précis se joint. . . . // Car nous voulons la Nuance encor, / Pas la Couleur, rien que la nuance! / Oh! La nuance seule fiance / Le rêve au rêve et la flûte au cor!"

78. See note 12.

79. Raymond Cogniat, interview with Bonnard, quoted in his *Bonnard*, trans. Anne Ross (New York, [1968]) p. 30.

80. Quoted in A. Terrasse 1967, p. 94: "Quand mes amis et moi voulûmes poursuivre les recherches des Impressionnistes et tenter de les développer, nous cherchâmes à les dépasser dans leurs impressions naturalistes de la couleur. L'art n'est pas la nature. Nous fûmes plus sévères pour la composition. Il y avait aussi beaucoup plus à tirer de la couleur comme moyen d'expression."

81. See, e.g., *Les Trois Ages* and *Les Deux Ages* (Dauberville 42, 141).

82. See Jacques Robichez, *Le Symbolisme au théâtre: Lugné-Poe et les débuts de l'Oeuvre* (Paris, 1957) pp. 177–187, 247–249, 364–365; and John A. Henderson, *The First Avant-Garde (1887–1894): Sources of the Modern French Theatre* (London, 1971) pp. 92–99. On Bonnard's activities in the theater see Giambruni 1983, pp. 110–121.

83. Maurice Maeterlinck, *Intérieur*, translated as *Home* in *The Plays of Maurice Maeterlinck*, trans. Richard Hovey (Chicago/New York, 1905) p. 173.

84. Angèle Lamotte, "Le Bouquet de roses: Propos de Pierre Bonnard recueillis en

1943," *Verve* 5:17–18 (1947) p. [75]; and Antoine Terrasse, "Le Dessin de Bonnard," *L'Oeil* 167 (1968) p. 13: "L'émotion surgit à son moment; le choc est instantané, souvent imprévu."

85. Quoted in Lamotte, "Le Bouquet de roses," p. [75]: "Si cette séduction, cette idée première s'efface, il ne reste plus que le motif, l'objet qui envahit, domine le peintre. A partir de ce moment-là, il ne fait plus sa propre peinture."

86. Henri Bergson, *Essai sur les données immédiates de la conscience*, trans. F. L. Pogson as *Time and Free Will* (New York, 1960), see esp. pp. 11–16, 128–132, 161–174, 231; and idem, *Matière et mémoire: Essai sur la relation du corps avec l'esprit*, trans. Nancy Margaret Paul and W. Scott Palmer as *Matter and Memory* (New York, 1910) pp. 119–120, 313–316.

87. Denis, *Nouvelles Théories*, p. 177. According to Henri Béhar, *Jarry, le monstre et la marionnette* (Paris, 1973) p. 17, Jarry followed Bergson's course of lectures.

88. Sérusier, *ABC de la peinture, suivi par une correspondance inédite*, p. 25, made a similar point, apparently drawing on Bergson.

89. Edmund Wilson, *Axel's Castle: A Study in the Imaginative Literature of 1870–1930*, orig. publ. 1931 (New York, 1959) p. 160.

90. Hedy Hahnloser-Bühler, *Félix Vallotton et ses amis* (Paris, 1936) p. 265.

91. On Bonnard's concern for maintaining his own deliberateness of choice and his precautions against the dangers of ingrained habit, even in everyday matters like food, see Natanson 1948, pp. 322, 325.

92. Although Loevgren, *The Genesis of Modernism* (orig. publ. 1959), p. xii, made this point, as have others (George L. Mauner, *The Nabis: Their History and Their Art, 1888–1896* [New York, 1978]; and Goldwater, *Symbolism*), the confusion has continued almost unabated. See Burhan 1979, pp. 6–12, for a discussion of the problem.

93. Cogniat, *Bonnard*, p. 30.

94. From Mallarmé's celebrated definition of poetry, submitted in response to a query and printed in "Curiosités," *La Vogue* 1:2 (1886) pp. 70–71: "La Poésie est l'expression, par le langage humain ramené à son rythme essentiel, du sens mystérieux des aspects de l'existence: elle doue ainsi d'authenticité notre séjour et constitue la seule tâche spirituelle."

95. Mauner, *The Nabis*, pp. 199–204.

96. John Elderfield, *The "Wild Beasts": Fauvism and Its Affinities*, exh. cat. (New York, 1976) pp. 18–19.

97. See Sasha M. Newman, "Bonnard 1900–1920," in Newman 1984, pp. 11–18; and Steven A. Nash, "Tradition Revised:

Some Sources in Late Bonnard," in ibid., pp. 19–28.

98. Bonnard, letter to George Besson, ca. 1944, quoted by Stanislas Fumet, "Bonnard comme expression française de la peinture," *Formes et couleurs* 6:2 (1944) p. 18: "Je flotte entre l'intimisme et la décoration, on ne se refait pas."

3 CITY LIFE

1. Bonnard's nephew Charles Terrasse dates the commission from a letter sent by the artist to his father in 1889; see C. Terrasse 1927, pp. 21–22.

2. Conversation with Raymond Cogniat recorded in *Les Nouvelles littéraires, artistiques, et scientifiques* (July 29, 1933); quoted by Antoine Terrasse, "Chronology," in Newman 1984, p. 243.

3. Denis 1920, p. 9; from "Définition du néo-traditionnisme," *Art et critique* (August 1890).

4. In a letter written to Lugné-Poe late in 1890, Bonnard declared, "I have abandoned chromolithography (*ouf!*) for the moment," a comment that suggests some difficulties. See Aurélien Lugné-Poe, *La Parade*: I. *Le Sot du tremplin: Souvenirs et impressions du théâtre* (Paris, 1930) pp. 242–243; quoted in Rewald 1948, p. 17. The date of the publication of the poster is confirmed by Bonnard's letters to his mother dated March 13 and 19, 1891; quoted in Perucchi-Petri 1976, n. 127, p. 36.

5. Quoted in Giambruni 1983, pp. 303–304 n. 16.

6. Natanson 1951, p. 19. This event was confirmed by Bonnard in a letter of 1923; see Roger-Marx, p. 11.

7. Bonnard's letter is dated May 21, 1891; quoted in Giambruni 1983, p. 85.

8. Other drawings related to the France-Champagne poster include a preliminary ink study (possibly a tracing) in the Musée des Beaux-Arts, Reims, and a sketch (probably after the fact) reproduced in C. Terrasse 1927, p. 21.

9. C. Terrasse 1927, p. 22.

10. See Giambruni 1983, p. 77.

11. The present location of the *Hamlet* drawing is unknown; it is discussed and reproduced in Giambruni 1983, pp. 51–55. The design for *Le Cid*, in the collection of Mr. and Mrs. James Burke, New Jersey, is reproduced and described in Boyer 1988, pp. 141–142, col. pl. 2.

12. There are drawings for Thomé's *Espièglerie* (see Boyer 1988, pp. 147–148; and sale cat., Hôtel Drouot, Paris, June 17, 1989, lot 17) and *Mandoline* (Cabinet des Dessins, Musée du Louvre). Cover sketches for piano pieces by Terrasse are in the Zimmerli Art Museum, Rutgers University, New Brunswick, N.J., and in private collections; see Boyer 1988, pp. 109, 147–148.

13. See Boyer 1988, p. 144, nos. 18–20. Another watercolor modeled on Berthe Schaedlin, showing her seated and holding a glass, may have been planned as a poster or program cover; reproduced in Matthias Arnold, "Toulouse-Lautrec and the Art of His Century," in *Henri de Toulouse-Lautrec: Images of the 1890s*, ed. Riva Castleman and Wolfgang Wittrock, exh. cat. (New York, 1985) p. 64, fig. 34.

14. See Geneviève Aitken, "Les Peintres et le théâtre autour de 1900 à Paris," *mémoire* (Ecole du Louvre, 1978) pp. 117–119. Patricia Boyer kindly provided copies of pertinent pages of this text.

15. See Lugné-Poe's autobiography, *La Parade*: I. *Le Sot du tremplin*, quoted in John Russell, *Edouard Vuillard, 1868–1940*, exh. cat. (Toronto, 1971) p. 84; and Boyer 1988, p. 15. The first program illustration that Vuillard made for the Théâtre Libre, *The Sower* (1890), is very similar in color and in its expressive use of outline to Bonnard's *France-Champagne*. Another unexecuted design by Bonnard for the Théâtre Libre is owned by the Atlas Foundation, Washington, D.C. (see fig. 216).

16. Reproduced and discussed in Boyer 1988, pp. 140–141. It is worth noting that the foreground figure in this design is derived from Seurat's painting *Le Cirque*, 1890–91.

17. Aitken, "Les Peintres et le théâtre," p. 117. See also Jacques Robichez, *Le Symbolisme au théâtre: Lugné-Poe et les débuts de l'Oeuvre* (Paris, 1957) p. 199, where the name of the play taken from the Chinese is given as *La Fleur palan enlevée* (I am grateful to Helen Giambruni for this reference). It has been suggested that Bonnard may also have illustrated the program for the play *Dans la nuit* by A. de Lorde and E. Morel, performed at Escholiers, November 16, 1897 (Aitken, "Les Peintres et le théâtre," p. 119), but this cannot be confirmed.

18. A letter in the collection of Antoine Terrasse dated June 25, 1891, from Mme Eugène Bonnard (the artist's mother) to her daughter, Andrée, states: "Il y a une affiche en train pour le Moulin Rouge." Sasha Newman has kindly brought to my attention an undated calling card in the collection of Antoine Salomon with Bonnard's name and his address in the early 1890s (8 rue de Parme); it bears the message: "Mon cher Vuillard, J'ai accepté un rendez-vous avec Zidler [the Moulin Rouge proprietor] pour 10h. demain matin." In addition to the two designs illustrated here, two others exist: one in the Cabinet des Dessins, Musée du Louvre, and the other in a French private collection (see Boyer 1988, pp. 22, 142). Related studies are contained in one of Bonnard's sketchbooks formerly in the Zadok Collection (see sale cat., Sotheby's, New York, November 12, 1988, lot 108). The Moulin Rouge appears in two paintings dated 1896: Dauberville 132 (see fig. 138) and 135.

19. See William Rubin, "Shadows, Pantomimes and the Art of the 'Fin de Siècle,' " *Magazine of Art* 46:3 (1953) pp. 114–122.

20. The influence of the shadow theater is studied extensively in Boyer 1988, pp. 53–75.

21. Maurice Denis, "De Gauguin et de van Gogh au classicisme," *L'Occident* (May 1909), reprinted in Denis 1920, p. 263: "Les synthèses des décorateurs japonais ne suffisaient pas à alimenter notre besoin de simplification. Idoles primitives ou extrême-orientales, calvaires bretons, images d'Epinal . . . tout cela se mélangeait à des souvenirs de Daumier."

22. Ibid., pp. 262–263: "Aux audaces des impressionnistes et des divisionnistes, les nouveaux venus ajoutaient la gaucherie d'exécution et la simplification presque caricaturale de la forme: et c'était là le symbolisme."

23. Bonnard's participation in these efforts is described by a writer identified as "La Cagoule" in *Echo de Paris* (April 1, 1898); also by A. Ferdinand-Herold, "Claude Terrasse," *Mercure de France* (August 1, 1923) pp. 695–696. Both articles are quoted in George L. Mauner, *The Nabis: Their History and Their Art, 1888–1896* (New York, 1978) p. 185.

24. Bouvet 46–51.

25. The undated holograph letter is published among those recollected and reinvented by Bonnard as memoirs in his illustrated *Correspondances* (Paris, 1944) p. 67: "Mais oui, il existe toujours. J'y vais souvent. C'est tout près de mon nouveau domicile. Je m'amuse toujours au cirque et pour un solitaire il a l'avantage inappréciable de posséder des entractes amusants, tandis qu'au théâtre ils sont odieux. On va au bar où les clowns boivent leur gobelet. L'écurie offre son entrée pour dire bonjour aux chevaux et autres bestes" (punctuation and accents added).

26. At least five preliminary sketches attest to Bonnard's preparatory work, particularly in resolving Massine's pose. One drawing is in the library of the Paris Opéra; two are in the Cabinet des Dessins, Musée du Louvre.

27. Natanson 1948, p. 131: "Un pas sau-

tillant sur des talons aussi hauts et fins que des pattes.''

28. An additional preparatory study, in the collection of Dr. A. Wilhelm, Bottmingen, is reproduced in Perucchi-Petri 1976, p. 83.

29. The Nabis' relationship with popular imagery is discussed at length in Boyer 1988, pp. 1–79. She suggests (p. 68) as a possible source of inspiration for Bonnard's *Woman with an Umbrella* Maurice Radiguet's illustration *Nos Trottins* in *La Caricature* (April 2, 1892).

30. For Bonnard's contributions to *La Revue blanche* see chapter 1, esp. note 28. See also Wildenstein and Co., *La Revue Blanche: Paris in the Days of Post-Impressionism and Symbolism*, exh. cat. (New York, 1983); and Bret Waller and Grace Seiberling, *Artists of La Revue Blanche*, exh. cat. (Rochester, N.Y., 1984).

31. In a letter to Hedy Hahnloser dated January 4, 1946, Bonnard wrote, ''Fénéon called me *Bonnard très japonard.*'' Quoted in Annette Vaillant, *Bonnard*, trans. David Britt (Greenwich, Conn., 1966) p. 182.

32. Others are the painted screens: *Femmes au jardin*, ca. 1890–91 (Dauberville 01716); *Paravent* (street scenes), ca. 1895 (Dauberville 205); *Ensemble champêtre*, ca. 1895 (Dauberville 128); *Panneau décoratif* (pair of folding screens with rabbits), ca. 1902 (Dauberville 01836); and *Au bord de l'eau*, ca. 1919 (Dauberville 02159). Preparatory studies for these projects or possibly additional ones are discussed and illustrated in Claire Frèches-Thory, ''Pierre Bonnard: Tableaux récemment acquis par le musée d'Orsay,'' *La Revue du Louvre et des musées de France* 6 (1986) pp. 417–431. It should be noted also that Bonnard painted at least three triptychs of Paris life around 1895–97 (Dauberville 131, 136, 150).

33. Michael Komanecky, '' 'A Perfect Gem of Art,' '' in Michael Komanecky and Virginia Fabbri Butera, *The Folding Image: Screens by Western Artists of the Nineteenth and Twentieth Centuries*, exh. cat. (New Haven, 1984) pp. 58–63. See also Phylis Floyd, ''Documentary Evidence for the Availability of Japanese Imagery in Europe in Nineteenth-Century Public Collections,'' *Art Bulletin* 68 (1986) p. 119.

34. Dauberville 01716. See also Komanecky, '' 'A Perfect Gem of Art,' '' pp. 72–73, 115 n. 105.

35. Giambruni 1983, p. 102–103. See illustrations in Galeries nationales du Grand Palais, *Le Japonisme*, exh. cat. (Paris, 1988) no. 298, pp. 292–293; and in Boyer 1988, no. 7, pp. 114, 141.

36. See Douglas Druick and Peter Zegers, *La Pierre Parle: Lithography in France, 1848–*

1900, exh. cat. (Ottawa, 1981) pp. 76, 97, 101. Among the large prints Verneau published were Henri Rivière's *Les Aspects de la nature* (1897–98). This development is also noted in contemporary periodicals; see *La Plume* (January 15, 1897), and Raymond Bouyer, ''L'Estampe murale,'' *Art et décoration* 4 (1898) pp. 185–191.

37. In a letter to his mother, Bonnard describes the setting as in the Place de la Concorde, near the Tuileries (Huguette Berès, *Graphisme de Bonnard* [Paris, 1981] no. 73).

38. Note, for instance, the similarities between the silhouetted Parisiennes featured in Bonnard's *Woman with an Umbrella* (fig. 145), in his poster for *La Revue blanche* (fig. 151), and in *Promenade* (figs. 155, 156).

39. According to Patricia Boyer, ''a horizontal row of silhouetted carriages, seen in profile, was a device used frequently to fill background space in shadow play productions''; for reproductions of cutout carriages from one of Caran d'Ache's shadow plays and similar silhouettes used by Vallotton in his zincograph *L'Averse* (1894) see Boyer 1988, p. 58.

40. Giambruni 1983, pp. 101–102, notes Bonnard's decorated frames on his earlier paintings *Berthe Schaedlin* and *La Fille assise au lapin*, as well as the fact that Seurat, too, had extended painted elements in his pictures from canvas to frame.

41. The catalogue of the Durand-Ruel exhibition in 1896 lists forty-nine titles in the first section, all of these presumably paintings, including no. 49, *Promenade*, identified as the property of ''M.T.N.'' [Monsieur Thadée Natanson]. The second section of the catalogue lists prints, including five items: no. 50, poster for *La Revue blanche*; no. 51, poster for France-Champagne; no. 52, ''Paravent''; no. 53, ''Deux Cadres de lithographies''; no. 54, *Petit Solfège*. As the exhibition opened in January 1896, the ''Paravent'' included as no. 52, which can be no other than the lithographed *Promenade*, must be dated to the previous year and not later. The date of Vuillard's letter to Vallotton in which he says, ''Bonnard is busy making four lithograph panels of his horse-cab screen,'' is most certainly incorrectly deciphered as July 1, 1898, in Gilbert Guisan and Doris Jakubec, *Félix Vallotton: Documents pour une biographie et pour l'histoire d'une oeuvre*: I. *1884–1899* (Lausanne/Paris, 1973) p. 175.

42. Announcements of the lithographed ''Paravent'' appeared in the October 1896 issue of the American magazine *Studio* (ill. p. 67) and in *L'Estampe et l'affiche* (March 15, 1897) p. 24; see Komanecky and Butera, *The Folding Image*, no. 6, pp. 143–145.

43. The author has been able to locate no more than twenty complete examples of the lithographed screen. According to Hubert Prouté (letter to Barbara Shapiro, Museum of Fine Arts, Boston, dated July 13, 1976, kindly provided by the recipient, and conversations with the author in October 1986), his father, the Parisian print dealer Paul Prouté, purchased about thirty sets from Edouard Joseph just before World War II. Many of the panels were water-damaged and cut into sections. Most of these lithographs were sold to a London dealer, Rex Nankivell of the Redfern Gallery.

44. The title ''La Rentrée de l'écolière,'' the most appropriately descriptive one seen thus far by the author, is inscribed on an impression in the collection of Frau Steiner-Jaeggli, Winterthur, Switzerland. Another, in the collection of Smith College, Northampton, Mass., is inscribed on the verso: ''le départ pour l'Ecole,'' and ''vers 1895–96,'' suggesting a more probable date for the print than that of ''*c.* 1900'' given in Bouvet 71.

45. Eugen Weber, *France, Fin de Siècle* (Cambridge, Mass., 1986) p. 79.

46. Eunice Lipton, *Looking into Degas: Uneasy Images of Women and Modern Life* (Berkeley/Los Angeles/London, 1986) pp. 128, 214 n. 16, referring to Pierre Villoteau, *La Vie parisienne à la Belle Epoque* (Geneva, 1968) pp. 427–428.

47. In comments elicited by an early exhibition of works by Bonnard and other Nabis at St.-Germain-en-Laye, Alphonse Germain defined their aims (''Théorie des déformateurs,'' *La Plume* [September 1, 1891] p. 289): ''Leur but: conserver pieusement la sensation originale et la rendre par des lignes et des couleurs bellement rares et harmonieuses, mais par des moyens *primitifs* et une liberté d'interprétation allant jusqu'à l'étrange, jusqu'à la déformation: un contour abrégé, peu ou point de modelé, des tonalités étendues sans dégradations, voire sans rapports de valeurs.''

48. The prospectus that survives advertising Vollard's publication *L'Estampe moderne*, which was promised for October 2, 1895, but never materialized, is mentioned in Pat Gilmour, ''Cher Monsieur Clot... Auguste Clot and His Role as a Colour Lithographer,'' in *Lasting Impressions: Lithography as Art*, ed. Pat Gilmour (Philadelphia, 1988) p. 133. Bonnard evidently changed the date drawn on the lithography stone for *La Petite Blanchisseuse* from 95 to 96. See chapter 1, note 33.

49. See Ives, *The Great Wave*, pp. 24–25.

50. Publication was announced in *L'Estampe et l'affiche* (April 15, 1899) p. 102, as follows: ''Bonnard (Pierre)—Album de

douze estampes et une couverture. Lithographies en couleurs. Tirage à 100 exemplaires. Chaque album… 175 fr.''

51. Arsène Alexandre mentioned the show in *Le Figaro* of March 27, 1899, calling it ''one of the most interesting exhibitions at the present time.''

52. A maquette for an unpublished announcement of Bonnard's illustrated book *Parallèlement*, now in the collection of Mr. and Mrs. Paul Mellon, which was prepared by Vollard around 1897–98, cites as ''in preparation'': ''Pierre Bonnard: Croquis Parisiens, suite de douze lithographies en couleurs.'' Traces of erased titles are especially apparent in the Clark Art Institute's proof of the album title page (fig. 168) and in the later, though not final, state in The Metropolitan Museum of Art (fig. 195).

53. Bouvet 61, 63, 68 are usually numbered and signed: *P. Bonnard*. Bouvet 70 is usually numbered and initialed: *P.B.* The other prints in the suite are seldom found signed; those that bear signatures are believed to have been signed by the artist much later. Since the portfolio was issued without a contents page, no order is specified for the prints, nor are they titled. The titles that appear in this book are descriptive and depend largely upon those given by Floury, p. 192.

54. Bonnard's handwritten notes to his nephew Charles Terrasse in 1926 contain references to a studio rented from 1896 to 1899 ''in the Batignolles district''; see Terrasse, ''Chronology,'' in Newman 1984, p. 245. Catalogues of exhibitions of La Libre Esthétique in Brussels in 1896 (February 22–March 30) and 1897 (February 25–April 1) give Bonnard's address as 29 rue Capron; the catalogue of his exhibition at Durand-Ruel in 1899 (March 10–31) gives his address as 14 rue Le Chapelais. However, neither of these addresses seems to present a vista that aligns with that in Bonnard's window views from this period. It is likely, given the perspective, that the studies were made from a room in Bonnard's grandmother's apartment at 8 rue de Parme, into which he moved in the late 1880s, and in which he pictured himself at work drawing in his autobiographical sketches (see fig. 32). Regarding the rue Tholozé, with which Bonnard's street scenes are often identified, see note 58 below.

55. See Newman 1984, p. 146, no. 20: *La Fenêtre ouverte*, 1921 (Dauberville 1062).

56. See Redon's lithograph *Le Jour* (fig. 15). Bonnard said of Redon: ''What strikes me most in his work is the blending of two almost opposite features: a very pure plastic substance and a very mysterious expression.'' Pierre Bonnard, ''Hommage à Odilon Redon,'' *La Vie* 41 (November 30, 1912),

quoted in John Rewald, ''Odilon Redon,'' in Museum of Modern Art, *Odilon Redon, Gustave Moreau, Rodolphe Bresden*, exh. cat. (New York, 1961) p. 35.

57. Stéphane Mallarmé in Jules Huret, *Enquête sur l'évolution littéraire*, orig. publ. *L'Echo de Paris* (March 3–5, 1891), notes and preface by D. Grojnowski (Vanves, 1984) p. 77: ''*Nommer* un objet, c'est supprimer les trois quarts de la jouissance du poème qui est faite du bonheur de deviner peu à peu: le *suggérer*, voilà le rêve.''

58. The street, which also appears in the painted triptych *Les Ages de la vie*, 1895–96 (Dauberville 136), cannot be the rue Tholozé, with which so many of Bonnard's street scenes are associated. The rue Tholozé is so steep that ground-floor levels must step up along the curb line to adjust to the incline, as Bonnard showed in later paintings (e.g., Dauberville 158, 163, 316), in which the street can be identified by the Moulin de la Galette rising at its peak.

59. See Charles Terrasse, ''Bonnard: An Intimate Memoir of the Man and the Artist Revealed by His Nephew,'' *Art News Annual* 28 (1959) pp. 87–107; Ives, *The Great Wave*, pp. 60–64; and Perucchi-Petri 1976, pp. 55–69.

60. Rémy G. Saisselin, *The Bourgeois and the Bibelot* (New Brunswick, N.J., 1984) pp. 25–27.

61. Charles Baudelaire, *The Painter of Modern Life and Other Essays*, trans. and ed. Jonathan Mayne (London, 1964) p. 12.

62. Roger Marx, ''Les Indépendants,'' *Le Voltaire* (March 28, 1893): ''Il possède le don de dégager et de saisir rapidement le pittoresque de tout spectacle''; quoted in Giambruni 1983, pp. 148–149.

63. Natanson 1948, p. 340: ''La promenade il l'aimait autant que Rousseau. Non moins que pour la superbe des montagnes ou des ponts de Paris, pour la charmante humilité d'une graminée ou rien que la rencontre d'un chapeau de fillette. Tous les jours de sa vie il est sorti de bon matin. Sorti à jeun. Comme ceux qui vont communier. Il ne mangeait légèrement qu'au retour. Pour se remettre au travail.''

64. Bonnard's diary for May 13, 1932, quoted in Antoine Terrasse, ''Bonnard's Notes,'' in Newman 1984, p. 69: ''What is beautiful in nature is not always beautiful in painting. For instance: evening or night effects.''

65. Charles Rearick, *Pleasures of the Belle Epoque: Entertainment and Festivity in Turn-of-the-Century France* (New Haven/London, 1985) p. 154; and Wolfgang Schivelbusch, *Disenchanted Night: The Industrialization of Light in the Nineteenth Century*, trans. Angela Davies (Berkeley, 1988) pp. 146–149.

66. Striking similarities to Bonnard's color lithograph *Street at Evening in the Rain* can be seen in Auguste Lepère's wood engraving *The Audience Leaving the Théâtre du Châtelet* (1888) and in Félix Buhot's etching *The Return of the Artists: The Avenue of the Champs Elysées on the Last Day for Sending Paintings to the Salon, 6 p.m.* (1877).

67. Rearick, *Pleasures of the Belle Epoque*, p. 189. According to Heilbrun and Néagu, p. 8, Bonnard met Louis and Auguste Lumière through his brother-in-law, Claude Terrasse.

68. Bonnard must have sat in the café that still exists in the Place Blanche when he prepared this design. Today, the café's awning bears the initials P.B., which stand both for the location and for the artist, a coincidence that probably amused Bonnard.

69. Among the very rare exceptions are *La Place Clichy, vue du ''Petit Poucet''* and *La Place Clichy* (Dauberville 90, 01809).

70. *Le Livre et l'image* 1 (March–July 1893) pp. 183–184.

71. For additional information regarding the prints and illustrated books of this era see Phillip Dennis Cate, ''Paris Seen Through Artists' Eyes,'' in *The Graphic Arts and French Society*, *1871–1914*, ed. Phillip Dennis Cate (New Brunswick, N.J., 1988) pp. 1–53; and Gordon N. Ray, *The Art of the French Illustrated Book, 1700 to 1914* (New York/Ithaca, 1982) II, pp. 381–521.

72. Bonnard evidenced an attraction to the Pont du Carrousel, with its eye-catching circular struts, in his painting *Remorqueur: Pont sur le Seine*, ca. 1899 (Dauberville 01793 bis).

73. Valerie Steele, *Paris Fashion: A Cultural History* (New York, 1988) pp. 170–171.

74. Pissarro's letter to his son Lucien, dated February 6, 1896, is quoted in Rewald 1948, p. 30; for the 1899 quotation see ibid., p. 36.

75. A photograph taken on September 10, 1898, shows Bonnard and Renoir together among the small party of mourners assembled for Mallarmé's burial; it is reproduced in Annette Vaillant, ''Livret de famille,'' *L'Oeil* 24 (1956) pp. 30–31. Later, the two artists often met in the South of France, and around 1916 Bonnard etched a portrait of Renoir (see Bouvet, pp. 194–195).

76. André Mellerio, *Le Mouvement idéaliste en peinture* (Paris, 1896) p. 51: ''Cette différence se marque bien entre les oeuvres faites à la campagne et celles de Paris. Dans les premières plus de simplicité, de calme, dans les autres plus d'acuité, du chatoiement ténu et nerveux.''

77. Quoted in Terrasse, ''Chronology,'' in Newman 1984, p. 262, and Giambruni 1983, p. 214. Fuller reference to the source is

given in Giambruni 1983, p. 331 n. 66: Pierre Courthion, "Impromptus, Pierre Bonnard," *Les Nouvelles littéraires* (June 24, 1933).

78. Octave Mirbeau, *Dingo* (Paris, 1924) p. 175: "A Paris, Dingo redevint triste. Il ne sut plus que faire. Trop de gens, trop de maisons, de rues encombrées, plus assez d'espaces et de grands horizons. Il languissait, s'étiolait, ne montrait aucun empressement à sortir, dormait presque tout le jour, roulé en boule, sur des coussins. Les promenades à travers les foules lui étaient devenues un supplice."

79. Quoted in Henry Dauberville, "Bonnard vivant," in Dauberville I, pp. 19–20: "J'éprouve une grande joie à habiter ce genre d'établissements, me dit-il. Ils sont palpitants de vie, c'est la continuation du mouvement des trains. Regardez ce tableau: quel charmant spectacle de voir ce monde de travailleurs s'échappant de la gare, comme les abeilles d'une ruche… Ils courent à leur gain, ils vont chercher leur pâture. // Pour un homme d'âge comme moi, ces allées et venues deviennent touchantes, elles assument une certaine grandeur. Du haut de mon balcon, ils ne dépassent pas la taille d'un insecte, ils sont dépersonnalisés, mais représentent un symbole de la force laborieuse. Je les vois le matin, ils coulent d'une fourmilière pour retourner le soir en longs cortèges… Je puis imaginer qu'ils rapportent le butin de leur journée en rejoignant leurs alvéoles… Brave petit peuple, je l'aime de tout mon coeur."

4 NUDES AND LANDSCAPES

1. See, for example, the earliest monograph on Bonnard: François Fosca, *Bonnard* (Geneva, 1919). Fosca's viewpoint represents a critical treatment of the artist that remained consistent from this post–World War I date until Bonnard's death in 1947.

2. This essay is based on my forthcoming Ph.D. dissertation, "Pierre Bonnard and the Reinvention of the French Tradition" (Institute of Fine Arts, New York University). I would like to thank Kirk Varnedoe for his continued support of this work. I would also like to thank Antoine Terrasse and Antoine Salomon for access to important documents and for their tremendous generosity, and Richard Field and Anne Coffin Hanson for invaluable bibliographic advice.

3. Claude Digeon, *La Crise allemande de la pensée française, 1870–1914* (Paris, 1959), gives the most detailed account of this phenomenon, and I rely heavily on Digeon's conclusions on French-German intellectual relations after the Franco-Prussian War. See

also Zeev Sternhell, *Maurice Barrès et le nationalisme français*, Cahiers de la fondation nationale des services politiques 182 (Paris, 1972); and Raoul Girardet, *Le Nationalisme français, 1871–1914* (Paris, 1983).

4. The "proper" use of tradition by artists seeking originality was of particular interest to the Symbolists; the subject will be treated in depth in Newman, "Bonnard and the Reinvention of the French Tradition." For Maurice Denis's early writings on the question see Maurice Denis, *Journal*: I. *1884–1904* (Paris, 1957). For later discussions see Louis Lourmel, "L'Individualisme et l'école traditionaliste," *La Rénovation esthétique* 5 (1907) p. 174; and Charles Chassé, "Les Nabis et l'imitation des maîtres," *L'Amour de l'art* 14 (1933) pp. 69–71. Gustave Geoffroy, "Causerie sur le style, la tradition et la nature," *Revue des arts décoratifs* 18 (1898) pp. 179–181, which I recently found in the papers of Edouard Vuillard, was also important to Nabi theory.

5. Education was at the center of the Third Republic's social and political achievements, and lycée course work, despite curriculum revisions in the 1880s, was quite standardized. It is not accidental that there was such an established community of feeling between those young men who came of age during the republic's early years. See Antoine Prost, *Histoire de l'enseignement en France, 1800–1967* (Paris, 1968), incl. bibliography; and Luc Decaunes, ed., *Réformes et projets de réforme de l'enseignement français de la Révolution à nos jours, 1789–1960* (Paris, 1962). Pierre Nora, ed., *Les Lieux de mémoire*, 2 vols. (Paris, 1984–86) I. *La République*, includes a series of essays on education.

6. Hippolyte Taine, whose major art-historical work was *Philosophie de l'art* (Paris, 1865), and Ernest Renan were France's leading positivist philosophers during the second half of the nineteenth century. On Taine in France after the Franco-Prussian War see Digeon, *La Crise allemande*, pp. 219–235. For contemporary opinions particularly relevant to Bonnard and the Nabis see "Quelques Opinions sur l'oeuvre de H. Taine," *La Revue blanche* 13 (1897) pp. 263–295; and Paul Bourget, "M. Taine," in *Essais de psychologie contemporaine* (Paris, 1881; 3rd ed. 1899) I, pp. 187–261. Hugues Rebell, "L'Histoire de l'esprit français, 1850–1900: Taine, (1850…?) ou l'intelligence moderne," *La Plume* 14 (1902) pp. 664–669, remarked on the fact that Taine was claimed by all parties.

7. See L. Roger-Milès, *Comment discerner les styles du VIIIe au XIXe siècle*, 2 vols. (Paris, 1896–97), for a contemporary manual on identifying the language of style.

8. See Walter Benjamin, "Paris, Capital of the Nineteenth Century," in idem, *Charles Baudelaire: A Lyric Poet in the Era of High Capi-*

talism, trans. Harry Zohn (London, 1973); and F. W. J. Hemmings, *Culture and Society in France, 1848–1898: Dissidents and Philistines* (New York, 1971).

9. The bibliography of articles devoted to Rococo interests and painters from 1885 to 1905 is immense. See Musée du Petit Palais, *Le Triomphe des mairies: Grands Décors républicains à Paris, 1870–1914*, exh. cat. (Paris, 1986); and Pierre Vaisse, "Décoration et la Troisième République," thesis, 3rd cycle (Paris, 1981). The Rococo was also connected with the vogue for Japanese art: see S. Bing, "Les Arts de l'Extrême-Orient dans la collection des Goncourts," in *La Collection des Goncourts: Arts de l'Extrême-Orient. Catalogue du Vente* (Paris, 1897); and "Introduction," *Exposition de la gravure japonaise à l'Ecole des Beaux-Arts* (Paris, 1890).

10. For Chéret and his relationship to the Rococo revival see Bradford Ray Collins, Jr., "Jules Chéret and the Nineteenth-Century French Poster," Ph.D. diss. (Yale University, 1980) pp. 119–123. For a discussion of the issue earlier in the century see Carol Duncan, *The Pursuit of Pleasure: The Rococo Revival in French Romantic Art* (New York, 1976). See also Debora L. Silverman, "Nature, Nobility, and Neurology: The Ideological Origins of 'Art Nouveau' in France, 1889–1900," Ph.D. diss. (Princeton University, 1983), for the most interesting and complete analysis of the relationship between the Rococo and Art Nouveau.

11. Collins, "Chéret," p. 120. Among those who commented on Chéret's relationship to the Rococo were the Goncourt brothers, whose eighteenth-century preferences were well known; see Edmond and Jules de Goncourt, *L'Art du dix-huitième siècle, et autres textes sur l'art*, ed. J.-P. Bouillon (Paris, 1969).

12. On Besnard, whose portraits most clearly reflected the aristocratic aspirations of his day, see Roger Marx, "La Vie naît de la mort d'Albert Besnard," *Revue encyclopédique* 6:146 (1896) p. 434. One of Bonnard's early panels, *Le Peignoir*, a mélange of Japanese and Rococo inspiration exhibited at the Barc de Boutteville gallery in November 1892, was purchased by Besnard. Another fashionable painter, Henri Lerolle, bought the companion panel. Bonnard wrote to his mother on December 15, 1892 (letter in the collection of Antoine Terrasse): "Crois-tu que j'ai encore vendu un panneau, et encore à une célébrité? C'est le peintre Besnard qui l'a acheté."

13. Bourget, *Essais de psychologie contemporaine*, I, p. xix, discusses the loss of "la vieille gaieté française," a gaiety he links explicitly to the "pure tradition française," and attributes the contemporary fascination with the Rococo to this loss.

14. See Adrien Mithouard, "Le Classique occidental," *L'Occident* 1 (1902) pp. 179–187, as a premonition and codification of what was to follow. See also Charles Morice, "Enquête sur les tendances actuelles des arts plastiques," *Mercure de France* 56 (1905) pp. 346–349; André Gide, "Promenade au Salon d'Automne," *Gazette des Beaux-Arts*, 3rd ser., 34 (1905) pp. 475–485; L. Dumont-Wilden, "La Muse française," *L'Occident* 84 (November 1905); and Maurice Pujo, "La Réaction classique," *L'Action française* 18 (1905) no. 141, pp. 200–215, no. 142, pp. 295–308. *L'Occident* and *L'Action française* represented the reactionary axis of French nationalism. The views expressed early in these reviews became more and more the critical norm in the decade before World War I. For Denis's commentary on the new vogue for the neoclassic see "De Gauguin et de Van Gogh au classicisme," *L'Occident* (May 1909), reprinted in Denis 1920, pp. 262–278, esp. 266–267.

15. Critical attitudes toward Impressionism, which was increasingly considered dangerous, anarchic, and contaminating for young artists, underwent a steady evolution from 1890 through World War I. See Camille Mauclair, *L'Impressionnisme: Son Histoire, son esthétique, ses maîtres* (Paris, 1904); J. C. Holl, *Après l'impressionnisme* (Paris, 1910); and Francis Paulhan, *L'Esthétique du paysage* (Paris, 1913). See also Sasha M. Newman, "Bonnard 1900–1920," in Newman 1984, p. 15 n. 7.

16. For the relationship of psychological theory to the Nabis see Burhan 1979. Burhan correctly redefines the Nabis' scientific and materialist attitudes, but is mistaken in believing that there was across-the-board acceptance of Taine's determinist systems.

17. See Henri Bergson, *Essai sur les données immédiates de la conscience* (Paris, 1889); and idem, *Matière et mémoire: Essai sur la relation du corps avec l'esprit* (Paris, 1896).

18. See Eric Hobsbawm, "Mass-Producing Traditions: Europe, 1870–1914," in *The Invention of Tradition*, ed. E. Hobsbawm and T. Ranger (New York, 1983) pp. 263–307; Maurice Agulhon, *Marianne into Battle: Republican Imagery and Symbolism in France, 1789–1880*, trans. Janet Lloyd (New York, 1981); and Nora, *Les Lieux de mémoire*. See also Arno J. Mayer, *The Persistence of the Old Regime: Europe to the Great War* (New York, 1981). For an account of these issues in relation to the genesis of Art Nouveau, although without specific reference to the Nabis, see Silverman, "Nature, Nobility, and Neurology."

19. In the late 1880s and early 1890s Bonnard's interest was monistically focused on the Japanese. The entry for July 13, 1894, in Edouard Vuillard's journal (Bibliothèque de l'Institut de France) describes a typical visit

to the Louvre with Bonnard: "Promenade au Louvre avec Bonnard dans les dessins d'abord. Ennue rapide devant les italiens. . . . Réflexion de Bonnard. Toute l'impression que donne ce dessin a-t-elle été consciente quelle est la part du temps, en dehors de la forme la couleur peut elle lui être attribuée. Bonnard: jamais de doute de ce genre devant un japonais." I am grateful to Antoine Salomon for access to the typescript (unedited) of Vuillard's journal.

20. Frederick R. Karl, *Modern and Modernism: The Sovereignty of the Artist, 1885–1925* (New York, 1985) pp. 86–95, discusses the explorations of sexuality in literature and psychology at the end of the nineteenth century, and their relevance to an understanding of Modernism.

21. Henri Bergson, Paul Bourget, Alfred Jarry, and Félix Fénéon all responded, in different ways, to this interest. Groups such as Jules Lévy's Incohérents (1882–92), a relatively casual association of caricaturists and illustrators in which Chéret was a participant, organized exhibitions to promote their idea of *fumisme*, or creative fun. As Lévy explained ("L'Incohérence," *Le Courrier français* 2 [March 12, 1885] p. 4): "La gaieté est le propre des Français, soyons français. . . . Il faut réhabiliter cette gloire nationale qu'on nomme l'esprit français." However, for authors like Bourget and artists like Lévy and Chéret humor was primarily linked to this revitalization of a French nationalistic tradition, while for Fénéon or Jarry or Bonnard humor was an essential vehicle in combating the bourgeois philistinism of the Third Republic.

22. The relationship of Bonnard's stylistic development to French and Japanese traditions of caricature is an important one, and much of the invention in Bonnard's work and its subversive quality originate in his exploration of these genres. I am indebted to Elizabeth C. Childs ("Honoré Daumier and the Exotic Vision: Studies in French Culture and Caricature, 1830–1870," Ph.D. diss. [Columbia University, 1989]) for her advice and particularly for drawing my attention to the study of the French caricatural tradition by the critic Arsène Alexandre, *L'Art du rire et de la caricature* (1882).

23. On Fénéon see Joan Ungersma Halperin, *Félix Fénéon: Aesthete and Anarchist in Fin-de-Siècle Paris* (New Haven/London, 1988). For bibliographies and selections of Fénéon's criticism see Félix Fénéon, *Au-delà de l'impressionnisme*, ed. Françoise Cachin (Paris, 1966); and idem, *Oeuvres plus que complètes*, ed. J. U. Halperin, 2 vols. (Geneva, 1970).

24. F.F., "Quelques Peintres idéistes," *Le Chat noir* 505 (September 19, 1891) p. 1821, reprinted in Fénéon, *Oeuvres plus que complètes*, I, p. 201: "Nous verrions sur les

murs des effigies d'un érotisme serpentin et cruel si, après Chéret et ses masques de joie lyrique, [M. Pierre Bonnard] était chargé d'achanlander [*sic*] Cirques, Elysées, Jardins, Moulins." Translations not otherwise attributed are by the author.

25. This design is also based on Japanese theater masks. For a discussion of the Nabis and Japanese popular art see Perucchi-Petri 1976.

26. This aspect of Symbolism, the notion of remaking the art form, is essential to an understanding of both Bonnard and Jarry, as is the importance of humor, and helps explain a close friendship that some continue to find mystifying. For Jarry's relationship with Bonnard and the Nabis see Harald Szeemann, *Alfred Jarry und die Nabis*, exh. cat. (Zurich, 1984). Burhan 1979, pp. 172–276, discusses the relationship of linguistic theory to Symbolism. See also Sven Loevgren, *The Genesis of Modernism: Seurat, Gauguin, Van Gogh and French Symbolism in the 1880's*, rev. ed. (Bloomington/London, 1971); and Kirk Varnedoe, "Gauguin," in *"Primitivism" in 20th Century Art: Affinity of the Tribal and the Modern*, ed. William Rubin, exh. cat. (New York, 1985) pp. 179–209.

27. See Claire Goldberg Moses, *French Feminism in the Nineteenth Century* (Albany, 1984). See also Ann Ilan-Alter, "Paris as Mecca of Pleasure: Women in Fin-de-Siècle France," in *The Graphic Arts and French Society, 1871–1914*, ed. Phillip Dennis Cate (New Brunswick, N.J., 1988) pp. 55–82; Jean-Paul Aron, ed., *Misérable et glorieuse: La Femme du XIXe siècle* (Paris, 1980); and Steven C. Hause with Anne R. Kenney, *Women's Suffrage and Social Politics in the French Third Republic* (Princeton, N.J., 1984). For a contemporary view see "Les Femmes et les féministes," *La Revue encyclopédique* 6:169 (1896) pp. 825–916.

28. See Susanna Barrows, *Distorting Mirrors: Visions of the Crowd in Late Nineteenth-Century France* (New Haven, 1981). Theories of sexual, racial, and cultural degeneration abounded and were linked to opposition to modernism. For particularly virulent attacks on feminism and feminists see Max Nordau, *Degeneration* (New York, 1968), published in German in 1892 and in French in 1893; and Otto Weininger, *Sex and Character* (New York, 1975), published in German in 1903.

29. A. Terrasse 1989, 9, 10, 16.

30. For positivist, determinist theorists like Weininger and Nordau sex was identified with mystery, with anarchy, and with societal disruptions, and feminism was a symbol of a more far-reaching cultural degeneration. However, it is a mistake to regard the Symbolists' embrace of the irrationality of sexuality as linked to an acceptance of feminism. Certainly, the assumption of female inferiority was exten-

sive—from Nietzsche, to Jarry, to Fénéon, to Strindberg, probably to Bonnard himself—so that while the embrace of sexuality is considered a form of liberation or rebellion, it does not imply acceptance of the tenets of feminism.

31. Most critics at the time, Fénéon among them, had been quick to identify Degas's bathing women as whores. See F.F., "VIIIe Exposition impressionniste," *La Vogue* 1:8 (1886) pp. 261–275, reprinted in Fénéon, *Oeuvres plus que complètes*, pp. 29–38. For Degas criticism in 1886 see Martha Ward, "The Rhetoric of Independence and Innovation," Fine Arts Museums of San Francisco, *The New Painting: Impressionism, 1874–1886*, exh. cat. (San Francisco/Washington D.C., 1986) pp. 430–434. Norma Broude ("Edgar Degas and French Feminism, ca. 1880: 'The Young Spartans,' the Brothel Monotypes, and the Bathers Revisited," *Art Bulletin* 70 [1988] pp. 640–659) interprets these bathers as ordinary women—not prostitutes—at their toilette, attributing the confusion to the fact that contemporary critics were unable to accept depictions of respectable women engaged in sensual acts.

32. Darien (1862–1921), whose real surname was Adrien, published two novels of particular interest: *Biribi*, in 1890, and *Le Voleur*, in 1898. Both were largely autobiographical and were direct attacks on bourgeois mores, sexual and political.

33. Quoted in Galerie des Beaux-Arts, *Hommage à Bonnard*, exh. cat. (Bordeaux, 1986) p. 164: "Les dessinateurs de l'Escarmouche sont des gens de goût bizarre et indépendant et prétendent faire absolument ce qui leur plaît."

34. She was perhaps intended to be a *montmartroise*—a type recognized in much contemporary literature as a resident of that part of Paris considered a haven from bourgeois hypocrisies; see Octave Uzanne, *The Modern Parisienne*, trans. (New York/London, 1912), first published in French in 1894. Bonnard lived and worked in Montmartre, initially at 28 rue Pigalle and then farther west in the Batignolles district.

35. Paul Sérusier, *L'ABC de la peinture* (Paris, 1921). Sérusier insisted upon the fundamentally natural character of universal style, which could be found in the naive drawings of children. This notion of universal style was also reflected in other contemporary attitudes that seem to have been influential for Bonnard, linking Greek, Japanese, and children's art in their purity and simplification of formal language. See E. Pottier, "Grèce et Japon," *Gazette des Beaux-Arts*, 3rd ser., 4 (1890) pp. 105–132, esp. p. 115.

36. For the influence of Hokusai's *manga* on Manet and subsequent artists see Anne

Coffin Hanson's review of Alain de Leiris, *The Drawings of Edouard Manet*, in *Art Bulletin* 53 (1971) pp. 542–547.

37. Broude ("Edgar Degas and French Feminism") distinguishes between Degas's brothel monotypes and his portrayals of women at their toilette by virtue of such accessories as black ribbons and black stockings, which she considers indicative of prostitution. The argument is an interesting one but fails to take into account the sheer profusion of certain of these elements as fashion items worn by all women.

38. The nude became a preferred subject of the Symbolist generation. See Uzanne, *The Modern Parisienne*, p. 18. See also Camille Mauclair, "La Femme devant les peintres modernes," *La Nouvelle Revue*, n.s. 1 (1899) pp. 190–213; and Marius-Ary LeBlond, "Les Peintres de la femme nouvelle," *La Revue* 39 (1901) pp. 275–290.

39. Issues of censorship in these years cannot be ignored. The novelist Louis Desprez was tried in 1884 for his book *Autour d'un clocher* (described by Fénéon as one of the best books on village life), was imprisoned for a year, and died shortly afterwards. Paul Adam was also imprisoned for six months for his first novel, *Chair molle*, about the life and death of a prostitute called Lucie. One wonders if the name Lucie that appears written in many of Bonnard's works of this period is a reference to Adam's book and to his plight (I am grateful to Colta Ives for pointing out to me this use of the name Lucie).

40. Uzanne, *The Modern Parisienne*, pp. 199–200.

41. Fénéon, for example, had female pseudonyms—Félice, Luce, Thérèse—and delighted in using them when writing to a mistress; see Halperin, *Fénéon*, pp. 324–347.

42. There was a rash of lesbian stories and novels—interestingly enough, uncensored—in the 1880s, among them Alphonse Daudet's *Sapho: Moeurs parisiennes*, August Strindberg's *Le Plaidoyer d'un fou*, and Pierre Louÿs's *Les Chansons de Bilitis*. Hence the publication of Verlaine's "Amies" (a group of lesbian verses) in *Parallèlement* had a significant context.

43. See Newman 1984, no. 2, p. 110.

44. Victor Joze, "Le Féminisme et le bon sens," *La Plume* 154 (September 15, 1895) p. 392: "Que la femme reste telle que la Nature l'a faite: une femelle idéale, compagne et amante de l'homme, maîtresse du foyer ou bacchante. Qu'elle soit libre de sa personne, que la Loi la protège contre l'exploitation des mâles; mais qu'elle ne vienne pas se poser en virago: ce rôle ne lui sied point. . . . Pas d'eunuques, pas d'androgynes!" See Silverman, "Nature, Nobility, and Neurology," pp. 120–143, for a related discussion of feminism and *la femme nouvelle*.

45. The two did not marry until 1925, and the legality of their marriage was questioned in the dispute over the estate following Bonnard's death. Bonnard had other models in the course of his life and was intimately involved with two of them. One, Lucienne Dupuy de Frenelle, appears in paintings around 1915–16 (e.g., Dauberville 928). The other, Renée Monchaty, known as Chati, was a statuesque blonde who fulfilled Bonnard's vision of more monumentally classical forms (e.g., Dauberville 898); she committed suicide in Rome in 1923. These relationships, which are essential to an understanding of Bonnard's later nudes, will be discussed in Newman, "Pierre Bonnard and the Reinvention of the French Tradition."

46. *La Revue blanche* provided a forum for Scandinavian literature and art, whose psychological realism strongly appealed to those in the journal's circle. For an index and history of this important publication see Fritz Hermann, *Die Revue blanche und die Nabis* (Munich, 1959); and A. B. Jackson, *La Revue blanche (1889–1903): Origine, influence, bibliographie* (Paris, 1960).

47. Letter in the collection of Antoine Terrasse: "Je confie cette lettre à Vollard pour vous dire que je trouve vos dessins de la revue blanche tout ce qu'il y a de plus exquis. C'est bien à vous. Gardez cette art."

48. See Geneviève Aitken, "Les Peintres et le théâtre autour de 1900 à Paris," *mémoire* (Ecole du Louvre, 1978) pp. 117–118. I would like to thank Juliet Wilson Bareau for bringing this source to my attention. The plays billed were *La Fleur enlevée*, adapted from the Chinese by Jules Arène, *L'Errante* by P. Quillard, and *La Dernière Croisade* by Maxime Gray.

49. Thadée Natanson reviewed Munch's exhibition in Oslo in *La Revue blanche* in September 1895. Munch's lithograph *The Scream* (*L'Anxiété*) appeared in the December 1895 issue of the magazine, prior to its publication in Vollard's *Album des peintres-graveurs*. A Munch exhibition at Bing's Maison de l'Art Nouveau in June 1896 was reviewed by August Strindberg (*La Revue blanche* 10:72 [1896] p. 525). In 1897 ten paintings from Munch's *Frieze of Life* cycle were shown at the Salon des Indépendants. Munch designed the sets and program covers for Ibsen's *Peer Gynt* and *John Gabriel Borkman*, staged at the Théâtre de l'Oeuvre in 1896 and 1897 respectively.

50. On the Bonnard-Vollard collaborations see Claude Roger-Marx, "Bonnard: Illustrateur et lithographe," *Art et décoration* 43 (1923) pp. 115–120; J. E. Pouterman, "Les Livres d'Ambroise Vollard," *Arts et métiers graphiques* 64 (1938) pp. 45–56; Louis Parrot, "Pierre Bonnard et le livre," *Les Lettres françaises* 4:34 (December 16, 1944) p. 3; Pascal

Pia, "Ambroise Vollard, marchand et éditeur," *L'Oeil* 3 (March 15, 1955) pp. 18–27; and Una E. Johnson, *Ambroise Vollard, Editeur: Prints, Books, Bronzes*, exh. cat. (New York, 1977).

51. See Ambroise Vollard, *Recollections of a Picture Dealer*, trans. Violet M. Macdonald (Boston, 1936) pp. 251–254. See also Gordon N. Ray, *The Art of the French Illustrated Book, 1700 to 1914* (New York/Ithaca, 1982) II, pp. 504–506.

52. Claude Roger-Marx, *Pierre Bonnard*, Les Artistes du Livre (Paris, 1931) p. 15: "Il fallut donc déboulonner Minerve, ou plutôt remplacer titre et couverture." Vollard had already released "a certain number of copies" before the change was ordered (Vollard, *Recollections*, p. 253).

53. Quoted in A. E. Carter, *Paul Verlaine* (New York, 1971) p. 105.

54. Maurice Denis illustrated *Sagesse* in 1889, moved by its relationship to his own religious feelings about the nature of art. These illustrations were not published until 1911. Denis's format for *Sagesse*, although innovative, was entirely rectangular, with bands of illustrations entering into the margins and framing the text. He retained a rigorous arabesque in his design and did not shatter form, as Bonnard did in *Parallèlement*. For Denis's attitudes toward book illustration see "Définition du néo-traditionnisme" (1890) in Denis 1920, pp. 10–11. Denis, like Bonnard, wanted a transformation of book illustration, but he wanted one that would embrace the purity and medievalizing aspect of wood engraving.

55. Verlaine's account of his dependence on *filles* is quoted in Carter, *Paul Verlaine*, p. 19: "Cheap prostitutes obsessed me. I had them in my blood. If a decent woman . . . had offered herself, I'd have asked her to let me alone"; "I continued my experiments with a frequency which only increased my curiosity, and my curiosity is still unsatisfied even now when I'm over fifty."

56. Alfred Jarry, review of *Parallèlement*, in *La Revue blanche* 24 (1901) p. 317. For the full text see the Appendix following this chapter.

57. See *L'Estampe et l'affiche* 3 (1889) p. 118.

58. See note 67 below.

59. See Maurice Denis, "Définition du néo-traditionnisme" (1890) in Denis 1920, pp. 1–2, for his discussion of how perception is influenced by memory and associations.

60. Quoted in J. Daurelle, "Chez les jeunes peintres," *Echo de Paris* (December 28, 1891) p. 2: "Je ne suis d'aucune école. Je cherche uniquement à faire quelque chose de personnel."

61. Vuillard's journal from 1888 to 1894 (see note 19 above) records his obsessive search for a subject that would release his subconscious, enabling him to create a *tableau* full of resonance and not an artificial copy of nature. "Pratiquement nécéssité de travailler surtout de mémoire," he wrote on November 11, 1888. He became more and more convinced of the need to liberate the memory by concentrating on what was familiar, or *intime*.

62. See Denis 1920, p. 2.

63. Natanson 1948, p. 336 (these observations date from 1912).

64. For Bonnard the actions involved in painting and sculpture were extremely important. He once said: "Le tableau est une suite de taches qui se lient entre elles et finissent par former l'objet, le morceau sur lequel l'oeil se promène sans aucun accroc. La beauté d'un morceau de marbre antique réside dans toute une série de mouvements indispensables aux doigts"; quoted in E. Tériade, "Propos de Pierre Bonnard, à Tériade," *Verve* 5:17–18 (August 1947) p. [59]. While working on *Daphnis et Chloé*, Bonnard began making sculpture, encouraged by Vollard and by Maillol; the latter was his neighbor in Marly-le-Roi. About a dozen sculptures were the result—tiny Rococo-inspired figurines and table ornaments in terracotta, which were produced by Vollard in bronze editions.

65. Quoted in Marguette Bouvier, "Pierre Bonnard revient à la litho...," *Comoedia* 82 (January 23, 1943) p. 1: "J'ai commencé les lithographies de *Daphnis et Chloé*, d'un inspiration plus classique. Je travaillais rapidement, avec joie. *Daphnis* a pu paraître en 1902."

66. The use of lithography in an *édition de luxe* seemed like a publishing heresy at the time. See Clément-Janin, "La Gravure sur bois," *L'Estampe et l'affiche* 2:5 (May 15, 1898) pp. 103–106, for a discussion of the change from illustrators' books to painters' books and the ensuing problems with artists ill-equipped to deal with the laws of book illustration and with traditional techniques.

67. Clément-Janin, review of *Parallèlement* in "Les Editions de bibliophiles," *Almanach du bibliophile* (1901) pp. 245–246. Clément-Janin's reviews of *Parallèlement* and *Daphnis et Chloé* are reprinted in the Appendix following this chapter.

68. Clément-Janin, review of *Daphnis et Chloé* in "Les Editions de bibliophiles," *Almanach du bibliophile* (1902) pp. 232–234.

69. Ibid., p. 234: "*Daphnis* est en progrès sur *Parallèlement*, même au point de vue du livre. . . . Vous voyez que M. Vollard s'assagit et qu'à l'encontre de beaucoup de ses confrères, il ne craint pas d'évoluer."

70. Throughout his life Bonnard found it difficult to discuss *Parallèlement* and its hostile reception. *Daphnis et Chloé* was in certain ways an about-face for him, and it influenced most of the large-scale decorations that he produced in the years preceding World War I.

71. See Edmond de Goncourt, *Catalogue raisonné de l'oeuvre peint, dessiné et gravé de P. P. Prud'hon* (Paris, 1876). Bonnard became interested in Prud'hon between 1895 and 1900. Prud'hon's graphic work, his large-scale decorative compositions, the furniture he designed for the empress Josephine, his studies of nude children and of the *Medici Venus* and the *Sleeping Hermaphrodite* are all significant in connection with Bonnard's work at this time.

72. Natanson 1951, p. 167: "Dans son *Daphnis* Bonnard me paraît se rapprocher des traductions qu'ont faites des anciens les écrivains du XVIIe [siècle]."

73. René Jean, "Pierre Bonnard: Illustrateur de *Daphnis et Chloé*," *Das graphische Kabinett* (1917) p. 139: "[*Daphnis et Chloé*] peut ajouter à sa gloire celle d'avoir provoqué des illustrateurs, tels que Prud'hon, tels que Pierre Bonnard, et celle d'avoir suscité, à un siècle d'intervalle, deux éloquents interprètes de la sensibilité et des émotions d'une race."

74. Roger-Marx, *Pierre Bonnard*, p. 19: "Le génie de Bonnard s'est prodigué là avec une générosité extraordinaire, . . . créant, en plein style 1900, un ouvrage . . . à la fois grec et moderne, et sûr ainsi de ne jamais se démoder."

75. The different aspects of sensuality explored in *Parallèlement* and *Daphnis et Chloé* are related to Baudelaire's exploration of the dualities of modern love in *Spleen et Idéal*— the former, cosmopolitan and even perverse, in distinct contrast with the pastoral, childlike innocence of the latter.

76. Issues of landscape become extremely complicated in the years leading up to World War I. For a discussion of these issues as they emerge from the Symbolist dialogue see Ellen C. Oppler, *Fauvism Reexamined* (New York, 1976) pp. 180–230; Richard Shiff, *Cézanne and the End of Impressionism: A Study of the Theory, Technique, and Critical Evaluation of Modern Art* (Chicago/London, 1984); and Newman, "Pierre Bonnard and the Reinvention of the French Tradition," chap. 3. Bonnard's early experiments in the repopulated landscape are unique in that they incorporate the northern vocabulary of Impressionism with figures more generally identified with the Mediterranean.

77. See Robert L. Herbert, "Impressionism, Originality and Laissez-Faire," *Radical History Review* 38 (1987) pp. 7–15.

78. Quoted in Raymond Cogniat, *Bonnard*, Les Maîtres de la peinture moderne (Paris, 1969): "Je me souviens très bien qu'à cette époque je ne connaissais pas du tout l'impressionnisme; et l'oeuvre de Gauguin nous a enthousiasmé pour elle-même, non contre quelque chose. D'ailleurs, quand, un peu plus tard, nous avons découvert l'impressionnisme, ce fût un nouvel enthousiasme, une sensation de découverte et de libération, car Gauguin est un classique, presque un traditionaliste, et l'impressionnisme nous a apporté la liberté."

79. On the criticism surrounding Monet in the 1890s and the distinction between uninflected perception and the *tableau* see Steven Z. Levine, *Monet and His Critics* (New York, 1976), particularly those sections devoted to Natanson and *La Revue blanche*.

80. Quoted in A. Terrasse 1967, p. 94: "Quand mes amis et moi voulûmes poursuivre les recherches des Impressionnistes et tenter de les développer, nous cherchâmes à les dépasser dans leurs impressions naturalistes de la couleur. L'art n'est pas la nature. Nous fûmes plus sévères pour la composition."

81. Elie Faure, *Catalogue Salon d'Automne* (Paris, 1905) p. 3: "Le révolutionnaire d'aujourd'hui est le classique de demain." Interestingly enough, this exhibition was distinguished by its Ingres retrospective and the place of honor given to Ingres's paean to pastoral iconography, his *L'Age d'or*. The Salon des Indépendants, which continued to be a vehicle of the Neo-Impressionists, had a Seurat retrospective in the same year.

82. For an account of the publication and reception of Nietzsche in France in the 1890s see Geneviève Bianquis, *Nietzsche en France: L'Influence de Nietzsche sur la pensée française* (Paris, 1929). Nietzsche eulogized France and her Mediterranean history, and came to represent the "great man" who, despite his Germanness, embodied the pure French tradition. His philosophy satisfied both the left-wing anarchists, who emphasized the Mediterranean and anti-Christian possibilities of his writings, and the monarchist traditionalists, who lauded him as a spokesman for France's Latin, imperial heritage—delineating the difference between Mediterraneanism and *latinité* in attitudes toward the South.

83. For a catalogue raisonné of Cross's work and a selection of his correspondence see Isabelle Compin, *H. E. Cross* (Paris, 1964).

84. These postcards are fascinating records of the odysseys and concerns of the Nabis and Neo-Impressionists during the first decade of the twentieth century, and I am indebted to Antoine Salomon and Antoine Terrasse for giving me the opportunity to study them. Both image and text are relevant, and often interrelated. For example, many postcards from 1904 reveal Vuillard's intensifying interest in Poussin, and postcards from Bonnard to Vuillard in 1907 record an interest in the sixteenth-century sculptural program at the Palais de Fontainebleau.

85. Quoted in Halperin, *Fénéon*, p. 100.

86. See Heilbrun and Néagu for a catalogue raisonné of Bonnard's photographs and a description of his photographic activities.

87. Marta Braun, "Muybridge's Scientific Fictions," *Visual Communications* 10:3 (1984) pp. 2–21, discusses Muybridge's use of the camera "not as an analytic tool, but as an instrument of representation." Bonnard had a related interest in filmmaking and was friendly with the Lumière brothers, who often visited him and his brother-in-law, Claude Terrasse, during the 1890s. This is a relationship that needs further exploration.

88. Antoine Terrasse, "Bonnard's Notes," in Newman 1984, pp. 53–70.

89. On Bonnard's various country residences see Charles Terrasse, "Maisons de campagne de Bonnard," *Formes et couleurs* 6:2 (1944) pp. 27–38.

90. *La Grande Jatte* continued to be significant for Bonnard and the Nabis as they formulated their conception of the decorative. See Halperin, *Fénéon*, pp. 75–77, 137–141, for Fénéon's response to the painting and for Seurat's own account of his technique and his intentions in terms of unifying the historical and the contemporary.

91. See Waldemar George, "Pierre Bonnard et l'antique," *L'Art et les artistes* 31:162 (1935) pp. 85–88.

92. Maillol and Renoir were both important to Bonnard as he reoriented himself to classical Western traditions. Renoir's late works were a model for Bonnard's development of the monumental nude in the land-scape and as he invested his paintings with mythological and narrative content in the prewar years. Of all the Nabis, Maillol was the most lauded for his embrace of Greco-Roman traditions. Mithouard ("Le Classique occidental," cited in note 14 above), for example, recognized Maillol as the purveyor of the classical simplicity and restraint that united French work in all media from the Middle Ages to his own day.

93. Contemporary criticism increasingly divorced Renoir from his Impressionist heritage and transformed him into a fountainhead of the classical French tradition, an attitude that culminated in Robert Rey, *La Peinture française à la fin du XIXe siècle. La Renaissance du sentiment classique: Degas, Renoir, Gauguin, Cézanne, Seurat* (Paris, 1931).

94. Roger-Marx, *Pierre Bonnard*, p. 20: "Bonnard a retrouvé dans le Dauphiné ou près de Paris l'atmosphère de ces temps heureux que les dieux et les demi-dieux habitent encore; . . . la vie a toujours les mêmes limites, le désir suit les mêmes pistes, les saisons ont le même cours; et la ceinture de Chloé se défait en Ile-de-France comme dans l'Ile de Mytilène."

95. Following the publication of *Daphnis et Chloé* Bonnard became increasingly involved with private decorative commissions, an activity that continued through World War I and then ceased abruptly as he retreated more and more into isolation in the Midi. In 1910 he painted three panels for Morosov entitled *Méditerranée* (Dauberville 657); these were included, together with the preparatory drawings, in his exhibition at the Galerie Bernheim-Jeune in 1911. The year 1910 also saw the completion of an important four-panel decoration for Misia Sert's home on the Quai Voltaire in Paris: *Le Plaisir*, *Le Voyage*, *L'Etude*, and *Le Jeu* (Dauberville 432–435). Three decorative panels were included in Bonnard's 1913 exhibition: *Le Printemps*, *L'Eté*, and *L'Automne* (Dauberville 718, 695, 716).

96. *Pastoral Symphony*, with *Méditerranée* (Dauberville 867), is southern in orientation. The other two, *Le Paradis terrestre* and *Paysage de ville* (Dauberville 867a, 868), are recognizably northern in landscape and iconography.

97. See above, note 45.

LENDERS TO THE EXHIBITION

FRANCE

Paris
 Bibliothèque Nationale
 Musée du Louvre
 Musée d'Orsay
 Private collections

FEDERAL REPUBLIC OF GERMANY

Karlsruhe
 Kupferstichkabinett, Staatliche Kunsthalle
Munich
 Sabine Helms

HUNGARY

Budapest
 Szépmüvészeti Múzeum (Museum of Fine Arts)

SWITZERLAND

 Private collections

UNITED STATES OF AMERICA

Boston
 Museum of Fine Arts
Cambridge
 Harvard University Art Museums (Fogg Art Museum)
 The Houghton Library, Harvard University
Chicago
 The Art Institute of Chicago
Flint
 Flint Institute of Arts

Houston
 Virginia and Ira Jackson Collection
New Brunswick
 The Jane Voorhees Zimmerli Art Museum,
 Rutgers, The State University of New Jersey
New Orleans
 New Orleans Museum of Art
New York
 The Brooklyn Museum
 Alice Mason Collection
 The Metropolitan Museum of Art
 The Museum of Modern Art
 New York Public Library,
 Astor, Lenox, and Tilden Foundations
 The Family of Mr. and Mrs. Derald H. Ruttenberg
 Mr. and Mrs. Eugene V. Thaw
Northampton
 Smith College Museum of Art
San Francisco
 The Fine Arts Museums of San Francisco
Toledo
 The Toledo Museum of Art
Washington, D.C.
 National Gallery of Art
 The Phillips Collection
Williamstown
 Sterling and Francine Clark Art Institute

 Anonymous lenders
 Josefowitz Collection
 Rodés Collection

CATALOGUE

1. France-Champagne, 1889–91 [figs. 125, 203]

Poster
Lithograph in three colors
Commissioned by E. Debray in 1889
Printed by Edward Ancourt & Cie, Paris, in 1891

Image: 780 x 500 (30¾ x 19¾)
Cream wove paper: 810 x 605 (31⅞ x 23¹³⁄₁₆)

New Brunswick, Rutgers, The State University of New Jersey,
The Jane Voorhees Zimmerli Art Museum, Gift of Ralph and
Barbara Voorhees

Floury 1; Roger-Marx 1; Bouvet 1; Boyer 1988, 9; Galerie Laffitte,
Catalogue des peintures, pastels, aquarelles et dessins modernes
(Paris, 1895) p. 3; Galeries Durand-Ruel, *Exposition P. Bonnard*
(Paris, 1896) no. 51; Ernest Maindron, *Les Affiches illustrées
(1889–1895)* (Paris, 1896) pp. 40–41

A full-size preliminary ink drawing is in the Musée des Beaux-
Arts, Reims (Royal Academy of Arts, *Pierre Bonnard, 1867–
1947*, exh. cat. [London, 1966] no. 256, pp. 13, 66, ill.); another
(double-sided) sheet of studies is in the collection of Virginia
and Ira Jackson, Houston (see cat. 2). A related sketch (C.
Terrasse 1927, p. 21, ill.) was probably made after the fact.

A letter from Bonnard to his father establishes 1889 as the
date for the 100-franc commission (C. Terrasse 1927, pp. 21–
22). Writing to his mother on March 13 and 19, 1891, Bonnard
reported first that he had collected a proof of the poster in
black ink from the printer and then that the poster would be
done by the end of the month (Perucchi-Petri 1976, p. 36). On
May 21 he announced, "Everyone's asking for my poster"
(Antoine Terrasse, *Bonnard Posters and Lithographs* [New York,
1970] n.p.). In the same letter to his mother Bonnard mentions
his decoration of the cover for the piano music *France-Cham-
pagne, Valse de Salon* (fig. 128): "I have also designed the cover
of a book of music for the gentleman of the Champagne post-
er, for which he has paid me 40 francs!" (Giambruni 1983,
p. 85).

Bonnard's model for the poster, his cousin and supposed
sweetheart at this time, Berthe Schaedlin, was portrayed by
him in a similar pose in the painting *La Jeune Fille assise au
lapin*, 1891 (Dauberville 24).

2. Studies for **France-Champagne,** ca. 1889
 [figs. 129, 130]

Pencil and ink (recto and verso)

Wove paper: 190 x 323 (7½ x 12¾)

Ex coll.: Cass Canfield
Houston, Virginia and Ira Jackson Collection

Phillips, New York, sale cat. (November 11, 1985) lot 71

These sketches may also be related to Bonnard's design for
the cover to the piano music *France-Champagne, Valse de Salon*,
1891 (fig. 128).

3. La Petite qui tousse (The Girl with a Cough),
 ca. 1890 [fig. 7]

Front cover design for sheet music by Claude Terrasse, lyrics by
Jean Richepin
Ink and watercolor over pencil

Off-white laid paper: 276 x 365 (10⅞ x 14⅜)
Watermark: DAMBRICOURT FRERES
Initialed in ink and watercolor lower right: *PB*

Houston, Virginia and Ira Jackson Collection

Boyer 1988, pp. 20, 58, 144 (no. 18, col. pl. 3), also two related
drawings (nos. 19, 20); A. Terrasse 1989, p. 311; see also
Galerie Krugier & Cie, *Bonnard,* Suites no. 23 (Geneva, 1969)
p. 1 (in which the publication of a limited-edition album
containing a "lithograph" of this watercolor is announced.
The same announcement appears in Albert Loeb and Krugier
Gallery, *Taurus,* no. 11 [New York, 1969].)

4. Infant on a Cabbage Leaf, ca. 1890–91 [fig. 91]

Ink over pencil

Beige wove paper (irregular sheet): 157 x 130 (6⅛ x 5⅛)

The Fine Arts Museums of San Francisco, Achenbach
Foundation for Graphic Arts, Gift of R. E. Lewis, Inc.

Phyllis Hattis, *Four Centuries of French Drawings in the Fine Arts
Museums of San Francisco* (San Francisco, 1977) no. 206

This drawing may have originated as a design for a birth an-
nouncement.

5. Moulin Rouge, 1891 [fig. 133]

Design for a poster
Pencil, crayon, ink, watercolor, and pastel

Paper: 365 x 325 (14⅜ x 12¹³⁄₁₆)

Ex coll.: Charles Terrasse; Georges Bernier
Private collection

C. Terrasse 1927, repr. opp. p. 68; Galerie de l'Oeil, *Dessins et tableaux de Pierre Bonnard* (Paris, 1968) no. 15 (see also nos. 16, 17); Antoine Terrasse, "Le Dessin de Bonnard," *L'Oeil* 167 (November 1968) p. 15; Sotheby's, London, sale cat. (April 16, 1970) lot 55; Galerie Sapiro, *Dessins et aquarelles de Bonnard* (Paris, 1975) p. 10

An unpublished letter in the collection of Antoine Terrasse dated June 25, 1891, from Bonnard's mother to his sister reports, "Il y a une affiche en train pour le Moulin Rouge." At least four designs survive that were made in anticipation of a poster commission. In addition to the one cited here, they are: one in the Cabinet des Dessins, Musée du Louvre (40.979); one in a French private collection (Boyer 1988, 12); and another (fig. 134) sold at the Hôtel Drouot, Paris, on May 16, 1955, lot 168.

6. Villa Bach: Andrée with Dog, 1891 [fig. 52]

Cover design for a concert program
Watercolor, pencil, and ink

Wove paper: 160 x 257 (6¼ x 10⅛)
Initialed in ink lower right: *PB*

Switzerland, private collection

Galerie Krugier & Cie, *Bonnard*, Suites no. 23 (Geneva, 1969) (with the announcement of the publication of a limited-edition album containing a "lithograph" of this watercolor. The same announcement appears in Albert Loeb and Krugier Gallery, *Taurus*, no. 11 [New York, 1969].)

A group of twenty-two watercolors and drawings designed as programs for concerts at the rented house of Bonnard's sister and brother-in-law, the Villa Bach, Arcachon, is in the collection of the Humanities Research Center, The University of Texas at Austin, and described in Carlton Lake, *Baudelaire to Beckett: A Century of French Art and Literature. A Catalogue of Books, Manuscripts, and Related Material Drawn from The Collections of the Humanities Research Center* (Austin, 1976) no. 72.
See also cat. 7.

7. Villa Bach: Woman in a Landscape, 1891 [fig. 53]

Front cover design for a concert program
Watercolor, pencil, and ink

Wove paper: 160 x 129 (6¼ x 5¹⁄₁₆)

Switzerland, private collection

Galerie Krugier & Cie, *Bonnard*, Suites no. 23 (Geneva, 1969) (with the announcement of the publication of a limited-edition album containing a "lithograph" of this watercolor. The same announcement appears in Albert Loeb and Krugier Gallery, *Taurus*, no. 11 [New York, 1969].)

See cat. 6.

8. Women with Dog, 1891 [fig. 97]

Oil on canvas

406 x 324 (16 x 12¾)
Signed and dated lower right: *PBonnard 1891*

Williamstown, Mass., Sterling and Francine Clark Art Institute

Dauberville 20

The painting's dependence upon the compositions and surface patterns found in Japanese prints is explored in Ursula Perucchi-Petri, "Das Figurenbild in Bonnards Nabis-Zeit," in Marianne Matta and Toni Stooss, *Bonnard*, exh. cat. (Zurich, 1984) pp. 37–39.

9. Andrée with a Dog, ca. 1891–92 [fig. 98]

Graphite and ink

Wove paper: 310 x 220 (12³⁄₁₆ x 8⅝)
Initialed in ink lower left: *PB*

Ex coll.: Marcel Guiot
Private collection

A related and probably slightly later drawing of the same subject with the addition of watercolor is in the collection of the Museum of Fine Arts, Springfield, Massachusetts (see "Woman with Dog," *Springfield Museum of Fine Arts Bulletin* 13 [1947] pp. 3–5; Bret Waller and Grace Seiberling, *Artists of La Revue Blanche*, exh. cat. [Rochester, N.Y., 1984] p. 49; Boyer 1988, 111).

10. Woman on a Windy Day, ca. 1891–92 [fig. 143]

Pencil, ink, and wash

Heavy gray wove paper: 325 x 258 (12¾ x 10⅛)
Estate stamp lower left

Private collection

11. Pas du tout, passionnément
(Not at All, Passionately), 1891–92 [fig. 8]

Pencil and ink

Paper: 400 x 300 (15¾ x 11¹³⁄₁₆)

Josefowitz Collection

12. Picking Plums, ca. 1892–93 [fig. 244]

Pencil, ink, and watercolor

Paper: 184 x 114 (7¼ x 4½)

Switzerland, private collection

Ursula Perucchi, ed., *Nabis und Fauves: Zeichnungen, Aquarelle, Pastelle aus Schweizer Privatbesitz,* exh. cat. (Zurich, 1982) no. 5, p. 25

The subject is one that Bonnard treated often, for example, in Dauberville 204 and 01794 (cat. 80). Here, the highly simplified composition, the cylindrical shape of the figure, and the "patterned" surface suggest a date around the time of the *Petit Solfège illustré* (cat. 19).

13. Family Scene, 1892 [fig. 58]

Lithograph in five colors

Image: 210 x 260 (8¼ x 10¼)
Cream wove paper: 295 x 397 (11⅝ x 15⅝)
Signed in pencil lower left: *no 1 PBonnard*

Switzerland, private collection

Floury 2; Roger-Marx 2; Bouvet 2

The subjects are Bonnard's father and sister with her son Jean (born May 6, 1892).

Although Roger-Marx supposes that only about thirty impressions of the print were made, examples have been located that are numbered 42 and 55 by the artist. The blue in the baby's eyes and the grandfather's spectacles is present in most impressions although difficult to distinguish.

Two preparatory watercolor-and-ink drawings are extant; see cat. 14.

14. Family Scene, 1892 [fig. 60]

Preparatory drawing for the lithograph, 1892 (cat. 13)
Watercolor and ink over pencil

Wove paper: 246 x 319 (9⅝ x 12½)
Signed upper left: *PBonnard* (in pencil) and *PB* (in ink); lower right: *PBonnard* (in pencil)

Switzerland, private collection

Ursula Perucchi, ed., *Nabis und Fauves: Zeichnungen, Aquarelle, Pastelle aus Schweizer Privatbesitz,* exh. cat. (Zurich, 1982) no. 1, p. 22

A closely related watercolor-and-ink drawing of the mother and child was auctioned at Sotheby's, New York, November 12, 1988, lot 105.

15. The Family, 1892 [fig. 89]

Design for a fan
Watercolor and pencil

Paper: 267 x 511 (10½ x 20⅛)
Signed in ink lower right: *Bonnard*

Private collection

Sotheby's, London, sale cat. (December 3, 1986) lot 422

A closely related drawing (fan-shaped) of the same subject is reproduced in the sale catalogue for Hôtel Rameau, Versailles (December 2, 1973) lot 198.

Bonnard drew at least three other designs for fans: *Women and Flowers,* ca. 1890 (Boyer 1988, no. 6, pp. 114, 139); *Lapins dans une prairie,* ca. 1891–92, Musée du Louvre (Orsay); and *Promeneurs et cavaliers, avenue du Bois,* 1894 (Galeries nationales du Grand Palais, *Le Japonisme,* exh. cat. [Paris, 1988] nos. 295, 296, pp. 210–211, ill.).

16. Mother and Child, ca. 1892–93 [fig. 92]

NOT IN EXHIBITION

Watercolor and ink

Paper: 246 x 163 (9⅝ x 6⅜)

Karlsruhe, Kupferstichkabinett, Staatliche Kunsthalle

Staatliche Kunsthalle, *Die französischen Zeichnungen, 1570–1930,* exh. cat. (Karlsruhe, 1983) no. 91

17. Family Scene, 1893 [fig. 62]

Lithograph in four colors
From *L'Estampe originale,* Album I, March 30, 1893, pl. 2 (portfolio of ten prints)
Published by André Marty, Paris (edition of 100)

Image: 312 x 177 (12¼ x 7)
Heavy cream wove paper: 578 x 406 (22¾ x 16)
Blind stamp of *L'Estampe originale*
Signed in pencil lower right: *no 73 PBonnard*

New York, The Metropolitan Museum of Art, Rogers Fund, 1922 (1922.82.1-3)

Floury 4; Roger-Marx 4; Bouvet 4; Donna M. Stein and Donald H. Karshan, *L'Estampe Originale: A Catalogue Raisonné,* exh. cat. (New York, 1970) no. 9, p. 21; Colta Feller Ives, *The Great Wave: The Influence of Japanese Woodcuts on French Prints* (New York, 1974) pp. 58–59

The subjects are Bonnard's sister, Andrée, her son Jean, and the artist himself, at lower right. (Andrée's second son, Charles, with whom the infant is usually identified, was born on October 1, 1893, several months after this lithograph was published.)

A preliminary watercolor done before the addition of the artist's profile (Royal Academy of Arts, *Pierre Bonnard, 1867–1947*, exh. cat. [London, 1966] no. 262, p. 67, ill.), an impression of the print with watercolor additions, and related pencil sketches (see Boyer 1988, nos. 21–23, pp. 144–145) exist. Two related watercolors were exhibited by the gallery Huguette Berès (*Bonnard, illustrateur* [Paris, 1970] nos. 2, 3). The lithograph is based on Bonnard's painting *Mme Claude Terrasse and Her Son Jean* (cat. 18).

18. Mme Claude Terrasse and Her Son Jean, 1893
[fig. 63]

New York only

Oil on canvas

370 x 300 (14⁹/₁₆ x 11¹³/₁₆)
Signed and dated upper left: *PBonnard 1893*

Ex coll.: Jacques Helft, New York
New York, Alice Mason Collection

Dauberville 01737; Colta Ives, "French Prints in the Era of Impressionism and Symbolism," *Metropolitan Museum of Art Bulletin* 46:1 (1988) p. 36

The painting, which is the basis for the color lithograph Bonnard published in 1893 (cat. 17), is related to two other paintings that show Bonnard's sister, Andrée, in a checkered dress in the gardens of the family's house at Le Grand-Lemps: *Crépuscule*, 1892 (fig. 51; Dauberville 38 as "La Partie de croquet"), and *Les Trois Ages* (or *Maternité*), 1893 (Dauberville 42).

19. Petit Solfège illustré
(Little Illustrated Solfeggio), 1893 (begun 1891)
[figs. 9, 55, 65, 71, 73–75, 77, 78]

Music primer for children by Claude Terrasse
Illustrated with 32 lithographs (including front and back covers)
Published by Librairies-Imprimeries Réunies, Ancienne Maison Quantin, Paris, 1893 (edition of 2,000; this copy: "deuxième mille")
Printed by F. Allier Père et Fils, Grenoble

Wove paper: 213 x 283 (8³/₈ x 11¹/₈)

New York, The Metropolitan Museum of Art, Mary Martin Fund, 1987 (1987.1117)

A. Terrasse 1989, 6; Galerie Laffitte, *Catalogue des peintures, pastels, aquarelles et dessins modernes* (Paris, 1895) p. 3; Galeries Durand-Ruel, *Exposition P. Bonnard* (Paris, 1896) no. 54; Peter H. Deitsch, *Bonnard: Fifty Watercolors and Drawings for "Petit Solfège Illustré" (1893)* (New York, 1962); Eleanor M. Garvey, Anne B. Smith, and Peter A. Wick, *The Turn of a Century, 1885–1910: Art Nouveau–Jugendstil Books*, exh. cat. (Cambridge, Mass., 1970) p. 53

Bonnard's collaboration on this book with his brother-in-law, Claude Terrasse, which began early in 1891, was fraught with difficulties (see chapter 2). At least seventy-two drawings for the project survive: the group auctioned at the Hôtel Drouot, Paris, on May 10, 1962 (lot 27), purchased by New York dealers Peter Deitsch and Lucien Goldschmidt. Correspondence relating to the endeavor and invoices from the printer Allier testify to the fact that the illustrations are indeed lithographs and not, as previously thought, photomechanical reproductions of drawings.

Some copies of the edition of two thousand are distinguished by the words "deuxième mille" on the title page and cover, but inconsistencies in the color printing exist throughout the edition. For instance, a page that is printed blue in one copy may be beige in another. Bonnard exhibited his book at the Galerie Laffitte in the spring of 1895 (offered for sale at 3 francs) and in his first one-man show at Durand-Ruel in January 1896. It is listed for sale on the back page of the sheet music *Petites Scènes familières* (1895): "*Petites Scènes familières*, 6 francs; *Petit solfège*, 3 francs."

See cat. 20–24.

20. Solfège, ca. 1892–93
[fig. 112]

Preliminary cover design for *Petit Solfège illustré*, 1893
Lithograph in three colors

Cream wove paper: 216 x 267 (8½ x 10½)

New York, The Metropolitan Museum of Art, The Elisha Whittelsey Collection, The Elisha Whittelsey Fund, 1967 (1967.753.1)

Peter Deitsch Fine Arts, Inc., *Important Prints of the Nineteenth and Twentieth Centuries*, no. 12 (New York, 1968) no. 16, pl. XVIII

The text of this rejected cover design for *Petit Solfège illustré* reads: "Solfège / Leçons par C. Terrasse / Illustrations par Bonnard / Verdeau Edit." Seven impressions of this print survived with the group of drawings for the book auctioned at the Hôtel Drouot, Paris, May 10, 1962, lot 27. Before publication the image was altered, the title expanded, and the publisher changed to Quantin (see cat. 19, fig. 65). Another, slightly earlier proof of the rejected front cover exists with the words "Partie Théorie," suggesting that the project may have originally included more than one volume (Peter H. Deitsch, *Bonnard: Fifty Watercolors and Drawings for "Petit Solfège Illustré"* [1893], exh. announcement [New York, November 6–December 1, 1962]).

The figure of Andrée Terrasse seen playing the piano at the upper right, which was eliminated from the final cover, ap-

pears in Bonnard's design for sheet music by Claude Terrasse, *Suite pour piano, 3 pièces, op. 9* (fig. 111), for which related drawings survive (see Perucchi-Petri 1976, p. 64; Boyer 1988, 157, p. 147). It is also the subject of a painting from this period (Marianne Matta and Toni Stooss, *Bonnard*, exh. cat. [Zurich, 1984] no. 2, pp. 72–73, ill.; not in Dauberville).

21. Study for front cover, **Petit Solfège illustré,**
ca. 1893 [fig. 64]

Watercolor, ink, and wash

Wove paper: 221 x 280 (8¹¹⁄₁₆ x 11)

New York, The Museum of Modern Art, Peter H. Deitsch
 Bequest

Two other preliminary drawings for the cover survive: one, which is earlier, retains the piano and violin duet that appears in the rejected lithograph (cat. 20; see Boyer 1988, 28, pp. 109, 145); the other is closer to the final design (Peter H. Deitsch, *Bonnard: Fifty Watercolors and Drawings for "Petit Solfège Illustré" [1893]* [New York, 1962] ill.; Sotheby's, London, sale cat. [December 11, 1969] lot 42).

 See cat. 19 and 20.

22. Study for **Gamme majeure** (Major Scale),
ca. 1891–93 [fig. 70]

Preparatory drawing for page 8 of *Petit Solfège illustré*, 1893 (see
 cat. 19)
Pencil, ink, and watercolor

Paper: 177 x 265 (7 x 10⅜)

Private collection

Sotheby's, London, sale cat. (February 4, 1981) lot 484; J.P.L.
 Fine Arts, *Pierre Bonnard* (London, 1985) no. 2

Studies for *Petit Solfège illustré* have been located in the following public collections: the Houghton Library, Harvard University (cat. 24); the Museum of Modern Art, New York (cat. 21); Smith College Art Museum, Northampton, Mass.; Victoria and Albert Museum, London; Musée des Beaux-Arts, Rouen; and in the private collections of Walter Bareiss, Mrs. Robert F. Dall (Boyer 1988, 14), Mr. and Mrs. Lucien Goldschmidt (Boyer 1988, 28), Virginia and Ira Jackson, Samuel Josefowitz (Boyer 1988, 30), Matt Phillips, and Hubert Prouté.

 Examples have appeared in the following catalogues and auctions: Hôtel Drouot, Paris, May 10, 1962, lot 27; Peter H. Deitsch, *Bonnard: Fifty Watercolors and Drawings for "Petit Solfège Illustré" (1893)* (New York, 1962); Hôtel Rameau, Ver-

sailles, December 3, 1967, lots 40–42; Peter Deitsch Fine Arts, Inc., *Important Prints of the Nineteenth and Twentieth Centuries,* no. 12 (New York, 1968) no. 16; Sotheby's, London, December 11, 1969, lots 42, 43; Sotheby's, London, April 16, 1970, lots 61, 107; Sotheby's, London, July 8, 1970, lot 7; Sotheby's, London, June 28, 1972, lots 18, 19; Sotheby's, London, April 8, 1976, lot 75; Sotheby's, London, February 4, 1981, lot 484; Lucien Goldschmidt, sale cat., no. 55 (New York, 1983) no. 48; David and Constance Yates, *European Drawings and Works of Art* (New York, 1984) cover ill.; Christie's, London, June 25, 1985, lot 327; Sotheby's, New York, May 12, 1987, lot 101; Hôtel Drouot, Paris, June 10, 1987, lots 16–22.

 For the pencil-and-ink drawing for *Gamme mineure*, see Lucien Goldschmidt, sale cat., no. 55 ([New York, 1983] no. 48, ill.).

23. Studies for **La Valse** (The Waltz), ca. 1891–93
 [figs. 10, 11]

Preparatory drawings for the illustration on page 22 of *Petit
 Solfège illustré,* 1893
Ink over pencil (recto and verso)

White wove paper: 202 x 108 (8 x 4¼)

Munich, Sabine Helms

When Bonnard traced his initial drawing on the back of the sheet, he showed the couple as if seen from the other side.

 A related drawing, closer to the printed illustration and showing three waltzing couples in a row, is in the Smith College Museum of Art, Northampton, Massachusetts.

24. Mother and Child, 1893 [fig. 54]

Preparatory drawing for the back cover of *Petit Solfège illustré,*
 1893
Ink over pencil, with brown wash

Wove paper: 205 x 282 (8⅛ x 11⅛)
Initialed and dated in ink lower right: *PB 1893*

Cambridge, Mass., The Houghton Library, Harvard University,
 Department of Printing and Graphic Arts

Peter H. Deitsch, *Bonnard: Fifty Watercolors and Drawings for
 "Petit Solfège Illustré" (1893),* exh. announcement (New York,
 November 6–December 1, 1962); David P. Becker, *Drawings
 for Book Illustration: The Hofer Collection* (Cambridge, Mass.,
 1980) no. 43, pp. 56–58

A touched proof of the final printed cover design, in which the figures are reduced in size and centered in an open space, is in the collection of the Metropolitan Museum (62.657).

25. Les Chiens (The Dogs), 1893 [fig. 166]

Lithograph
Published by the weekly magazine *L'Escarmouche* (edition of 100)
Printed by Edward Ancourt & Cie, Paris

Off-white wove paper: 370 x 270 (14⁹⁄₁₆ x 10⅝)
Signed in pencil left of center: *n[o.]5 PBonnard*

New York, The Metropolitan Museum of Art, Purchase, Mr. and Mrs. Dave H. Williams Gift, 1988 (1988.1098)

Floury 6; Roger-Marx 25; Bouvet 25

The lithograph is reproduced in the December 10, 1893, issue of *L'Escarmouche*, the illustrated magazine directed by Georges Darien. In the magazine's first issue (November 12, 1893) the publication was announced of "les lithographies originales, tirées à cent exemplaires seulement, signées et numérotées par l'artiste, des dessins paru dans *L'Escarmouche*. Ces lithographies seront mises en vente, aux bureaux du journal, au prix de 2 fr. 50 et expédiées franco contre 2 fr. 75." Bouvet mentions another twenty impressions of the lithograph on japan paper; some examples bear the stamp of the publisher Kleinmann, as do some of Toulouse-Lautrec's prints for *L'Escarmouche* (see Wolfgang Wittrock, *Toulouse-Lautrec: The Complete Prints* [London, 1985] nos. 30–41).

Bonnard produced three other illustrations for the magazine: *L'Amusement des enfants—La Tranquillité des parents* (*The Amusement of Children—The Tranquillity of Parents*; Bouvet 26, as "Municipal Guard"), *Dans l'intimité* (*In Private*; Bouvet 27, as "Young Woman in Black Stockings"; see cat. 27), and *Conversation* (fig. 14; Bouvet 28). The third illustration, although editioned as a lithograph, never appeared in *L'Escarmouche*, the last issue of which is dated March 16, 1894.

26. Two Dogs in a Deserted Street (Street in Eragny), ca. 1893

Oil on wood

351 x 270 (13⅞ x 10⅝)
Signed right of center: *PBonnard*

Ex coll.: Thadée Natanson; Bernheim-Jeune; Capt. Edward Molyneux; Ailsa Mellon Bruce
Washington, D.C., National Gallery of Art, Ailsa Mellon Bruce Collection, 1970.17.3

Dauberville 63; Rewald 1948, no. 5; Galeries Durand-Ruel, *Exposition P. Bonnard* (Paris, 1896) no. 45; Marianne Matta and Toni Stooss, *Bonnard*, exh. cat. (Zurich, 1984) no. 16

The painting is presumably that listed in the catalogue of Le Barc de Boutteville, *Cinquième Exposition des peintres impressionnistes et symbolistes* (Paris, 1893), as "Rue d'Eragny" (no. 14).

27. Dans l'intimité (In Private), 1893 [fig. 206]

Lithograph
Published by *L'Escarmouche* (edition of 100)

Image: 288 x 127 (11⅜ x 5)
White wove paper: 378 x 279 (14⅞ x 11)
Signed in pencil lower left: *no 59 PBonnard*

Washington, D.C., National Gallery of Art, Ailsa Mellon Bruce Fund

Floury 8; Roger-Marx 27; Bouvet 27

The lithograph is reproduced (with some cropping of the lower margin) in the January 14, 1894, issue of *L'Escarmouche* magazine with the legend "Dans L'Intimité. Dessin inédit de Bonnard" (see cat. 25).

The edition of one hundred lithographs includes signed and numbered impressions in black ink on dark blue paper, as well as examples in black or brownish ink on off-white wove.

See preliminary drawing, cat. 28.

28. Study for Dans l'intimité, 1893 [fig. 208]

Preparatory drawing for the lithograph, 1893 (see cat. 27)
Ink and wash

Wove paper: 305 x 187 (12 x 7⅜)
New York, Mr. and Mrs. Eugene V. Thaw

Another preparatory drawing is now in the Musée des Beaux-

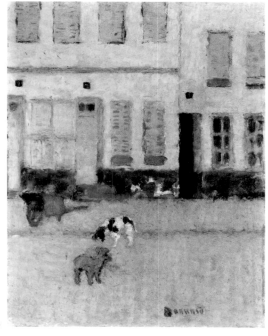

26

Arts, Marseilles (Paul Prouté, *Dessins . . . estampes anciennes . . . estampes originales*, sale cat. [Paris, 1985] no. 84, p. 37, ill.). The subject is close to the one shown in Peter Nansen's *Marie* (1898; see fig. 210). See related paintings in Dauberville 44–46 (fig. 209) and later works on the same theme, for example, Dauberville 222, 225, 226, and 230.

29. Figure Studies, ca. 1893 [fig. 207]

NOT IN EXHIBITION

Ink

Wove paper: 313 x 196 (12⁵⁄₁₆ x 7¾)

Budapest, Szépmüvészeti Múzeum

Véronique Kaposy, "Une Feuille de croquis de Pierre Bonnard," *Bulletin du Musée Hongrois des Beaux-Arts*, no. 44 (1975) pp. 123ff.

Three of the seven figure sketches on this sheet appear to be studies for the painting *Young Woman in Black Stockings*, 1893 (fig. 209; Dauberville 46). Another sheet of two similar figure studies in black ink is reproduced in National Museum of Western Art, *Bonnard*, exh. cat. (Tokyo, 1968) no. 89.

30. Parisiennes, 1893 [fig. 144]

Lithograph
Published in *La Revue blanche* magazine, no. 26 (December 1893)

Cream wove paper: 216 x 137 (8½ x 5⅜)

Houston, Virginia and Ira Jackson Collection

Floury 11; Roger-Marx 34; Bouvet 31; Fritz Hermann, *Die Revue blanche und die Nabis* (Munich, 1959) pp. 570–571

The lithograph was published (hors texte) in *La Revue blanche* magazine with the caption "Estampe de Pierre Bonnard." It was issued again in 1895 in the *Petite Suite de la Revue blanche*, which contained the five prints by Vuillard, Roussel, Denis, Ranson, and Bonnard that had been published in the magazine during the year 1893.

31. Woman with an Umbrella, 1894 [fig. 145]

Lithograph in two colors
Published by *L'Estampe originale* in the *Album de la Revue blanche*, 1895 (edition of 50): previously issued in *La Revue blanche* magazine, no. 35 (September 1894)

Image: 220 x 127 (8⅝ x 5)
Cream wove paper: 321 x 252 (12⅝ x 10)
Signed in pencil lower right: *PBonnard*

Boston, Museum of Fine Arts, Bequest of Betty Bartlett McAndrews

Floury 12; Roger-Marx 35; Bouvet 33

The *Album de la Revue blanche*, for which Bonnard designed the cover (fig. 18), contained this lithograph (usually signed and numbered) along with eleven other prints—by Toulouse-Lautrec, Vuillard, Redon, Vallotton, Denis, Ibels, Cottet, Rippl-Ronaï, Ranson, Roussel, and Sérusier—that had been issued monthly in *La Revue blanche* magazine during 1894. (Impressions of the print published in the magazine as "Estampe de Bonnard" are on wove paper approximately 245 x 159 mm. [9⅝ x 6¼ in.], the enlarged page size the journal adopted in 1894.)

Antoine Terrasse has pointed out the existence of a publicity notice printed by *La Revue blanche* on February 1, 1895, advertising the *Album* in an edition of fifty examples at 25 francs each.

See preparatory drawing, cat. 32.

32. Studies for Woman with an Umbrella, 1894 [fig. 146]

New York only

Preparatory drawings for the lithograph, 1894 (cat. 31) (verso: *Woman Putting On Gloves*)
Graphite, ink, and wash, with touches of watercolor

Wove paper: 310 x 198 (12¼ x 7¾)
Initialed in pencil lower center: *PB*

Ex coll.: Ambroise Vollard
The Art Institute of Chicago, Gift from The Estate of Grant J. Pick, 1963.397a

Harold Joachim, *French Drawings and Sketchbooks of the Nineteenth Century* (Chicago, 1978) II, nos. 1A10 and 1A11, p. 8

Another sheet of preparatory drawings (recto and verso) is in a Swiss private collection (figs. 147, 148). And one, which places the figure in a street scene, is in the Wilhelm Collection, Bottmingen (see Ursula Perucchi, ed., *Nabis und Fauves: Zeichnungen, Aquarelle, Pastelle aus Schweizer Privatbesitz*, exh. cat. [Zurich, 1982] p. 23).

33. La Revue blanche, 1894 [fig. 151]

Poster for the monthly magazine
Lithograph in four colors
Printed by Edward Ancourt, Paris

Off-white wove paper: 800 x 630 (31½ x 24¾)

New York, The Metropolitan Museum of Art, Purchase, Gift of Joy E. Feinberg of Berkeley, California, 1986 (1986.1081)

Floury 10; Roger-Marx 32; Bouvet 30; Galeries Durand-Ruel, *Exposition P. Bonnard* (Paris, 1896) no. 50; Ernest Maindron, *Les Affiches illustrées (1889–1895)* (Paris, 1896) p. 41

The principal figure probably represents Misia Natanson, wife of Thadée Natanson (publisher of *La Revue blanche*), who commissioned the poster. A man in a cape and top hat bends over

the newsstand behind the newsboy at the right. See related paintings: *La Rue en hiver*, 1894, and *L'Enfant à l'écharpe*, 1895 (Dauberville 54, 01774).

According to Fritz Hermann the poster was published in late autumn (*Die Revue blanche und die Nabis* [Munich, 1959] p. 83). It was exhibited—and sold for 5 francs—at the Galerie Laffitte (20 rue Laffitte) from May 10 to June 10, 1895, and shown in Bonnard's first one-man exhibition at the Galeries Durand-Ruel, January 6 to 22, 1896.

See preparatory drawing, cat. 34.

34. Study for **La Revue blanche**, 1894 [fig. 152]

Preparatory drawing for the poster, 1894 (cat. 33)
Ink, charcoal, watercolor, and chalk

Heavy off-white wove paper: 794 x 597 (31¼ x 23½)
Initialed and dated in watercolor lower left: *94 PB*
Signed in brown ink lower right: *PBonnard*

Ex coll.: Thadée Natanson
New Orleans Museum of Art, Gift of Mr. and Mrs. Frederick Stafford, 1976

Pierre Berès, *L'Oeuvre graphique de Bonnard* (Paris, 1944) no. 7; *Catalogue-Guide*, Musée National d'Art Moderne (Paris, 1954) p. 14; Agnès Humbert, *Les Nabis et leur époque* (Geneva, 1954) p. 149, no. 6 (ill.); Bernard Dorival and Agnès Humbert, *Bonnard, Vuillard, et les Nabis (1888–1903)*, exh. cat. (Paris, 1955) no. 81; Musée des Beaux-Arts, *Maîtres modernes*, exh. cat. (Pau, 1957) no. 1; New Orleans Museum of Art, *Odyssey of an Art Collector*, exh. cat. (New Orleans, 1966) no. 191, ill. p. 121; Musée des Beaux-Arts d'Orléans, *Peintures françaises du Museum of Art de la Nouvelle Orléans*, exh. cat. (Orléans, 1984) no. 25, p. 68; Bret Waller and Grace Seiberling, *Artists of La Revue Blanche*, exh. cat. (Rochester, N.Y., 1984) no. 2, pp. 10–11

A small ink drawing of the same subject (now in a private Paris collection) was probably done by Bonnard after the fact rather than as a preparatory study. It is similar in style to the drawing of the *France-Champagne* poster illustrated in C. Terrasse 1927, p. 21 (see Huguette Berès, *Graphisme de Bonnard*, exh. cat. [Paris, November 1981] no. 2).

The ink, crayon, and gouache drawing "Study for the Poster 'La Revue Blanche'" (Sotheby's, London, April 30, 1969, lot 86) is probably by another hand.

35. Promenade, 1894 [fig. 155]

New York only

Four-panel folding screen
Distemper on canvas with carved wood frame

Each panel: 1470 x 450 (58 x 17¾)
Initialed third panel lower right: *PB*

Signature and date carved in wood frame, fourth panel, upper right: *PBonnard 94*

Ex coll.: Thadée Natanson, Albert S. Henraux, Paris
Private collection

Dauberville 60; Galeries Durand-Ruel, *Exposition P. Bonnard* (Paris, 1896) no. 49; James Thrall Soby, James Elliott, and Monroe Wheeler, *Bonnard and His Environment*, exh. cat. (New York, 1964) no. 3, ill. p. 31; Michael Komanecky and Virginia Fabbri Butera, *The Folding Image: Screens by Western Artists of the Nineteenth and Twentieth Centuries*, exh. cat. (New Haven, 1984) pp. 73–75

In a letter to his mother, Bonnard described the scene "où passe une jeune mère avec ses enfants, des nounous, des chiens et en haut, faisant bordure, une station de fiacres, le tout sur un fond blanc qui rappelle tout à fait la place de la Concorde quand il y a de la poussière et qu'elle ressemble à un petit Sahara" (quoted in Huguette Berès, *Graphisme de Bonnard*, exh. cat. [Paris, November 1981] no. 73).

This screen is probably the work listed in the catalogue of Bonnard's first one-man exhibition at the Galeries Durand-Ruel, Paris, January 6 to 22, 1896: "49—Promenade. Appartient à M. T[hadée]. N[atanson]."

Bonnard reproduced his painted screen (with some compositional alterations) in color lithographs printed in 1895 (cat. 36, 37). Bonnard's adoption of the folding-screen format is discussed in chapter 3.

36. Promenade, 1895 [fig. 156]

New York and Houston only

Four-panel folding screen
Lithographs in five colors
Published by Molines, Galerie Laffitte, 20 rue Laffitte, Paris (edition of 110)

Off-white wove paper: each panel (sight) approx. 1499 x 479 (59 x 18⅞)

Ex coll.: Anne Burnett Tandy
Houston, Virginia and Ira Jackson Collection

Floury 35; Roger-Marx 47; Bouvet 55; G. M., "Studio Talk," *Studio* (October 1896) pp. 67–68; Galeries Durand-Ruel, *Exposition P. Bonnard* (Paris, 1896) no. 52; "Les Estampes et les affiches du mois, février 1897," *L'Estampe et l'affiche* (March 15, 1897) p. 24; Sotheby Parke-Bernet, New York, sale cat. (November 12, 1981) lot 25; Michael Komanecky and Virginia Fabbri Butera, *The Folding Image: Screens by Western Artists of the Nineteenth and Twentieth Centuries*, exh. cat. (New Haven, 1984) no. 6, pp. 143–145

The lithographed version of Bonnard's painted folding screen (cat. 35) was exhibited with its model in the artist's first one-man show at the Galeries Durand-Ruel, Paris, January 6 to 22, 1896. It is listed as "no. 52 Paravent" in the final section of the

exhibition with the posters for *France-Champagne* and *La Revue blanche*, with *Petit Solfège illustré*, and with "deux cadres de lithographies" (probably proofs from *Petites Scènes familières*). The American magazine *Studio* announced the publication of the screen by Molines, including an illustration in its issue of October 1896 (pp. 67–68). The prints were offered for sale either mounted (60 francs) or loose (40 francs) in the first issue of *L'Estampe et l'affiche* (March 15, 1897).

Only about twenty complete sets of the four lithographed panels appear to have survived, all of which are in private collections in the United States and abroad except for those in the Museum of Modern Art, New York, the Cleveland Museum, and the Museum of Fine Arts, Boston (cat. 37). The example most recently on the market was auctioned at Christie's, New York, May 9, 1989, as lot 487. Evidently many sets were damaged by water and cut into salvageable sections (see chapter 3, note 43), examples of which are now in the Baltimore Museum of Art, the Boston Public Library, the British Museum, the Brooklyn Museum, the Museum of Modern Art, and the National Gallery of Art, Washington, D.C.

37. Promenade, 1895

Boston only

Four-panel folding screen
Lithographs in five colors
Published by Molines, Galerie Laffitte, 20 rue Laffitte, Paris
(edition of 110)

Off-white wove paper: each panel approx. 1518 x 505
(59⅞ x 19⅞)

Ex coll.: Mrs. Ivor Leclerc; Mrs. Ralph J. Hines
Boston, Museum of Fine Arts, Ernest Longfellow Fund, 1976

Floury 35; Roger-Marx 47; Bouvet 55

See cat. 36.

38. The Schoolgirl's Return, ca. 1895 [fig. 160]

Lithograph in four colors (edition of 100)

Image: 260 x 130 (10¼ x 5⅛)
Cream wove paper: 340 x 203 (13⅜ x 8⅛)
Signed in pencil lower left: *no 27 PBonnard*

Houston, Virginia and Ira Jackson Collection

Floury 17; Roger-Marx 46; Bouvet 71

The appropriately descriptive title, "La Rentrée de l'écolière," is inscribed on an impression in the collection of Frau Steiner-Jaeggli, Winterthur, Switzerland (see chapter 3, note 44).

In color and compositional details the print may be related to Bonnard's painting *L'Omnibus*, ca. 1895 (Dauberville 100),

in subject matter to *Les Enfants de l'école* and *La Sortie de l'école* (Dauberville 174, 513).

Two preliminary drawings survive; see cat. 39.

39. Study for The Schoolgirl's Return, ca. 1895

 [fig. 159]

Preparatory drawing for the color lithograph, ca. 1895 (see
cat. 38)
Pencil, ink, pastel, and watercolor

Off-white wove paper: 273 x 115 (10¾ x 4½)
Watermark: ANC^NE^ MANU . . .

Ex coll.: Floury
Houston, Virginia and Ira Jackson Collection

Another, slightly less detailed pencil-and-watercolor study of the same composition is in a French private collection.

40. Petites Scènes familières
(Familiar Little Scenes), 1895 [fig. 86]

Album of piano music by Claude Terrasse with 19 lithographed
illustrations and lithographed cover; 62 pp.
Published by E. Fromont, Paris
Printed by Crevel Frères, Paris

Off-white wove paper: 360 x 280 (14⅛ x 11)

Josefowitz Collection

Floury 5; Roger-Marx 5–24; Bouvet 5–24; *Centenaire de la
lithographie,* exh. cat. (Paris, September 1895) nos. 1012, 1013;
Galerie Laffitte, *Catalogue des peintures, pastels, aquarelles et
dessins modernes* (Paris, 1895) p. 3

Antoine Terrasse has brought to the author's attention an announcement in *La Revue blanche* on May 1, 1895, which sets the publication date of this album two years later than was previously believed. The lithographs ("épreuves d'artiste chine signées") were exhibited in May 1895 at the Galerie Laffitte and later the same year at the "Centenaire de la Lithographie."

Several sets of proofs (said by Roger-Marx to be about twenty) were printed from the lithograph stones Bonnard drew on before his designs were transferred for incorporation with the nineteen music scores. (The published album appears to have been printed lithographically also.)

The proofs, which show greater contrast and more precise detail than do the illustrations in the published music sheets, are usually printed on china paper and generally bear Bonnard's initials in blue or red ink. (Proofs on cream wove paper are encountered much less frequently.) The off-center placement of the images and incomplete plate marks (stone edges)

suggest that more than one image was drawn on each lithograph stone. There are groups of proofs in the Bibliothèque Nationale, Paris, the Museum of Fine Arts, Boston (cat. 43), the Josefowitz Collection, and the Virginia and Ira Jackson Collection, Houston. Complete sets of proofs were sold at Christie's, New York, May 10, 1988 (lot 79), and in May 1989 (lot 316). The back cover gives the price of this album as 6 francs and the price of the *Petit Solfège illustré* (see cat. 19) as 3 francs.

Two preliminary drawings for the illustration "Papa, Maman, le (Marie)" are cited in the exhibition catalogue Huguette Berès, *Graphisme de Bonnard* (Paris, November 1981) nos. 13, 14.

41. La Chanson du grand-père
(Grandfather's Song), ca. 1893–94 [fig. 88]

Proof impression of illustration on page 12, *Petites Scènes familières*, 1895 (see cat. 40)
Lithograph

Image: 226 x 105 (8⅞ x 4⅛)
China paper: 345 x 215 (13⅝ x 8½)

New York, The Metropolitan Museum of Art, The Elisha Whittelsey Collection, The Elisha Whittelsey Fund, 1988 (1988.1010)

Floury 5(6); Roger-Marx 11; Bouvet 11

Although this work is unsigned, other proofs of this print bear the artist's initials in red ink at lower left.

The music this image illustrates is dedicated to Claude-Marie Terrasse, the paternal grandfather of Bonnard's nephews and nieces.

A preparatory ink drawing for this print is cited in the exhibition catalogue Huguette Berès, *Graphisme de Bonnard* (Paris, November 1981) no. 15.

42. Les Heures de la nuit (The Night Hours),
ca. 1893–94 [fig. 83]

Proof impression of illustration on page 16, *Petites Scènes familières*, 1895 (see cat. 40)
Lithograph, early state, before corrections to the letter *s*

Image: 132 x 233 (5¼ x 9⅛)
Cream wove paper: 191 x 270 (7½ x 10⅝)

New York, The Metropolitan Museum of Art, The Elisha Whittelsey Collection, The Elisha Whittelsey Fund, 1983 (1983.1112)

Floury 5(9); Roger-Marx 13; Bouvet 13

The dreamy-eyed face in the center is probably that of Marthe de Méligny, whom Bonnard met in 1893.

This proof precedes those printed on china paper with the letter *s* corrected, which are usually initialed by the artist in red ink at lower right.

A preliminary drawing for this print in pencil and ink was cited in the exhibition catalogue Huguette Berès, *Graphisme de Bonnard* (Paris, November 1981) no. 16.

43. Danse, ca. 1893–94 [fig. 87]

Proof impression of illustration on page 28, *Petites Scènes familières*, 1895 (see cat. 40)
Lithograph

Image: 215 x 85 (8½ x 3⅜)
China paper: 350 x 175 (13¾ x 6⅞)
Initialed in red ink upper right: *PB*

Boston, Museum of Fine Arts, Lee M. Friedman Fund

Floury 5(13); Roger-Marx 18; Bouvet 18

The music that this image illustrates is dedicated to "Mademoiselle Berthe Schnédelin" (presumably Bonnard's cousin, known in the literature on Bonnard as Berthe Schaedlin).

44. Card Game by Lamplight, 1895 [fig. 118]

Lithograph in brown ink
From an album of *L'Epreuve* (nos. 9–10)
Published by Maurice Dumont (edition of 215)
Printed by Paul Lemaire, Paris

Image: 133 x 236 (5¼ x 9¼)
China paper: 279 x 378 (11 x 14⅞)

New York, The Metropolitan Museum of Art, Gift of Mrs. Maurice E. Blin, 1977 (1977.582.1)

Floury 14; Roger-Marx 29; Bouvet 35

The lithograph is usually found printed in gray-green on japan paper, less commonly in brown on china paper.

45. The Great-Grandmother, 1895 [fig. 115]

Lithograph in brown ink with touches of watercolor
From an album of *L'Epreuve* (nos. 11–12)
Published by Maurice Dumont (edition of 215)
Printed by Paul Lemaire, Paris

Image: 202 x 230 (8 x 9)
China paper: 280 x 380 (11 x 15)
Signed in pencil lower right: *PBonnard*; unidentified circular stamp on verso

Houston, Virginia and Ira Jackson Collection

Floury 15; Roger-Marx 30; Bouvet 36

The subjects in this print, formerly known as *The Grandmother*,

are Bonnard's Alsatian maternal grandmother Mertzdorff and one of her great-grandchildren, probably Renée Terrasse, born in December 1894.

Like *Card Game by Lamplight* (cat. 44), the lithograph is usually found printed in gray-green on japan paper, less commonly in brown on china paper. Impressions printed in black-green (Josefowitz Collection) or dark blue-green (private collection, Switzerland) on japan paper are found even less frequently.

The example exhibited is a rare instance in which Bonnard hand-colored his print with touches of watercolor in yellow, turquoise, pink, and beige, a color scheme related to that used in his lithographed folding screen *Promenade* (cat. 36). Listings for such a hand-colored impression of the print appeared in the auction catalogues of Kornfeld and Klipstein (June 7–8, 1978, lot 38; June 20–22, 1979, lot 119) and Christie's, New York (May 7, 1981, lot 102), the source of the present impression.

A preliminary pencil drawing is now in a French private collection (see J.P.L. Fine Arts, *Pierre Bonnard* [London, 1985] no. 15). Bonnard's painting *The Great-Grandmother* (fig. 116; Dauberville 160) is closely related in composition and size.

46. Rooftops, ca. 1895 [fig. 172]

Oil on cardboard

343 x 368 (13½ x 14½)
Signed lower right: *Bonnard / a Paul / Bonis*

Ex coll.: Dr. and Mrs. David M. Levy, New York
Northampton, Mass., Smith College Museum of Art, Gift of
 Adele R. Levy Fund, Inc., 1962

Rewald 1948, 6a; Dauberville 154

The view from the window of the artist's studio is also depicted in the lithograph *Houses in the Courtyard* (cat. 60, figs. 2, 169), in a pastel (cat. 61, fig. 171), and in several paintings (Dauberville 155, 157, 244; see figs. 170, 173).

The person to whom the painting is inscribed has not been identified.

47. The Orchard, 1895 [fig. 247]

Oil on canvas

410 x 590 (16⅛ x 23¼)
Signed and dated lower left: *PBonnard 95*

Ex coll.: Jos. Hessel, Paris; Bellier, Paris; Sam Salz, New York;
 Mr. and Mrs. Norton Simon, Los Angeles
Rodés Collection

Dauberville 113

The subject is the orchard at Le Clos, the Bonnard family's country house at Le Grand-Lemps in the Dauphiné (now Isère).

This may be the painting shown in Bonnard's first one-man exhibition at the Galeries Durand-Ruel in 1896, listed in the catalogue as "Le Verger" (no. 26).

48. La Petite Blanchisseuse
(The Little Laundry Girl), 1895–96 [fig. 161]

Lithograph in five colors
From *Album des peintres-graveurs*, 1896
Published by Ambroise Vollard (edition of 100)
Printed by Auguste Clot

Image: 294 x 200 (11⅝ x 7⅞)
China paper: 581 x 432 (22⅞ x 17)
Signed in pencil lower right: *no 87 PBonnard*

New York, The Metropolitan Museum of Art, Harris Brisbane
 Dick Fund, 1939 (39.102.3)

Floury 25; Roger-Marx 42; Bouvet 40; "Les Estampes et les
 affiches du mois, décembre 1897–janvier 1898," *L'Estampe et
 l'affiche* (January 15, 1898) p. 20; Una E. Johnson, *Ambroise
 Vollard, Editeur: Prints, Books, Bronzes*, exh. cat. (New York,
 1977) no. 11

One of twenty-two prints issued in Vollard's first *Album*, *La Petite Blanchisseuse* was probably originally intended for the portfolio *L'Estampe moderne*, which was scheduled for October 1895 but never materialized (see chapter 3, note 48). It was exhibited with the other prints in the *Album* at the Galerie Vollard, June 15–July 20, 1896.

The sale of Vollard's 1896 album of twenty-two prints ("tirées à cent exemplaires numérotés et signés"), including *La Petite Blanchisseuse*, was publicized in *L'Estampe et l'affiche* (January 15, 1898, pp. 19–20), where it was noted that copies of the portfolio were still available for sale at 150 francs each.

Three preparatory drawings for the print survive (cat. 50, fig. 162; cat. 51, fig. 163; fig. 164), as well as proofs (color separations; see cat. 49). Also extant are some impressions of an earlier state of the print, before the additions in black that outline cobblestones and fill in the left side of the silhouetted figure at the waistline and the base of the left foot (Museum of Modern Art, New York, and British Museum, London). Working proofs of the first state (before the additions in black and also before the yellow stone) with touches of pencil and wash are listed in Colnaghi and Co., *A Survey of European Prints* (London, 1974), and Frederick Mulder, *Master Prints Catalogue 9* (London, 1984) no. 29, ill. (the latter now in the collection of the University of Regina, Canada).

49. La Petite Blanchisseuse, 1895–96

Boston only

Lithograph in three colors; proof before printing of yellow and black (see cat. 48)

Image: 294 x 200 (11⅝ x 7⅞)
China paper: 572 x 432 (22½ x 17)
Signed in pencil lower right: *3e etat PBonnard*

Boston, Museum of Fine Arts, Lee M. Friedman Fund, 1976

This impression is evidently from one of two special albums made up of proofs of the prints in Vollard's 1896 portfolio; these two albums are mentioned in a publicity announcement in *L'Estampe et l'affiche*, January 15, 1898, p. 20: "Il a été tiré des *Peintres Graveurs* deux exemplaires de tous les états, c'est-à-dire deux albums comprenant chacun plus de cent planches. Il reste un album." Two earlier proofs from the same sequence of color separations (both on china paper), one (in one color) signed "premier etat PBonnard" and the other (in two colors) signed "2e etat PBonnard," are listed in Arsène Bonafous-Murat, *Artistes, amis, collaborateurs*, sale cat. (Paris, 1988), as nos. 5 and 6. There were presumably five "états" in all, one progressive proof for each color.

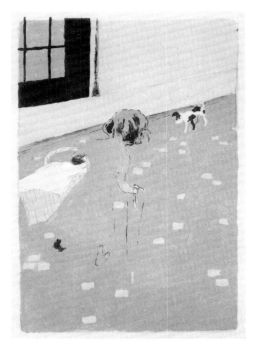

49

50. Study for La Petite Blanchisseuse, 1895–96
[fig. 162]

Preparatory drawing for the color lithograph, 1895–96 (see cat. 48)
Crayon

Wove paper: 305 x 195 (12 x 7⅝)
Artist's estate stamp lower left: *PB*

Paris, private collection

James Thrall Soby, James Elliott, and Monroe Wheeler, *Bonnard and His Environment*, exh. cat. (New York, 1964) no. 88; Victor Waddington, *Bonnard, 1867–1947: Drawings, Gouaches, Watercolours* (London, 1966) no. 4; Huguette Berès, *Bonnard, illustrateur* (Paris, 1970) no. 14; Galerie Claude Bernard, *Bonnard: Dessins* (Paris, 1972) no. 87

This drawing is the earliest of three surviving studies directly related to Bonnard's color lithograph (cat. 48, fig. 161). The two other drawings are cat. 51 (fig. 163) and fig. 164.

Other drawings treating the subject of the laundry girl in the city street are *Street Scene*, ca. 1896 (see fig. 184); *Dans la rue, le cheval blanc* (Hôtel Drouot, Paris, sale cat., June 7, 1985, lot 40); and a pencil drawing now in the Virginia and Ira Jackson Collection, Houston. A related painting on the same theme is *La Blanchisseuse dans la rue*, 1897 (Dauberville 01778).

51. Study for La Petite Blanchisseuse, 1895–96
[fig. 163]

Preparatory drawing for the color lithograph, 1895–96 (see cat. 48)
Lithographic crayon

Cream wove paper: 312 x 210 (12¼ x 8¼)

Ex coll.: Alfred Ayrton
New York, The Metropolitan Museum of Art, The Elisha Whittelsey Collection, The Elisha Whittelsey Fund, 1988 (1988.1016)

André Fermigier, *Bonnard* (New York, 1969) p. 60, ill.; American Federation of Arts, *Bonnard: Drawings from 1893–1946*, exh. cat. (New York, 1972) no. 5; Arts Council of Great Britain, *Drawings by Bonnard*, exh. cat. (London, 1984) no. 5 (ill. in reverse); J.P.L. Fine Arts, *Pierre Bonnard: Drawings—Landscapes, Seascapes, and Exterior Subjects* (London, 1987) no. 55; Colta Ives, "French Prints in the Era of Impressionism and Symbolism," *Metropolitan Museum of Art Bulletin* 46:1 (1988) p. 38

This drawing represents work preparatory to the color litho-graph (cat. 48) but later than cat. 50 (fig. 162), where the dog is shown at the lower right, and before the drawing repro-duced in fig. 164, where pedestrians have been eliminated from the sidewalk at upper right and additions in watercolor

indicate a cobblestone street and a door with mullions at upper left.

On the verso there are traces of an ink drawing of the same figural subject, apparently offset from another sheet.

52. Boating at Chatou, 1896 [fig. 30]

Oil on wood

320 x 595 (12⅝ x 23⅜)
Signed lower left: *Bonnard*

Ex coll.: Jos. Hessel, Paris; Kapferer, Paris
Private collection

Dauberville 01777

The painting is the basis for Bonnard's color lithograph *Le Canotage* (cat. 53).

53. Le Canotage (Boating), 1896–97 [fig. 29]

Lithograph in four colors
From *Album d'estampes originales de la Galerie Vollard*, 1897
Published by Ambroise Vollard, Paris (edition of 100)
Printed by Auguste Clot, Paris

Image: 270 x 470 (10⅝ x 18½)
China paper: 429 x 572 (16⅞ x 22½)
Signed in pencil lower left: *PBonnard*

New York, The Metropolitan Museum of Art, Harris Brisbane Dick Fund, 1936 (36.11.12)

Floury 27; Roger-Marx 44; Bouvet 42; "Les Estampes et les affiches du mois, décembre 1897–janvier 1898," *L'Estampe et l'affiche* (January 15, 1898) p. 19; Una E. Johnson, *Ambroise Vollard, Editeur: Prints, Books, Bronzes*, exh. cat. (New York, 1977) no. 13

Bonnard's color lithograph reproduces his painting *Boating at Chatou* (cat. 52) with a few modifications, the most important of which are the increased depth of the foreground and the dissolution of the trestle bridge that in the painting forms a band across the top, confining the picture space and, by its crisscross pattern, flattening the image. To further emphasize spatial recession, Bonnard widened the pylon supporting the bridge.

Bonnard designed the cover, title, contents, and end pages (figs. 25–28) of the Vollard album, which included thirty-two prints ("tirées à 100 ex. numérotés et signés"). Its sale (at 400 francs) was announced in *L'Estampe et l'affiche* on January 15, 1898.

Le Canotage is usually found signed in pencil at left, but not numbered. Two unusual impressions, probably proofs, are printed in a pale yellow-green (Fogg Art Museum, Harvard University, and the British Museum).

54. Child in Lamplight, ca. 1897 [fig. 119]

Lithograph in five colors, preliminary state
Published by Ambroise Vollard, Paris (edition of 100)
Printed by Auguste Clot, Paris

Image: 330 x 455 (13 x 17⅞)
China paper: 435 x 570 (17⅛ x 22½)

Paris, private collection

Floury 26; Roger-Marx 43; Bouvet 43; Una E. Johnson, *Ambroise Vollard, Editeur: Prints, Books, Bronzes*, exh. cat. (New York, 1977) no. 15

The lithograph was evidently intended for a third annual album of prints, to be issued by Ambroise Vollard in 1898, which was never published.

The impression exhibited is a proof of the print in a preliminary state, showing additions in blue and green to the earliest state, in which the lamp base still appears nearly all white (Bouvet p. 54, ill.). In the final state the red-orange tablecloth receives additional color, and several areas, including margins and an open registration mark in the lower right corner, are filled in.

55. Study for Indolence, ca. 1897–98 [fig. 232]

Oil on canvas

240 x 270 (9½ x 10⅝)
Artist's estate stamp lower left

Private collection

Dauberville 01802

This oil sketch is preliminary to two large oil paintings of the same composition, Dauberville 219 (Musée d'Orsay, Paris) and Dauberville 01803 (fig. 233). Bonnard's lover, Marthe, appears in a similar posture in his illustration to Verlaine's poem "Séguidille" on page 27 of *Parallèlement*, 1900 (fig. 228), and in studies for another of the book's illustrations (see figs. 229, 230).

56. Marthe, ca. 1897–98 [fig. 224]

New York only

Two photographs; original contact prints

Negative: 38 x 55 (1½ x 2⅛)
Together on filmstrip: 44 x 111 (1¾ x 4⅜)

Paris, Musée d'Orsay, Promised Gift of the Children of Charles Terrasse

Heilbrun and Néagu 112, 108

Bonnard's photographs of Marthe were taken in his Paris apartment probably around 1897 or 1898, when he began

drawing illustrations for Verlaine's poems in *Parallèlement*. These two photographs were used in creating the figures on pages 18 and 77 of the 1900 edition of the book.

57. Birth Announcement
for Marie-Louise Mellerio, 1898 [fig. 82]

Lithograph in rose (edition ca. 200)

Heavy cream wove paper: 158 x 120 (6¼ x 4¾)

New York, The Metropolitan Museum of Art, The Elisha Whittelsey Collection, The Elisha Whittelsey Fund, 1950 (50.616.7)

Floury 36; Roger-Marx 69; Bouvet 54

58. Marie, 1898 [figs. 210, 213–215]

Peter Nansen's novel (translated from the Danish by Gaudard de Vinci), illustrated with 20 process prints (9 full-page illustrations, 9 headpieces and insets, a vignette, and the cover design [repeating page 177]); 243 pp.
Published by Editions de la Revue Blanche, Paris
Printed by Lucien Marpon, Paris

Machine wove paper (pulp): page 185 x 116 (7¼ x 4½)

New York, The Metropolitan Museum of Art, The Elisha Whittelsey Collection, The Elisha Whittelsey Fund, 1969 (69.636)

A. Terrasse 1989, 8; Fritz Hermann, *Die Revue blanche und die Nabis* (Munich, 1959) pp. 581, 599

The novel (written in 1895) was published in installments with Bonnard's illustrations in the magazine *La Revue blanche* from May 1 to June 15, 1897 (nos. 94–97). The printing of the first French edition of the book dates to October 1897, although the title page bears the date 1898. Second and third "editions" printed during 1898 are identified as such on their title pages.

Two preparatory drawings for *Marie*, formerly in the Ayrton Collection, are reproduced in American Federation of Arts, *Bonnard: Drawings from 1893–1946*, exh. cat. (New York, 1972) no. 2 ("Young Girl Putting On Her Hat") and no. 3 ("Young Woman . . . Putting On . . . Her Stocking"). Both drawings are also in Arts Council of Great Britain, *Drawings by Bonnard*, exh. cat. (London, 1984) nos. 2, 3; and J.P.L. Fine Arts, *Pierre Bonnard: Drawings—Nudes, Portraits, Still Lifes, and Interior Subjects* (London, 1987) nos. 2, 3. A double-sided ink study of a woman putting on her stockings is in the collection of E. W. Kornfeld, Bern.

In Bonnard's 1925 painting *La Fenêtre* (Dauberville 1318) a book with the title *Marie* on the cover is shown lying on a table in the foreground.

59. Quelques Aspects de la vie de Paris
(Some Aspects of Paris Life) [fig. 195]

Title page, ca. 1898, from the suite of 12 color lithographs plus title page, 1899
Lithograph in two colors
Published by Ambroise Vollard, Paris (edition of 100)
Printed by Auguste Clot, Paris

Image: 410 x 333 (16⅛ x 13⅛)
China paper: 530 x 406 (20⅞ x 16)

New York, The Metropolitan Museum of Art, Harris Brisbane Dick Fund, 1928 (28.50.4-1)

Floury 16(1); Roger-Marx 56; Bouvet 58; "Les Estampes et les affiches du mois, mars–avril 1899," *L'Estampe et l'affiche* (April 15, 1899) p. 102; André Mellerio, "Expositions: Les Editions Vollard," *L'Estampe et l'affiche* (April 15, 1899) pp. 98–99; Sterling and Francine Clark Art Institute, *Pierre Bonnard: Lithographs*, exh. cat. (Williamstown, Mass., 1963) no. 2; Una E. Johnson, *Ambroise Vollard, Editeur: Prints, Books, Bronzes*, exh. cat. (New York, 1977) no. 10

Bonnard's suite of color lithographs was first exhibited at the Galerie Vollard in March 1899 and its sale announced in the *Almanach du Père Ubu* (January–March 1899) and in *L'Estampe et l'affiche* (April 15, 1899). The stylistic diversity of the set suggests that work on the prints must have begun at least by 1896, perhaps even as early as 1895. Only four of the prints are regularly signed and numbered (cat. 60, 62, 64, 66); evidently these are the earliest plates in the set, and either they were first envisioned as single prints to be editioned individually, or a plan to sign and number every impression in the set was abandoned as work progressed. Occasionally, other plates in the series were signed later.

The portfolio was issued without a contents page, thus neither titles nor any definite order to the prints can be determined. The titles cited in this catalogue are based on those given in Floury; dates are ascribed here on the basis of style. The twelve plates in the suite were regularly printed on sheets of cream wove paper ("vélin mince") with deckle edges, measuring approximately 530 x 405 mm. (21 x 16 in.); the title page or cover is on china paper of the same dimensions.

The successive titles given to the suite ("Croquis Parisiens," "Quelques Aspects de Paris," and *Quelques Aspects de de* [sic] *la vie de Paris*) all appear on the title page, although just traces of the erased first title remain. A proof in black ink, printed before the addition of the orange stone and before Vollard's name and address were inserted in the upper margin and further adjustments were made to the lettering at lower left, bears the date 1898 (fig. 168). The Metropolitan Museum's impression was printed before further erasures of letters in the key stone. The background scenery is the Place Blanche,

looking toward the rue Lepic and the Moulin de la Galette. See also chapter 3.

60. Houses in the Courtyard, 1895–96 [figs. 2, 169]

Lithograph in four colors
From *Quelques Aspects de la vie de Paris*, 1899 (see cat. 59)

Image: 345 x 257 (13⅝ x 10⅛)
Cream wove paper: 530 x 395 (20⅞ x 15½)
Signed in pencil lower right: *no 93 PBonnard*

New York, The Metropolitan Museum of Art, Harris Brisbane Dick Fund, 1928 (28.50.4-4)

Roger-Marx 59; Bouvet 61

The view from the window of Bonnard's studio is also represented in paintings dating between 1895 and 1900, for example, Dauberville 154, 155, and 244 (see figs. 170, 172, 173). A preparatory study in pastel is in the Museum of Fine Arts, Boston (cat. 61, fig. 171).

Unusual impressions of the print are in the collections listed below.

Art Institute of Chicago: one impression in brown ink of the key stone (without traces of the two shutters at the far left and without the lower border) printed on the verso of a working proof of *Boulevard* (52.1115; see cat. 63); another impression heightened with subtle additions of yellow and pink crayon (48.20).

National Gallery, Washington, D.C.: two signed and numbered impressions exhibiting variations in ink tones ranging from warm beige to charcoal-gray.

Hubert Prouté, Paris: an impression composed of two spliced proofs of the key stone in an earlier state printed in green.

The print is regularly signed and numbered in pencil at lower right.

61. Study for Houses in the Courtyard, 1895–96

New York and Boston only

[fig. 171]

Preparatory drawing for the color lithograph, 1895–96 (see cat. 60)
Pastel

Cream wove paper: 397 x 311 (15⅝ x 12¼)

Ex coll.: Maurice L'Oncle
Boston, Museum of Fine Arts, Jesse H. Wilkinson Fund, 1979

Except for some adjustments to the open window and the addition of two shutters at the far left and one chimney pot at the far right, the view in Bonnard's lithograph (cat. 60) is little changed from that shown here in the preparatory pastel.

62. Boulevard, ca. 1896 [fig. 179]

Lithograph in four colors
From *Quelques Aspects de la vie de Paris*, 1899 (see cat. 59)

Image: 173 x 435 (6¾ x 17⅛)
Cream wove paper: 406 x 527 (16 x 20¾)
Signed in pencil lower right: *no 10 PBonnard*

New York, The Metropolitan Museum of Art, Harris Brisbane Dick Fund, 1928 (28.50.4-6)

Floury 16(6); Roger-Marx 61; Bouvet 63

Bonnard often depicted the assorted pedestrian and vehicular traffic along the boulevard de Clichy, which was near his apartment and studio.

There are two studies in pencil for this print, one in the Cabinet des Estampes, Musée du Louvre (Orsay) (see National Museum of Western Art, *Bonnard*, exh. cat. [Tokyo, 1968] no. 91, ill.), and another that was sold at Sotheby's, London, December 3, 1980, lot 198a. A working proof exists; see cat. 63.

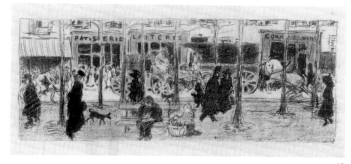

63

63. Working proof of Boulevard, ca. 1896

Preliminary study for the color lithograph, ca. 1896 (see cat. 62)
Lithograph in four colors with additions in black and red crayon

Image: 173 x 435 (6¾ x 17⅛)
Cream wove paper: 400 x 530 (15¾ x 20⅞)

The Art Institute of Chicago, Print and Drawing Club Fund, 1925.1115

In this proof of an early state of the print (cat. 62), before the addition to the lithograph stones of the pedestrian behind the bench, that figure is drawn in entirely by hand.

A trial proof of the key stone for *Houses in the Courtyard* (cat. 60) is printed on the verso.

64. Street at Evening in the Rain, 1896–97 [fig. 181]

Lithograph in five colors
From *Quelques Aspects de la vie de Paris*, 1899 (see cat. 59)

Image: 257 x 355 (10⅛ x 14)
Cream wove paper (trimmed): 387 x 533 (15¼ x 21)
Signed in pencil lower right: *no 45 PBonnard*

New York, The Metropolitan Museum of Art, Harris Brisbane
 Dick Fund, 1928 (28.50.4-11)

Floury 16(11); Roger-Marx 66; Bouvet 68

In subject matter and composition this lithograph is closely related to Bonnard's (undated) painting called *Place Pigalle la nuit* (Dauberville 171). A pastel on which the print was based is now in the Bibliothèque Nationale, Paris (cat. 65).

A year or two later, Bonnard reinterpreted this subject of the crowded street at night in another print, *The Square at Evening* (cat. 74), also in *Quelques Aspects de la vie de Paris*.

The Library of Congress, Washington, D.C., has a working proof with corrections in lithographic crayon to an early state printed in four colors, before all the details of the background and foreground were completed. There is an impression of the key stone in black ink in the Josefowitz Collection, and one of the canceled key stone in the Metropolitan Museum. The fifth color (blue-gray) is often difficult to distinguish even on signed and numbered impressions.

65. Study for **Street at Evening in the Rain,** 1896–97
 [fig. 182]

New York only

Preliminary drawing for the color lithograph, 1896–97 (see
 cat. 64)
Pastel

Cream wove paper: 275 x 375 (10⅞ x 14¾)

Paris, Cabinet des Estampes, Bibliothèque Nationale, Donation
 Curtis

Musée National d'Art Moderne, *Bonnard, Vuillard et les Nabis,
 1888–1903*, exh. cat. (Paris, 1955) no. 78; Sylvie Bacot,
 "Bibliographie à propos du catalogue Bonnard," *Nouvelles de
 l'estampe* (November–December 1982) p. 48

66. Narrow Street Viewed from Above, 1896–97
 [fig. 175]

Lithograph in four colors
From *Quelques Aspects de la vie de Paris*, 1899 (see cat. 59)

Image: 368 x 210 (14½ x 8¼)
Cream wove paper (trimmed): 527 x 387 (20¾ x 15¼)
Initialed in pencil lower right: *PB*

New York, The Metropolitan Museum of Art, Harris Brisbane
 Dick Fund, 1928 (28.50.4-13)

Floury 16(13); Roger-Marx 68; Bouvet 70

The street is that seen from the artist's Montmartre studio and often portrayed in paintings done between 1896 and 1900, for example, in Dauberville 136, 155, and 157 (fig. 173), and especially in *Narrow Street in Paris* (cat. 67, fig. 174). This may be the rue Le Chapelais, where Bonnard maintained a studio at number 14 from about 1896 to 1899, or the rue de Parme, where his grandmother had an apartment at number 8; neither site looks the same today. (The street depicted cannot be the extraordinarily steep rue Tholozé, which Bonnard sometimes painted; see Dauberville 158 and 01967.)

Narrow Street Viewed from Above is usually initialed and numbered and often varies in color from blue to beige or gray in the clothing and objects carried by foreground figures and in the windows and shop signs in the background.

Bonnard shows a chimney in the left foreground that does not appear in his painting of the same street (see cat. 67).

67. Narrow Street in Paris, 1896–97 [fig. 174]

Oil on cardboard

371 x 196 (14⅝ x 7¾)
Signed lower right: *PBonnard*

Ex coll.: Jos. Hessel, Paris
Washington, D.C., The Phillips Collection

Dauberville 156; William de Looper and Kevin Grogan, *Pierre
 Bonnard* (Washington, D.C.: The Phillips Collection, 1979)
 no. 3

68. The Bridge, ca. 1896–97 [fig. 189]

Lithograph in four colors
From *Quelques Aspects de la vie de Paris*, 1899 (see cat. 59)

Image: 270 x 410 (10⅝ x 16⅛)
Cream wove paper (trimmed): 381 x 533 (15 x 21)

New York, The Metropolitan Museum of Art, Harris Brisbane
 Dick Fund, 1928 (28.50.4-9)

Floury 16(9); Roger-Marx 64; Bouvet 66

Bonnard sometimes painted the Pont du Carrousel (see especially Dauberville 01793 bis), but the bridge in his lithograph is too generalized to be identified.

A chalk study (seen in a photograph in the archives of Paul Prouté, S.A., Paris) and an impression of an early state of the key stone (Josefowitz Collection) indicate that Bonnard had at first included more figures in the foreground. A proof of an early state of the print in which a small dog accompanies the

woman and child near the center, and before the completion of the top-hatted figure behind them, was sold at Galerie Kornfeld, Bern, Auction 176, June 24–25, 1981, lot 46 (pl. 38).

The background color varies in printing from gray-green to beige.

69. Street Corner, ca. 1897 [fig. 190]

Lithograph in four colors
From *Quelques Aspects de la vie de Paris*, 1899 (see cat. 59)

Image: 270 x 355 (10⅝ x 14)
Cream wove paper (trimmed): 349 x 464 (13¾ x 18¼)

New York, The Metropolitan Museum of Art, Harris Brisbane
Dick Fund, 1928 (28.50.4-3)

Floury 16(3); Roger-Marx 58; Bouvet 60

In an undescribed early state in the Josefowitz Collection (ex coll. Clot) the foreground is printed beige, figures and ground are not yet filled in with crayon and tusche, and margins (particularly at left) are very uneven. The impression in the Bibliothèque Nationale (reproduced in Bouvet 60) still shows the registration mark (middle left margin), later erased. The color added to the figures ranges from blue to gray; the foreground color varies from beige to gray-green or blue-green.

70. The Pushcart, ca. 1897 [fig. 34]

Lithograph in five colors
From *Quelques Aspects de la vie de Paris*, 1899 (see cat. 59)

Image: 290 x 340 (11⅜ x 13⅜)
Cream wove paper (trimmed): 381 x 530 (15 x 20⅞)

New York, The Metropolitan Museum of Art, Harris Brisbane
Dick Fund, 1928 (28.50.4-8)

Floury 16(8); Roger-Marx 63; Bouvet 65

Proofs printed with the key stone in light green and before the addition of the gray-blue stone are in the Minneapolis Institute of Art and the Virginia and Ira Jackson Collection, Houston.

71. Two working proofs of The Pushcart, ca. 1897 [figs. 35, 36]

Preliminary studies for the color lithograph, ca. 1897 (see cat. 70)
Lithographs in four colors, with additions in colored crayons and chalk

Cream wove paper: 325 x 535 (12¾ x 21); 235 x 530 (9¼ x 20⅞)

Paris, private collection

These working proofs were pulled before four more windows were drawn in at the top of the composition and before the fifth and final (blue-gray) stone was added. They were printed on trial impressions of Bonnard's designs for the contents and end pages of the *Album d'estampes originales de la Galerie Vollard*, published in 1897 (see figs. 27, 28).

The subject is one that Bonnard frequently treated (see, for example, Dauberville 642, 1577, 01837).

72. Street Seen from Above, ca. 1897 [fig. 191]

Lithograph in three colors
From *Quelques Aspects de la vie de Paris*, 1899 (see cat. 59)

Image: 370 x 225 (14⅝ x 8⅞)
Cream wove paper (trimmed): 473 x 330 (18⅝ x 13)

New York, The Metropolitan Museum of Art, Harris Brisbane
Dick Fund, 1928 (28.50.4-5)

Floury 16(5); Roger-Marx 60; Bouvet 62

73. At the Theater, ca. 1897–98 [fig. 139]

Lithograph in four colors
From *Quelques Aspects de la vie de Paris*, 1899 (see cat. 59)

Image: 210 x 400 (8¼ x 15¾)
Cream wove paper (trimmed): 381 x 530 (15 x 20⅞)

New York, The Metropolitan Museum of Art, Harris Brisbane
Dick Fund, 1928 (28.50.4-10)

Floury 16(10); Roger-Marx 65; Bouvet 67

Similarities in subject matter and style suggest that this print was executed about the time that Bonnard prepared the color lithograph frontispiece to André Mellerio's book *La Lithographie originale en couleurs*, 1898 (Bouvet 53).

74. The Square at Evening, ca. 1897–98 [fig. 186]

Lithograph in five colors, final state
From *Quelques Aspects de la vie de Paris*, 1899 (see cat. 59)

Image: 170 x 430 (6¾ x 16⅞)
Cream wove paper (trimmed): 381 x 533 (15 x 21)

New York, The Metropolitan Museum of Art, Harris Brisbane
Dick Fund, 1928 (28.50.4-7)

Floury 16(7); Roger-Marx 62; Bouvet 64

This is a later interpretation of the subject represented in an earlier print in the Vollard suite (cat. 64).

Two impressions in the National Gallery, Washington, D.C., show variations in the ink colors and in their order of printing; one is on a heavier wove paper than that of the regular edition.

See preliminary drawings, figs. 187 and 188 (cat. 75).

75. Study for **The Square at Evening,** ca. 1897–98

[fig. 188]

New York only

Preliminary drawing for the color lithograph, ca. 1897–98 (see cat. 74)
Charcoal

White wove paper: 310 x 198 (12¼ x 7¾)
Estate stamp lower left: *PB*

Paris, Musée du Louvre (Orsay), Cabinet des Dessins

Perucchi-Petri 1976, p. 85

76. Avenue du Bois de Boulogne, ca. 1898 [fig. 192]

Lithograph in five colors
From *Quelques Aspects de la vie de Paris,* 1899 (see cat. 59)

Image: 310 x 460 (12¼ x 18⅛)
Cream wove paper: 406 x 533 (16 x 21)

New York, The Metropolitan Museum of Art, Harris Brisbane
Dick Fund, 1928 (28.50.4-2)

Floury 16(2); Roger-Marx 57; Bouvet 59

Three unusual impressions from the estate of Auguste Clot, now in the Josefowitz Collection, include two proofs with the mauve stone printed instead in blue and an impression of the key stone in black on china paper.

77. Arc de Triomphe, ca. 1898 [fig. 193]

Lithograph in five colors
From *Quelques Aspects de la vie de Paris,* 1899 (see cat. 59)

Image: 310 x 465 (12¼ x 18¼)
Cream wove paper: 406 x 533 (16 x 21)

New York, The Metropolitan Museum of Art, Harris Brisbane
Dick Fund, 1928 (28.50.4-12)

Floury 16(12); Roger-Marx 67; Bouvet 69

The view is taken from the avenue Foch (formerly avenue du Bois de Boulogne), one of the principal routes of equestrians riding to and from the Bois de Boulogne. Bonnard included the Arc de Triomphe in paintings he made around the same time (see Dauberville 313 and 01793).

Like *Avenue du Bois de Boulogne* (cat. 76), this print, in its patterned texture, exhibits the use of transfer paper, which Bonnard seems to have adopted for the preparation of his lithographs around 1897.

78. The Lamp, ca. 1899

Oil on board

540 x 699 (21¼ x 27½)
Artist's estate stamp lower left: *Bonnard*

Ex coll.: A. J. L. McDonnell, London
Michigan, Flint Institute of Arts, Gift of the Whiting Foundation
and Mr. and Mrs. Donald E. Johnson, Sr.

Dauberville 210; "Favourite Picture in a Familiar Setting: 'La
Lampe' by Bonnard in the Apartment of Mr. A. J. L. McDon-
nell," *Studio* 155 (1958) pp. 118–119, 126; *Flint Institute of Arts:
Highlights from the Collections* (Flint, Mich., 1979) pp. 40–41

Bonnard's sister, his niece (or nephew), and his maternal grandmother Mertzdorff are gathered around the dining table.

78

79. The Orchard, 1899 [fig. 246]

Lithograph in five colors
From *Germinal, Album de XX estampes originales,* 1899
Published by Julius Meier-Graefe, Paris (edition of 100)
Printed by Auguste Clot, Paris

Image: 330 x 350 (13 x 13¾)
China paper: 420 x 461 (16½ x 18⅛)
Signed in pencil lower right: *PBonnard*

Northampton, Mass., Smith College Museum of Art, Selma
Erving Gift

Floury 21; Roger-Marx 48; Bouvet 56; Christine Swenson,
*Nineteenth and Twentieth Century Prints: Selections from the
Selma Erving Collection,* exh. cat. (Northampton, Mass., 1984)
no. 4; Christine Swenson et al., *The Selma Erving Collection:
Nineteenth and Twentieth Century Prints* (Northampton, Mass.,
1985) no. 12

80. In the Garden, Picking Fruit, ca. 1899 [fig. 245]

Oil on canvas

340 x 480 (13⅜ x 18⅞)

Stamped lower left: *Bonnard*

New York, The Family of Mr. and Mrs. Derald H. Ruttenberg

Dauberville 01794; Waddington Gallery, *Bonnard* (London, 1970) no. 5

81. Landscape at Le Grand-Lemps, ca. 1897–99
 [fig. 250]

Oil on cardboard

480 x 430 (18⅞ x 16⅞)
Stamped lower right: *Bonnard*

Private collection

Dauberville 01745

82. Parallèlement, 1900 [figs. 223, 227, 228, 231]

Poems by Paul Verlaine illustrated with 109 lithographs (in rose ink; including a frontispiece) and 9 wood engravings; 139 pp.
Published by Ambroise Vollard, Paris (edition of 200: 30 on china paper, including 10 with extra suites of lithographs; 170 on Van Gelder wove paper, or "vélin de Hollande," with the watermark PARALLELEMENT)
Lithographs printed by Auguste Clot, Paris
Wood engravings cut and printed by Tony Beltrand
Text printed by L'Imprimerie Nationale, Paris
Copy no. 190

Holland paper: page 305 x 250 (12 x 9⅞)

New York, The Metropolitan Museum of Art, The Elisha Whittelsey Collection, The Elisha Whittelsey Fund, 1970 (1970.713)

Floury 40; Roger-Marx 94; Bouvet 73; André Mellerio, "Expositions: Les Editions Vollard," *L'Estampe et l'affiche* (April 15, 1899) p. 99; Alfred Jarry, "Paul Verlaine: *Parallèlement,* illustré par Pierre Bonnard," *La Revue blanche* 24 (February 15, 1901) p. 317; Clément-Janin, "Les Editions de bibliophiles," *Almanach du bibliophile* (1901) pp. 245–246; Ambroise Vollard, *Recollections of a Picture Dealer,* trans. Violet M. MacDonald (Boston, 1936) pp. 90, 251–255; Eleanor M. Garvey, *The Artist and the Book, 1860–1960, in Western Europe and the United States,* exh. cat. (Boston, 1961) no. 27; Una E. Johnson, *Ambroise Vollard, Editeur: Prints, Books, Bronzes,* exh. cat. (New York, 1977) no. 166; Rolf Söderberg, *French Book Illustration, 1880–1905,* trans. Roger Tanner (Stockholm, 1977) pp. 140–144; Gordon N. Ray, *The Art of the French Illustrated Book, 1700 to 1914* (New York, 1982) II, pp. 497–499, 504–507; Patrick Sourget and Elisabeth Sourget, *Deux Cents Livres précieux de 1467 à 1959,* sale cat. (Luisant, 1986) no. 191, pp. 334–339; Eleanor M. Garvey, *A Catalogue of*

an Exhibition of the Philip Hofer Bequest in the Department of Printing and Graphic Arts, exh. cat. (Cambridge, Mass., 1988) no. 79

This copy of *Parallèlement* contains the front matter as originally published along with the three pages revised when government officials discovered that the Imprimerie Nationale had inadvertently printed a text banned in France on moral grounds. A new frontispiece (showing two female nudes on a bed) was produced, replacing the Ministry of Justice's imprint notation; a new half title in italics was created; and the title page was reprinted with a new vignette (two reclining women) substituted for the emblem of the French Republic (a seated woman). These leaves are usually printed on Arches paper.

According to Johnson, in addition to the edition of two hundred, twenty-one copies were printed on holland paper, signed by Vollard, and lettered *a* to *u,* and there exist also two copies on holland with extra suites of both published and unpublished illustrations, without text. One of the latter, now in the collection of Mr. and Mrs. Paul Mellon, is numbered 86 and contains fifteen unpublished lithographs, including the unused design for "Le Sonnet de l'homme au sable" on page 100 (see fig. 230), unused lithographs for pages 32, 57, 60, 61, 64, 99, 101, 102, 129, 132, 133, 135, 136, and another full-page composition (see also cat. 87). Thirteen loose proofs of the final illustrations are in the Philip Hofer Collection in the Houghton Library, Harvard University.

Ninety-seven preparatory sketches for the book are contained in two albums in the Mellon Collection. They are drawn in graphite and crayon around blocks of typeset text that were printed on newsprint stamped with dates between March 24 and May 4, 1897. The drawings are very freely rendered, often with greater vigor and boldness than is evident in the printed illustrations. Rarely, however, do the compositions vary to any remarkable extent from the final versions.

Five other drawings for *Parallèlement* are cited in Pierre Berès, *L'Oeuvre graphique de Bonnard,* sale cat. (Paris, 1944) nos. 29–33; and there is another in J.P.L. Fine Arts, *Pierre Bonnard,* sale cat. (London, 1985) no. 18.

83. Parallèlement, 1900 [fig. 225]

See cat. 82

Copy no. 78 (unbound)

Holland paper: page 305 x 250 (12 x 9⅞)
Watermark: PARALLELEMENT

New York Public Library, Astor, Lenox, and Tilden Foundations, Division of Art, Prints, and Photographs, The Spencer Collection

84. Parallèlement, 1900 [fig. 38]

New York and Houston only

See cat. 82.

Copy no. 5

China paper: page 292 x 241 (11½ x 9½)

Ohio, The Toledo Museum of Art, Gift of Molly and Walter Bareiss

Marilyn F. Symmes, *The Bareiss Collection of Modern Illustrated Books from Toulouse-Lautrec to Kiefer*, exh. cat. (Toledo, Ohio, 1985) no. 8

This edition contains the brown-paper wrapper and the title page in its initial state, with the effigy of the Republic, before reprinting of the title page and frontispiece. An extra suite of the 108 lithograph illustrations without text is included.

85. Parallèlement, 1900

Boston only

See cat. 82

Unbound, unnumbered copy

Holland paper: page 302 x 245 (11⅞ x 9⅝)
Watermark: PARALLELEMENT

Boston, Museum of Fine Arts, William A. Sargent Fund, 1981

This copy contains the revised wrapper, title page, and the lithograph frontispiece substituted for the government imprint notation.

 Ink color varies greatly in this example from mauve and dusty rose to salmon and brown.

86. Prospectus for Parallèlement, 1900

See cat. 82

Holland paper: 302 x 492 (11⅞ x 19⅜)
Watermark: PARALLELEMENT

New York, The Metropolitan Museum of Art, The Elisha Whittelsey Collection, The Elisha Whittelsey Fund, 1951 (51.535.5)

The front page of the prospectus is *Parallèlement*'s title page in its first state with the emblem of the French Republic; inside are pages 130 and 135 of the book (Verlaine presiding over a dinner table from "Ballade de la mauvaise réputation"; the lovers of "Ballade Sappho"). On the back page are printed the colophon and *justification du tirage* with offering prices for copies numbered 1 to 10 (450 francs), 11 to 30 (250 francs), and 31 to 200 (150 francs).

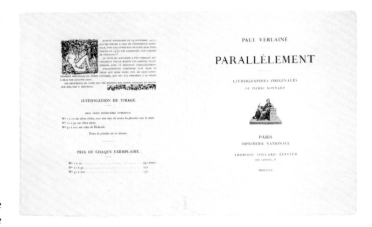

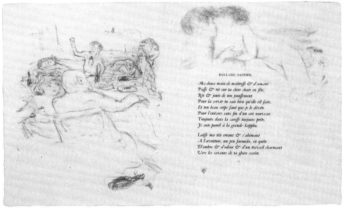

86

87

87. Eté (Summer), ca. 1898

Proof of unused illustration for page 17 of *Parallèlement*, 1900
(see cat. 82)
Lithograph in black ink

Image: 156 x 241 (6⅛ x 9½)
China paper (irregular margins): 238 x 279 (9⅜ x 11)

New York, The Metropolitan Museum of Art, The Elisha
Whittelsey Collection, The Elisha Whittelsey Fund, 1978
(1978.637.1)

88. Marthe, 1900–1901 [fig. 240]

New York only

Two photographs; original contact prints
Negative: 38 x 55 (1½ x 2⅛)
Together on filmstrip: 44 x 108 (1¾ x 4¼)

Paris, Musée d'Orsay, Promised Gift of the Children of Charles
Terrasse

Heilbrun and Néagu 129, 131

The photographs are from a group of nude studies taken by
Bonnard (and Marthe) in the garden of a house he rented in
Montval, near Marly-le-Roi, around 1900. Bonnard's litho-
graph illustration on page 69 of *Daphnis et Chloé*, 1902 (cat. 92),
is based on one of these photographs.

89. Daphnis et Chloé, 1902
 [figs. 39, 94, 234, 237, 241, 249]

Pastoral romance by Longus, French translation by Jacques
Amyot, revised and completed by Paul-Louis Courier,
illustrated with 151 lithographs and one wood engraving
printed in black; 294 pp.
Published by Ambroise Vollard, Paris (edition of 250: 10 on
japan paper with 2 extra suites of lithographs in rose ink; 40
on china paper with 2 extra sets of lithographs in blue; 200 on
Van Gelder wove paper, or "hollande à la forme," with the
watermark: DAPHNIS ET CHLOE)
Lithographs printed by Auguste Clot, Paris
Text printed by L'Imprimerie Nationale, Paris
Copy no. 145

Holland paper: page approx. 302 x 245 (11⅞ x 9⅝)

New York, The Metropolitan Museum of Art, Harris Brisbane
Dick Fund, 1928 (28.90.1)

Floury 42; Roger-Marx 95; Bouvet 75; Clément-Janin, "Les
Editions de bibliophiles," *Almanach du bibliophile* (1902)
pp. 232–234; Eleanor M. Garvey, *The Artist and the Book,
1860–1960, in Western Europe and the United States*, exh. cat.
(Boston, 1961) no. 28; Una E. Johnson, *Ambroise*

Vollard, Editeur: Prints, Books, Bronzes, exh. cat. (New York,
1977) no. 168; Gordon N. Ray, *The Art of the French Illustrated
Book, 1700 to 1914* (New York, 1982) II, pp. 506–509

Because Bonnard worked quickly on these illustrations, ap-
parently drawing directly on lithographic stones, few prelim-
inary studies exist. Five proof impressions of the lithographs
are in the Philip Hofer Collection in the Houghton Library,
Harvard University. Proofs of five unused illustrations are in
the Josefowitz Collection and in the collection of Virginia and
Ira Jackson (Bouvet 76a–d, f).

A preparatory drawing in lithographic pencil for page 181
(formerly Ayrton Collection) is reproduced in American Fed-
eration of Arts, *Bonnard: Drawings from 1893–1946*, exh. cat.
(New York, 1972) no. 10. Two others, for pages 185 and 211,
are listed in Huguette Berès, *Graphisme de Bonnard*, exh. cat.
(Paris, November 1981) nos. 24, 25.

A copy of the prospectus in The Metropolitan Museum of
Art offers the book at almost twice the price of *Parallèlement*:
copies numbered 1 to 10 (800 francs), 11 to 50 (600 francs), 51
to 250 (250 francs). See also cat. 86.

90. Daphnis and Chloe, 1902 [fig. 238]

See cat. 89

Copy no. 27 with extra suite of lithographs printed in blue

China paper: page 330 x 254 (13 x 10)

Josefowitz Collection

91. Daphnis Currying His Goat [fig. 236]

Proof impression of illustration on page 225 of *Daphnis et Chloé*,
1902 (see cat. 89)
Lithograph

Image: 105 x 140 (4⅛ x 5½)
Holland paper: 320 x 225 (12⅝ x 8⅞)

Cambridge, Mass., The Houghton Library, Harvard University,
Department of Printing and Graphic Arts

92. Chloe Bathing [fig. 239]

Proof impression of page 69, *Daphnis et Chloé*, 1902 (see cat. 89)
Lithograph

Image: 150 x 140 (5⅞ x 5½)
China paper (with proofs for pages 67–70): 330 x 511 (13 x 20⅛)

New York, The Metropolitan Museum of Art, Purchase,
E. Powis Jones Gift, 1988 (1988.1148.1)

93. Daphnis and Chloe [fig. 248]

Proof impression of illustration on page 171 of *Daphnis et Chloé*, 1902 (see cat. 89)
Lithograph

Image: 135 x 140 (5¼ x 5½)
China paper: 330 x 260 (13 x 10¼)

New York, The Metropolitan Museum of Art, The Elisha Whittelsey Collection, The Elisha Whittelsey Fund, 1985 (1985.1082.1)

The "variant" for page 171 reproduced by Bouvet (76e) differs only in that it was more heavily inked.

94

94. Daphnis and Chloe Embracing

Proof impression of page 91, *Daphnis et Chloé*, 1902 (see cat. 89)
Lithograph

Image: 140 x 140 (5½ x 5½)
China paper (with proofs for pages 91–94): 330 x 511 (13 x 20⅛)

New York, The Metropolitan Museum of Art, Purchase, E. Powis Jones Gift, 1988 (1988.1148.2)

95. Histoires naturelles, [1904] [figs. 45, 100, 106]

Book of animal studies by Jules Renard illustrated with 67 process prints of ink drawings and a cover illustration with stenciled color; 346 pp.
Published by Ernest Flammarion, Paris
Printed by Hemmerlé and Company, Paris

Wove (pulp) paper: page 186 x 124 (7⅜ x 4⅞)

New York, The Metropolitan Museum of Art, Gift from The Josefowitz Collection, 1989 (1989.1074)

A. Terrasse 1989, 17

A special edition of twenty copies on japan paper was numbered and initialed by the publisher. The book was reprinted with a different layout and cover in 1922 and in 1945.

In addition to the drawings exhibited (cat. 96–98), there are examples in the Phillips Collection, Washington, D.C. (see *The Phillips Collection: A Summary Catalogue* [Washington, D.C., 1985] nos. 133, 138, 142), and in private collections, including a group formerly the E. Weyhe Collection (see Rewald 1948, 95–103).

96. Study for Histoires naturelles, ca. 1904 [fig. 99]

Preliminary design for the front cover of the book by Jules Renard, [1904] (see cat. 95)
Brush and ink

Off-white wove paper: 307 x 204 (12⅛ x 8)
Signed in pencil lower right: *PBonnard*

Switzerland, private collection

Ursula Perucchi, ed., *Nabis und Fauves: Zeichnungen, Aquarelle, Pastelle aus Schweizer Privatbesitz*, exh. cat. (Zurich, 1982) no. 6

Another preliminary drawing for the book cover, formerly in the E. Weyhe Collection, is reproduced in Rewald 1948, p. 15.

97. The Cat, ca. 1904 [fig. 104]

Study for illustration on page 75 of *Histoires naturelles*, [1904] (see cat. 95)
Brush and ink

China paper: 305 x 194 (12 x 7⅝)

Switzerland, private collection

Ursula Perucchi, ed., *Nabis und Fauves: Zeichnungen, Aquarelle, Pastelle aus Schweizer Privatbesitz*, exh. cat. (Zurich, 1982) no. 7

98. Farmyard Animals, ca. 1904 [fig. 107]

Sketches for *Histoires naturelles*, [1904] (see cat. 95)
Brush and ink

Cream wove paper: 485 x 317 (19⅛ x 12½)
Watermark: CRAYON ANC^NE MAN . . . (see also cat. 39)

The Art Institute of Chicago, Bequest of William McCormick Blair

On the verso is a study of a rooster.

99. Nude with Peignoir, ca. 1916–17 [fig. 259]

Pencil and charcoal

Off-white wove paper: 325 x 255 (12¾ x 10)
Signed in pencil lower left: *Bonnard*

Switzerland, private collection

Ursula Perucchi, ed., *Nabis und Fauves: Zeichnungen, Aquarelle,
Pastelle aus Schweizer Privatbesitz*, exh. cat. (Zurich, 1982) no. 15

100. Winter Landscape, ca. 1910–20 [fig. 253]

Pencil and watercolor

Cream wove paper: 283 x 227 (11⅛ x 9)
Signed in pencil lower right: *PBonnard*

Switzerland, private collection

Ursula Perucchi, ed., *Nabis und Fauves: Zeichnungen, Aquarelle,
Pastelle aus Schweizer Privatbesitz*, exh. cat. (Zurich, 1982)
no. 21

101. Place Clichy, 1922 [fig. 197]

Lithograph in five colors
Published by Bernheim-Jeune, Paris (edition of 100)
Printed by Auguste Clot, Paris

Image: 470 x 635 (18½ x 25)
Heavy cream wove paper: 500 x 650 (19⅝ x 25⅝)

New York, The Metropolitan Museum of Art, Purchase, Mr.
and Mrs. Derald H. Ruttenberg Gift, 1987 (1987.1157)

Roger-Marx 77; Bouvet 88; The Metropolitan Museum of Art,
Recent Acquisitions: A Selection, 1987–1988 (New York, 1988)
p. 41

Bonnard's print is closest in subject matter to his painting of
about 1906 called *Place Clichy* or *Le Tramway vert* (Dauberville
409). The composition, however, with figures pressed close to
the picture plane before a yawning public square, resembles
the *Piazza del Popolo, Rome* (Dauberville 1108), which Bonnard
finished painting in 1922, after a trip to Italy.

The lithograph was evidently prepared in at least three
stages. An early state in the Virginia and Ira Jackson Collec-
tion is printed with the signature (upper left) in reverse and
before considerable reworking of the blue and black stones. A
proof on china paper in the Josefowitz Collection (Clot Estate)
shows the signature corrected, but the faces in the foreground
remain unfinished.

A preliminary study in colored chalk is now in the Biblio-
thèque Nationale, Paris (Christie's, London, sale cat., May 20,
1960, lot 74, ill.). A more closely related pastel is in a private
collection, Paris (cat. 102).

102. Place Clichy, 1922 [fig. 198]

See cat. 101

Pastel

450 x 810 (17¾ x 31⅞)
Stamped lower left: *Bonnard*

Paris, private collection

Huguette Berès, *Bonnard, illustrateur*, sale cat. (Paris, 1970)
no. 23

103. Dingo, 1924 [figs. 41, 50, 95, 101, 103, 201]

Book by Octave Mirbeau illustrated with 55 etchings (including
14 hors texte, one on the wrapper, and one on the title page;
some with drypoint); 194 pp.
Published by Ambroise Vollard, Paris (edition of 370: 30 copies
on old japan paper; 40 on Shidzuoka japan paper; 280 on
Arches laid paper ["vergé d'Arches"]; 20 hors commerce
on Arches laid paper)
Etchings printed by Louis Fort
Text printed by Emile Fequet
Copy no. 313

Arches laid paper: page 381 x 279 (15 x 11)

New York, The Metropolitan Museum of Art, Harris Brisbane
Dick Fund, 1928 (28.90.2)

Floury 56; Bouvet 90; Eleanor M. Garvey, *The Artist and the
Book, 1860–1960, in Western Europe and the United States*, exh.
cat. (Boston, 1961) no. 30; Una E. Johnson, *Ambroise
Vollard, Editeur: Prints, Books, Bronzes*, exh. cat. (New York,
1977) no. 169

Bonnard apparently began work on the illustrations for *Dingo*
shortly after the story was first published in 1912. His "croquis
d'après le *Dingo* de M. Octave Mirbeau" appeared as an illus-
tration in the June 1913 issue of *Les Cahiers d'aujourd'hui*.

An examination of proofs for the etchings in the book and
of impressions of the unpublished illustrations listed by Bou-
vet (91a–d) suggests that he at first prepared four of his de-
signs in soft-ground etching and drypoint, which were then
reproduced on photogravure plates of a slightly larger size.
For example, the soft-ground etching of *Cat and Dog* (Bouvet
91a) on a beveled plate measures 273 x 210 mm. (10¾ x 8¼
in.), whereas the photogravure plate measures 286 x 229 mm.
(11¼ x 9 in.). Bonnard's adoption of line etching with dry-
point, which he employed for the first time with the illustra-
tions for *Dingo*, evidently followed. (To protect the fragile
drypoint lines and their burr, the plates must have been steel-
faced for the book's large edition.)

Fifty extra suites of the fourteen large etchings in the book
were issued on japan and on Arches laid paper and were often
sold with the book.

A pencil sketch for the etching opposite page 8 is in one of the artist's sketchbooks (private collection, France), and a sketch for page 173 is in the Cabinet des Dessins, Musée du Louvre. See also fig. 102.

104. Dingo in the Town Square [fig. 167]

> Illustration facing page 46 of *Dingo*, 1924 (see cat. 103)
> Etching and drypoint, loose impression from copy no. 249
>
> Plate: 286 x 225 (11¼ x 8⅞)
> Arches laid paper: 378 x 274 (14⅞ x 10¾)
>
> Houston, Virginia and Ira Jackson Collection

105. Dingo and Miche on the Terrace [fig. 255]

> Proof impression of illustration facing page 130 of *Dingo*, 1924 (see cat. 103)
> Etching and drypoint
>
> Plate: 288 x 231 (11⅜ x 9⅛)
> Japan paper: 437 x 333 (17¼ x 13⅛)
>
> Cambridge, Mass., Fogg Art Museum, Harvard University, William M. Prichard Fund

106. Dingo Under the Mountain Ash [fig. 254]

> Trial proof of the illustration facing page 140 of *Dingo*, 1924 (see cat. 103)
> Etching and drypoint
>
> Plate: 288 x 227 (11⅜ x 9)
> Arches laid paper: 352 x 270 (13⅞ x 10⅝)
>
> New York, The Museum of Modern Art, The Louis E. Stern Collection

107. The Menu, ca. 1924–25 [fig. 121]

> Lithograph, second state (of three)
> Published by Edmond Frapier, Galerie des Peintres-Graveurs, Paris (edition of 25)
>
> Image: 309 x 167 (12⅛ x 6⅝)
> China paper: 495 x 321 (19½ x 12⅝)
> Signed in pencil lower right: *PBonnard*
> Blind stamp lower right: Galerie des Peintres-Graveurs, Paris (Lugt 1057b)
> State and proof stamps of Frapier lower left (Lugt 2921b and 2921d)
>
> New York, The Metropolitan Museum of Art, The Elisha Whittelsey Collection, The Elisha Whittelsey Fund, 1988 (1988.1017.2)
>
> Floury 49; Roger-Marx 86; Bouvet 99; Eugène Rouir, "Lithographs by Bonnard," *Print Collector*, no. 3 (July–

August 1973) pp. 13, 18 (first published as "Quelques Remarques sur les lithographies de Pierre Bonnard," *Le Livre et l'estampe*, nos. 53–54 [1968])

The lithograph is closely related to Bonnard's painting *Before Dinner*, 1924 (fig. 122; Dauberville 1266).

Contrary to information given by Rouir and Bouvet, the states of this lithograph are:

 I. A vertical line borders the right margin of the image.
 II. The vertical line is erased.
 III. The pointed collar of Marthe's blouse is rounded.

A preliminary drawing for the print is now in a Swiss private collection; see cat. 108.

108. Marthe and the Maid, ca. 1924–25 [fig. 120]

> Preparatory drawing for *The Menu* (cat. 107)
> Pen and ink over pencil
>
> Heavy beige wove paper: 137 x 105 (5⅜ x 4⅛)
> Signed in pencil lower right: *PBonnard*
>
> Switzerland, private collection
>
> National Museum of Western Art, *Bonnard*, exh. cat. (Tokyo, 1968) no. 105

109. Le Bain (The Bath), ca. 1925 [fig. 261]

> Lithograph, second (final) state
> From *Les Peintres-lithographes de Manet à Matisse, Album de lithographies originales* (fourth fascicule), ca. 1925
> Published by Edmond Frapier, Galerie des Peintres-Graveurs, Paris
> Printed by E. Duchâtel
>
> Image: 330 x 225 (13 x 8⅞)
> China paper: 365 x 268 (14⅜ x 10⅝)
> Blind stamp lower right: Galerie des Peintres-Graveurs, Paris (Lugt 1057b)
>
> New York, The Brooklyn Museum
>
> Floury 51; Roger-Marx 79; Bouvet 92, 92a; Eugène Rouir, "Lithographs by Bonnard," *Print Collector*, no. 3 (July–August 1973) pp. 10–12

When the first lithograph stone on which *Le Bain* was drawn (Bouvet 92) was accidentally ruined, the image was transferred to another stone and reworked (Bouvet 92a). Although the edition is said to have totaled 670 impressions, many prints were destroyed when the town of Royan, to which the publisher Frapier retired, was bombed in 1945.

110. Standing Nude, ca. 1925 [fig. 260]

> Lithograph printed in red-brown, second (final) state
> Published by Edmond Frapier, Galerie des Peintres-Graveurs,
> Paris (edition of 25 in black ink and 10 in red-brown; also
> 5 proofs of the first state)
>
> Image: 290 x 165 (11⅜ x 6½)
> Japan paper: 492 x 321 (19⅜ x 12⅝)
> Signed in pencil lower right: *PBonnard*
> Numbered in pencil lower left: 4/10
> Blind stamp lower right: Galerie des Peintres-Graveurs, Paris
> (Lugt 1057b)
> State stamp of Frapier lower left corner (Lugt 2921d)
>
> New York, The Metropolitan Museum of Art, The Elisha
> Whittelsey Collection, The Elisha Whittelsey Fund, 1988
> (1988.1017.1)
>
> Floury 50; Roger-Marx 84; Bouvet 97; Eugène Rouir,
> "Lithographs by Bonnard," *Print Collector*, no. 3 (July–
> August 1973) p. 17

This lithograph of Marthe, shown in the balanced stance of an archaic Greek *kouros*, exists in two states. The line along the print's right margin was erased in the second state, and shading was added in several areas, including the figure and door and the clothing hung nearby.

111. Paysage du Midi (Landscape in the
South of France), 1925 [fig. 48]

> Lithograph, fourth (final) state
> From an album in the series *Maîtres et petits maîtres
> d'aujourd'hui*
> Published by Edmond Frapier, Galerie des Peintres-Graveurs,
> Paris, 1925 (edition of 150 in 125 albums: 100 numbered
> copies; 25 lettered copies containing the prints in two states)
> Printed by E. Duchâtel
>
> Image: 216 x 292 (8½ x 11½)
> Heavy cream wove paper: 327 x 476 (12⅞ x 18¾)
> Signed in pencil lower right: *PBonnard*
> Numbered in pencil lower left: 3/100
> Blind stamp lower right: Galerie des Peintres-Graveurs, Paris
> (Lugt 1057b)
>
> New York, The Metropolitan Museum of Art, Bequest of
> Dorothy Varian, 1985 (1986.1135.2)
>
> Floury 53 III; Roger-Marx 82 IV; Bouvet 95 IV; Eugène Rouir,
> "Lithographs by Bonnard," *Print Collector*, no. 3 (July–
> August 1973) p. 19

This lithograph was one of four in the Frapier album *Pierre Bonnard, peintre et lithographe,* which also included the following prints, listed by title: *Femme dans sa baignoire* (Bouvet 94); *Femme assise faisant sa toilette* (Bouvet 96); and *La Coupe* (Bouvet 93). The portfolio included an introduction by Claude Roger-Marx in French, English, and German celebrating the publi-

cation as a renaissance of Bonnard's work as a lithographer.

Contrary to information given in Rouir, the print was initialed in the stone first at the lower right and later at the lower left. It is evidently the fourth (final) state, not a fifth, that is illustrated in Bouvet.

112. Last Light, ca. 1927–28 [fig. 256]

> Lithograph, trial proof
> Image: 240 x 320 (9½ x 12⅝)
> Off-white, machine laid paper: 320 x 495 (12⅝ x 19½)
>
> New York, The Metropolitan Museum of Art, The Elisha
> Whittelsey Collection, The Elisha Whittelsey Fund, 1985
> (1985.1096.2)
>
> Roger-Marx 90; Bouvet 103; Eugène Rouir, "Lithographs by
> Bonnard," *Print Collector*, no. 3 (July–August 1973) p. 23

The lithograph was commissioned by the publisher Edmond Frapier, but his note on an impression belonging to Eugène Rouir states that only five impressions were printed and that the stone was destroyed when Frapier's house in Royan was bombed in 1945.

113. The Tiger-Cat in the Garden [fig. 258]

> Illustration following page 106 of Ambroise Vollard, *Sainte
> Monique,* 1930
> Lithograph, loose impression from copy no. 268 (unbound)
> Published by Ambroise Vollard, Paris (book edition 340 plus
> 50 copies hors commerce)
> Printed by Auguste Clot
>
> Image: 280 x 207 (11 x 8⅛)
> Arches wove paper: 323 x 252 (12¾ x 9⅞)
>
> New York, The Museum of Modern Art, The Louis E. Stern
> Collection
>
> Floury 64; Roger-Marx 96; Bouvet 111; Una E. Johnson,
> *Ambroise Vollard, Editeur: Prints, Books, Bronzes,* exh. cat.
> (New York, 1977) no. 170

The book, which Bonnard began working on in 1920, was produced in a combination of techniques and includes 17 etchings, 29 transfer lithographs, and 178 wood engravings.

Copy no. 268 (unbound) in the collection of the Museum of Modern Art, from which this plate is drawn, includes an extra suite of wood engravings and an unpublished and possibly unique lithograph (initialed in the stone: *PB*) depicting a female nude bent over to the right in a sketchy setting, possibly a garden.

A special copy of the book on imperial japan paper is bound with twenty-nine preliminary ink drawings. (See Nicolas Rauch, S.A., *Les Peintres et le livre, 1867–1957* [Geneva, 1957] no. 6, pp. 38–39, 221.)

CHRONOLOGY
OF BONNARD'S GRAPHIC WORK

Works are listed alphabetically under the year they were published or, in the case of unpublished material, under the year they were executed. Dates within brackets are approximate, based on the best available evidence. References are to catalogue entries in this volume or, in the absence of such an entry, to the most recent catalogue raisonné and/or other pertinent source.

1889

Danse macabre and/or **La Marche héroïque:** watercolor design(s), probably for music by Camille Saint-Saëns [C. Terrasse 1927, p. 201; Galerie Claude Bernard, *Pierre Bonnard: Dessins et aquarelles*, Paris, 1977, no. 92; Giambruni 1983, pp. 51–53, 377].

Hamlet: watercolor design for an unpublished poster for Ambroise Thomas's opera [Christie's, London, sale cat., October 17, 1967, lot 93; Giambruni 1983, pp. 51–55, 378].

1890

Mandoline: three designs in pencil, ink, and watercolor for an unpublished cover to piano music by Francis Thomé [see A. Terrasse 1967, p. 51; National Museum of Western Art, *Bonnard*, exh. cat., Tokyo, 1968, nos. 87, 88].

Théâtre Libre (fig. 131): two ink-and-watercolor designs of a woman with a fan for an unpublished theater program [see George L. Mauner, *The Nabis: Their History and Their Art, 1888–1896*, New York, 1978, fig. 6].

Théâtre Libre (fig. 216): two watercolor designs with a figure holding masks of tragedy and comedy for an unpublished theater program [George L. Mauner, *The Nabis: Their History and Their Art, 1888–1896*, New York, 1978, fig. 5; Phillip Dennis Cate and Patricia Eckert Boyer, *The Circle of Toulouse-Lautrec: An Exhibition of the Work of the Artist and of His Close Associates*, exh. cat., New Brunswick: The Jane Voorhees Zimmerli Art Museum, Rutgers, The State University of New Jersey, 1985, no. 30].

[1890]

La Petite qui tousse (fig. 7): two unpublished watercolor-and-

gouache designs for the cover to sheet music by Claude Terrasse; lyrics by Jean Richepin [cat. 3].

Sonatine Terrasse: two pencil-and-ink designs for an unpublished cover to sheet music, *Sonatine en ut* by Claude Terrasse (published without illustration) [Floury Collection].

Woman Holding a Glass: ink-and-watercolor design for a poster or program cover [Riva Castleman and Wolfgang Wittrock, eds., *Henri de Toulouse-Lautrec: Images of the 1890s*, exh. cat., New York: Museum of Modern Art, 1985, p. 64].

1891

France-Champagne (figs. 125, 129, 130, 203): color-lithographed poster commissioned by E. Debray in 1889 and published in March 1891 [cat. 1, 2].

France-Champagne, Valse de Salon (fig. 128): zincograph cover to piano sheet music by "M.G.," commissioned in March 1891 and published by P. Schott & Cie, Paris [Boyer 1988, 10; A. Terrasse 1989, 1; see cat. 2].

La Geste du roy: illustration on the cover of *Le Livre d'art*, program for the Théâtre d'Art, December 11 [Boyer 1988, 8; A. Terrasse 1989, 2]; a second version of this drawing, in watercolor, is dated 1892 [Giambruni 1983, pp. 143, 401].

Moulin Rouge (figs. 133, 134): four ink, watercolor, and pastel designs for an unpublished poster [cat. 5].

Villa Bach (figs. 52, 53): twenty-four ink-and-watercolor program designs for concerts at the Terrasse villa in Arcachon [cat. 6, 7].

[1891]

Espièglerie: three ink-and-watercolor designs for an unpub-

lished cover to a piano piece by Francis Thomé [Boyer 1988, 34; Hôtel Drouot, Paris, sale cat., June 17, 1989, lot 13].

Suite pour piano (fig. 111): three designs in pencil and ink for an unpublished cover to three piano pieces by Claude Terrasse [Perucchi-Petri 1976, p. 64; Boyer 1988, 33; A. Terrasse 1989, p. 313].

[1891–92]

Le Cid: watercolor design for a poster or sheet-music cover for the opera by Jules Massenet [Boyer 1988, 11].

1892

Cheval: illustration in *Le Livre d'art,* program for the Théâtre d'Art, March 28 and 30, 1892 [A. Terrasse 1989, 3].

Family Scene (figs. 58, 60): color lithograph [cat. 13].

Menuet: watercolor design for a sheet-music cover, rejected by the music publisher Cranz; used to illustrate G.-Albert Aurier, "Les Symbolistes," *La Revue encyclopédique,* no. 32, April 1, and the magazine *La Croisade,* April 1893 [A. Terrasse 1989, 4].

Reine de joie: Moeurs du demi-monde by Victor Joze (fig. 204): color-lithographed, wraparound cover for the book published by Henry Julien, Paris [Bouvet 3].

Woman and Child in the Street: illustration in G.-Albert Aurier, "Les Symbolistes," *La Revue encyclopédique,* no. 32, April 1 [A. Terrasse 1989, 5].

1893

Alphabet sentimental (figs. 79, 80, 93): five or six designs in pencil, ink, and watercolor for an unfinished alphabet book [Denys Sutton, *Pierre Bonnard, 1867–1947,* exh. cat., London: Royal Academy of Arts, 1966, no. 260; Antoine Terrasse, "Le Dessin de Bonnard," *L'Oeil,* November 1968, p. 15; A. Terrasse 1989, p. 312].

L'Amusement des enfants—La Tranquillité des parents: lithograph published by *L'Escarmouche* and reproduced in the magazine, no. 8, December 31 [Bouvet 26 as "Municipal Guard"].

Les Chiens (fig. 166): lithograph published by *L'Escarmouche* and reproduced in the magazine, no. 5, December 10 [cat. 25].

Conversation (figs. 12–14): lithograph published by the magazine *L'Escarmouche* [Bouvet 28].

Dans l'intimité (figs. 206, 208): lithograph published by *L'Escarmouche* and reproduced in the magazine, no. 2, January 14, 1894 [cat. 27, 28].

Family Scene (fig. 62): color lithograph in *L'Estampe originale,* Album I, March 30 [cat. 17].

Parisiennes (fig. 144): lithograph published in *La Revue blanche,* no. 26, December 1893, and reprinted in the *Petite Suite de la Revue blanche,* 1895 [cat. 30].

Petit Solfège illustré (figs. 9–11, 54, 55, 64, 65, 70, 71, 73–78, 112): front and back covers and thirty lithographs, most in color, for the music primer by Claude Terrasse; begun in 1891 [cat. 19–24].

1894

L'Oeuvre: logo used in publicity for the Théâtre de l'Oeuvre, e.g., in *La Revue blanche,* no. 46, May 1, 1895 [A. Terrasse 1989, 7].

La Revue blanche (figs. 151, 152): color-lithographed poster for the magazine [cat. 33, 34].

The Tub (fig. 205): lithograph in the catalogue for the exhibition sponsored by *La Dépêche de Toulouse,* May [Bouvet 29].

Woman with an Umbrella (figs. 145–148): color lithograph published in *La Revue blanche,* no. 35, September 1894, and reprinted in the *Album de la Revue blanche,* 1895 [cat. 31, 32].

[1894–95]

J'ai tout donné pour rien: design in charcoal and ink for unpublished sheet music for a poem by Théophile Gautier set to music by Claude Terrasse; datable to late 1894 or early 1895 by letters from Claude Terrasse to Bonnard [Denys Sutton, *Pierre Bonnard, 1867–1947,* exh. cat., London: Royal Academy of Arts, 1966, no. 13; Acquavella Galleries, *Pierre Bonnard,* New York, 1977, no. 5].

1895

Album de la Revue blanche (fig. 18): lithographed cover to the portfolio of prints published by *L'Estampe originale* for *La Revue blanche* magazine [Bouvet 34].

Card Game by Lamplight (fig. 118): color lithograph, published in *L'Epreuve,* nos. 9–10, August–September [cat. 44].

The Great-Grandmother (fig. 115): color lithograph, published in *L'Epreuve,* nos. 11–12 [cat. 45].

Nib carnavalesque (fig. 137): lithographs illustrating a four-page supplement to *La Revue blanche*, April 1; text by Romain Coolus [Bouvet 32].

Petites Scènes familières (figs. 81, 83, 84, 86–88, 136): album of piano music by Claude Terrasse with nineteen lithographed illustrations and a cover, published by E. Fromont, Paris; begun in 1893 [cat. 40–43].

Promenade (fig. 156): color-lithographed four-panel folding screen published by Molines, Galerie Laffitte, Paris [cat. 36].

[1895]

The Schoolgirl's Return (figs. 159, 160): color lithograph [cat. 38, 39].

1896

Les Peintres-graveurs (fig. 23): color-lithographed poster for the exhibition at the Galerie Vollard, June 15–July 20 [Bouvet 38].

La Petite Blanchisseuse (figs. 161–164): color lithograph, probably begun in 1895, published by Ambroise Vollard for the *Album des peintres-graveurs* [cat. 48–51].

Salon des Cent (fig. 19): color-lithographed poster for the exhibition, August–September [Bouvet 39].

Théâtre de l'Oeuvre (fig. 217): lithographed program cover for a triple bill opening April 21, made up of Maxime Gray's *La Dernière Croisade*, Pierre Quillard's *L'Errante*, and a translation by Jules Arène of a Chinese play, *La Fleur enlevée* [Bouvet 37; Geneviève Aitken, ''Les Peintres et le théâtre autour de 1900 à Paris,'' *mémoire*, Ecole du Louvre, 1978, pp. 117–118].

[1896]

Eau de cologne: watercolor design for an unpublished poster advertising a cologne produced by the artist's brother, Charles, a chemist [Natanson 1951, fig. 12].

[1896–97]

Le Cri de Paris: ink design for an unpublished poster advertising the magazine founded by Alexandre Natanson in November 1896 [C. Terrasse 1927, p. 52].

1897

Album d'estampes originales de la Galerie Vollard (figs. 24–28): color-lithographed, wraparound cover and lithographed title, contents, and end pages for Vollard's second print album [Bouvet 41, cover only; Eberhard W. Kornfeld and Christine E. Stauffer, *Von Goya bis Warhol: Meisterwerke der Graphik des 19. und 20. Jahrhunderts aus einer Schweizer Privatsammlung*, exh. cat., Winterthur: Kunstmuseum, 1985, pp. 98–99].

Le Canotage (fig. 29): color lithograph in *Album d'estampes originales de la Galerie Vollard* [cat. 53].

L'Estampe et l'affiche: color-lithographed poster offered as a premium with the first issue, dated March 15, of the magazine edited by Clément-Janin and André Mellerio [Bouvet 44].

Marie by Peter Nansen (figs. 210, 213–215): nineteen illustrations for the novel, published serially in *La Revue blanche*, nos. 94–97, May 1–June 15, 1897; published as a book by Editions de la Revue Blanche, 1898 [cat. 58].

L'Omnibus de Corinthe: lithograph published by Fernand Clerget for the quarterly magazine [Bouvet 45].

[1897]

Child in Lamplight (fig. 119): color lithograph, probably intended for Ambroise Vollard's third (unpublished) print album [cat. 54].

1898

Birth Announcement for Marie-Louise Mellerio (fig. 82): color lithograph announcing the birth of the daughter of André Mellerio [cat. 57].

La Lithographie originale en couleurs by André Mellerio (fig. 33): color-lithographed cover and frontispiece for the book published by *L'Estampe et l'affiche* [Bouvet 52, 53].

Répertoire des Pantins: six lithographed covers for songs in the marionette theater's repertory; music by Claude Terrasse, lyrics by Franc-Nohain; published by *Mercure de France* for the Théâtre des Pantins [Bouvet 46–51].

1899

Almanach du Père Ubu illustré by Alfred Jarry: twenty illustrations for the ''petit'' almanac published by Ambroise Vollard (unnamed); Charles Bonnard, the artist's brother, given as *gérant* [A. Terrasse 1989, 9].

The Orchard (fig. 246): color lithograph in *Germinal, Album de XX estampes originales* published by Julius Meier-Graefe, Paris [cat. 79].

Panthéon-Courcelles: color lithograph for front cover and title page of sheet music for *Lieds de Montmartre*, no. 1; music by Claude Terrasse and lyrics by Georges Courteline [Bouvet 57].

Quelques Aspects de la vie de Paris (figs. 2, 34–36, 139, 168, 169, 171, 175, 179, 181, 182, 186–193, 195): suite of twelve color lithographs and title page published by Ambroise Vollard; begun in 1895 or 1896 [cat. 59–77].

[1899]

Fables by Jean de La Fontaine (fig. 108): 121 marginal illustrations drawn in a copy of the 1876 edition published by Delarue, Paris [Claude Roger-Marx, "Bonnard, illustrateur de La Fontaine," *Le Portique* 5, 1947, pp. 42–50].

1900

Bernheim-Jeune et fils: illustration of a seated female nude in the catalogue for the group exhibition in Paris, April 2–22 [Bernheim-Jeune et fils, *Oeuvres de Bonnard, Maurice Denis, Ibels . . .*, Paris, 1900, n.p.].

The Boulevards: color lithograph published in *Das Mappenwerk der Insel* by Insel Verlag, Leipzig [Bouvet 72].

Parallèlement by Paul Verlaine (figs. 37, 38, 222, 223, 225, 227–231): 108 color-lithographed illustrations plus a color-lithographed frontispiece and nine wood engravings in the book published by Ambroise Vollard; begun in 1897 or 1898 [cat. 82–87].

1901

Almanach illustré du Père Ubu (XXe siècle) by Alfred Jarry (figs. 220, 221): seventy-nine lithographs in red or blue for the "grand" almanac published by Ambroise Vollard (unnamed) [A. Terrasse 1989, 10].

La Plume: two illustrations and a tailpiece for the magazine, no. 287, April 1, p. 212, and no. 290, May 15, pp. 351, 355 [A. Terrasse 1989, 12].

La Revue blanche: eleven vignettes published in the magazine, nos. 185–190, some of which were repeated in later issues [A. Terrasse 1989, 11].

1902

Daphnis et Chloé by Longus (figs. 39, 94, 234, 236–239, 241, 248, 249): 151 lithographs and one wood engraving in the book published by Ambroise Vollard [cat. 89–94].

La Leçon d'amour dans un parc by René Boylesve: cover illustration for the novel published by Editions de la Revue Blanche [A. Terrasse 1989, 13].

Messaline by Alfred Jarry: illustration in an advertisement for the novel in *La Revue blanche*, no. 209, February 15 [A. Terrasse 1989, 14].

Le Surmâle by Alfred Jarry: illustration in an advertisement for the novel in *La Revue blanche*, no. 218, July 1 [A. Terrasse 1989, 15].

[1902–1905]

Contes italiens (fig. 40): twenty-two drawings to illustrate translations by Victor Barrucand intended for publication by *La Revue blanche*; one of these illustrations was published in Isabelle Eberhardt's *Notes de route* (1908) and appeared again, with six others, in Barrucand's *D'un pays plus beau* (1910) [Nicolas Rauch, *Les Peintres et le livre, 1867–1957*, Geneva, 1957, pp. 34–36].

1903

Le Figaro: color-lithographed poster for the newspaper [Bouvet 77].

Lire dans Le Figaro: color-lithographed poster announcing a novel by Abel Hermant to appear in the newspaper [Bouvet 78].

Soleil de printemps by Alfred Jarry: twelve illustrations in *Le Canard sauvage*, March 21–28 [A. Terrasse 1989, 16].

[1904]

Histoires naturelles by Jules Renard (figs. 45, 99, 100, 104, 106, 107): sixty-seven illustrations and a cover for the book published by Ernest Flammarion, Paris [cat. 95–98].

1906

Exposition Bonnard, Bernheim-Jeune: illustration of a standing female nude on the announcement of the exhibition, November 9–20 [A. Terrasse 1989, 18].

1908

Thadée Natanson Sale Catalogue: drawing for an unpublished colophon for the catalogue of the Natanson Collection sale, June 13 [A. Terrasse 1989, p. 310].

Notes de route: Maroc–Algérie–Tunisie by Isabelle Eberhardt: illustration of a woman and a horse in the book published by Eugène Fasquelle, Paris; repeated in Victor Barrucand's *D'un pays plus beau* (1910) [A. Terrasse 1989, 19, 24].

La 628-E8 by Octave Mirbeau (figs. 46, 252): a cover and thirty-nine marginal illustrations for the deluxe edition of the book published by Eugène Fasquelle, Paris [A. Terrasse 1989, 20].

1909

Exposition Bonnard (Oeuvres récentes), Bernheim-Jeune & Cie: illustration of a young woman on the invitation to the exhibition, February 1–20; later reused by the gallery [A. Terrasse 1989, 22].

Der schlechtgefesselte Prometheus by André Gide: six illustrations for the first German edition of the book published by Hans von Weber, Munich; second edition printed by Hyperionverlag, Berlin, 1919 [A. Terrasse 1989, 21].

Le Vieux Page by Francis de Croisset: illustration of a woman with Eros for a poem published in the magazine *Schéhérazade*, December 25 [A. Terrasse 1989, 23].

1910

D'un pays plus beau: Afrique, Espagne, Italie. Heures de France by Victor Barrucand (fig. 40): seven illustrations in the book published by H. Floury, Paris; the last illustration repeats one in Isabelle Eberhardt's *Notes de route* (1908) [A. Terrasse 1989, 24].

1912

Les Cahiers d'aujourd'hui: five marginal illustrations for the December issue (no. 2) of the magazine edited by George Besson [A. Terrasse 1989, 26].

Salon d'Automne: color-lithographed poster for the exhibition, October 1–November 8 [Bouvet 79].

Salon d'Automne 1912: illustration on the cover of the exhibition catalogue; also used on the invitation [A. Terrasse 1989, 25].

1913

Bernheim-Jeune & Cie: color lithograph of a standing female nude on the cover of a gallery announcement [Bouvet 80, 81, incorrectly cited as two different works].

Croquis d'après le "Dingo" de M. Octave Mirbeau: marginal illustration in the June issue (no. 5) of *Les Cahiers d'aujourd'hui* [A. Terrasse 1989, 28].

Claude Terrasse: portrait illustration for the menu of a banquet given on February 24 by Le Gratin, Société dauphinoise; reprinted in the August issue (no. 23) of the magazine of the same name [A. Terrasse 1989, 27].

1914

Cézanne by Octave Mirbeau et al.: lithograph of a bather after Cézanne for the book published by Bernheim-Jeune & Cie [Bouvet 82].

Les Constructeurs by Elie Faure: headpiece illustration of a mermaid for the chapter on Lamarck in the book published by G. Crès et Cie, Paris [A. Terrasse 1989, 29].

Légende de Joseph (figs. 140, 141): color-lithographed poster for the Ballets Russes [Bouvet 83].

Les Marges: four illustrations for Pierre Laprade's essay, "Bonnard," in the June 15 issue (no. 50) of the magazine [A. Terrasse 1989, 30].

[1914–16]

Auguste Renoir: portrait, etching and drypoint, commissioned by Ambroise Vollard [Bouvet 84].

1915

Le Blessé dans sa famille: illustration for the *Album national de la guerre* published for the Comité de la fraternité des artistes by Bernheim-Jeune & Cie [A. Terrasse 1989, 31].

1917

Bonnard Exposition, Bernheim-Jeune & Cie: illustration of a standing female nude on the invitation to the exhibition, October 25–November 3 [A. Terrasse 1989, 32].

Le Père Ubu à l'hôpital by Ambroise Vollard: two illustrations, one repeated on the cover, for the booklet published by Georges Crès et Cie, Paris, reprinted (with text changes) in 1918 [A. Terrasse 1989, 33].

[1917–20]

Le Plus Beau Site de la Normandie: pastel design for an unpublished poster advertising a beach resort [Günter Busch, "'Projet d'affiche pour une plage'—Ein Plakatentwurf von Pierre Bonnard in der Kunsthalle Bremen," in *Festschrift Dr. H. C. Eduard Trautscholdt zum siebzigsten Geburtstag*, Hamburg, 1965, pp. 164–169].

1918

Le Père Ubu à l'aviation by Ambroise Vollard: two illustrations, one repeated on the cover, for the booklet published by Georges Crès et Cie, Paris [A. Terrasse 1989, 34].

1919

Bulletin de la vie artistique: lithographed poster for the magazine published by Editions Bernheim-Jeune [Bouvet 85].

1920

Le Prométhée mal enchaîné by André Gide: forty-three illustrations and a cover for the book published by Editions de la Nouvelle Revue Française, Paris [A. Terrasse 1989, 35].

[1920]

Bookplates for Misia Natanson Edwards Sert: a sheet of preliminary designs in drypoint [Bouvet 86].

Bookplates for Charles Terrasse: two designs in drypoint [Bouvet 87, 87a].

1921

Les Cahiers d'aujourd'hui: two illustrations in the May issue (no. 4) of the magazine [A. Terrasse 1989, 36].

1922

Bonnard by Gustave Coquiot: cover design and seven vignettes for the book published by Editions Bernheim-Jeune, Paris [A. Terrasse 1989, 39].

Les Cahiers d'aujourd'hui: illustration (self-portrait) in the May issue (no. 10) of the magazine [A. Terrasse 1989, 37].

Notes sur l'amour by Claude Anet: a cover design and thirteen illustrations engraved on wood by Yvonne Mailliez for the book published by G. Crès & Cie, Paris [A. Terrasse 1989, 38].

Place Clichy (figs. 197, 198): color lithograph published by Bernheim-Jeune [cat. 101, 102].

1923

Histoire du poisson scie et du poisson marteau by Léopold Chauveau: thirty-eight illustrations, one repeated on the cover, for the book published by Payot & Cie, Paris; reprinted in Henry de Montherlant, *La Rédemption par les bêtes*, Paris: Fernand Mourlot (private edition), 1959 [A. Terrasse 1989, 40, 40a].

1924

L'Ame du cirque by Louise Hervieu: illustration of a bareback rider for the book published by Sant'Andréa-Mancerou et Cie, Paris [A. Terrasse 1989, 43].

Pierre Bonnard by Claude Roger-Marx: cover and title-page illustration (self-portrait) engraved on wood by Yvonne Mailliez for the book published by Editions de la Nouvelle Revue Française [A. Terrasse 1989, 42].

Dingo by Octave Mirbeau (figs. 41, 50, 95, 101–103, 167, 201, 254, 255): fifty-five etched illustrations, begun about 1913, for the book published by Ambroise Vollard, Paris [cat. 103–106].

Seins by Ramón Gómez de la Serna: seven illustrations for a special issue of *Les Cahiers d'aujourd'hui*, no. 15 [A. Terrasse 1989, 41].

[1924]

Ambroise Vollard (fig. 21): portrait etching commissioned by Vollard [Bouvet 89].

1925

Birth Announcement for Claude Terrasse: illustration announcing the birth of Bonnard's grandnephew, son of M. and Mme Jean Terrasse, October 11 [A. Terrasse 1989, 44].

La Fin d'un monde by Claude Anet: vignette of an Upper Paleolithic ivory female head for the novel published by Bernard Grasset, Paris [A. Terrasse 1989, 45].

Maîtres et petits maîtres d'aujourd'hui: Pierre Bonnard, peintre et lithographe (fig. 48): a portfolio of four lithographs published by Edmond Frapier, Galerie des Peintres-Graveurs, Paris [Bouvet 93–96; cat. 111].

[1925]

Le Bain (fig. 261): lithograph in the album *Les Peintres-lithographes de Manet à Matisse* published by Edmond Frapier, Galerie des Peintres-Graveurs, Paris [cat. 109].

The Letter: lithograph published by Frapier [Bouvet 98].

The Menu (figs. 120, 121): lithograph published by Frapier [cat. 107, 108].

Au petit chien qui fume: ink design for a shop sign or placard [Floralies, Versailles, sale cat., June 10, 1987, lot 106].

La Rue Molitor: lithograph published by Frapier [Bouvet 100].

Standing Nude (fig. 260): lithograph published by Frapier [cat. 110].

1926

Birth Announcement for André Terrasse: illustration announcing the birth of Bonnard's grandnephew, son of M. and Mme Jean Terrasse, October 26 [A. Terrasse 1989, 47].

En suivant la Seine by Gustave Coquiot: three illustrations for the book published by André Delpech, Paris [A. Terrasse 1989, 46].

1927

Art d'aujourd'hui: drypoint of an old woman, child, and dachshund, for a deluxe edition [Bouvet 104].

Bonnard by Charles Terrasse: cover illustration of a female bather (repeated as a frontispiece) and two drypoints, *Toilette* and *Trottins*, the first version of which, along with the etching *French Windows*, was rejected; for the book published by Floury, Paris [Bouvet 106–108, 108a; A. Terrasse 1989, 48].

Les Histoires du petit Renaud by Léopold Chauveau (figs. 47, 96): forty-nine illustrations with stenciled coloring (one repeated on the cover and title page) for the book published by Librairie Gallimard, Paris [A. Terrasse 1989, 49].

Tableaux de Paris by Paul Valéry et al. (fig. 200): lithograph frontispiece, *The Street*, in the book published by Emile-Paul Frères, Paris [Bouvet 105].

[1927–29]

Last Light (fig. 256): lithograph commissioned by Edmond Frapier, but never published in an edition [cat. 112].

Nightfall: lithograph commissioned by Frapier, but never published in an edition [Bouvet 102].

Stockings: lithograph commissioned by Frapier, but never published in an edition [Bouvet 101].

Two Nudes: drypoint, perhaps for an album of nudes planned by Ambroise Vollard [Bouvet 109].

1929

Maria Lani by Jean Cocteau et al.: an illustration for the book published by Editions des Quatre Chemins, Paris [Bernard Thibault, "Essai de bibliographie des ouvrages illustrés par Pierre Bonnard," *Le Portique* 7 (1950), p. 20].

Sainte Monique by Ambroise Vollard (figs. 42, 258): 17 etchings, 29 lithographs, and 178 wood engravings begun in 1920 for the book published by Ambroise Vollard, Paris [cat. 113].

Simili by Claude Roger-Marx: seven drypoint illustrations for the text of the play published by Au Sans Pareil, Paris [Bouvet 112].

La Vénus de Cyrène by Josse Bernheim-Jeune: illustration for the cover of the novel published by G. Crès et Cie, Paris [A. Terrasse 1989, 50].

[1930]

The Bath Mitt: drypoint [Bouvet 110].

1931

Les Ballets suédois dans l'art contemporain by Fokine et al.: illustration in the book published by Editions du Trianon, Paris [Bernard Thibault, "Essai de bibliographie des ouvrages illustrés par Pierre Bonnard," *Le Portique* 7 (1950) p. 20].

Birth Announcement for Pierre François Marie Floury: drypoint announcing the birth of Bonnard's grandnephew, June 6 [Christie's, New York, sale cat., September 17, 1986].

1932

Birth Announcement for Françoise Marie Claude Antoinette Floury: drypoint announcing the birth of Bonnard's grandniece, July 14 [Bouvet 113].

1937

Paris 1937 by Paul Valéry et al. (fig. 43): etching and drypoint, *Le Parc Monceau*, in the book published by Daragnès, Paris [Bouvet 114].

1938

En écoutant Cézanne, Degas, Renoir by Ambroise Vollard: illustration (portrait of Ambroise Vollard) on the title page of the book published by Bernard Grasset, Paris [A. Terrasse 1989, 51].

Verve: wraparound cover for the summer issue (vol. 1, no. 3) of the magazine published by Tériade [A. Terrasse 1989, 52].

1942

Maurice Chevalier recital: illustration on the program cover, dated August 14, of a woman seated in her bath [Bouvet 115].

[1942–46]

Bonnard-Villon collaboration: eleven color lithographs by Jacques Villon after gouaches by Bonnard; project conceived by the publisher Louis Carré [Bouvet 116–126].

1944

De Jeanne d'Arc à Philippe Pétain by Sacha Guitry: reproduction of a 1942 gouache (a bouquet dedicated "hommage de Pierre Bonnard à Octave Mirbeau") in the folio published by Sant'Andréa and Lafuma [A. Terrasse 1989, 53].

Correspondances by Pierre Bonnard: cover, title page, and twenty-eight illustrations for a book of semifictional Bonnard family letters, published by Tériade, Editions de la Revue Verve, Paris [A. Terrasse 1989, 54].

Trois Oiseaux by André Beucler: seven zincographs for an unpublished text [Bouvet 129; Gaston Diehl, "Fidélité de Bonnard," *Comoedia*, April 15, 1944].

Visages d'enfants: lithograph, for a charity auction at Hôtel Drouot, Paris, May 26, benefiting children evacuated from the Alpes-Maritimes [Bouvet 127].

1945

F.F. ou le critique by Jean Paulhan: illustration of a woman on a beach for the book published by Editions Gallimard, Paris [A. Terrasse 1989, 55].

Guérin-Thomé catalogue: drawing in lithographic crayon on transfer paper of a child by a doorway, intended as a frontispiece to the revised catalogue of Bonnard's prints by Marcel Guérin and J. R. Thomé, planned by Jean Floury but never published [see chapter 1, note 56].

1946

Le Crépuscule des nymphes by Pierre Louÿs: twenty-four lithographs for the book published by Editions Pierre Tisné [Bouvet 128].

Eloge de Pierre Bonnard by Léon Werth: ten lithographs printed by André Clot in the book published by Manuel Brucker, Paris [Bernard Thibault, "Essai de bibliographie des ouvrages illustrés par Pierre Bonnard," *Le Portique* 7 (1950) p. 20].

La Table ronde: illustration of a female bather published in the first "cahier" [A. Terrasse 1989, 56].

1947

Belles Saisons by Colette: seven illustrations in the book published by La Gazette des Lettres, Paris [Bernard Thibault, "Essai de bibliographie des ouvrages illustrés par Pierre Bonnard," *Le Portique* 7 (1950) p. 20].

Christmas Card for Aimé Maeght [A. Terrasse 1989, 58].

Le Vent des épines by Jacques Kober: illustration of a frightened cat for a book of poetry published by Editions Pierre à feu, Paris [A. Terrasse 1989, 57].

Verve: wraparound cover and frontispiece of "Couleur de Bonnard," vol. 5, nos. 17 and 18, a special issue of the magazine devoted to the artist, published by Tériade [A. Terrasse 1989, 59].

ABBREVIATED REFERENCES

Bouvet
Bouvet, Francis. *Bonnard: The Complete Graphic Work*. Translated by Jane Brenton. New York and London, 1981.

Boyer 1988
Boyer, Patricia Eckert. "The Nabis, Parisian Vanguard Humorous Illustrators, and the Circle of the Chat Noir," pp. 1–79; and Catalogue, pp. 139ff. In *The Nabis and the Parisian Avant-Garde*, edited by Patricia Eckert Boyer. Exh. cat. New Brunswick, N.J., and London, 1988.

Burhan 1979
Burhan, Filiz Eda. "Vision and Visionaries: Nineteenth Century Psychological Theory. The Occult Sciences and the Formation of the Symbolist Aesthetic in France." Ph.D. diss. Princeton University, 1979.

Dauberville
Dauberville, Jean and Henry. *Bonnard: Catalogue raisonné de l'oeuvre peint*. 4 vols. Paris, 1965–74.

Denis 1920
Denis, Maurice. *Théories, 1890–1910, du symbolisme et de Gauguin vers un nouvel ordre classique*. 4th ed. Paris, 1920.

Floury
Floury, Jean. "Essai de catalogue de l'oeuvre gravé et lithographié de Pierre Bonnard." In C. Terrasse 1927, pp. 189–199.

Giambruni 1983
Giambruni, Helen Emery. "Early Bonnard, 1885–1900." Ph.D. diss., University of California, Berkeley, 1983.

Heilbrun and Néagu
Heilbrun, Françoise, and Néagu, Philippe. *Pierre Bonnard photographe*. Paris, 1987.

Natanson 1948
Natanson, Thadée. *Peints à leur tour*. Paris, 1948.

Natanson 1951
Natanson, Thadée. *Le Bonnard que je propose, 1867–1947*. Geneva, 1951.

Newman 1984
Newman, Sasha M., ed. *Bonnard: The Late Paintings*. Exh. cat. (Washington, D.C., and Dallas). New York and London, 1984.

Perucchi-Petri 1976
Perucchi-Petri, Ursula. *Die Nabis und Japan: Das Frühwerk von Bonnard, Vuillard und Denis*. Studien zur Kunst des neunzehnten Jahrhunderts 37. Munich, 1976.

Rewald 1943
Rewald, John, ed., with the assistance of Lucien Pissarro. *Camille Pissarro: Letters to His Son Lucien*. Translated from the French manuscript by Lionel Abel. New York, 1943.

Rewald 1948
Rewald, John. *Pierre Bonnard*. Exh. cat. New York, 1948.

Roger-Marx
Roger-Marx, Claude. *Bonnard lithographe*. Monte Carlo, 1952.

A. Terrasse 1967
Terrasse, Antoine. *Pierre Bonnard*. Paris, 1967.

A. Terrasse 1989
Terrasse, Antoine. *Pierre Bonnard, Illustrator: A Catalogue Raisonné*. Translated by Jean-Marie Clarke. New York, 1989.

C. Terrasse 1927
Terrasse, Charles. *Bonnard*. Paris, 1927.

SELECTED BIBLIOGRAPHY

Oeuvre Catalogues

Bouvet, Francis. *Bonnard: The Complete Graphic Work.* Translated by Jane Brenton. Introduction by Antoine Terrasse. New York: Rizzoli; and London: Thames and Hudson, 1981. French ed.: *Bonnard: L'Oeuvre gravé.* Paris: Flammarion, 1981.

Dauberville, Jean and Henry. *Bonnard: Catalogue raisonné de l'oeuvre peint.* 4 vols. Paris: Editions J. et H. Bernheim-Jeune, 1965–74.

Floury, Jean. "Essai de catalogue de l'oeuvre gravé et lithographié de Pierre Bonnard." In Terrasse, Charles. *Bonnard.* Paris: Henri Floury, 1927.

Heilbrun, Françoise, and Néagu, Philippe. *Pierre Bonnard photographe.* Paris: Philippe Sers, Réunion des Musées nationaux, 1987.

Roger-Marx, Claude. *Bonnard lithographe.* Monte Carlo: André Sauret, 1952.

Terrasse, Antoine. *Pierre Bonnard, Illustrator: A Catalogue Raisonné.* Translated by Jean-Marie Clarke. New York: Harry N. Abrams, 1989. French ed.: *Bonnard illustrateur: Catalogue raisonné.* Paris: Editions Adam Biro, 1988.

Thibault, Bernard. "Essai de bibliographie des ouvrages illustrés par Pierre Bonnard." *Le Portique* 7 (1950) pp. 19–20.

Exhibition and Sale Catalogues

American Federation of Arts. *Bonnard: Drawings from 1893–1946.* Texts by Antoine Terrasse and Patrick Heron. New York: The Finch College Museum of Art, 1972.

Arts Council of Great Britain. *Drawings by Bonnard.* Introduction by Sargy Mann. London, 1984.

Le Barc de Boutteville. *Peintres Impressionnistes et Symbolistes, 6e exposition.* Preface by Camille Mauclair. Paris, 1894.

Galerie des Beaux-Arts. *Hommage à Bonnard.* Essays by Philippe Le Leyzour and Claire Frèches-Thory. Bordeaux, 1986.

Becker, David P. *Drawings for Book Illustrations: The Hofer Collection.* Cambridge, Mass.: Department of Printing and Graphic Arts, Houghton Library, Harvard University, 1980, no. 43, pp. 56–58.

Huguette Berès. *Bonnard, illustrateur.* Paris, 1970.

———— *Graphisme de Bonnard.* Paris, 1981.

Pierre Berès. *L'Oeuvre graphique de Bonnard.* Paris, 1944.

———— *Pierre Bonnard: Dessins et aquarelles.* Paris, 1977.

Galerie Claude Bernard. *Bonnard: Dessins.* Preface by Pierre Schneider. Paris, 1972.

Bernheim-Jeune et Cie. *Exposition de tableaux par Bonnard, Roussel, Vallotton & Vuillard; sculptures de Aristide Maillol; suite de lithographies originales de Bonnard, M. Denis & Vuillard.* Paris, 1904.

———— *Coup de chapeau à Bonnard: Peintures, aquarelles, dessins, lithographies.* Paris, 1967.

Arsène Bonafous-Murat. *Artistes, amis, collaborateurs.* Paris, 1988.

Pierre Bonnard: Gemälde, Aquarelle, Zeichnungen und Druckgraphik. Text by Hans Platte. Hamburg: Kunstverein, 1970.

Boyer, Patricia Eckert, ed. *The Nabis and the Parisian Avant-Garde.* Essays by Patricia Eckert Boyer and Elizabeth Prelinger. New Brunswick, N.J., and London: Rutgers University Press and The Jane Voorhees Zimmerli Art Museum, 1988.

Carey, Francis, and Griffiths, Antony. *From Manet to Toulouse-Lautrec: French Lithographs, 1860–1900.* London: British Museum, 1978.

Cate, Phillip Dennis, and Boyer, Patricia Eckert. *The Circle of Toulouse-Lautrec: An Exhibition of the Work of the Artist and of His Close Associates.* New Brunswick, N.J.: The Jane Voorhees Zimmerli Art Museum, Rutgers, The State University of New Jersey, 1985.

Cate, Phillip Dennis, and Hitchings, Sinclair Hamilton. *The Color Revolution: Color Lithography in France, 1890–1900.* New Brunswick, N.J.: Rutgers University Art Gallery, 1978.

Centenaire de la lithographie, 1795–1895: Catalogue officiel de l'exposition. Paris, September 1895.

Sterling and Francine Clark Art Institute. *Pierre Bonnard: Lithographs.* Williamstown, Mass., 1963.

Cleve, Jane. *The Elisabeth Dean Collection: French Prints from La Belle Epoque.* Fresno, Calif.: Fresno Arts Center and Museum, 1986.

Colnaghi and Co. *A Survey of European Prints*. London, 1974.

Peter H. Deitsch. *Bonnard: Fifty Watercolors and Drawings for "Petit Solfège Illustré" (1893)*. New York, 1962.

Peter Deitsch Fine Arts, Inc. *Important Prints of the Nineteenth and Twentieth Centuries*. New York, 1968.

Dorival, Bernard, and Humbert, Agnès. *Bonnard, Vuillard, et les Nabis (1888–1903)*. Paris: Musée National d'Art Moderne, 1955.

Druick, Douglas, and Zegers, Peter. *La Pierre Parle: Lithography in France, 1848–1900*. Ottawa: National Gallery of Canada, 1981.

Galeries Durand-Ruel. *Exposition P. Bonnard*. Paris, 1896.

Fine Art Society. *Pierre Bonnard, 1867–1947: The Complete Collection of One Hundred Four Brush and Chinese Ink Drawings for Octave Mirbeau's 1908 Travelogue "La 628-E8."* Introduction by Richard Nathanson. London, 1978.

Garvey, Eleanor M. *The Artist and the Book, 1860–1960, in Western Europe and the United States*. Introduction by Philip Hofer. Boston: Museum of Fine Arts, 1961.

——— *A Catalogue of an Exhibition of the Philip Hofer Bequest in the Department of Printing and Graphic Arts*. Cambridge, Mass.: Harvard College Library, 1988.

Garvey, Eleanor M.; Smith, Anne B.; and Wick, Peter A. *The Turn of a Century, 1885–1910: Art Nouveau–Jugendstil Books*. Cambridge, Mass.: The Houghton Library, Harvard University, 1970.

Gerkens, Gerhard; Köcke, Ulrike; and Schnackenburg, Bernhard. *Die Stadt: Druckgraphische Zyklen des 19. und 20. Jahrhunderts*. Bremen: Kunsthalle, 1974.

Gradmann, Erwin. *Bonnard–Vuillard: Handzeichnungen, Druckgraphik*. Zurich: Eidgenössische Technische Hochschule, 1952.

Heusinger, Christian von. *Japonism: Bonnard, Vuillard, und Lautrec in europäischer Jugendstil Druckgraphik. Handzeichnungen und Aquarelle Plakate Illustrationen und Buchkunst um 1900 aus dem Besitz der Kunsthalle Bremen*. Bremen: Kunsthalle, 1965.

Hogben, Carol, and Watson, Rowan, eds. *From Manet to Hockney: Modern Illustrated Books*. London: Victoria and Albert Museum, 1985.

Johnson, Una E. *Ambroise Vollard, Editeur: Prints, Books, Bronzes*. New York: The Museum of Modern Art, 1977. Originally published in 1944 as *Ambroise Vollard, éditeur, 1867–1939*.

J.P.L. Fine Arts. *Pierre Bonnard (1867–1947): Drawings*. Introduction by Sargy Mann. London, 1979.

——— *Pierre Bonnard*. London, 1985.

——— *Pierre Bonnard: Drawings—Nudes, Portraits, Still Lifes, and Interior Subjects*. London, 1987.

——— *Pierre Bonnard: Drawings—Landscapes, Seascapes, and Exterior Subjects*. London, 1987.

Keller, Heinz. *Schenkung Vollard: Originalgraphik und illustrierte Bücher herausgegeben von Ambroise Vollard, 1867–1939*. Winterthur: Kunstverein, 1949.

Komanecky, Michael, and Butera, Virginia Fabbri. *The Folding Image: Screens by Western Artists of the Nineteenth and Twentieth Centuries*. New Haven: Yale University Art Gallery, 1984.

Kornfeld, Eberhard W., and Stauffer, Christine E. *Von Goya bis Warhol: Meisterwerke der Graphik des 19. und 20. Jahrhunderts aus einer Schweizer Privatsammlung*. Winterthur: Kunstmuseum, 1985.

Galerie Krugier & Cie. *Bonnard*. Suites no. 23. Texts by Antoine Terrasse and Hans R. Hahnloser. Geneva, 1969.

Galerie Laffitte. *Catalogue des peintures, pastels, aquarelles et dessins modernes*. Paris, 1895.

Leicester & Sickert Gallery. *Bonnard: Lithographs and Drawings*. London, 1932.

La Libre esthétique. Brussels, 1894.

——— Brussels, 1897.

Albert Loeb and Krugier Gallery. "Pierre Bonnard." *Taurus*, no. 11. New York, 1969.

Frederick Mulder. *Master Prints Catalogue 9*. London, 1984, no. 29 (ill.).

National Museum of Western Art. *Bonnard*. Text by Antoine Terrasse. Tokyo, 1968.

Newman, Sasha M., ed. *Bonnard: The Late Paintings*. Introduction by John Russell. Essays by Sasha M. Newman et al. [The Phillips Collection, Washington, D.C.; Dallas Museum of Art]. New York and London: Thames and Hudson, 1984.

Galerie de l'Oeil. *Dessins et tableaux de Pierre Bonnard*. Paris, 1968.

Orangerie des Tuileries. *Pierre Bonnard: Centenaire de sa naissance*. Preface by Antoine Terrasse. Paris, 1967.

Perucchi, Ursula, ed. *Nabis und Fauves: Zeichnungen, Aquarelle, Pastelle aus Schweizer Privatbesitz*. Zurich: Kunsthaus, 1982.

Paul Prouté. *Dessins . . . estampes anciennes . . . estampes originales*. Paris, 1985.

Nicolas Rauch. *Les Peintres et le livre, 1867–1957*. Catalogue no. 6. Geneva, 1957.

Stiftung Oskar Reinhart. *Pierre Bonnard: Daphnis und Chloe*. Winterthur, 1973.

Rewald, John. *Pierre Bonnard*. New York: The Museum of Modern Art; and Cleveland: The Cleveland Museum of Art, 1948.

Rich, Daniel Catton, and Stanton, Dorothy. *Loan Exhibition of Paintings and Prints by Pierre Bonnard and Edouard Vuillard.* Chicago: The Art Institute of Chicago, 1939.

Galerie Sapiro. *Dessins et aquarelles de Bonnard.* Paris, 1975.

Soby, James Thrall; Elliott, James; and Wheeler, Monroe. *Bonnard and His Environment.* New York: The Museum of Modern Art, 1964.

Patrick Sourget and Elisabeth Sourget. *Deux Cents Livres précieux de 1467 à 1959.* Luisant, 1986, no. 191, pp. 334–339.

Stein, Donna M., and Karshan, Donald H. *L'Estampe Originale: A Catalogue Raisonné.* New York: The Museum of Graphic Art, 1970.

Sutton, Denys. *Pierre Bonnard, 1867–1947.* Preface by Charles Wheeler. London: Royal Academy of Arts, 1966.

Swenson, Christine. *Nineteenth and Twentieth Century Prints: Selections from the Selma Erving Collection.* Northampton, Mass.: Smith College Museum of Art, 1984.

Swenson, Christine, et al. *The Selma Erving Collection: Nineteenth and Twentieth Century Prints.* Northampton, Mass.: Smith College Museum of Art, 1985.

Symmes, Marilyn F. *The Bareiss Collection of Modern Illustrated Books from Toulouse-Lautrec to Kiefer.* Toledo, Ohio: The Toledo Museum of Art, 1985.

Galerie Vollard. *Exposition P. Bonnard: Tableaux, paysages et intérieurs, livres illustrés, surtout de table en bronze.* Paris, 1906.

Victor Waddington. *Bonnard, 1867–1947: Drawings, Gouaches, Watercolors.* Text by Patrick Heron. London, 1966.

Waller, Bret, and Seiberling, Grace. *Artists of La Revue Blanche.* Rochester, N.Y.: Memorial Art Gallery of the University of Rochester, 1984.

Weyhe Gallery. *Pierre Bonnard: Drawings, Watercolors, Prints.* New York, 1942.

Wheeler, Monroe. *Modern Painters and Sculptors as Illustrators.* New York: The Museum of Modern Art, 1936.

Wildenstein and Co. *La Revue Blanche: Paris in the Days of Post-Impressionism and Symbolism.* Text by Georges Bernier. New York, 1983.

General

Aitken, Geneviève. "Les Peintres et le théâtre autour de 1900 à Paris." Ecole du Louvre, *mémoire*, 1978.

Alexandre, Arsène. *Le Figaro* (March 27, 1899).

Amoureux, Guy. *L'Univers de Bonnard: Les Carnets de dessins.* Paris: Henri Scrépel, 1985.

Ashton, Dore. "New York Commentary: [Peter Deitsch Gallery]." *The Studio* 165 (1963) p. 67.

Aurier, G.-Albert. "Choses d'art." *Mercure de France* 5 (1892) p. 280.

———— "Les Symbolistes." *La Revue encyclopédique* 2:32 (1892) pp. 475–486.

"Ausstellung, graphische Sammlung der ETH, Zürich." *Werk* 39:4 (1952) p. 38 supplement.

Bacot, Sylvie. "Bibliographie à propos du catalogue Bonnard." *Nouvelles de l'estampe* (November–December 1982) p. 48.

Benedikt, Michael. "The Continuity of Pierre Bonnard." *Art News* 63 (1964) pp. 20–23, 55–56.

Bonnard, Pierre. [Statement.] In Crauzat, E. de. "Murailles: Opinions des artistes et des critiques sur les concours d'affiches." *L'Estampe et l'affiche* (April 15, 1898) p. 87.

———— "Hommage à Odilon Redon." *La Vie* 4 (1912).

———— *Correspondances.* Paris: Tériade, Editions de la Revue Verve, 1944.

"Bonnard, i dipinti e l'opera grafica del maestro in mostra a Milano." *Le Arti*, n.s. 1 (April 1955) pp. 6–22.

"Bonnard Lithographs Shown at the Sterling and Francine Clark Art Institute." *American Artist* 27 (1963) p. 8.

"Bonnard's Graphics at the New York Galleries." *Art News* 47 (1948) p. 8.

Bouvier, Marguette. "Pierre Bonnard revient à la litho…." *Comoedia* 82 (January 23, 1943).

Buchheim, Lothar-Günther. *Um 1900: Lithographien von Toulouse-Lautrec, Bonnard, Vuillard.* Feldafing, Obb.: Buchheim Verlag, 1954.

Burhan, Filiz Eda. "Vision and Visionaries: Nineteenth Century Psychological Theory. The Occult Sciences and the Formation of the Symbolist Aesthetic in France." Ph.D. diss., Princeton University, 1979.

Busch, Günter. "'Projet d'affiche pour une plage'—Ein Plakatentwurf von Pierre Bonnard in der Kunsthalle Bremen." In *Festschrift Dr. H. C. Eduard Trautscholdt zum siebzigsten Geburtstag.* Hamburg, 1965, pp. 164–169.

Cassou, Jean. "Bonnard." *Arts et métiers graphiques* 46 (1935) pp. 9–18.

Cate, Phillip Dennis, ed. *The Graphic Arts and French Society, 1871–1914.* Essays by Phillip Dennis Cate, Ann Ilan-Alter, Jack Spector, and Patricia Eckert Boyer. New Brunswick, N.J., and London: Rutgers University Press, 1988.

Chapon, François. "Ambroise Vollard éditeur." *Gazette des Beaux-Arts*, 6th ser., 94 (1979) pp. 33–47; 95 (1980) pp. 25–38.

Clément-Janin. "L'Art dans le livre." *La Revue artistique de la famille* (1895) pp. 149–152.

———— [Review of *Parallèlement*.] "Les Editions de bibliophiles." *Almanach du bibliophile* (1901) pp. 245–246.

———— [Review of *Daphnis et Chloé*.] "Les Editions de bibliophiles." *Almanach du bibliophile* (1902) pp. 232–234.

Collins, Bradford Ray, Jr. "Jules Chéret and the Nineteenth-Century French Poster." Ph.D. diss., Yale University, 1980.

Coquiot, Gustave. *Bonnard*. Paris: Editions Bernheim-Jeune, 1922.

Cousturier, Edmond. "Galeries S. Bing." *La Revue blanche* 10:63 (1896) pp. 92–95.

———— "Exposition internationale du livre moderne à l'art nouveau." *La Revue blanche* 11:74 (1896) pp. 42–44.

Crauzat, E. de. "Murailles: Opinions des artistes et des critiques sur les concours d'affiches." *L'Estampe et l'affiche* (April 15, 1898) pp. 83–89.

Denis, Maurice. *Théories, 1890–1910, du symbolisme et de Gauguin vers un nouvel ordre classique*. 4th ed. Paris: L. Rouart et J. Watelin, 1920.

De Teliga, Jane. "Pierre Bonnard: Poster for *La Revue Blanche*." Collection Series: Prints and Drawings Collection I. Sydney: Art Gallery of New South Wales, 1981.

Diehl, Gaston. "Fidélité de Bonnard." *Comoedia* (April 15, 1944).

Dorival, Bernard. "'Le corsage à carreaux' et les japonismes de Bonnard." *La Revue du Louvre et des musées de France* 19:1 (1969) pp. 21–24.

"Les Estampes et les affiches du mois, février 1897." *L'Estampe et l'affiche* (March 15, 1897) p. 24.

"Les Estampes et les affiches du mois, décembre 1897–janvier 1898." *L'Estampe et l'affiche* (January 15, 1898) pp. 19–20.

"Les Estampes et les affiches du mois, mars–avril 1899." *L'Estampe et l'affiche* (April 15, 1899) p. 102.

"Expositions: Exposition de la deuxième année de l'album d'estampes originales, Galerie Vollard." *L'Estampe et l'affiche* (January 15, 1898) pp. 10–11.

Fénéon, Félix. "Sur les murs." *Le Chat noir* 10 (June 1891).

Fermigier, André. *Bonnard*. New York: Harry N. Abrams, 1969.

Garvey, Eleanor M. "Art Nouveau and the French Book of the Eighteen Nineties." *Harvard Library Bulletin* 12 (1958) pp. 375–391.

Gauthier, E. Paul. "Lithographs of the Revue Blanche, 1893–95." *Magazine of Art* 45 (1952) pp. 273–278.

Geffroy, Gustave. Introduction to the *Germinal* album (Editions de la Maison Moderne), reprinted in *La Critique* 5:119 (1900) pp. 22–23.

H.G. [Henri Ghéon]. "Lettre d'Angèle." *L'Ermitage* 10:5 (1899) pp. 394–395.

Giambruni, Helen Emery. "Bonnard's Lithographs." M.A. thesis, University of California, Berkeley, 1966.

———— "Early Bonnard, 1885–1900." Ph.D. diss., University of California, Berkeley, 1983.

Gilmour, Pat. "Cher Monsieur Clot... Auguste Clot and His Role as a Colour Lithographer." In *Lasting Impressions: Lithography as Art*. Edited by Pat Gilmour. Philadelphia: University of Pennsylvania Press, 1988.

Goldwater, Robert J. "'L'Affiche moderne': A Revival of Poster Art after 1880." *Gazette des Beaux-Arts*, 6th ser., 22 (1942) pp. 173–182.

———— "Symbolist Art and Theater: Vuillard, Bonnard, Maurice Denis." *Magazine of Art* 39 (1946) pp. 366–370.

"Graphic Exhibition at Deitsch Gallery." *Art News* 61 (1962) p. 12.

Groschwitz, Gustave von. "The Significance of XIX Century Color Lithography." *Gazette des Beaux-Arts*, 6th ser., 44 (1954) pp. 243–266.

Haggvist, A. "Des Peintures et des lithographies à la Galerie Svensk-Franska de Stockholm." *Arts* (February 27, 1948) p. 3.

Heilbut, E. "Lithographien von P. Bonnard." *Kunst und Künstler* 4 (1906) pp. 210–224.

Hermann, Fritz. *Die Revue blanche und die Nabis*. 2 vols. Munich: Mikrokopie G.m.b.H., 1959.

Hoefliger, Alfred. "Bonnard und Maillol als Illustratoren von 'Daphnis und Chloe.'" *Werk* 34:6 (1947) pp. 193–197.

Hofer, Philip. "Four Modern French Illustrated Bestiaries." *Gazette des Beaux-Arts*, 6th ser., 33 (1948) pp. 301–316.

———— "Some Precursors of the Modern Illustrated Book." *Harvard Library Bulletin* 4 (1950) pp. 191–202.

Humbert, Agnès. *Les Nabis et leur époque*. Geneva: Pierre Cailler, 1954.

Ives, Colta Feller. *The Great Wave: The Influence of Japanese Woodcuts on French Prints*. New York: The Metropolitan Museum of Art, 1974.

———— "French Prints in the Era of Impressionism and Symbolism." *The Metropolitan Museum of Art Bulletin* 46:1 (1988).

———— "Pierre Bonnard: *Place Clichy*." In The Metropolitan Museum of Art. *Recent Acquisitions: A Selection, 1987–1988*. New York, 1988, p. 41.

Jackson, A. B. *La Revue blanche (1889–1903): Origine, influence, bibliographie.* Paris: M. J. Minard, Lettres Modernes, 1960.

Jarry, Alfred. "Paul Verlaine: *Parallèlement*, illustré par Pierre Bonnard." *La Revue blanche* 24 (1901) p. 317.

Jean, René. "Pierre Bonnard: Illustrateur de *Daphnis et Chloé*." *Das graphische Kabinett* (1917) pp. 136–139.

Joachim, Harold. [The Art Institute of Chicago.] *French Drawings and Sketchbooks of the Nineteenth Century.* Chicago and London: University of Chicago Press, 1978.

Johnson, Lincoln F., Jr. "Toulouse-Lautrec, the Symbolists and Symbolism." Ph.D. diss., Harvard University, 1956.

Johnson, Una E. *Ambroise Vollard, Editeur, 1867–1939: An Appreciation and Catalogue.* New York: Wittenborn and Company, 1944.

—————— "Lithographs of Pierre Bonnard." *Brooklyn Museum Bulletin* 11:2 (1950) pp. 1–9.

Jourdain, Francis. "Sagesse de Bonnard." *Arts* 135 (1947) pp. 1, 5.

Kaposy, Véronique. "Une Feuille de croquis de Pierre Bonnard." *Bulletin du Musée Hongrois des Beaux-Arts* 44 (1975) pp. 123ff.

Lake, Carlton. *Baudelaire to Beckett: A Century of French Art and Literature. A Catalogue of Books, Manuscripts, and Related Material Drawn from The Collections of the Humanities Research Center.* Austin: The University of Texas, 1976.

Laprade, Jacques de. "Gravures, illustrations, dessins de Pierre Bonnard." *Formes et couleurs* 6:2, special issue (1944) pp. 50–62.

"Lithographies de Bonnard pour 'Parallèlement.'" *Labyrinthe* 16 (1946) pp. 7–9.

"The Little Laundress." In "Art Across North America: Outstanding Exhibitions." *Apollo* 98:137 (1973) pp. 59–60, fig. 3.

Lugné-Poe, Aurélien. *La Parade*: I. *Le Sot du tremplin: Souvenirs et impressions du théâtre.* Paris: Editions de la Nouvelle Revue Française, 1930.

G.M. "Studio Talk." *Studio* (October 1896) ill. pp. 67–68.

Mahé, Raymond. *Les Artistes illustrateurs: Répertoire des éditions de luxe de 1900 à 1928 inclus.* Paris: René Kieffer, 1943.

Maindron, Ernest. *Les Affiches illustrées (1889–1895).* Paris: G. Boudet, 1896.

Martini, Alberto. "Gli inizi difficili di Pierre Bonnard." *Arte antica e moderna* 1 (1958) pp. 255–279.

Marx, Roger. "L'Art décoratif et les symbolistes." *Le Voltaire* (August 23, 1892) p. 1.

—————— "Mouvement des arts décoratifs." *La Revue encyclopédique* 2:45 (1892) pp. 234–235.

—————— "Les Arts décoratifs (1893–1894)." *La Revue encyclopédique* 4:77 (1894) pp. 73–78.

—————— "Toulouse-Lautrec et Pierre Bonnard." *Le Voltaire* (February 9, 1896) p. 1.

Mauner, George L. *The Nabis: Their History and Their Art, 1888–1896.* New York and London: Garland Publishing, 1978.

Mellerio, André. "Exposition de tableaux et gravures de Pierre Bonnard." *La Revue artistique de la famille* 2:1 (1896) p. 15.

—————— *Le Mouvement idéaliste en peinture.* Paris: H. Floury, 1896.

—————— "Nos Illustrations." *L'Estampe et l'affiche* (March 15, 1897) p. 1.

—————— "La Rénovation de l'estampe: L'Estampe en 1896." *L'Estampe et l'affiche* (March 15, 1897) pp. 4–6.

—————— "L'Estampe en couleurs." *L'Estampe et l'affiche* (June 15, 1898) pp. 128–129.

—————— *La Lithographie originale en couleurs.* Paris: L'Estampe et l'Affiche, 1898.

—————— "Expositions: Les Editions Vollard (Exposition d'estampes)." *L'Estampe et l'affiche* (April 15, 1899) pp. 98–99.

Michel, Jacques. "Bonnard illustrateur." *Le Monde* (July 16, 1970).

Mornand, Pierre. "Pierre Bonnard." *Le Courrier graphique* 6 (1947) pp. 3–10.

—————— *Vingt-deux artistes du livre.* Paris: Le Courrier Graphique, 1948.

Munhall, Edgar. Commentary. In Renard, Jules. *Natural Histories.* Translated by Richard Howard. Illustrations by Toulouse-Lautrec, Bonnard, and W. Stein. New York: Horizon Press, 1966.

Natanson, Thadée. "Expositions: II. Estampes et dessins de MM. H. de Toulouse-Lautrec, F. Vallotton et P. Bonnard." *La Revue blanche* 8:48 (1895) pp. 523–524.

—————— "Pierre Bonnard." *La Revue blanche* 10:63 (1896) pp. 71–74.

—————— "Petite Gazette d'art." *La Revue blanche* 15:117 (1898) pp. 614–619.

—————— "Des Peintres intelligents." *La Revue blanche* 21:166 (1900) pp. 53–56.

—————— *Peints à leur tour.* Paris: Editions Albin Michel, 1948.

—————— "Le Bonnard que je propose." *Art-Documents* 1 (1950) p. 7.

—————— *Le Bonnard que je propose, 1867–1947.* Geneva: Pierre Cailler, 1951.

"Parisian Prints at Museum of Modern Art." *Art News* 48 (1949) p. 47.

Parrot, Louis. "Pierre Bonnard et le livre." *Les Lettres françaises* 4:34 (December 16, 1944) p. 3.

Perucchi-Petri, Ursula. *Die Nabis und Japan: Das Frühwerk von Bonnard, Vuillard und Denis.* Studien zur Kunst des neunzehnten Jahrhunderts 37. Munich: Prestel Verlag, 1976.

The Phillips Collection: A Summary Catalogue. Washington, D.C., 1985.

Pia, Pascal. "Ambroise Vollard, marchand et éditeur." *L'Oeil* 3 (1955) pp. 18–27.

Pouterman, J.-E. "Les Livres d'Ambroise Vollard." *Arts et métiers graphiques* 64 (1938) pp. 45–46.

Preston, Stuart. "Current and Forthcoming Exhibitions: Paris. Bonnard: *Graphisme de Bonnard* (at Huguette Berès . . .)." *Burlington Magazine* 124 (1982) p. 54.

Ray, Gordon N. *The Art of the French Illustrated Book, 1700 to 1914.* 2 vols. New York: The Pierpont Morgan Library; and Ithaca, N.Y.: Cornell University Press, 1982.

Rewald, John. *Bonnard.* [Prefatory statement in portfolio of six reproductions of lithographs.] New York: Albert Carman for The Museum of Modern Art, 1948.

——— *Post-Impressionism: From Van Gogh to Gauguin.* 3rd rev. ed. New York: The Museum of Modern Art, 1978.

Rewald, John, ed., with the assistance of Lucien Pissarro. *Camille Pissarro: Letters to His Son Lucien.* Translated from the French manuscript by Lionel Abel. New York: Pantheon Books, 1943.

Robichez, Jacques. *Le Symbolisme au théâtre: Lugné-Poe et les débuts de l'Oeuvre.* Paris: L'Arche, 1957.

Roger-Marx, Claude. "Bonnard: Illustrateur et lithographe." *Art et décoration* 43 (1923) pp. 115–120.

——— "Les Illustrations de Bonnard." *Plaisir du bibliophile* 2:5 (1926) pp. 1–10.

——— "Pierre Bonnard: Painter, Illustrator, and Portrayer of the Elements of Parisian Middle-Class Life." *Creative Art* 7, incorporating *The Studio* 100 (1930) pp. 112–115.

——— "L'Oeuvre gravé de Pierre Bonnard." *L'Art vivant* 145 (1931) pp. 2–5.

——— *Pierre Bonnard.* Les Artistes du Livre 19. Paris: Henry Babou, 1931.

——— *French Original Engravings from Manet to the Present Time.* New York and London: Hyperion Press, 1939. French ed.: *La Gravure originale en France de Manet à nos jours.* Paris: Editions Hypérion, 1939.

——— "Bonnard, illustrateur de La Fontaine." *Le Portique* 5 (1947) pp. 42–50.

——— "Les Lithographies de Bonnard." *Arts* (May 22, 1957).

——— *Graphic Art: The 19th Century.* Translated by E. M. Gwyer. New York, Toronto, and London: McGraw-Hill Book Company, 1962.

Rouir, Eugène. "Lithographs by Bonnard." *Print Collector* 3 (July–August 1973) pp. 8–23. First published as "Quelques Remarques sur les lithographies de Pierre Bonnard." *Le Livre et l'estampe* 53–54 (1968) pp. 27–35.

Russoli, Franco. "Bonnard e l'arte utile." *Casabella continuità* 205 (April–May 1955) pp. 78–79.

Saunier, Charles. "Notes d'art." *La Revue indépendante* 22:63 (1892) p. 143.

Sertat, Raoul. "La Société des Peintres-Graveurs." *La Revue encyclopédique* 2:40 (1892) p. 1103.

Shapiro, Barbara Stern. "Pierre Bonnard: *Maisons dans la cour.*" In *Promised Gifts '77.* Poughkeepsie: Vassar College, 1977.

Skira, Albert. *Anthologie du livre illustré par les peintres et sculpteurs de l'Ecole de Paris.* Foreword by Claude Roger-Marx. Geneva: Editions Albert Skira, 1946.

Söderberg, Rolf. *French Book Illustration, 1880–1905.* Translated by Roger Tanner. Stockholm: Almqvist & Wiksell International, 1977.

Stubbe, Wolf. *Die Graphik des zwanzigsten Jahrhunderts.* Berlin: Rembrandt Verlag, 1962.

Sutton, Denys. "The 'Revue Blanche.'" *Signature: A Quadrimestrial of Typography and Graphic Arts,* n.s. 18 (1954) pp. 21–43.

Terrasse, Antoine. *Pierre Bonnard.* Paris: Gallimard, 1967.

——— "Le Dessin de Bonnard." *L'Oeil* 167 (1968) pp. 10–17.

——— *Bonnard Posters and Lithographs.* New York: Tudor, 1970.

Terrasse, Charles. *Bonnard.* Paris: Henri Floury, 1927.

——— "Bonnard: An Intimate Memoir of the Man and Artist Revealed by His Nephew." Translated by Shannon Eames. *Art News Annual* 28 (1959) pp. 84–107.

——— "Recollections of Bonnard." *Apollo* 83 (1966) pp. 62–67.

Thiem, Gunther. *Französische Maler illustrierten Bücher: Die illustrierten Bücher des 19. und 20. Jahrhunderts in der Graphischen Sammlung der Staatsgalerie Stuttgart.* Stuttgart: Höheren Fachschule für das graphische Gewerbe, 1965.

Thomé, J.-R. "Pierre Bonnard (1867–1947)." *Le Livre et ses amis* 3:17 (1947) pp. 9–17.

——— "Pierre Bonnard (1867–1947): Graveur et illustrateur." *Le Courrier graphique* 24:105 (1959) pp. 3–10.

Vaillant, Annette. *Bonnard ou le bonheur de voir*. Neuchâtel: Editions Ides et Calendes, 1965. English ed.: *Bonnard*. Translated by David Britt. Dialogue between Jean Cassou and Raymond Cogniat. Commentaries by Hans R. Hahnloser. Greenwich, Conn.: New York Graphic Society, 1966.

Verlaine, Paul. *Parallèlement*. Monte Carlo: Editions du Cap, 1957.

——— *Parallèlement*. Illustrations by Bonnard. [Frontispiece and 24 illustrations reproduced from the Vollard edition of 1900.] Les Peintres du Livre 2. Paris: Editions L.C.L., n.d.

Verve 5:17–18 (1947). Special issue: "Couleur de Bonnard." Contents: Charles Terrasse, introduction; E. Tériade, ed., "Propos de Pierre Bonnard à Tériade (Le Cannet, 1943)"; Angèle Lamotte, "Le Bouquet de roses: Propos de Pierre Bonnard recueillis en 1943."

Vollard, Ambroise. "Comment je devins éditeur." *L'Art vivant* (December 15, 1929).

——— "Catalogue complet des éditions Ambroise Vollard." Paris: Le Portique, 1930.

——— *Recollections of a Picture Dealer*. Translated from the original French manuscript by Violet M. MacDonald. Boston: Little, Brown and Co., 1936. French ed.: *Souvenirs d'un marchand de tableaux*. Paris: Editions Albin Michel, 1937, 1948. Bibliography edited by Bernard Gheerbrant. Paris: Club des Librairies de France, 1957.

Waldfogel, Melvin. "Bonnard and Vuillard as Lithographers." *The Minneapolis Institute of Arts Bulletin* 52 (1963) pp. 66–81.

Wang, Robert T. "The Graphic Art of the Nabis, 1888–1890." Ph.D. diss., University of Pittsburgh, 1974.

"Watercolors and Drawings at Weyhe." *Art News* 41 (1942) p. 26.

Werth, Léon. *Bonnard*. Paris: Georges Crès et Cie, 1923. First edition, 1919.

——— *Eloge de Pierre Bonnard, orné de dix lithographies*. Paris: Manuel Bruker, 1946.

——— "Pierre Bonnard illustrateur." *Le Portique* 7 (1950) pp. 9–17.

Photograph Credits

PHOTOGRAPHS have for the most part been supplied by the owners of the works reproduced. Exceptions and additional credits are listed below by figure number.

After Guy Amoureux, *L'Univers de Bonnard: Les Carnets de dessins* (Paris, 1985) 187
Artephot/Babey, 6
Charles Choffet, Besançon, 199
Christie's, London/A. C. Cooper Ltd., 40, 233
After Hôtel Drouot, sale cat. (May 16, 1955) 134
Fine Art Photography/Nathan Rabin, 18
Gallimard/Hubert Josse, 4, 20, 22, 32, 44
Lynton Gardiner, 63, 114
Rick Gardner, Houston, 70, 115, 129, 130, 144, 156, 159, 160, 167, 200
Helen Giambruni, 131, 173
Gerhard Howald, Bern, 60, 99, 104, 120, 244, 253, 259
Colta Ives, 37, 222
Hubert Josse, Paris, 1, 66, 102, 111, 128
Michel Kemps, 209
Galerie Jan Krugier, 52, 53
Marlborough Fine Art (London) Ltd., 217
After Marlborough Fine Art Ltd., *XIX and XX Century Masters* (London, 1959) 142
The Metropolitan Museum of Art Photograph Studio, 7
Robert Meulle, Reims, 194
Musée d'art et d'histoire, Fribourg, 58
After Musée Paul-Dupuy, *Nos Ancêtres les enfants* (Toulouse, 1983) 67
After National Museum of Western Art, *Bonnard* (Tokyo, 1968) 113
After Ursula Perucchi-Petri, *Die Nabis und Japan* (Munich, 1976) 153
Philip Pocock, 177
After *Le Portique* 5 (1947) 108
After Gordon N. Ray, *The Art of the French Illustrated Book, 1700 to 1914* (New York, 1982) 229, 230
Réunion des Musées Nationaux, 51, 68 (A. Guey), 90, 141, 158, 188, 212, 219, 224, 240, 242, 243
Rheinisches Bildarchiv, Cologne, 185
Robert D. Rubic, New York, 14, 42, 225, 226
Sotheby's, London, 76
E. V. Thaw & Co., New York, 79
Malcolm Varon, New York, 2, 29, 34, 62, 112, 139, 150, 151, 155, 161, 175, 179, 189–193, 195, 260
G.u.E. von Voithenberg, 11
Herbert P. Vose, 172
Wildenstein and Co., 132

INDEX

Catalogue and figure references precede page references.
Catalogue numbers are printed in bold type, figure numbers in italic.